Moira Roth

Native American Art and
the New York Avant-Garde

American Studies Series
William H. Goetzmann, Editor

Native American Art and the New York Avant-Garde

A History of Cultural Primitivism

W. Jackson Rushing

University of Texas Press
Austin

Copyright © 1995 by the
University of Texas Press

All rights reserved

Printed in the
United States of America

First edition, 1995

Requests for permission to reproduce material from
this work should be sent to Permissions, University
of Texas Press, Box 7819, Austin, TX 78713-7819.

∞ The paper used in this publication meets the
minimum requirements of American National Stan-
dard for Information Sciences—Permanence of Paper
for Printed Library Materials, ANSI z39.48-1984.

Publication of this book was supported by a grant
from the National Endowment for the Humanities,
an independent federal agency.

Library of Congress Cataloging-in-Publication Data

Rushing, William J. (William Jackson), 1950–
 Native American art and the New York avant-
garde : a history of cultural primitivism /
W. Jackson Rushing. — 1st ed.
 p. cm. — (American studies series)
 Includes bibliographical references and index.
 ISBN 0-292-75547-3
 1. Indian art—Collectors and collecting—United
States. 2. Indian art—United States—Themes,
motives. 3. Primitivism in art—New York (N.Y.)—
Themes, motives. 4. Avant-garde (Aesthetics—New
York (N.Y.)—History—20th century. 5. Art,
Modern—New York (N.Y.)—History—20th
century. I. Title. II. Series.

E98.A7R87 1995
759.13'09'04—dc20 94-14250

In memory of my father,
William J. Rushing, Jr., 1914–1994

Contents

Acknowledgments

The topic of this book, and of the doctoral dissertation on which it is based, was first suggested to me in the summer of 1983 by Linda Dalrymple Henderson, who chaired my committee and whose wisdom and encouragement have been of inestimable value. I thank her warmly and sincerely for both her patience and guidance. Several of my professional colleagues have offered constructive criticism of the manuscript at various points in its development. I am very grateful to them all and hereby absolve them from any responsibility for its content: Janet Catherine Berlo, John R. Clarke, Terence Grieder, Peter Jelavich, Susan Rather, Richard Shiff, M. Jane Young, and especially William H. Goetzmann, Ann Gibson, and Irving Sandler.

I benefited greatly from the recollections of many individuals, including Will Barnet, Fritz Bultman, Oscar Collier, Joe H. Herrera, Reuben Kadish, Richard Pousette-Dart, Helen Farr Sloan, and Joy S. Weber. My thanks to the members and former members of the Department of Twentieth-Century Art at the Los Angeles County Museum of Art for their cooperation and enthusiasm: Ann Carnegie Edgerton, Judy Freeman, Maria de Herrera, and Maurice Tuchman. Research support in New Mexico was provided by Phyllis M. Cohen, Museum of Fine Arts, Museum of New Mexico; Joseph Traugott and Tiska Blankenship, the Jonson Gallery of the University of New Mexico; Ellen Landis, the Albuquerque Museum; Julie Schimmel, University of Northern Arizona; and David Witt, the Harwood Museum, Taos.

My research in New York was facilitated by Janice Ekdahl and Clive Philpott, the Museum of Modern Art; Belinda Kaye, the American Museum of Natural History; Selene Singer, the National Museum of the American Indian; Ira Jacknis, formerly of the Brooklyn Museum; Bonnie Clearwater, formerly of the Mark Rothko Foundation; Elaine Barratti, the Whitney Museum of American Art; Steve Schlesinger; Francis V. O'Connor; and the Pollock-Krasner Foundation. Parts of Chapter 6 were written while in residence at the Pollock-Krasner House and Study Center on Long Island; a special thanks to Helen Harrison and her staff. Support in Washington, D.C., was provided by Charles Eldredge, formerly of the National Museum of American Art; Myles Libhart, Indian Arts and Crafts Board; Richard Crawford, National Archives; and Colleen Hennesey, formerly of the Archives of American Art. I am grateful also to Michael H. Lewis, University of Maine, and Genevieve S. Owens, Thomas Jefferson Library, University of Missouri—St. Louis, for their assistance.

Introduction

Ancient and historic Native American objects are displayed as *art* in dozens of impressive public collections across the United States. With increasing frequency, major museums mount important exhibitions of these unique "aesthetic treasures," which in many institutions are now clearly distinguished from ethnographic material.[1] Scholarly journals, as well as sophisticated popular magazines for the serious collector, are devoted exclusively to Native American art and culture. At auctions and in private galleries, artifacts and ritual objects that originally were stolen or acquired by barter or were bought for trivial sums now realize prices rivaling those paid for Chinese, African, and Oceanic art.[2] In recent years it has been taken for granted that works of art from the so-called New World are precious heirlooms of a universal human condition expressed through the globally understood language of art. These objects, in short, are perceived as aesthetic masterpieces that transcend time, place, and even culture. Such has not always been the case.

The recognition of Indian *art* as such was coincident with the emergence of modernism in America. In fact, I intend to show that the modernism of New York's avant-garde, 1910–1950, was dependent on Native American art and culture to a degree previously unrecognized in the art-historical literature. Simultaneous with their concern for the expressive and symbolic value of "significant form," learned from the European avant-garde, the emergent New York avant-garde began to value the forms, especially geometric, and structures of Native American art. Early New York modernists saw in Indian art a vitality and a "primitive" purity that they sought to embody in their own work. And yet, understanding the indivisibility of form and content, these modernists were attracted to the forms and designs of Indian art because they perceived in them unity with nature, unbridled psychic and mythic forces, and continuity with the primordial origins of humanity. Thus, the aesthetic shift manifest in the New York avant-garde's collecting practices and emulation of Indian art was but the outward sign of an ideational shift.

This is a study in the history of ideas and cultural practices as they are expressed in, and shaped by, art. The first chapter establishes the fact that in Euro-American history, representations of Indians and Indian art were ideological constructs, and subsequent chapters show how such conceptualizations affect and are affected by paradigmatic changes in the artistic, literary, and scientific communities, as well as by social and political practices. In accordance with recent developments in the discipline itself, the notion "expressed in art" is conceived broadly to include patronage, exhibitions, and art criticism. So in terms of methodology, my analysis of the linkage between specific modernist works of art and Native American prototypes is embedded within a cultural context established by my "excavation" of a multitude of primary texts. In showing how avant-garde practice reflected a particular set of ideas about America, Native America, and modernity, I examine institutional policies and exhibition history, patronage patterns, and theoretical and critical texts. I consider these topics to be not mere adjuncts to the New York avant-garde's Indian-inspired primitivist painting but rather examples in themselves of modern nationalist appropriations of the cultural forms of Native America.

In keeping with another aspect of the "New Art History," this study is interdisciplinary in nature. Many of the New York avant-garde— artists, critics, patrons, and curators alike—had a significant personal and professional involvement with ethnology and its practitioners, and many of the developments in the "art world" related to Indian art were responsive to new anthropological theory. Likewise, as with recent treatments of ethnographic writing and literary criticism, I consider the theoretical and critical texts investigated here as (primitivist) art productions in their own right. The history of modern psychology is important here as well, since many of the texts and works of art that I examine were informed by an interest in the unity between primitive (Indian) art, modern art, myth, dream, and the collective unconscious. And yet, recognizing with George Kubler that "anthropological conclusions about a culture do not automatically account for the

art of that culture," and agreeing with Robert Goldwater's assertion that "art is thus its own model,"[3] I am equally concerned with the close stylistic relationship between Native American traditions, in general, and certain works in particular, and American modernist primitivism.

Collectively, the various ideas about Native Americans and their art expressed by modernist practice in America are an aspect of cultural primitivism. Granted, modernist primitivism has been dealt with before. The most notable examples are Goldwater's germinal text, *Primitivism in Modern Art* (1938), which makes but scant reference to Native American art and was entirely unconcerned with American modernism, and William Rubin's monumental, if problematic, exhibition "'Primitivism' in 20th Century Art" (1984). In the catalogue accompanying the latter, Rubin wrote, "Despite its size and ambition, this book should not be considered as aspiring to be definitive; it is best thought of as an opening to a new phase of scholarship in the subject."[4] I hope to rectify the relative lack of interest in Native American objects and their influence on modernism that characterized Rubin's exhibition and catalogue. The majority of the artists and critics who are the subjects of this study were absent from Rubin's exhibition, and those who were included are treated here with far more documentary evidence, linking their work in a tangible way to their interest in Indian art. In particular, my discussion of Abstract Expressionism demonstrates a much stronger attraction to Native American art, myth, and ritual than that suggested by Rubin's exhibition/catalogue.

By extending earlier studies of modernist primitivism, mine is part of a broad wave of revisionist history writing that seeks to restore to our understanding of modernism certain aspects that were either neglected or denied during the hegemony of formalist history/criticism of twentieth-century art. Along with Rubin's exhibition, other recent exhibitions have contributed to this process. For example, "The Spiritual in Art: Abstract Painting, 1890–1985," organized for the Los Angeles County Museum of Art by Maurice Tuchman, Judy Freeman, and a team of scholars, including myself, demonstrated unequivocally that much European and American abstraction in this period sought to embody a spiritual content derived from mystical, occult, and Native American sources.[5] My goal is to revise the received history of the New York avant-garde by demonstrating, for the first time, that ideas and images associated with Native American art and culture were primary factors in the genesis and subsequent development of modern art and theory in America in the years 1910 to 1950. In doing so I also want to show how such art and theory, as well as exhibitions, essentialized indigenous peoples as "children of nature," even as it ignored the racism and colonial violence of Euro-Americans—the "adults of culture."

A few brief comments about methodology are necessary. The date 1910 will seem a curious starting point to some, but the earliest twentieth-century response to Native American art by an American modernist which I have been able to document was made by Max Weber in that year. I begin, however, with an overview of the development in the nineteenth century of certain relevant issues. Admittedly, I am using the term *New York avant-garde* somewhat flexibly, as I give considerable attention to primitivist practice in the art colonies at Santa Fe and Taos. But these colonies, I will argue, were operating, metaphorically speaking, under a charter issued by "advanced culture" in New York. Similarly, the term *primitive art* should be read, everywhere it appears, as *sous rature*—necessary but inadequate. It is not a defensible art-historical term or category, but I have maintained it primarily to preserve the historical language of the period being narrated.

Native American Art and
the New York Avant-Garde

The Idea of The Indian/
Collecting Native America

Between 1910 and 1950, those Euro-Americans who studied American Indian culture, or collected, displayed, theorized, or responded artistically to Indian art, did so from an etic (outside) position. Despite significant attempts at unbiased observation and empathetic understanding of Indian art and ceremonial life, they remained outsiders. Even the most informed, enthusiastic admirers sought to know and describe Native American experience by means of concepts and taxonomies derived from their participation in Euro-American culture. If, over time, some of their cultural products began to suggest a more emic (inside) point of view, it was due to the impress of Boasian anthropology and its theory of cultural relativism.[1] But none of the subjects of this book were able to divorce themselves fully from their own cultural experience, and the terms of their engagement of Native American culture(s) were always established by such experience. Cultural relativism did have an important role, however, in shaping a critical self-consciousness, which made possible within Euro-American culture new kinds of etic "truths" about Indians.

Because avant-garde responses to Indian art and culture were based on etic knowledge and were essentially self-serving, it is necessary to begin with an overview of the idea and function of "The Indian" in Euro-American intellectual life. Thus, in the first part of this chapter I consider the following topics in terms of the received view of Indians in the late nineteenth and early twentieth centuries: the Indian as abstraction; the Indian as critique of non-Indian culture; primitives and primitivism; race, culture, and evolution; and ethnology and romanticism in the Southwest. These are the interdependent components of a larger, seamless cultural configuration, and because they are examined separately, some overlap and repetition is unavoidable. But this division allows an unwieldy subject to be approached in an orderly fashion, and the recurrence of certain issues only reinforces the organic quality of the larger configuration: perceptions of "The Indian" (and how such perceptions impinge on the desire to collect Native America, which is the focus of the second portion of this first chapter).

The Indian as Abstraction

The "American Indian" never existed, and there was no "Native American culture" in a homogenous sense, but rather, there were many indigenous cultures (e.g., Taino, Penobscot, Kiowa, Salish, etc.) with marked differences in language, modes of subsistence, social organization, and styles of art and architecture. Although there were powerful confederacies (Iroquois, Powhatan, Miami), the first inhabitants of North America had neither a collective term for themselves nor did they form a single political unit. Thus, "The Indian" was an abstraction of Euro-American creation, one based loosely on facts but mostly on preexisting ideas, themes, and motifs in Western culture.[2]

From an ideological point of view, the value of using a general category of description and analysis for distinct cultures was that it diminished their individuality and made the hegemony of Manifest Destiny less offensive: the violence associated with westward expansion was committed on a category—"The Indian"—not recognizably distinct peoples. By ignoring the specificity of culture(s), Euro-Americans had in "The Indian" an actor without subjectivity, whose perceived identity was manufactured by the visual and verbal discourses of explorers, priests, politicians, soldiers, and, not least of all, social scientists and artists. The figurative Indian may be likened to a signifier without a signified, so that each generation of Euro-Americans could (and did) determine according to its particular needs, the meaning of the sign. Another analogy for the conceptualization and categorization of diverse Native peoples is that of a malleable substance that could be shaped to any form/image and filled with any content desired by the politically dominant culture.

The Indian as Critique

This infinitely plastic figure has often functioned as a vehicle for cultural criticism, and in particular, the dichotomous trope of the good/bad Indian has been ubiquitous in the Columbian period. The bad Indian—naked, treacherous, violent, unlearned, sexually licen-

tious, communistic, lazy, filthy, and godless—represented a negative standard against which Euro-American peoples could judge themselves. Viewed in retrospect, the results of such a comparison naturally appear predictable and self-serving because they reinforced the notion of Euro-Americans as superior beings. Especially in the eighteenth and nineteenth centuries, such a comparison provided all the justification necessary for committing genocide against Native cultures and for the stealing of their lands. The other half of this Janus-conception, the good Indian, often existed in parallel to the negative image and served an opposite purpose. Heroically nude, trustworthy, peaceful, dignified, communal, industrious, as well as a pantheistic worshipper and an instinctual child of nature, the good Indian symbolized humankind's Arcadian past.[3]

At any historical moment the good Indian was a critique of the perceived degeneracy of Euro-American culture. Because it was a creation, the image of the good Indian had an inexhaustible flexibility, allowing it to change along with Euro-America. When used in a critical mode, the idea of "The Indian," whether good or bad, worked like a mirror, reflecting the "particular neurosis of that age."[4] It is essential to stress that even this good Indian, whose many desirable characteristics had been lost to Euro-America, was in many ways a fiction. Based partially on fact, the good Indian was mostly a wistful longing for a *temps perdu*. The tragic failure of both the good and bad images of the Indian was that Euro-Americans were forever prevented from seeing the first Americans as real people. Calculated or not, this was the specific function of the Indian as idea or concept, as opposed to Indian as human, existing in a different but valid and historically produced culture.

Primitives and Primitivism

The idea of "The Indian" as a critique of Western civilization, and especially its use as a symbol of an unspoiled Arcadian past, is inseparable from two larger phenomena in Euro-American intellectual (and political) life—the

primitive and its correlate, primitivism. Although the desire for the *primitive* dates from classical antiquity, the modern version of the primitive was developed during the European Enlightenment. Thus, it may be directly associated with a retrospective search for a defensible philosophy of human nature and social theory to counteract the secularization of incipient modernity then being initiated by the revolutionary bourgeoisie.[5] While Jean-Jacques Rousseau is generally credited with creating this "natural man," he was actually codifying ideas being expressed then by several eighteenth-century writers who drew on images of exotic life in the "new worlds" to fashion the critical trope known as the Noble Savage.

The Enlightenment's protomodern use of the primitive as counterculture critique signified a fully developed *cultural primitivism*, which Arthur O. Lovejoy described as "the discontent of the civilized with civilization. . . . It is the belief of men living in a relatively highly evolved and complex cultural condition that a life far simpler and less sophisticated in some or in all respects is a more desirable life."[6] However, one's state of civilization or cultural complexity is always relative. It has always been possible for some portion of humankind to conceive of a culturally simpler life somewhere in the past or present. Cultural primitivism, therefore, has been an intrinsic aspect of human nature and history, for even the belief among Native American peoples in totemic entities (progenitors of clans during the myth time) may well be an example of primitivizing.[7] Since the eighteenth century, Euro-American cultural primitivists have often identified the culturally simpler life not in antiquity but in the "exotic tribes" of Africa, Oceania, and Native America.

In this context I want to qualify and expand William Rubin's assertion that "primitivism is . . . an aspect of the history of modern, not tribal art."[8] *Modernist* primitivism in the visual arts belongs not only to the history of modern art but also to the more long-standing history of *cultural* primitivism. Furthermore, primitivism in modern art is not limited to the production of objects that have an affinity with or are

stimulated by an awareness of "tribal art" forms. As Marianna Torgovnick has demonstrated, modern primitivist discourse is also located in fiction, psychology, popular culture, and especially ethnography.[9] Patronage and criticism of Native American art, especially as they establish a critique of the dominant culture, are also modes of cultural primitivism. Furthermore, even where modern primitivist objects are clearly related to the objects and processes of primitive art, other factors pertinent to cultural primitivism may be operant as well. For example, the production of modern primitivist objects may be influenced not only by the visual arts but also by an awareness of myth and ritual and by theories about the evolution of culture, "racial memory," and spiritual consciousness. This more expansive and inclusive definition of modernist primitivism in the visual arts is the rubric under which my text is written.

Race, Culture, and Evolution

Early twentieth-century avant-garde representations of "The Indian" pictorialized ideas that were formed, in part, by later nineteenth-century social sciences. However, many of those intellectual currents were themselves modifications of even older Euro-American conceptions of history and biology. European imperialism and colonization produced, between 1700 and 1750, a corpus of travel literature focused on primitive tribes which concluded that they were comparable in many ways to the ancient peoples of Europe. By midcentury such literature had become a comparative method of analysis that generated a conjectural history of the world which conceived of a universal evolution of human beings through the stages of savagery, barbarism, and civilization.[10] More than a century later, following the publication in 1859 of Charles Darwin's treatise on evolution, social scientists in the 1870s were still writing a conjectural history of culture known as Social Darwinism. But the paradigmatic support of evolutionism made their belief in stages of cultural history appear less speculative and based more on the observable laws of nature.

Even as ethnography was providing more and better scientific data, the emergent discipline continued to operate within an evolutionist framework that modified only slightly a belief in the psychic unity of humankind. John Wesley Powell, who in 1879 was named first director of the Bureau of American Ethnology (cited hereafter as BAE), conceived of cultural stages comparable to the organic life cycle of humans, which allowed him to compare the "savagery" of American Indians to ethnic childhood.[11] Implicit in the dominance within anthropology of the evolutionist paradigm was the acceptance of a hierarchy of humanity predicated on the Enlightenment's invention of the idea of "race" and its substitution for "culture." For example, Tzvetan Todorov has argued that following the advent of the natural sciences and the first appearance of racialism (theories of *race*) in the eighteenth century, the term *race* became interchangeable with what we in the twentieth century understand as culture. Similarly, according to Anthony Appiah, in the later nineteenth century "race" functioned within Euro-American discourse as a metonym for culture, and did so at the "price of biologizing what *is* culture or ideology."[12] Along with the fictive *race*, other terms, including *nation*, *tribe*, and *people*, were also used to refer to *cultures*. These feats of linguistic ideology indicated the complete transformation of the eighteenth-century idea of world history as stages of social development into that of stages of racial development.

One distinctive aspect of evolutionism as the history and hierarchy of races was the idea of race-as-organism. Because it has been so central to twentieth-century cultural (primitivist) practice, one subtheory of this concept, known as recapitulation theory, is critically important for this study. Specifically, recapitulation theory provided justification for modern psychology's belief in a collective consciousness or racial memory. Derived from the so-called biogenetic law, often associated with the German biologist Ernst Haeckel, the theory states that ontogeny recapitulates philogeny, or that each organism repeats in its individual growth the previous evolution of its phylum.[13] According to psy-

chologist G. Stanley Hall, a popularizer of reca-
pitulation theory, it was essential to realize the
effect that the recapitulation of ancestral
(primitive) experience had on modern behavior:
"Only when the secrets of this lost record are
revealed can we understand the ultimate reason
why even civilized man after long periods of
settled and orderly existence is liable to spells of
upheaval and revolt against existing institutions.
. . . It is the call of the wild tribesman in him to
break away."[14] Recapitulationist thinking also
held that children and savages, who represented
racial youth, were different from civilized adults
in their intuitive and instinctual responses to
the environment.

By the turn of the century the evolutionist
paradigm had contributed to the following: the
conflation of race and culture; the notion of a
racial hierarchy (with the Aryan or Caucasian
races as the most civilized and, therefore, the
benchmark against which all others were mea-
sured and found wanting); the assignment of
primitives to the pseudoscientific culture stage
of "savagery"; and the idea that primitives were
the irrational youth of racial evolution. The re-
volt against this intellectual racism was initiated
by Franz Boas's insistence on historicism and
cultural relativism.

Boas and his students at Columbia Univer-
sity, where he founded the Department of An-
thropology in 1896, rejected the comparative
method, conjectural history, the hierarchy of
races, and the duality of primitive mind/racial
youth.[15] Perhaps the most significant legacy of
Boas's early scholarship was a shift from the
conception of *culture* as a singular entity that
embraces all humankind, to a plural one that
saw *cultures* as autonomous and operating ac-
cording to their own internal logic. Moreover,
Native American cultures were no longer
judged by an absolute moral standard provided
by Euro-American societies but were consid-
ered in terms of their own language, art, music,
mythology, and cosmology, which showed them
to be civilizations in their own right. Indeed,
the very idea of what constituted a civilization
was overthrown by Boasian anthropology. This
revolution in social science was made possible
largely by Boas's insistence on drawing conclu-

sions from fully contextualized empirical data.
Thus, he did not compare the cultural evolu-
tion of the Kwakiutl of the Northwest Coast to
that of Euro-America. Instead, he sought to
reveal how the actual facts of Kwakiutl life were
interdependent and created, culturally speaking,
a structural logic.[16]

But the idea of cultural pluralism did not
win immediate acceptance in academic circles,
and its impact on artistic practice was negligible
for at least a generation and fragmentary even
then. The struggle between Boasian anthro-
pologists and racial evolutionists for paradig-
matic supremacy was intense between the two
world wars, and the former did not actually
begin to dominate American social science until
the 1930s. As late as the 1940s, some notable
members of the avant-garde, such as Wolfgang
Paalen and Barnett Newman, who were
fascinated by Northwest Coast art and culture,
were still engaged in cultural work—curatorial
practice and art criticism—based on an
ideological melange of Boasian and older, more
romantic ideas. Certainly in the early years of
the twentieth century, especially in the South-
west, the image of the Indian both encountered
and (re)created by artists, writers, and art col-
lectors was a judicous blend of "science and
sentiment."[17]

Ethnology and Romanticism in the Southwest

By the late 1880s anthropologists working in
the Southwest were drawing conclusions about
the continuity between present-day Pueblo
peoples and the ancient inhabitants of the
archaeological sites they were excavating. This
living connection to "prehistory" made the
Southwest the premier site for ethnographic
study in the United States and engendered the
nation's infatuation with Puebloan and other
Southwestern Indian cultures. The image of
Pueblo life presented to the public in the late
nineteenth and early twentieth centuries
resulted from the combined efforts of popular-
izers such as Charles F. Lummis (*Land of Poco
Tiempo*, 1893) and a number of BAE ethnolo-
gists, including Powell, Frank Hamilton

4

Cushing, and Adolf Bandelier, whose reports emphasized its peaceful domesticity, a ritual life attuned to nature's rhythms, and the Indian's perpetuation of the primitive simplicity of ancient America. Similarly, "ethnophotographers," whose travel in the Southwest was facilitated by the Santa Fe Railway's desire to promote tourism, also contributed to the romanticization of Pueblo culture. Edward S. Curtis, John K. Hillers, Lummis, Adam Clark Vroman, and others believed that their photographs captured the real image of a vanishing world then being documented and celebrated in books by Lummis, Bandelier (*The Delight Makers*, 1890), and others (Fig. 1-1).[18]

According to William H. Truettner, such photographs echoed and affirmed contemporaneous anthropological representations that identified and stressed the most admirable characteristics of Pueblo culture: ancient, unspoiled, agricultural, traditional, and spiritual.[19] The image makers were thus exploring and recording a way of life that they perceived as being radically different from their own, which could be described as unsettlingly new, urbanized, industrial, transitional, and secularized. It is hardly surprising that they found aspects of Pueblo cul-

ture vastly superior to their own, given that cultural primitivism had long favored nature over and against the artifice of civilization.[20]

Collecting Native America

In addition to photographs and ethnographic texts, displays of Native American cultural artifacts, and later, art, also functioned as representations of the (good) Indian. Four hundred years after Christopher Columbus arrived in the Caribbean, Native American art was still considered a novelty: curious and primitive products of people low on the evolutionary ladder. But early in the twentieth century, as a direct result of Euro-America's primitivistic desire to appropriate the authentic life of the "Other"—one of the defining characteristics of the modernist project—a distinct taxonomic shift occurred in the valuation of primitive artifacts, including those of Native North American peoples.[21] William Rubin has commented on this "discovery" of primitive art: "That many today consider tribal sculpture to represent a major aspect of world art . . . is a function of the triumph of vanguard art itself. We owe to the voyagers, colonials, and ethnologists the arrival of these

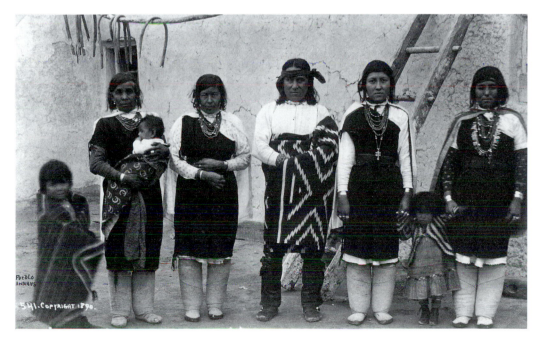

Figure 1-1
CHARLES F. LUMMIS
Pueblo Indians
(copyright 1890).

Cyanotype print.
11.1 cm x 17.5 cm.
University of New Mexico
Art Museum, Albuquerque.
Gift of Eleanor and
Van Deren Coke.

objects in the West. But we owe primarily to the convictions of the pioneer modern artists their promotion from the rank of curiosities and artifacts to that of major art, indeed, to the status of art at all."[22] Perhaps this is an accurate description of the relationship between the European avant-garde and African, Oceanic, and to a lesser extent, Native American art, but the promotion in the United States of objects arriving *from* the West (and the Northwest Coast) is another matter altogether. Here we must recognize the role played not only by modern artists but also by their patrons, as well as literati, anthropologists, and social critics—that is, a cultural avant-garde. And although many early twentieth-century American artists shared with their European counterparts a desire to attack the values of bourgeois culture, their fascination with indigenous art had a distinctly nationalist element, since they were seeking the basis for an authentic native American modernism. Furthermore, the transformation of artifact into art involved not only protomodernist recognition of the aesthetic value of Native cultural objects *and* political nationalism, but obviously also the site and system whereby "primitive" art was institutionalized.

The Cabinet of Curiosities and the Great Expositions

The well-traveled eighteenth-century gentleman or lady often maintained a "cabinet of curiosities" that housed the natural history specimens and objects of human manufacture that he or she had collected. The selection and presentation of the items was affected more by personality than science, and there was seldom, if ever, any indication that the objects had aesthetic value. Whenever Native American artifacts were exhibited in cabinets—private, public, or those of the various academies—their function and tribal origin was usually not indicated. Even when the objects were labeled, they were decontextualized, as they were shown alongside unrelated artifacts. Thus, a penchant for the rare and exotic, not taxonomic order, was the hallmark of curiosity cabinets.[23]

In the second half of the nineteenth century, stimulated by the accumulation of large collections of similar objects, important institutions, such as the Peabody Museum at Harvard University, began to organize materials by category (weapons, tools, etc.). Displayed in a definite series, such categories demonstrated how cultures the world over evolved from the "savagery" implied by crude tools toward the "civilization" indicated by Euro-American technology. The system of object arrangement that best revealed the teleology of material culture was the culture history series, often used by Otis T. Mason at the National Museum to prove that the history of culture was equivalent to the history of the evolution of tools and technology. By exhibiting together objects from diverse cultures, Mason continued to decontextualize the Native American artifacts he presented. In fact, his stated intention was to use Native American technology as a model for understanding a particular stage of evolution through which Euro-American civilization had already passed.

The great expositions of the late nineteenth and early twentieth centuries featured large, expensive, and carefully planned anthropological exhibits that employed new and different methodologies of display but that still supported an evolutionist/racial history of the world. For example, at the "Centennial Exhibition" in Philadelphia (1876), Smithsonian ethnologists Charles Rau and Frank Hamilton Cushing displayed a variety of ethnographic materials, including ceramics, totem poles, and weapons, alongside life-sized mannequins. Even though Rau and Cushing intended for the displays to demonstrate the evolutionary sequence of culture, many visitors found the exhibits chaotic. If the displays were remarkable for their lack of clear organization, they did succeed in creating an image of Native American culture as being the antithesis of technical progress. According to Robert Rydell, the need for a negative perception of Native culture(s) was related to the linkage made in the exhibition between ethnological and natural history. Ideological justification for American expansion was grounded on associating the "white" race with progress and also on a correlation between Indians and the

raw materials of nature, both of which could be exploited.[24]

There were two important sets of anthropological exhibits at "The Chicago World's Columbian Exposition" (1893), one directed by Frederick Ward Putnam of the Peabody Museum and a Smithsonian display organized by Mason. The former included life-sized sculptured figures engaged in "primitive" industries (e.g., Zuni breadmaking, Navajo weaving) accompanied by appropriate artifacts, a Hopi village, and groups of southwestern, Plains, and northwestern Indians on display. In keeping with the theme of the exposition, Mason presented objects that reflected Native American life in 1492. However, using linguistic stock as a guide, he created sixteen life-sized figure groups that were depicted performing representative tasks in their native environment, thus establishing the relationship between artifacts and geographic/culture areas.[25] In spite of this, a year following the exposition Mason still conceived Native American culture as determined more by "race" than environment: "Among the civilized communities . . . there has grown up a reverence for the government, called patriotism, and from this combined with the love of one's native land, comes a strong motive in holding the people of a nation together. . . . Not so in savagery. . . . Among the American tribes of Indians . . . the strongest civilized bond is that of kinship, which, after all is a racial characteristic."[26] However, there were clear racial overtones to certain aspects of the ethnological exhibits at the exposition itself. In contrast to the utopia symbolized by the exposition's "White City," the anthropology displays were housed in the carnival atmosphere of the "Midway Plaisance" along with the trinkets and toys.[27]

The Panama-California Exposition

Although Native Americans were implicated in the evolutionist content of such early twentieth-century fairs as the "Pan-American Exposition" in Buffalo (1901) and the "Louisiana Purchase Exposition" in Saint Louis (1904), the one most relevant in the context of cultural primitivism and the visual arts was the "Panama-California Exposition" held in San Diego (1915–1916). Like San Francisco's "Panama-Pacific International Exposition" (1915), the San Diego fair celebrated the completion of the Panama Canal, which had opened in August 1914. Focusing on Maya, Aztec, and southwestern Indians, the exposition's leitmotif was the parallel evolution of humankind and agriculture in Latin America and the southwestern states. Edgar L. Hewett, who was both director of the Archaeological Institute of America's School of American Research (SAR) in Santa Fe and director of exhibits at the exposition, intended the fair to chronicle the "growth of man in the New World from savagery to highest civilization."[28]

Hewett's records indicate that Native American materials were displayed in various places in the exposition: the Department of Anthropology and Ethnology housed collections of prehistoric and historic Pueblo pottery (Mimbres, Casas Grandes, Rio Puerco, and Jemez); basketry from various southwestern, Pacific Coast, and California peoples; and assorted skin material—painted hides, porcupine quill work, and beaded buffalo hides. However, most of the indigenous objects were shown in the Indian Arts Building, which housed six exhibits: ancient Indian arts—stone and metal; houses and house life; hall of southwestern archaeology; Mohave exhibits; the Tewa Indians; and Indian photography (i.e., pictures of Indians). An abbreviated list of the collections in this building includes stone sculpture from the eastern and middle-western United States; Eskimo (Inuit) and Northwest Coast objects; historic Pueblo pottery from Cochiti, Santo Domingo, and Zuni; and baskets from nearly a dozen southwestern and California tribes. W. H. Holmes of the Smithsonian noted that in Hewett's exhibits, "Native American culture is presented in a manner more illumining than ever before," revealing "the highest achievements of aboriginal America." Other related exhibits included Edward S. Curtis's photographs of Indian life (in the California Building) and one of American Impressionism (in the Fine Arts Building), which featured Robert Henri's Indian portraits.[29]

Although Hewett was disappointed in his efforts to organize a "Congress of Native Tribes," he explained that "it was attained in part and in a highly scientific and satisfactory manner by enlisting the interest of the Santa Fe Railway in an important exhibit of the Ethnology of the Southwest," known as the "Painted Desert."[30] In this display the organizers of the exposition and their financial supporters made manifest the ideology on which they based their relations with Native peoples of the Southwest. Furthermore, documentary evidence proves that exposition planners were not operating unconsciously in this regard, but that it was their conscious decision to generate tourism in the Southwest by using evolutionism to intensify the cultural primitivism already existing in their general audience. In this dehumanizing scheme Native peoples themselves were considered specimens, like pots and blankets, for display. Two of Hewett's associates, T. Harmon Parkhurst and John P. Harrington, coauthored a planning paper entitled "Suggestions for Exhibiting the Indians of the Southwest at the Panama-California Exposition," which mentioned the picturesque qualities of primitive life in the Southwest. This aspect of the region, they noted, was "one of the chief attractions to the tourist." Likewise, they hoped that the Hall of Indian Mythology would introduce exposition visitors to the "wonderland of Indian imagination, the weird mythologic background of the Indian's mind which exerts an influence upon all his thoughts and actions."[31]

Harrington wrote another planning paper that also reveals the willingness of the ethnologists to put their discipline at the service of the tourist industry, in general, and the Santa Fe Railway, in particular. He proposed to install a miniature Santa Fe Railway that would transport fair-goers from the entrance of the exposition to a series of model villages established in the same geographic order as their real-life counterparts. Thus, a ride on the train previewed a vacation through the Southwest on the Santa Fe line. Harrington intended to populate the villages with "carefully selected Indians, typical and representative, and versed in making

articles prized and sought by whites." Ritual objects were to be produced "before the eyes of the spectators" and offered up for sale. The goal of this enterprise was clearly not fostering an appreciation of cultural difference: "The sale of such articles would be large and the profit sufficient to defray the expense of bringing the Indians to the Fair and maintaining them while there."[32]

Harrington's plan was an ambitious attempt to acquaint fair-goers with all aspects of Native American life in the Southwest. Ceremonies were to be performed "frequently and fervently," and the "signification and symbolism of these religious festivals," as well as the customs of domestic life, would be explained in a series of lectures given by the staff. A variety of media, including phonographs and moving pictures, would help interpret the meaning of ceremonial paintings and ritual paraphernalia, making the "thought of the Indians very realistic to the visitors." But his plans and choice of words testify to a still prevalent evolutionist racism that conceived of *primitive* Indians as a cultural curiosity. For example, he observed that a presentation of the Navajo's Yebetchai healing ceremony would feature its "weird nightly dancing." Similarly, he described the Serrano Indians as "a group of naked desert Indians, the 'mountain rats' of the Mohave." The *savagery* of the Puebloans and the Navajos was underscored for the audience by Harrington's plan to have the tribes make "stealthy and furious" attacks on each other because the "paraphernalia and tactics of Southwest Indian warfare are particularly interesting."[33]

The various motivations behind the "Painted Desert" seem contradictory on the surface. To Harrington, however, they formed a logical ensemble. First, it was the consensus of many Euro-Americans that the primitive life of southwestern tribes was all but a matter of history. Harrington's position on this was explicit: "Now is the last time that such an exhibition of our Indians of the Southwest can be arranged." Second, because of the railroad's role in developing the West, it had an obligation "to make possible the exploiting and scientific study of the quaint people through whose

ancient lands it runs." In so doing, Indian customs would actually be saved from oblivion, and this, of course, would be "an asset to the Santa Fe Railroad as long as time lasts, inasmuch as the Indian life could be restored with data which would be secured and correctly made [arti?] facts shown and sold to tourists through all the future." That is, by promoting salvage ethnography the Santa Fe line could make it possible for future Indians to learn about their lost culture, enabling them to continue manufacturing "authentic" wares for tourists to purchase. Third, the intended audience for the planning paper was undoubtedly the railroad management, because Harrington was careful to stress the public relations values of such a venture: "It could go down forever as an interesting fact in history . . . that the Santa Fe Railroad took enough interest in Indians and in science to institute a study and scientific exposition of the American aborigines along their track."[34] And in fact, Holmes reported that the "Painted Desert," which was supervised by Hewett's associate Jesse L. Nusbaum, was made possible "through the munificent generosity of the Santa Fe Railway" and that it was one of the most attractive and successful features of the fair.[35]

Public Collections in New York

While many on the West Coast took the opportunity in 1916 to "travel" through the "Painted Desert," a watershed in the history of displaying Native American art was occurring in New York as well. In that year, George Gustav Heye's private museum of Indian art and culture was reborn as a public one—the Museum of the American Indian, Heye Foundation (recently renamed the National Museum of the American Indian). After graduating from Columbia University in 1896 with a degree in engineering, Heye collected his first object, a Navajo shirt, while supervising the construction of a railroad in Kingman, Arizona. His subsequent insatiable appetite for Native American art and artifacts had more to do with being bitten by the collecting bug than it did with a scientific fascination with indigenous cultures or

the evolution of art.[36] Neither was he especially fond of Native American peoples nor overly concerned with their supposedly vanishing culture. Although Heye was not a scholar and used the museum primarily as a means of expediting the growth of his collection, he researched his obsessive hobby in a conscientious manner and sought out "not only the beautiful, the strange, and the exotic, but also the commonplace, the plain, and the unremarkable."[37] By 1915 his extensive collection had completely filled his apartment (precipitating a divorce from his first wife) and a loft in midtown Manhattan, with the remainder on loan to the University Museum in Philadelphia. Although Heye declined opportunities to sell the collection to important eastern museums, he realized the necessity of formalizing his private museum and accepted in 1916 a gift of land and financial endowment from railroad magnate and philanthropist Archer M. Huntington.[38]

World War I delayed the official opening of the museum until 1922 when newspapers across New York State carried a wire story about Heye's new museum which housed the "Red Man's Record" in the form of "1,800,000 specimens."[39] Heye himself emphasized that the objects in the museum were of "practical value, aside from the historical and archaeological interest attached to them."[40] Just as the news wire referred to "specimens" that preserved the "races" of the "New World," Heye, too, failed to note either the aesthetic or the purely cultural value of his collection. This astonishing array of Native American art and material culture that Heye shared with the public, albeit grudgingly, remains one of unparalleled diversity (Plate 1). Geographically, it ranges from the Inuit of the Arctic to the Yagan of Tierra del Fuego. It is strong in both archaeology and ethnology, with excellent Northeast, Plains, Great Basin, and Southwest collections. And like the American Museum of Natural History, whose collections were established earlier and had been available to the public longer, the Museum of the American Indian presented New Yorkers with an outstanding assemblage of objects from the Northwest Coast.

The American Museum of Natural History, founded in Manhattan in 1869, began in 1878 to assemble what ultimately became one of the most comprehensive, high-quality, and well-documented collections of Northwest Coast art and ethnology in the world (Plate 3). Its first major acquisition—some eight hundred pieces shipped over a three-year period—were collected by Dr. J. W. Powell, superintendent of Indian Affairs in British Columbia. Many of the pieces in what remains the world's largest collection of Northwest Coast art were purchased for the museum by George Thornton Emmons, a naval officer who was the museum's field agent from 1882 until 1909. During this period Emmons sent to New York collections of Tlingit, Haida, and Bella Bella sculpture, some of which were purchased with funds provided by John Pierpont Morgan, John D. Rockefeller, and Cornelius Vanderbilt. In 1894 Emmons sold the museum a large, meticulously catalogued collection of Northwest Coast and Inuit objects that he had assembled for the World's Columbian Exposition in Chicago, where it had generated great enthusiasm. His final sale in 1909 was a group of more than three hundred Tsimshian sculptures from British Columbia.[41]

When Franz Boas joined the museum as assistant curator of the Ethnological Division in 1895, he expressed concern over the shortage of Kwakiutl material and the complete lack of objects of Nootka, Salish, and Makah origin. The museum's administration responded by organizing the "Jesup North Pacific Expedition" (1897–1902), whose overt goal, Boas announced, was "to investigate and establish the ethnological relations between the races of America and Asia." However, the real legacy of the expedition was both the qualitative and quantitative growth of the collections. Indeed, in 1900 Boas reported that the expedition had secured for the museum more than sixty-six hundred ethnographic artifacts and nearly two thousand specimens of physical anthropology.[42]

A central figure in collection development during the Boas years was George Hunt, who was part Tlingit but had been raised among the Kwakiutl, had been initiated into their presti-gious Hamatsa, or Cannibal, Society, and had twice married Kwakiutl women. Hunt had worked with Boas in the field as early as 1888 and served as his field agent until 1902, collecting art, artifacts, myths, and oral histories. From him the museum purchased more than twenty-five hundred ethnological objects, including houseposts and carved figures. Not only did Hunt's expertise result in substantial additions to the museum's collections, but he assisted Boas in finishing several significant studies on Kwakiutl culture.[43]

In the years immediately following the Jesup expedition the museum continued to acquire, from a variety of sources, impressive collections of Northwest Coast art. In 1905 the museum received a group of objects, including some Haida material, from the collection of the painter Albert Bierstadt and also purchased nearly two hundred objects from Juneau, Alaska, including a Tlingit shaman's box with requisite paraphernalia. The following year Haida and Bella Bella houseposts and totem poles were acquired at the paltry rate of a dollar per foot plus shipping costs. Among other purchases and donations was a collection of Tlingit and Haida carved spoons given by John Pierpont Morgan. As with Heye's collections, it was the quality, range, and completeness, as much as the size, which established the importance of the American Museum's Northwest Coast material.[44]

In this same period—the great age of museum anthropology—the Brooklyn Institute of Arts and Sciences (now the Brooklyn Museum) was also providing New York with yet another significant collection of Native American art, this one assembled under the guiding hand of Stewart Culin. Born in Philadelphia, Culin had not attended college but nevertheless had begun his career as curator of anthropology at the Free Museum of Art and Sciences at the University of Philadelphia in 1892. That same year he served as secretary of the United States Commission at the "Columbian Exposition" in Madrid, and in 1893 he was the director of the folklore exhibition at the Chicago World's Fair.

Culin's professional life in the museum world developed in three stages: as a folklorist interested in Chinese culture, and as a collector of, first, Native American, and later, Japanese materials. Thus, his interests moved from ethnology to decorative arts. Although he published little during his collecting phase, 1905–1920, his magnum opus, "Games of the North American Indian," appeared in 1907.[45]

The first sections of the original Brooklyn Institute of Arts and Sciences opened in 1897, its first accessions of "primitive" art were made circa 1900, and Culin founded its Ethnology Department in 1903. As he built both ethnographic and archaeological collections, Culin worked closely with a number of important ethnologists, including Frank Hamilton Cushing, and traveled across North America purchasing collections, often buying (and commissioning) objects directly from the Native communities themselves. The displays he built around these collections, according to Ira Jacknis, "were literally the foundation of the Museum's exhibits," with the first floor given over to the Hall of American Ethnology. The first of Culin's exhibits, of southwestern material, opened in 1905, followed by the California Hall (1910) and the Northwest Coast Hall (1912).[46]

Part of Culin's motivation for collecting Native American objects, as Diana Fane has noted, was the myth of the "vanishing Indian."[47] Convinced that there were "no real Indians among the young," he had insisted as early as 1900 that "if our museums are ever to have good collections of Indian things they must waste no time setting out after them, for none will be left ten years from now."[48] However, Culin's twin desires—for authenticity and for a comprehensive history of material culture—formed a paradox: the works he commissioned to fill in the gaps in the collection only underscored "the fiction of totality" he was seeking to construct. Because he was dependent on his precursors, notably Daniel Brinton and Cushing, Culin often selected objects to illustrate a preexisting ethnographic narrative. According to Fane, some objects he valued as much for their place in the history of collecting itself as for their ethno-

graphical importance.[49] Furthermore, since the material, which ranged from the spectacular (Plate 2) to the mundane, had to tell the story of the vanishing primitive, Culin displayed the objects as "anonymous and timeless representations," even though he often knew when and by whom they were made.[50]

It is worth noting, even in brief, some of the nine thousand objects Culin collected. During a purchasing expedition to British Columbia in 1905 Culin acquired some 182 objects, including a Tsimshian doctor's outfit, a chief's headdress, and three posts carved by the Quawshelah of southern Vancouver Island.[51] Also in 1905, and in 1907 as well, Culin collected among the Pomo Indians of California. In the spring of 1908 he spent another two months with the Pomo and then visited the Chico Maidu village of Miktsopodo—the site of present-day Chico, California. His arrival there was fortuitous: due to a lack of interest and respect on the part of the young people of the tribe, certain important elders sensed the imminent disintegration of their sacred dance society. Motivated by a desire to have their religion and its associated art forms preserved for posterity, they allowed Culin to secure a collection of rare ceremonial material. Among the fifty-plus objects Culin purchased were a variety of dance regalia, doctor's implements, mourning paraphernalia, and votive flags made from native fibers and decorated with feathers and beads.[52] Later in 1908 Culin collected Haida and Nootka objects, and on a trip to the West Coast in 1911 he purchased two large Haida house poles, Kwakiutl poles, potlatch figures, and some feast dishes.[53] The Northwest Coast and southwestern Native American works of art collected by Culin, especially the Kwakiutl and Zuni material, may well have provided artistic inspiration to New York artists in the 1940s, Adolph Gottlieb in particular.

Conclusion

In the roughly one hundred years that passed between the heyday of the curiosity cabinet and

Heye's decision to make his collection into a public museum, the rationale for, and approaches to, displaying Native American objects moved through distinct stages. The typical owner/creator of a curiosity cabinet conceived of the "Indian" items in the collection as belonging to a category that included curiosities, specimens, and mementos. As such, they could signify travels or nature, but not culture. As late as 1857 both the Peabody Museum at Harvard and the National Museum in Washington still conceived of indigenous artifacts as the products of a homogenous and anonymous entity— "The Indian." Even when a sense of order and classification was finally brought to bear on ethnographic material in the larger public cabinets-cum-museums after midcentury, there was still no attempt to provide the audience with any kind of cultural or historical context against which to view the objects. However, this lack of contextualization did make it possible to use the art(ifacts) in abstract systems that promoted the idea of civilization as inseparable from technology. Concomitant with this strategy was the valorization of those "races"—which were inevitably not "colored" ones—that had the most advanced tool kit. The emergence of Social Darwinism provided the ideological underpinning for elaborate, multivalent presentations of both Indians and their creations at the great expositions. These spectacles of technology, anthropology, and consumerism could well be described as the site for representing the ascendancy of Euro-American culture.

After the turn of the century, when "The Indian" (*a*) was no longer militarily able to oppose the exploitation of raw materials in the West (and elsewhere), (*b*) had been restricted to reservations, and (*c*) was perceived as vanishing, like any rare exotica, "it" was promoted as an object for consumption. The use at the Panama-Pacific Exposition of southwestern indigenes and their art and material culture to promote tourism is a classic example of the economics of cultural imperialism. *Art*, of course, is more valuable in the capitalist marketplace than *ethnographic material*. Because museums validate the judgment of the marketplace by rescuing from it (sometimes only temporarily) the most aesthetically successful objects, the creation of collections of Native American art in the late nineteenth and early twentieth centuries was one discreet element of a formative modern, national culture. Cultural primitivism was one of the primary elements of this incipient modernity, and it generated at least two kinds of desire. The first, a desire for the tangible landscape as well as the ambience of the rural tribal past, could be satisfied by tourism, while the desire for the cognitive landscape of the evolutionary past was satisfied by an "objective" social science in which the ethnographer is actually a *professional* tourist. Both these types of salvaging—tourism and museum anthropology—were modes of "Othering" and had a product in common: collections of art and culture. The presence of these collections, particularly in New York, made possible radical transformations in American art because the objects in them were studied avidly in the ensuing years by numerous avant-garde artists. However, the status of *art* was only conferred on these objects after 1915 in a unique critical context created by the New York–New Mexico continuum.

Avant-Garde Patronage and Criticism of Native American Art at the Santa Fe and Taos Colonies, 1915–1930

About the same time that George Heye conceived of the Museum of the American Indian in New York, the avant-garde art colonists at Santa Fe and Taos began a period of intense patronage of Native American art. Both of these outposts of avant-garde culture maintained close ties with New York, simultaneously representing an extension of its art world and a critique of the modern urbanism it typified. The artists, literati, and anthropologists who populated and interacted with these colonies had a romantic/racist conception of Native peoples and a preservationist approach to their art, both of which were reflected in their social activism and art criticism. Although they were motivated initially by the ethos of cultural primitivism, this was supplemented, especially after World War I, by a desire to identify and promote distinctly Native American values. As a result, they assembled significant collections of historic southwestern Indian art and instigated a revival of contemporary arts and crafts. These colonists were also the principals in new institutions and organizations devoted to preserving indigenous cultures and to protecting their religious freedom. Acting individually or in concert, the colonists encouraged *quality* and *authenticity* in art production by developing strong markets for Indian crafts, both in New Mexico and New York. Perhaps most important for the history of Native American art, these avant-garde patrons at Santa Fe and Taos acted as the midwives to the birth of a new, nonceremonial painting. In this chapter I examine the role of the colonists in the emergence of this new art form, as well as their participation in preservation and revival associations. Then I offer a close reading of selected essays and criticism relating to such patronage. This review of primitivist texts is divided into three sections. The first treats Edgar L. Hewett and the Santa Fe colony; the second, Mabel Dodge Luhan and the Taos colony. The third deals with writings by New York artists/critics whose length of stay in the Southwest varied but whose importance in the New York art world is undeniable: John Sloan, Walter Pach, Holger Cahill, and Marsden Hartley.

Introduction

America's turn-of-the-century romantic infatuation with Pueblo culture was related to other manifestations of primitivist desire. Native American life in the Southwest shared many of the desirable characteristics—including their image as picturesque, exotic, primitive—of other ethnic groups, such as folksy European peasants, or the more "oriental" Moors, Bedouins, and Turks often pictured in wistfully romantic, escapist paintings of the late nineteenth century. Similarly, the growing interest in southwestern Indian arts and crafts, which were handmade and fully integrated into domestic and ritual life, was not dissimilar to aspects of the Arts and Crafts Movement of the late 1880s, or to any of the various versions of Art Nouveau, all of which called for the merging of art and everyday life through fine design and craftsmanship.[1] The certainty that progress would eliminate the curious savages of the "Painted Desert" made the collection (read preservation) of their material culture so urgent that even before 1900 the dominant culture's hunger for Pueblo and Navajo art could not be satisfied by the producers or their agents.

In the later nineteenth century, museums generally sought to build collections of southwestern artifacts that represented a single group and that were purchased from the Native peoples themselves or from local traders. After 1900 it was more common for collections to result from museum-sponsored archaeological expeditions, such as those of the Museum of the American Indian.[2] But the legacy of this interaction between museum collectors and Indian traders was the creation within southwestern Indian societies of a cash economy centered around art production.[3] Not all collections left the Southwest for eastern (or European) museums. Especially after 1900, much important research, collecting, and patronage of Native arts was associated with southwestern institutions, particularly those linked to the politically astute Edgar L. Hewett. Although the eastern archaeological establishment was often critical of his credentials and skills, in 1907 Hewett established himself as a powerful force in Santa Fe's

cultural life—and in American archaeology as well—when he became director of two new institutions: the Museum of New Mexico and the SAR. His colleague in these activities was Kenneth Chapman, who had studied at the Art Institute of Chicago, had been a commercial illustrator in New York, and who became over the years a noted authority on Pueblo pottery.

If Hewett was not the consummate scientist, like his friend Charles F. Lummis, he was an enthusiastic promoter of the "land of enchantment."[4] Typical of Hewett's enterprising nature were the "summer camps" sponsored by the SAR at the Rito de los Frijoles archaeological site near Santa Fe, which offered students, artists, writers, and public officials a vacation among the ruins, where they dug by day and heard lectures on Native art and culture at night. In this shrewdly political move Hewett effectively promoted highbrow tourism by combining into a single package archaeology and romantic desire for the primitive. He and his associates extended the appeal of Santa Fe and the surrounding Pueblo country through *El Palacio*, the official journal of the Museum of New Mexico, founded in 1913. Inspired by *National Geographic*, *El Palacio* featured—still features, in fact—articles on a variety of subjects, but especially the art, ethnology, and archaeology of the Southwest. It also frequently published articles and reviews about the activities of the art colonies at Santa Fe and Taos. In addition, founding editor Paul A. F. Walter, Hewett, Chapman, Marsden Hartley, and others "sold" the romance of the Southwest to a national audience with their articles in *Art and Archaeology*, which was published by the SAR's parent organization.[5] And it bears repeating that Hewett, in conjunction with the Santa Fe Railway, was instrumental in promoting tourism and drawing the attention of artists and scientists to the primitive Southwest with his displays at the "Panama-California Exposition" in 1915.

*The New Indian Painting
and the Arts and Crafts Revival*

The interaction between Native and Euro-Americans in and around Santa Fe in the early decades of the twentieth century resulted in the emergence of a new style of art—nonceremonial painting—and a revival of well-made arts and crafts—pottery, basketry, weavings, and jewelry. The first of these, nondecorative (i.e., not painted on pottery), secular (i.e., made for sale and not ritual) watercolor painting, did not issue from a carefully planned government program or a museum-sponsored ethnological project, as did the drawings of kachinas that Hopi "informants" provided Jesse Walter Fewkes in 1900.[6] Instead, it was a gradual process of discovery, and to a certain extent, one of serendipity. However, much of this artistic phenomenon occurred along a line running, so to speak, from the SAR's site at Rito de los Frijoles to nearby San Ildefonso, and of course, on to Santa Fe and, eventually, New York, Chicago, and other urban centers.

Between 1908 and 1910, while camping at the Rito site, the Fred Henrys of Denver acquired watercolors made by Alfredo Montoya of San Ildefonso. Hewett himself gave colors and paper, perhaps as early as 1910, to Montoya's brother-in-law, the pottery decorator Crescencio Martinez (whose Tewa name was Ta-e, or Home of the Elk). In 1911, Elizabeth Richards, who taught at the day school in San Ildefonso and who encouraged the young students to draw and paint as they wished, sent watercolors and pencil and crayon sketches (identified subsequently as those of Montoya) to the archaeologist Barbara Freire-Marco in England. Dr. Herbert J. Spinden, who later became director of the Department of Ethnology at the Brooklyn Museum, collected drawings at the Pueblos of Nambe and Cochiti in the years 1909–1912.

Pueblo Indian laborers working at the Rito site (1909–1914) responded to the prehistoric murals excavated there, imitating them in watercolors that were purchased by SAR staff members. This, in all likelihood, was the source of the works collected by the Henrys. Olive Rush, painter and leading member of the Santa Fe art colony, acquired paintings at Tesuque Pueblo in 1914. In 1916, Alice Corbin

Henderson, poet, editor, and wife of artist William Penhallow Henderson, purchased paintings made by Crescencio Martinez. The following year she collected San Ildefonso paintings by Awa Tsireh (Cattail Bird, also known as Alfonso Roybal), nephew of Martinez (Fig. 2-1). Also in 1917, Hewett commissioned Martinez to illustrate the cycle of summer and winter dances at San Ildefonso; all but one of the twenty-three planned works were completed at the time of his death in 1918. These paintings, known as the "Crescencio Set," are now in the collection of the SAR. About the same time (c. 1918), Mrs. John DeHuff, wife of the superintendent of the Santa Fe Indian School, was encouraging the artistic aspirations of three other young Pueblo artists, Ma-We-Pi (Velino Herrera, also known as Velino Shije) from Zia and two Hopis, Fred Kabotie (Na-Ka-Voma) and Otis Polelonema.[7]

Almost immediately the patrons of this new art form were arranging public exhibitions, including two displays of Pueblo painting at the Museum of New Mexico in Santa Fe in 1919, one of which was purchased by Mabel Dodge (Luhan). By 1920 the museum had created a special "Indian Alcove" for exhibiting this "new art indigenous to the soil."[8] The new painting made its first New York appearance in 1920 at the Fourth Annual Exhibition of the Society of Independent Artists at the Waldorf-Astoria Hotel. The principal force behind this exhibition was the society's president, the painter John Sloan, who had begun to summer in Santa Fe in 1919. Paintings were loaned by Hewett, Mabel Luhan, and Sheldon Parsons, formerly a New York portrait painter who had been named the first director of the Museum of New Mexico's Museum of Fine Arts in 1918.[9]

The significance of this New York exhibition cannot be overstated. It represented the first time that art by living Native American artists was exhibited in the eastern United States as *art* and not curio, craft, or ethnographic material. By exhibiting the paintings of Pueblo artists alongside those of their non-Indian contemporaries, the work gained a credibility in the eyes of the public and the critics

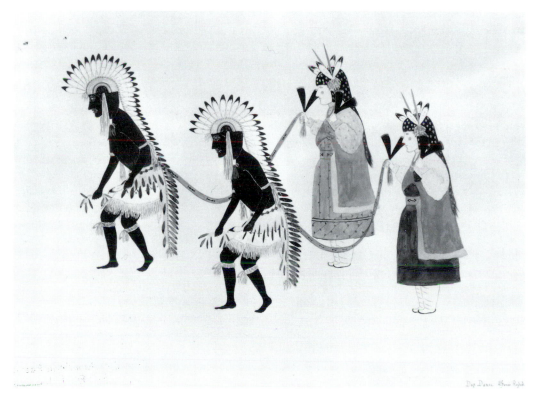

Figure 2-1
AWA TSIREH
(Alfonso Roybal,
San Ildefonso Pueblo)
Dog Dance
(c. 1917–1918).

Watercolor, 19" x 14".
School of American Research,
#IAF 13.

that it might not otherwise have attained. In a letter to Parsons, Sloan proclaimed the exhibition as immensely popular; in particular he noted that "the Indian drawings are a great success with both the knowing and the 'hoi polloi'" and that the crowd had exhausted the first printing of the catalogue.[10] In the brief text of the catalogue, an anonymous author—almost certainly Sloan himself—described the Pueblo painters as "probably the last representatives in the United States of the autochtonic [*sic*] artists of America." He went on to stress the fact that the society had chosen to "leave to museums the past art of these people and to concentrate upon the work produced today." The society felt that it was important to expose "works of great beauty" to a wider audience, and necessary also to demonstrate that contemporary Pueblo art expressed "the most ancient traditions of our continent with a vitality and with a style that show them to be at a very far remove from anything like decline." The text closed with a statement from Hewett that emphasized the cultural value, authenticity, and Americanness of the watercolors on display.[11]

There were at least two other exhibitions of the new Indian painting outside the Southwest in 1920. One of these, featuring watercolors from San Ildefonso, was organized for the American Museum of Natural History in New York by the writer Mary Austin, who had traveled widely in the Southwest and who became a permanent resident of Santa Fe in 1924. The other, organized for the Arts Club of Chicago by Alice Corbin Henderson, included watercolors by Awa Tsireh, line drawings by Sri Lankan artist and art historian Ananada Coomaraswamy, and watercolors by Czech-American painter Jan Matulka. According to *El Palacio*, it was an exhibition in which east met west.[12] But it was not the first such meeting; Coomaraswamy had been with the Hendersons at the SAR summer camp when they first encountered Awa Tsireh's paintings, and in fact, had purchased some himself.[13] Coomaraswamy's interest in Awa Tsireh's work is hardly surprising, for like the avant-garde, he believed

traditional art and culture could help modernity regain a lost spirituality. And perhaps the works exhibited by Matulka were the Indian-inspired ones he produced while traveling in the Southwest in 1918.

There was yet another manifestation in New York in 1920 of the Santa Fe colony's devotion to Native American culture. On a Sunday afternoon in July the SAR sponsored a service at Saint Mark's Church entitled "The Resurrection of the Red Man." Described as "An Afternoon in Honor of the Contribution of the American Aborigines to Our Future Civilization," it posed, rhetorically, a curious political question, "For which are you: Indian or Bolshevik?" and responded, "We celebrate the former." Following a devotional service based on aboriginal material collected by Mary Austin, who was then a Fellow of the SAR, several distinguished anthropologists, including Alice C. Fletcher, lectured on Native American folklore. Twenty of the Pueblo watercolors previously exhibited at the Society of Independent Artists were again on display, and the society's treasurer, painter-critic Walter Pach, lectured on these. Other Indian paintings were loaned for the occasion by noted ethnomusicologist Natalie Curtis Burlin, who led the congregation in the singing of Indian songs, accompanied by drums and rattles.[14]

The Santa Fe art colonists admired and collected not only the new Indian painting but also the whole range of indigenous southwestern crafts. By the late teens, however, they were concerned over the decline (once again) of quality pots, baskets, and textiles. Paradoxically, this was partially due to the growth of the tourist industry in New Mexico and to the impact on the marketplace of the ceramic revival that had begun circa 1890 at the Hopi Pueblos in Arizona.[15] Along with increased demand for quality goods created by the growing number of eastern collections, both public and private, the ceramic revival also led, inadvertently, to mass production, lower standards, and ultimately, to the production of souvenirs and trinkets. Even as traders and dealers sought to capitalize on the new tourist market by supplying inexpen-

sive Indian curios, the purists in the Santa Fe and Taos colonies (and elsewhere in the Southwest) sought to resist such commercialization by encouraging artists to pursue traditional forms and techniques. It was within this struggle for power over the direction of Native American crafts that the colonists made one of their most significant, if controversial, contributions to the history of art. I say controversial because their actions generated a paradoxical situation, one that Edwin L. Wade described as "the preservation of 'traditional' aesthetic culture straining against the forces of community development and individual creativity."[16]

The year 1922 marked the beginning of three preservation projects. The Hendersons, artist Gustave Baumann, and others founded the New Mexico Association on Indian Affairs, whose arts and crafts committee visited the fiestas at the various Pueblos where they judged works of art and awarded prizes.[17] Similarly, the Museum of New Mexico started an annual exhibition of Indian arts and crafts (but not in its "fine art" museum) with the expressed goals of encouraging artists to revive indigenous forms and of keeping "the arts of each pueblo as distinct as possible."[18] And in October of that year, Amelia Elizabeth White, a New Yorker who was devoted to Santa Fe because it was a place where she "could be sure of escaping the intolerable crowds that infest Eastern resorts in summers," opened her Gallery of American Indian Art in Manhattan, where she exhibited only authentic arts and crafts (i.e., not tourist curios) and the new Pueblo painting.[19]

In the autumn of 1923 the Santa Fe and Taos colonists again demonstrated their collective power to control the destiny of Native American art when they formed the Indian Arts Fund (IAF), whose original members were literally a Who's Who of southwestern art, anthropology, politics, and literary culture: Mary Austin, Taos modernist painter Andrew Dasburg, Alice Corbin Henderson, Taos writer and iconoclast Willard "Spud" Johnson, Mabel Dodge Luhan, Amelia Elizabeth White, and numerous others.[20] According to Johnson, the goal of the IAF was to "save Indian Art for Indians, and to preserve a complete historical

record of the varied Indian Arts of the Southwest."[21] The IAF patrons feared that the voracious appetite of the marketplace for historic objects would rapidly deplete the resources from which Native artists might draw inspiration. Writing in retrospect (1928), Austin noted, "Soon there would be nothing left by which the Indian Pueblo potters could refresh their inspiration and criticize their own output. With nothing to feed the stream of living traditions . . . it became quickly evident that the decorative quality of native designs would grow thin, lose interest and value."[22] Thus, as an IAF *Bulletin* explained, these Euro-American

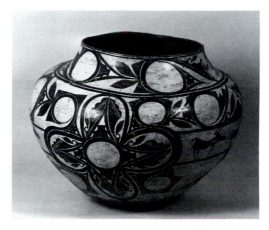

Figure 2-2
Zuni, pottery storage jar (c. 1850). Black-and-red painted design on white slip, polished, 63.5 cm in diameter, 48.2 cm high. School of American Research, #IAF1026, Zuni.

patrons sought to "revive the Arts and Crafts of the Indians by giving them free access to the choicest specimens of their tribal handiwork." In addition, the colonists wanted "to educate the people of the United States as to the value of America's only surviving indigenous art."[23] In 1927 the trustees transformed the IAF into the incorporated Laboratory of Anthropology, which received a $200,000 donation the following year from John D. Rockefeller to help fund construction of a Santa Fe–style building designed by John Gaw Meem. Although the collections were housed, studied, and exhibited in the new Laboratory of Anthropology, they remained the property of the IAF. In 1929 Austin donated the Alice Corbin Henderson collection of ceramics, which she had purchased, to the

Figure 2-3
JULIAN MARTINEZ
(San Ildefonso Pueblo)
Hunter and Deer
(c. 1925).

Tempera/paper, 14" x 22".
c594,
Katharine Harvey
Collection,
Museum of Northern
Arizona.
Photograph by Al Smith.

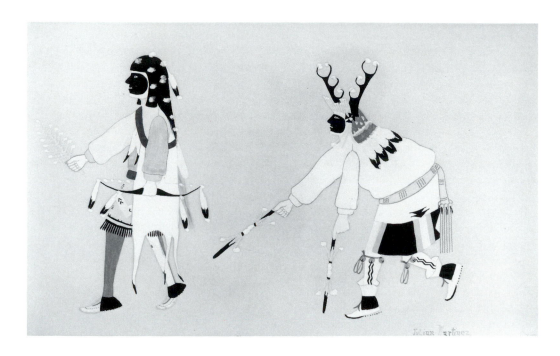

IAF collection of textiles, paintings, baskets, and more than one thousand pieces of pottery (Fig. 2-2).²⁴

The new Pueblo painting continued to garner much national and international attention in the late 1920s. In 1927 the Corona Mundi International Art Center (later the Riverside Museum) in New York exhibited works by several San Ildefonso artists, including Quah Ah (Tonita Peña), Crescencio Martinez, Julian Martinez (Fig. 2-3), Ma-We-Pi, Oqua Pi (Abel Sanchez), and Awa Tsireh, along with those of Fred Kabotie and Otis Polelonema from Hopi. By special request this popular show was on display at a dinner held by supporters of *The Nation* in honor of Native peoples. In the course of the evening, according to Dorothy Dunn, numerous tributes were paid to individuals "who had helped 'in inspiring the American Indian to this new effort at creative work and of again infusing his fine imaginative spirit into the sum total of America's creative fire.'"²⁵ Similar exhibitions were also held in 1929 and 1930 in Madrid, in Prague at the International Congress of Folk Arts, and at the Brooklyn Museum. The latter, organized by Herbert J. Spinden, featured works from the White collec-

tion and one volume of the *Codex Hopiensis* assembled by Fewkes.²⁶

Edgar L. Hewett and the Santa Fe Colony

Although Hewett was not a colonist per se, the institutions spawned by his energies—the SAR, the Museum of New Mexico and its Museum of Fine Arts—were at the heart of Santa Fe's cultural life, and he always understood the importance of art and artists to the future of the "City Different," as Santa Fe was called. Several important New York artists, including George Bellows, Stuart Davis, Robert Henri, and John Sloan, first came to Santa Fe as a result of his efforts and invitations. Lecturing widely and publishing often, Hewett was a vigorous advocate of contemporary Indian art and one of the first to assert the validity of studying ancient America. His article "America's Archaeological Heritage," which appeared in *Art and Archaeology* in December 1916, delineates many of his ideas about race, culture, and evolution, spirituality versus materialism, and the collective unconscious of the Indian. It is perhaps the prototype of primitivist writing in the New

Mexican art colonies because its themes, covert ideologies, and romantic language are found in many later texts.

Hewett began optimistically, noting the pleasure that Americanists took in the general awakening to the place in culture history of "the native American race," which was neither primitive nor inferior. Indians were, however, of noble character and destined for something more honorable than exploitation in fiction. Calling them a "race of splendid works," Hewett predicted for Indians a "future on the high plane of their ancient traditions." He also affirmed the elite nature of those to whom the nobility of the Indian would be appealing by describing the Indian race as "worthy of the consideration of the educated" because "their ideals of right and practice of justice" matched "the most exalted that civilization has brought forth." Furthermore, he cited Indian "masterpieces of art worthy of presentation to the public in museums, galleries, and publications devoted to art and culture."[27] Hardly disguised in these statements from 1916 are ideas, potent and troubling, that extended from the eighteenth and nineteenth centuries. Hewett has equated the civilized with the educated—and surely he means the literate—and assigned to them the power to deem "races" (un)worthy on the basis of their ability to meet the standards of Euro-American "ideals of right and practice of justice." The status of Native American "art" is linked to its appearance in those institutions most capable of signifying culture and civilization in the modern (i.e., secular) Western world—the museum and gallery. However odious these ideas are in retrospect, at least Hewett's position in 1916 accepted, tacitly, a Boasian kind of cultural pluralism that allows for the creation of profound works of art by non-Western cultures, even if the final criterion for accepting them as "masterpieces of art" was their display in Western institutions.

Hewett continued to use in this article his predecessors' problematic conception of "The Indian," as well as their consistent lack of distinction between cultural and racial inheritance.

Concerning the former he writes, "There has been a singular tendency to think of the ancient masterworks of the race found in Mexico, Central America, and South America as other than Indian art. It is necessary to repeat again and again that all native American remains, whether of plains tribes, mound-builders, cliff-dwellers, pueblo, Navaho, Toltec, Aztec, Maya, Inca, are just the works of the Indian. Chronologically it is without serious gaps, and ethnologically it is unbroken."[28] In his defense I should add that Hewett was trying to elevate the practice of North American archaeology to the level associated with the study of the "high" cultures of the Aztec, Maya, and Inca. And yet, in using the idea of a "New World race of Indians" as a battering ram against those who dismissed North American cultures as being the backwater of Central and South America, he diminished the uniqueness and legacy, for example, of the mound-builders of the Woodlands tradition or the cliff-dwelling Anasazi, whose cities become "just the works of the Indian." This generic lumping together of vastly different groups of indigenous peoples also allowed, indeed, was the basis for, generalizations about race/culture.

Hewett explained that between Euro-American peoples and the Greeks "only time intervenes, and but a small span of that when we think of it from the biological point of view." But between Euro- and Native Americans, he wrote, there is a "racial chasm which no mind can quite bridge." Accordingly, Caucasians of differing origins find each other's minds and characters "relatively transparent," but the Indian mind "remains a profound abyss." And in the ultimate conflation of biology and history, Hewett wrote that Indian culture "has been as long in developing as has the color of the skin; and is about as difficult to modify, for it is the expression of every cell of the organism."[29]

He was frank in his critique of Western values vis-à-vis the "good Indian," stating that in contrast to "our own spiritual character," Indian religion "measures up well." Despite their failure to master metallurgy, he was convinced that Native Americans surpassed their conquerors "in esthetic, ethical, and social efficiency."

19

In fact, "great material culture and physical force" were not signs of racial superiority, and he was not sure that material progress was necessarily conducive to "racial longevity." To his credit, one of the lessons Hewett learned from American archaeology was that material "efficiency in civilization is mainly a matter of racial [read cultural] point of view."[30]

The collective nature of Indian experience was indicated to Hewett in works of art, which he believed were unmediated expressions of unconscious urges: "The race has, like every other, revealed itself in art." And because there had been no *conscious* effort to reveal its racial character, the "picture" was a true one. Emphasizing collectivity, he wrote (in the past tense) that an Indian's life, "on the evidence of his cultural remains, was marvelously unified and socialized." In both ceremonial art and the creation of symbols and designs, the Native artist was "putting his whole spiritual life into it, and always with the thought of 'the people,' never of the individual or the self." In all these archaeological records and works of art Hewett found "no personal records—only tribal."[31] To convey fully the complete integration in Hewett's text of these various ideas, as well as the romantic language in which he cast them, perhaps he should speak for himself: "It is a noble heritage that comes down to us from the long past of America—a heritage . . . recorded in art, religion, social order; results of a fervent aspiration and mighty effort; a race pressing its way toward the sun. Its study is the finest aspect of the conservation of humanity; an attempt to rescue and preserve the life-history of a great division of the human species."[32]

Hewett's achievement as an archaeologist pales in comparison with his contribution as a patron of contemporary Pueblo art, which was motivated more by his ideas about the spiritual aesthetic of Native culture than by scholarly interest in ethnology. For example, when compared to Fewkes's attitude toward the works in the *Codex Hopiensis*, Hewett's interest in the series of watercolors that he commissioned from Martinez is revealed as more personal and less "scientific." Fewkes had questioned the authenticity of one Hopi artist's drawings and had rejected outright the work of another because it reflected non-Indian stylistic influences. But Hewett apparently never questioned the ethnological accuracy of the "Crescencio Set," nor did he use the drawings to stimulate discussion among other Pueblo "informants." Besides realizing that he was dealing with *art*, Hewett was also well aware of his position as an *animateur* of a "renaissance" of Pueblo painting.[33]

Just as he was commissioning and collecting art, Hewett recognized that he was dealing with *artists*, as indicated by the obituary he wrote for Martinez, who, he noted, "died an artist in the best sense of the word." An Indian artist, Hewett wrote, is taught by the spirits of anonymous ancients who equated beauty with happiness. As proof of this fact, he observed that in spite of years of interaction with modern art and artists, Martinez had never been influenced by them.[34] In eulogizing Martinez, Hewett underscored the importance of San Ildefonso men at SAR excavations for the development of the new Pueblo painting. Simultaneously, he revealed, albeit unintentionally, that his interpretation of these events was informed by recapitulationist theory: the legacy of the ancient cultures that was exposed at Parajito must have "quickened sacred fires that had been smouldering through generations of repression." While Martinez, "with an inscrutable Indian countenance," watched the retrieval of ancient Pueblo objects, deep inside him "the spirit of a great race was struggling." In fact, the notion of racial struggle as integral to the evolution of culture was absolutely central to Hewett's understanding of the emergence of the new Pueblo painting: "A renaissance is underway which is destined to bring back an art that is unmatched in the culture history of the world—a unique racial product." The new painting, he wrote, was "as distinctly racial as is Japanese art."[35]

On 15 August 1918 *El Palacio* published a short article by Hewett entitled "Primitive Art vs. Modern Art," which was based on a lecture given previously to his class on Indian culture. In it he characterized contemporary Pueblo

painting (and pottery decoration by Julian and Maria Martinez of San Ildefonso) as pictorial and "modern Caucasian" painting as impressionistic. Modern art he further divided into various schools in an effort to show his audience that the "ultra-modernists were groping to return to the primitive conventionalism and symbolism of the Pueblo." In Hewett's estimation, however, modern artists were having problems rediscovering primitive values, as demonstrated by modern art's failure to achieve "a sense of order and clearness of motive that underlies all Indian art."[36] By stressing order and clarity as the foundation of Indian art, Hewett subtly inscribed it with a latent classicism.

A similar conception of modern art appeared on the same page in *El Palacio* in a brief review of a lecture given in Santa Fe by a Mrs. Carroll Mitchell on "Bird Lore and Decorative Art among the Indians." Using as illustrations the decorative bird designs collected by Hewett's associate Kenneth Chapman, Mitchell claimed for Pueblo artists the distinction of being the "originators of Cubist Art." She based this opinion on a fairly sound but grossly oversimplified analysis of Cubism and Indian decorative art as styles of pictorial representation which moved from a Realism based on nature to a design-inspired imagery, arriving finally at an art of extreme conventionalism.[37] Thus, Mitchell was among the first Americans to equate the primitivist pictorial order inherent in much early modern art with Native American, as opposed to African or Oceanic, art.

In his annual report as director of the SAR (1919) Hewett wrote about the Native American "race" in relation to several ideas, including the following: racial purity and recapitulationist theory; environment and aesthetic experience; the Americanization of the aboriginal elements of the melting pot; and the role of artists and poets in documenting the "vanishing civilization." As for racial purity, he explained that the developmental stages of ancient America's "one race, unmixed for milleniums" [*sic*], was documented both by archaeological remains and by the "surviving intellectual possessions of the liv-

ing people." Recapitulationist theory, albeit modified, informed Hewett's qualification of these two kinds of remains: "The former class of evidence is buried in the debris of time, the latter submerged by foreign influence." Concerning the environment, he asserted unequivocally that the Native American was an autochthon, writing that the "Indian race took its character from the soil" and that its "unique mentality" was "related intimately to nature." And the veneration of natural forces by a "racial spirit keenly alive" resulted in an art—indeed, in a culture—that thoroughly integrated the aesthetic, the religious, the industrial, and the social. He went on to argue that since language and material culture had already been carefully recorded, anthropology's most pressing assignment was the "recovery and interpretation of purely spiritual revivals." Only thinly veiled in such an evaluation of the state of the discipline was a typically primitivist yearning for a spiritual revival of Euro-American culture. What Hewett described as the disappearance of the Indian into the citizenry of America only intensified this yearning and created a poetic and artistic imperative: take the Indian's "great racial experience" and derive from it a "true picture of what this continent made of its aboriginal . . . population."[38] Thus, Hewett fully expected that the "true picture" produced by the poets and painters of the New Mexican colonies would be evidence of the teleological nature, so to speak, of Native Americans (and hopefully, eventually of themselves): "The Indian is the result of the first and only process of Americanization that has been carried to completion. . . . It was inevitable that this region [the Southwest] should eventually impress itself powerfully upon the artist in America. It is a country of irresistible character; strong, compelling, elemental. . . . The country . . . moulded to its own definite character the Indians, Mexicans, trappers and traders, frontiersmen, cowboys—all those of its long romantic past."[39]

Hewett's comments on the process of Americanization recall the fact that after World War I there was a marked tendency on the part of artists and intellectuals, as well as politicians, to define American values and contrast them

with European ones. Just as a "lost generation" of American expatriate writers returned home to explore American themes in literature, so art theorists and critics also began to speak more emphatically about an *American* art.[40] One such voice was that of Dr. Hartley Burr Alexander, at that time professor of philosophy at the University of Nebraska, who presented a lecture on "Indian Myths and American Art" to the Santa Fe Women's Club at the New Mexico Museum of Fine Arts in August of 1921. Subsequently, a report on his lecture was featured in *El Palacio*. Alexander informed his audience that because classical mythology had formed the substance of all the arts of both the ancient and modern world, a distinctive American art would be determined by American mythology. Similar myths, he explained, were found in all cultures and reflected developmental stages seen on every continent. However, it was his belief that no other continent had as rich a pool of myths

as America. Alexander also observed, as did so many of his contemporaries, that the unique ecological awareness of the American Indian was the well-spring of his aesthetic expression. For example, he writes, "Here in America these primal human thoughts were clothed in an imagery that reflected the environment and thus became distinctive and therefore the real basis for American art." American artists, Alexander stated, had been fettered by European traditions, and it would probably "take another thousand years before those of European ancestry in the United States will be as good Americans as the Indians are today."[41]

In a 1922 article on "Native American Artists," illustrated with reproductions of watercolors by Awa Tsireh, Fred Kabotie (Fig. 2-4), and Velino Herrera, Hewett discussed once again the distinction between Native American and European values. For example, he explained that corn and metal were the sources of the two

Figure 2-4
FRED KABOTIE
(Hopi)
Hopi Ceremonial Dance
(1921).

Watercolor/paper, 18" x 22".
Philbrook Museum of Art,
Tulsa, Oklahoma.

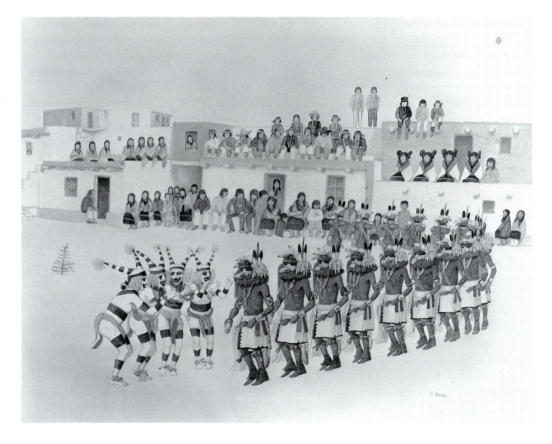

contrasting *races*, one dynamic and violent, the other passive and mystical: "The discovery and development of this plant [corn] was the dominant factor in the evolution of the culture of the native American race. As the discovery and development of metal gave direction to the culture of the European race, laid upon it a destiny of mechanical industrialism, control of natural forces, self-sufficiency, vast material advantages and potentiality of self-destruction, so corn shaped the destiny of the American race toward agrarian life, dependence upon nature, submission to powers outside itself, mysticism, and its resulting spiritual aesthetic culture, with marked inability to adapt to changes in environment."[42] Because Hewett had such ardent hopes that America the nation would not be a part of the inevitable and violent "end of the European race," it was important for him to observe that Indian peoples, with their mysticism and spiritual aesthetic culture, were "one hundred per cent American in ancestry and culture." Furthermore, Hewett claimed that the Indian race, whose spirit was still alive, was "certainly capable of being about the finest element in the American race that is in the making from so many diverse sources."[43]

Hewett continued his critique of the European race by questioning the idea that survival of a race depended "solely on material efficiency" and by insisting that "the culture that rests on material power is probably the most unstable of all." Accordingly, "the soundest insurance against spiritual decline and extinction by way of material violence" was for America to recognize that the ethical and aesthetic values of the primitive races were priceless and "persistent beyond all others." As evidence of this he pointed out the longevity and ethical/aesthetic culture of the Eastern races, which he contrasted with the rapid rise in material culture and quick disintegration of the European races.[44]

Similarly, he compared contemporary Native American painting, which was "a distinct revelation in racial aesthetics," to that of the "Orient." The art of both races, Hewett believed, shared a "flat, decorative character, absence of backgrounds and foregrounds, freedom from our system of perspective, unerring color sense and strangely impersonal character." Contradicting what he had written in 1918, he noted that Indian painting rarely became pictorial (read naturalistic), describing it instead as "essentially a symbolic, decorative art." However, writing more broadly of Native American art, Hewett used a romantic language often associated with a quintessentially American theme—the sublime and transcendent landscape. The Indian dance, which he insisted "always celebrates exalted relationships" and "unity with nature," was explained as the product of a long and reverent contemplation of nature. As if sensing a link between romanticism and modernism, Hewett advised the "ultra-modernists of today" that they might discover in Native American art "a true basis for a philosophy of art in which they seem as yet insecure."[45]

Alice Corbin Henderson

Alice Corbin Henderson, along with her artist husband, moved from Chicago to Santa Fe in 1916 because of her tuberculosis. Her health restored, she continued to be active as a poet and an editor, and in 1917 she opened a print shop.[46] In the years following her encounter with Awa Tsireh's watercolors at the SAR camp in 1917, she was instrumental in popularizing the new Pueblo painting, and her article on his work, which appeared in the *New York Times Magazine* in 1925, reveals her conception of the difference between naive and genuinely "primitive" art.

She recalled knowing immediately the significance of the watercolors shown her and Coomaraswamy: "I thought . . . that they pointed a new direction; and indeed, Alfonso's [Awa Tsireh] example proved to be the start for a genuine new development of Pueblo art. Other Pueblo artists . . . began to record their more realistic impressions of the life about them, and soon there was veritably a 'new school' of aboriginal water-color artists, whose

work was exhibited side by side with that of their white confreres in the Art Museum at Santa Fe."[47] Even though Henderson recognized the relative realism displayed in the watercolors and admitted that the Puebloans were being encouraged by primarily Euro-American painters living in Santa Fe, she could still claim that "there was not a trace of 'white influence'" in the Indian paintings. As an explanation she cited the "hands-off attitude" adopted by the Santa Fe colonists toward the development of this "purely native expression." Obviously, she and her associates felt that any attempt to shape the new painting would cloud the "clear primitive" vision of Awa Tsireh and his contemporaries.[48]

Henderson's generation of Pueblo art patrons often saw in it striking parallels to the art of the "Orient" (i.e., Chinese, Japanese, and especially Persian painting), and she was certainly no exception. Concerning Awa Tsireh's painting she wrote, "The figures had the clear precision of any fine example of primitive art, and it was natural that Dr. Coomaraswamy should appreciate this quality so closely allied to the pure contours of East Indian or Persian drawings." In the second group of Awa Tsireh's paintings shown to her she saw an "alert vitality" that she associated with primitive and Oriental artists. Although she spoke of Pueblo painters as primitives, Henderson chided an unnamed New York critic (Walter Pach) for referring to them as naive, untrained artists working in a new medium. She countered that Pueblo artists had for centuries mixed "native earth, mineral or vegetable pigments" with water and, furthermore, the new painting "was merely an extension of the centuries-old art tradition of the Pueblos." Her description of the relationship between the old and this new Pueblo art reflects the impact of the evolutionist paradigm: "The transition . . . from the incised hieroglyphs and deer hunts on the walls of the cliff dwellings, through the symbolic pottery designs, to these more realistic but still highly conventionalized drawings of human forms was a *purely natural progression and sequence*" (emphasis added).[49]

Henderson was determined to clarify the distinction between Awa Tsireh (and his contemporaries) and naive artists. She insisted, for example, that Pueblo artists were more civilized than Plains Indians but that even among the Pueblos one had to distinguish between the work of amateurs and that of genuine artists. For her, this distinction was something that admirers of the "'naive' in modern art" were inclined to ignore. Where others saw in Pueblo painting an aesthetic naivete, Henderson saw "simply the unspoiled purity of their vision." Thus, Awa Tsireh was the "genuine primitive, whose vision is still uncorrupted by any false canon of art, shop-talk or commercial end." And because its primitive vision was pure and clear, Henderson considered Pueblo art as the "finest possible contribution to our national life."[50]

Mary Hunter Austin

Before Mary Austin went to New Mexico, she was a founding participant in the art colony at Carmel, California, where her compatriot bohemian writers included Ambrose Bierce and Jack London. She had known Mabel Dodge (Luhan) since 1913 and had moved in the circle of radicals who populated her salon in Greenwich Village. Austin was a feminist and a prolific writer who, according to Lois Palken Rudnick, had already established herself as a nature writer and partisan of Native American culture when she arrived in New York.[51] However, she found New York boring and later recalled being troubled by the rage for success there.[52] At Luhan's invitation Austin came to New Mexico, perhaps as early as 1917, stopping first in Santa Fe and then traveling on to Taos.[53] From 1924 until her death in 1934, she lived in a Santa Fe house full of Native American and Spanish folk art.[54]

Given the circumstances of Austin's life, her involvement with Native American (and Hispanic) culture in New Mexico seems almost inevitable. In early childhood she had an encounter with god-as-nature, which formed the basis of the mystical, primitivist animism that underlies her poems, prose, plays, and art criticism. Austin always conceived of herself as

two selves: Mary-by-Herself, who was the functional Mary of the everyday world, and I-Mary, the transcendent creator of art and her own reality. When we consider, along with Austin's mysticism, her interest in the folklore and shamanic practices of California Indians, as well as her belief that the evolution of art and culture is shaped by the environment, it seems only natural that upon arriving in New Mexico, she was seduced, so to speak, by the romantic life of the Pueblo Indians.[55]

Austin began her first book about the physical, spiritual, and cultural environment of northern New Mexico, *The Land of Journey's Ending* (1924), by warning her readers, "This being a book of prophecy, a certain appreciation of the ritualistic approach is assumed for the reader." She went on to express with great passion her conviction that of all human societies, only Native American peoples had ever found, and kept for any appreciable length of time, "the secret of spiritual organization." But following this explanation was a foreshadowing of the ultimate darkness of her prophecy: "Over all the inestimable treasure of their culture lie our ignorance and self-conceit as a gray dust." As for Pueblo art, she ascribed its rhythms of color and design to an unconscious translation of intimate interaction with the environment. She explained also that "one of the empirical discoveries of our Ancients" was the relationship between "rhythmic movements" and "the powers of invention and discovery." Thus, for her, "instinctive movements" were the basis of all Native art and religion. Furthermore, she asserted that as a primary art, "no other national heritage touches it." And yet, she saw troubling signs of acculturation: "Nowadays you will find all manner of unlovely modern utilities: sewing machines, cook-stoves, victrolas. But among our Ancients there was never an article of the meanest use which had not its own aesthetic quality, if no more than that form of beauty which comes of perfect mastery over the material."[56]

Implied in Austin's reading of Pueblo culture are assumptions about evolution and recapitulationist theory. In fact, what she found

"priceless" was its "capacity for showing us the mind in the making."[57] Even so, she remained ambivalent about recapitulationist theory, especially the use of dream theory in contemporary psychology: "If you can slip inside the bubble of pueblo thinking . . . you see shaping on its iridescent surfaces, chiefly through the medium of dreams, vague large shapes of the life before we lived this life. But to come as close as that to the back of an Indian's mind, you must first realize that all this modern Freudian slough is no more the reality of dreams than the slime of a stagnant pond is the protoplasmic stuff from which Life made us."[58] Like so many of her contemporaries, Austin stressed the submergence of the individual Indian in the group: "The whole community lies at the center of one great bubble of the Indian's universe, from which the personal factor seldom escapes into complete individuation." At the center of the Amerind mind, she noted, "this reality is probably seldom personalized."[59]

Austin believed that the centrality of the group mind to Pueblo society made it the only one in the world without class, caste, or economic distinctions. Their "cultural wholeness," as she called it, was the result of a psychic unity so alien to Euro-American culture that there was no name for it. But in Pueblo life, the name for this unity "is woven out of the belief that there is god-stuff in man, and the sense of the flow of life continuously from the Right Hand to the Left Hand." It was useless, she explained, for modern culture to seek a word for this wholeness, because it was a state of being unrealized as yet in the Occidental world. Even so, spirituality and cultural completion hovered intuitively just beyond the pale of Western experience, waiting to be brought into consciousness by an observer of Pueblo culture. But this completion was being threatened by the potential demise of Pueblo life: "For this is what we have done with the heritage of our Ancients. We have laid them open to destruction at the hands of those elements in our own society who compensate their failure of spiritual power over our civilization, by imposing its drab insignia on the rich fabric of Amerindian culture, dimming it as the mud of a back-water

25

tide dims the iridescence of a sea-shell. . . .
[Thus] the great Left Hand of modernism
closes over the Puebleno." With a mystical
warning Austin urged modernity to seek that
complete flow of spiritual experience from the
left hand to the right: "For we cannot put our
weight on the Left Hand of God and not our-
selves, go down with it."[60]

Austin was one of the principal figures in the
Indian Arts Fund, and in a 1928 article, "Indian
Arts for Indians," she explained the origins and
goals of the IAF and elaborated further on her
generation's concept of Native American art
and culture. She wrote that because the preser-
vationist collectors had discovered the "living
quality of the Indian arts," they spent much of
their time and energies helping native artists
"recreate their ancient crafts." She remarked
also that the American public needed to be re-
minded that all the great cultures of antiquity
"possessed a native treasure of aboriginal art"
influenced only by its natural environment.
Due to the activities of the IAF, she envisioned
not only a United States with a national trea-
sure comparable to those of Greece, Egypt, and
England, but also a Museum of Indian Arts for
Indians that would promote Native artistic ac-
tivity while contributing to the development of
an American aesthetic.[61]

In explaining why Santa Fe was the logical
place for the IAF to emerge, Austin implicated
the modernness of Indian art: "In a community
which reaches the highest mark of modernity in
art in the studios of John Sloan and Andrew
Dasburg, there is bound to be a place for Awa
Tsireh, and Fred Kabotie, for Maria of San
Ildefonso and for the vanished nameless artists
who long before these, painted their inmost
thought on food bowl and water jar." However,
she hoped that preserving and promoting
Native American culture would not be a strictly
regional activity. She called instead for a na-
tionwide movement to resist the attempts by
government and missionary schools to infect
Indians "with something called Americanism."
If there were no Indians to be rescued in the
reader's own locale, they were invited by Austin
to journey to the "land of the 'sacred middle'"
and join the efforts of the IAF.[62]

What impressed Austin most about Indian
art was its "free, direct response to an American
environment." And yet, she likened "the psy-
chological progressions governing the aesthetic
of Pueblo design" to those of Chinese poetry.
The reason for this, she wrote, was that the Na-
tive American soul was actually more Mongo-
lian than American. She made other statements
as well that implied the organic continuum in-
herent to recapitulationist theory: "Like the
subtle alterations of a growing plant, the art of
the Indian links the observer with a past and a
future in true genetic relationships." And, like-
wise, "All racial decorative schemes have so far
shown a progressive relation to the evolving
tribal consciousness." Also consistent with
recapitulationist theory was her assertion that
Puebloans, whom she described as "agricul-
tural, communistic, and intensely republican,"
always used the type of expressional [*sic*] design
preferred by children and primitives.[63]

Mabel Dodge Luhan and the Taos Colony

Before her New Mexican period Luhan led a
cultured life in Florence and was an important
patron of the avant-garde "movers and shakers"
in New York prior to World War I.[64] Shortly
after her marriage to the artist Maurice Sterne
in 1917, Luhan was told by a medium that one
day she would be surrounded by Indians, whom
she was to help. Impressed, she began to won-
der about the Indians in the Southwest where
Sterne was then living. Subsequent to this (and
Sterne's arrival in Santa Fe in November 1917),
Luhan, who had remained in New York, had a
dream in which her new husband's face was
blotted out by that of a dark face that cleansed
her "like a medicine."[65] Then, in a letter writ-
ten in Santa Fe on 30 November 1917, Sterne
made the following suggestion to her: "Do you
want an object in life? Save the Indians, their
art-culture—reveal it to the world! . . . That
which . . . others are doing for the Negroes,
you could, if you wanted to, do for the Indians,
for you have the energy and are the most sensi-
tive little girl in the world—and, above all,

there is somehow a strange relationship between yourself and the Indians."[66]

Amazingly, even *before* Luhan joined Sterne in Santa Fe, she wrote to him of the Indians there: "They *are* the same blood and the same culture [as East Indians]—totally unmixed with our own known civilization. . . . When they mix they die, the ancient part of them dies. In their unconscious lie things that neither they nor we can fathom. Perhaps I too would feel this curious affinity with them that you do. Certainly the live heart of me—the inner life, is a life that finds no counterpart in Western civilization and culture."[67] Luhan arrived in Santa Fe in mid-December 1917, and on Christmas Day saw her first Indian dance at Santo Domingo Pueblo. She recalled this mystical experience in her memoirs: "For the first time in my life I heard the voice of the One coming from the many. . . . The singular raging lust for individuality and separateness had been impelling me all my years as it did everyone else on earth—when all of a sudden I was brought up against the Tribe, . . . where virtue lay in wholeness instead of dismemberment."[68] Early in 1918 she met the "dark Indian," Antonio Luhan from Taos Pueblo, who would become her fourth and final husband and who provided her spiritual introduction to the "Tribe."

While visiting New York in April 1919, Luhan was informed by yet another medium that there had been "since the earliest known civilization, a secret doctrine . . . kept alive throughout the ages by being transmitted through certain races." This doctrine, now in the hands of the Pueblo Indians, "was the psychic key to Nirvana on earth." Taos, in fact, was described to Luhan as "the beating heart of the world." Furthermore, the seer told Luhan that she would pass this secret doctrine from the Indians to the Occidental world. Specifically, Taos was going to attract "great souls," and thus, become the center of a reborn Western civilization. According to her biographer, Lois Palken Rudnick, Luhan needed nothing else to convince her that "Taos was the place and postwar America the time to institute a revitalization of American life."[69]

In her 1924 essay "From the Source," Luhan asked, concerning the Pueblo Indians, "Does any other race in the world today receive life at its immediate, pristine source?" She also alluded to the New York soothsayer's revelation of a secret doctrine now possessed by the Pueblo Indians: "If we draw them away from the centre, who, then, will fulfill their part in the whole? They are the first and oldest receivers of human life, and from them it passes in widening circles until it reaches us. It does not seem credible that power passes *back* and *forth* from race to race; it is more likely that it goes *forth* only, in an unbroken, unlawful succession."[70] Luhan described Native Americans as pure being at the heart of the sun, neither thinking nor feeling, only worshipping and receiving. And because they were neither "coming or going, but abiding only," they could pass their special powers on to non-Indians, who might become "time binders and supermen." However, in order for the Western world to be redeemed, to be spiritually transformed by the secrets of primitive life, not only was it necessary for *power to go forth unlawfully* from Pueblo people, but it was also essential for Pueblo culture to remain static: "And that we may travel as light travels, the Indian must remain motionless at the centre, transmitting the power to move."[71]

Through the 1920s Luhan continued to expound on the messianic role being played, so she believed, by Pueblo Indians in the spiritual evolution of the cosmic clock. In her essay "A Bridge between Cultures" (1925), she discussed the idea of the Indian as natural man; Native American art as ritual expression of landscape; and the displacement of New York as the artistic and spiritual center of America. And yet, an integral part of her thesis remained the notion of the Pueblo Indians as the chosen keepers of the mystery of life. For example, she writes, "Though the evolutionary will produces strong men in New York, these others will outlast them. For they are not only the hosts of the life force but . . . they are the favorites of the will of nature: through the shifting and changing of other races of men they have harbored the vital

energy in an unbroken security since before we began to reckon history."[72]

Luhan's conception of the Indian as natural man, like Austin's, was equivalent to the idea of the Indian as embodiment of natural rhythms: "The Indians are never any more in a hurry than nature, since they have accepted her rhythm, and she is never in any impatience." This was obviously a key to the secret doctrine held by the Puebloans, for by living in harmony with nature they were only fulfilling "the destiny they have inherited."[73] The art of this natural native, logically, was the expression of the natural world. According to Luhan, Pueblo art—inspired by the landscape and a wondrous awe of the fertile soil—was the American continent's only great contribution to the totality of world culture. The pattern of existence that she observed at the Pueblos was "at the same time both life and art." It is hardly surprising then that, concerning urbanized, industrialized New York, Luhan declared, "Organic art ceases to exist [there], for the life-force is withdrawn from it to energize the downward turn of the wheel of change."[74]

Luhan believed that the competitiveness of life in New York kept people concerned with time, whereas "their older brothers along the Rio Grande continue to live outside of Time in a life of religious devotion." But if New York was being displaced as a center of culture, and if there were those who suffered spiritually because organic art was dead in the Eastern United States, Luhan offered them succor: "Entertainment, expressionism, interpretation, symbolism, and religion—all these are alive now in the southwest for anyone who needs them." Indeed, like Austin, she speculated that the "Southwest may be the land of the new birth, of the synthetic American culture we have all desired."[75] Luhan's prediction of an artistic rebirth in the American West and her repeated references to the evolution of a secret doctrine and to life/art as unity with nature have a decidedly Hegelian undercurrent. Her vision, in fact, contains a number of dialectical resolutions: East and West, urban/secular, modern and ancient, and timeless and

timebound. The synthesis of these elements, she noted, along with the recognition of the bond between landscape and primal spirit, would produce not only a new art but also the new American culture for which so many were longing. Moreover, Hegel's notion of the progressive unfolding of the predestined absolute is assumed in Luhan's belief that "each generation brings man a little nearer to the ultimate indwelling god."[76]

Some of the first Pueblo watercolors exhibited in New York were works by Awa Tsireh from Luhan's collection. In 1927 she published a critical text about his work that began with comments on memory taken from the Greek philosopher Plotinus and the German Theosophist Rudolph Steiner, the latter stating, "The blood carries the burden of memory."[77] In this manner she announced, tacitly, that one premise of her discussion would be the idea that racial memory is a biological, as opposed to a cultural, inheritance. And by invoking the wisdom of Plotinus (A.D. 205–270), Luhan established a cosmic context for her discussion of Awa Tsireh's paintings.[78]

The Indian, Luhan explained, is able to see the landscape organizing itself "into the designs that all organic nature intends to express," and in doing so, "he notes their order and symmetry." That is, the One, as it manifests itself in nature, does so with volition. Luhan assigned the essential quality of the One to both nature and the Indian: "Everything in nature . . . is as definite and as irrevocable as the pattern of himself or as the indelible writing in the palm of his hand." And because the Indian's is an "intensely visual experience" that recognizes order and symmetry, he perceives nature as cosmos, not chaos. This was proof that the Indian was an *Urmensch*: "The Indian has the gift of seeing organized form so clearly because he has cultivated his senses instead of the faculty of analysis. . . . He sees instead of thinking about what he sees. . . . He hears; he does not think about hearing."[79]

Luhan used four of modernism's recurrent themes to convey the importance of Awa Tsireh's artistic achievement: the underlying geometry of nature (attendant to Cézannism);

Clive Bell's significant form; the unconscious as the source of art; and the authenticity of primitive experience. According to Luhan, as an artist Awa Tsireh was like Cézanne, Van Gogh, and the Egyptians in that "he discovered the law of form which states that all life is a manifest geometry, that every concrete expression of art or nature has a determinable structure." She explained that to do this, these artists had to remove themselves from the mundane world: "A straight experience of any object, uninterrupted by opinion or cerebration . . . will reveal it in its essential form." Therefore, because "no thoughts dart back and forth through" Awa Tsireh's brain, "the significance and verity of his form are unquestionable when he has captured it." He had "perceived the significant form" in Pueblo ritual and "transcribed it in his memory . . . together with conscious or unconscious symbolism of its geometry." Like other Indian artists, Awa Tsireh took his designs from "the sensitive plasm of the unconscious" where they were recorded. His was "a more authentic record of it all," because he had sacrificed cerebration for sensory experience. However, any artist who, like the Indian, was willing to abandon analysis and confront nature could attain a vision of the "perpetual movement and vibration in matter."[80]

Luhan emphasized the relationship between Pueblo ceremonial art and the mystic One in other contexts as well. In "Beware the Grip of Paganism," written in 1929 ostensibly as a note on the dances at Santo Domingo Pueblo, she observed: "A hundred men are beating out the dance, it is a dance of the sun energy converted into a man form. . . . They are not separate from each other or from the sun. They are all one, and the earthen houses and silent watchers are one with them." Watching the pageantry of this "dark immobile race," Luhan felt as if she were losing her identity and "becoming one with the sound and the sun-beats." As her sense of individuation gave way, she experienced, apparently, a sensuous, religious catharsis: "The movement has become one with the movement of our breathing—we float in it; we are living in

rhythm—we are rhythm. There is no more you or me, or hot or cold, or dark or light. There is only sun-beat."[81]

Although not an artist herself, Luhan did take photographs of Taos Indians. More important, however, were the invitations to visit Taos that she extended to artists, writers, and musicians. In fact, it was largely she who made Taos into the Greenwich Village of New Mexico. Luhan was directly responsible for the first presence in New Mexico of Andrew Dasburg, Marsden Hartley, John Marin, and Georgia O'Keeffe. At various times the guests at her Taos compound included the writers Willa Cather, Edna Ferber, Robinson Jeffers, and Thornton Wilder; the conductor Leopold Stokowski; and the critics Leo Stein and Carl Van Vechten. But not all of the cultural luminaries who passed through or stayed on in Taos during its heyday were completely smitten with the romance of Pueblo culture. Luhan's most distinguished, or at least most notorious, invitee, D. H. Lawrence, was ambivalent in his primitivism.[82] On occasion, he could write of America's need to reject the European artistic tradition and "catch the spirit of her own dark, aboriginal continent." According to Lawrence, to find their own tradition, Americans needed to embrace the mysteries of "Red Indian" life, which Cortés and Columbus had murdered.[83] At other times he was quite cynical about the avant-garde's primitivist infatuation with Native American art and ritual. In 1924 he published an article, "Just Back from the Snake Dance—Tired Out" (Fig. 2-5), in Spud Johnson's *Laughing Horse*, which features the following acid-tongued indictment: "The Southwest is the great playground of the White American. The desert isn't good for anything else. But it does make a fine national playground. And the Indian, . . . he's a wonderful live toy to play with. More fun than keeping rabbits, and just as harmless. . . . Oh, the wild west is lots of fun; The Land of Enchantment. Like being right inside the circus-ring! Lots of sand, and painted savages jabbering and snakes and all that."[84]

A more typical "appreciation of Indian art" was that expressed by the first art colonists at

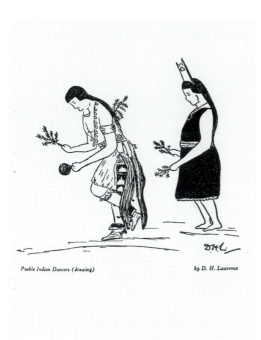

Pueblo Indian Dancers (drawing) *by D. H. Lawrence*

these two painters reiterated the idea, expressed by Luhan and others, that a causal relationship existed between the spiritual quality of Indian art and the Indians' lack of civilization, as it was defined by modern, urban, Western culture.

John Sloan and The New Yorkers

Sloan, at the suggestion of Robert Henri, first visited Santa Fe in 1919. For the next thirty-one years he made the "City Different" his summer home. He was elected president of the Santa Fe Painters and Sculptors in 1944 and president of the New Mexico Alliance for the Arts in 1949.[87] Although he was a semipermanent colonist at Santa Fe and a central figure in its artistic life, his formidable presence in New York's art world during those same years is undeniable. In 1918 Sloan was a founding member of the Whitney Studio Club. He was president of the Society of Independent Artists from 1918 until it became inactive in 1945. He taught intermittently at, and in 1931–1932 was the president of, the Art Students League, where his students included Adolph Gottlieb, John D. Graham, George L. K. Morris, and Barnett Newman, all of whom were involved, in varying degrees, with Native American art and culture. It seems unlikely—even improbable—that this shared interest did not owe a significant debt, perhaps even its origin, to Sloan's enthusiasm for Indian art. Because Sloan was responsible for the first New York showing (at the Independents in 1920) of the new Pueblo Indian painting, and because of his role in the Exposition of Indian Tribal Arts, which opened in New York's Grand Central Galleries in 1931, I am treating him here, somewhat artificially, as a "New Yorker" and not a member of the Santa Fe colony.

In 1924 the Committee on Indian Affairs of the Young Women's Christian Association declared Pueblo dances degrading and immoral and urged the government to ban them. In an article entitled "The Indian Dance from an Artist's Point of View," Sloan responded to the public outcry by announcing, "I am very much against the stopping of these dances; but for

Taos, the painters Ernest L. Bluemenschein and Bert G. Phillips. The latter, who was concerned that efforts to civilize the Indians would destroy their aesthetic gift to the world, favorably compared Indian blankets to the finest Persian rugs. Phillips also stated that Indian concepts were as racial in character as those of the Japanese.[85] Bluemenschein, too, worried about the detrimental effects of acculturation: "If in the adoption of a 'higher' civilization the Indian gives up his own remarkable gifts to the world, the loss will be irreparable." He urged fellow artists, ethnologists, educators, and businesspeople to appreciate the fact that the aboriginal Americans had contributed more to the arts than had "two hundred years of 'civilized' occupation of North America." Insisting on the link between art and spiritual growth, Bluemenschein called the San Felipe Buffalo Dance a true manifestation of high art. Similarly, he stated that the music of the Santo Domingo dances was equal in aesthetic quality to that of Beethoven. However, he warned that this "fine intelligent race who have developed a distinctive and absolutely original art" would be destroyed by too much civilization.[86] Thus,

that matter, I am not in favor of stopping anybody from doing anything." Like Luhan, Marsden Hartley, and others, Sloan understood that the "dances" were actually ritual celebrations of nature: "The stopping of these dances in a free country means the stopping of religious ceremonials of profound significance to the people performing them." Sloan felt he was speaking for American artists and writers, as well as all those interested in the beauty of American life, when he stated, "The dances should not be interfered with, . . . they stand as relics of a picturesque and beautiful civilization." He claimed that Indian art had already "proved a refreshing influence for American art" but that Indians had not found much inspiration in American public festivals, such as jazz dancing.[88]

His appreciation of the aesthetic component of the dances formed an integral part of Sloan's advocacy. He was convinced that any and all beauty-loving people who witnessed the dances would "express themselves as delighted with the general aesthetic quality of Indian culture." And he knew that among the Pueblos, aesthetic experience was indivisible from spiritual experience: "The American Indians, the few that are left, have a most closely knit religious and aesthetic culture." Although Sloan denied that the dances were immoral, he thought keeping non-Indians away from the dances was preferable to stopping them: "People who love beautiful things, beautiful color, a beautiful expression of emotion, would lose a great deal by such an order; just as here in New York we would lose a great deal if none but musicians were allowed to attend the opera, none but painters to attend picture exhibitions. I should feel such an order to be great loss to me personally, but it would save what is vital and fundamental to the Indian at least."[89]

Race was likewise a factor in Sloan's arguments for preserving Native American culture. For example, he explained that "spiritually and mentally the races do not amalgamate." Thus, their fundamental differences made any essential intimacy between the white races and the Indian impossible. The government's policy to-

ward the Indian race was perplexing to Sloan: "If they are not a race with something to give us in the way of beauty, in their ceremonial and art, why should they have been held apart from the white people and given what we call protection?" He found it illogical, therefore, that having "reserved" Indian peoples to ensure their survival, the government now wanted to destroy them by stamping out their religious/artistic/cultural expressions (i.e., the dances), which were indispensable to their existence. And Sloan, like his contemporaries, never lost sight of the unique gift that Native American culture could make to twentieth-century America: "I still hope that the value of the Indians to this country, their philosophy, their art, their dignity, their immense inspiration to modern artists and writers, will be recognized by the Indian bureau and what is left of a beautiful, early civilization will be allowed to survive with its soul as well as its body intact."[90] It was appropriate that Sloan's description of Indians might well have been one chosen by all the Indian art preservationists for themselves: "Above all things they are friends of art."

In 1926 Sloan spoke of American Indians in reference to the death of modern art. By modern art, however, Sloan meant the conservative art of contemporary academicians. Accordingly, *ultramodern art*, which used mind-sight, as opposed to eyesight, would be the medicine to cure the sickness of modern art. He compared mind-sight of this ultramodernism to primitive sign-making: "Some of the best examples of great art in the past are in the pictures drawn on the roof of a cave in Spain. . . . Art is a means of sign making which says [for example] buffalo. If it does without signs it isn't art. Not that all art is pure sign making, but the elements of sign making must be there. It must signify the thing to the mind, not the eyes." For Sloan the greatness of Pueblo art was its use of these elemental signifiers. And because he believed the artistic future lay in an ultramodernism typified by sign-making, Sloan speculated that if there were ever to be a "real American art," it would develop in the prehistoric environment of New Mexico.[91]

Walter Pach

Pach was a painter, journalist and critic, teacher and lecturer, and noted art consultant; his real métier, however, was "spokesman for modernism."[92] From 1903 until 1913 he lived primarily in France, where he became acquainted with many avant-garde artists, including Picasso, Braque, Matisse, the Duchamp brothers, and the Salon Cubists, such as Albert Gleizes. Because of his firsthand knowledge of European modernism and his fluent command of both French and German, he had a major hand in organizing and publicizing the Armory Show. One of the first Americans to write on the art of Cézanne, he also published studies on Ingres, Van Gogh, Seurat, and Duchamp-Villon. Pach organized a New York exhibition for his former teacher, Matisse (1915), and advised the poet Wallace Stevens on collecting modern art and John Quinn and Walter Arensberg on collecting modern and pre-Columbian art. Certainly it was no exaggeration when Sandra Phillips described him as an influential "explicator of modernism" and principal figure in early twentieth-century cultural history.[93]

Pach knew Sloan well, first as his student and later as a fellow member of the Society of Independent Artists, whose treasurer he was from 1916 to 1921, often exhibiting his own Cubist-oriented works in the annual show. As an officer of the Independents, he must have assisted Sloan in arranging the 1920 exhibit of Pueblo watercolors at the Waldorf-Astoria. Furthermore, Pach was well acquainted with the collections of Indian art at the American Museum of Natural History, the Brooklyn Museum, George Heye's Museum of the American Indian, the Museum of New Mexico in Santa Fe, and the Field Museum in Chicago. As such, his 1920 article on "The Art of the American Indian" was written with a genuine experience, visually at least, of the objects. This text, which appeared in *The Dial* (1920), is a virtual compendium of the primitivist themes inherent to Euro-American intellectual and spiritual life in the early twentieth century. Pach's well-established position as proselytizer of avant-garde art encouraged the public, no doubt, to take seriously his belief in Native American art's relevance to modernity. In truth, it is precisely because Pach was a purveyor of modernism that cultural primitivism informed his perceptions of Indian art.

Although Pach was willing to categorize Native American objects as art and not "the relics of a savage period," his aesthetic judgments were clouded by the duality of race/evolution. The fact that contemporary southwestern arts and crafts equaled the best ancient work was proof to Pach that the artists were outside of historical time. As with all really primitive people, he wrote, the art of Native America revealed no "period evolution" (read stylistic development). Not only were Indian cultures unchanged, but according to Pach, it was also imperative that they not change: "If we 'civilize' the Indians of the Southwest, there will be no more tribes possessing an ancient life of which we might deprive them." Pach managed to find justification for the historic assault on Native cultures "in the higher needs of the white race." And yet he deplored the government policy of his own day, which was to suppress Native cultures. It was time for society to realize, he wrote, "that even backward peoples have their rights." Poets, artists, and scientists concerned with aesthetics were becoming "aware of the profound value of the Primitive," and Pach assumed that the general public would follow the lead of these "specialists."[94]

For Pach, the value of the autochthonous cultures of the Southwest was in their complete integration of art and life, which he associated with the dignity of national character and religious spirit. Like Henderson and others, Pach, too, found similarities in Pueblo and "Oriental" art, comparing the bold, vigorous designs of Santa Clara Pueblo black pottery with the art of early dynastic Egypt. He insisted also on racial character as the source of the Indian "genius for expression in plastics." In Pach's reckoning, because Indian life is free and natural—that is, lacking the artifice of civilization—its art "has the unbounded sincerity of a free people." Indeed, at the core of Indian life and art was a "satisfaction of instinct" comparable to the im-

mediacy of expression sought by modern artists. Even the new Pueblo watercolors, in which he saw original, more complex designs (but apparently not period development), had the authenticity of ancient art.[95]

Pach's appreciation of Indian art as the instinctual expression of primal experience is inseparable from the antipositivist and antimaterialist components of his cultural primitivism. He warned his readers that history had proven time and again that spiritual attainment should not be neglected for scientific knowledge or material accomplishments. Furthermore, he saw cultural pluralism—embracing the primitive—as an antidote to the spiritual ills of the West, explaining that modernity was finding a "wealth of intuition" in the "countries and periods that are backward in material development." He thought it was logical, given that the premodern tradition in western art had actually been a barrier to intuition, immediacy, and authenticity, that avant-garde artists seeking to overturn that tradition were finding "special pleasure" in Indian art.[96]

Pach's first article on Indian art in *The Dial* generated so much interest that he published a second, "Notes on the Indian Water-Colours" (March 1920). However, the real justification for the article, he noted, was "the beauty of the paintings" being exhibited by the Independents at the Waldorf-Astoria. His "notes" were about the watercolors as a group and in general, with only one artist, Fred Kabotie, being named—hardly the way that he would have dealt with a show of contemporary Euro-American art. And yet, Pach was appreciative, naturally, of the *modern* character of the paintings, citing the way the artists achieved an abstract quality by reduction to the essential elements. Overall, the review was almost fulsome in its praise, as Pach wrote of the grandeur, expressive rhythms, and vital designs of the paintings.[97]

Although Pach lamented the loss of the work's true color in the black-and-white illustrations, he noted their sense of decoration and the pure, intense expression that marked the artists as "great Primitives." In fact, in his de-scription of their style he provided, indirectly, his working definition of the "Primitive": "They are Primitives in the true sense of the word, their form and content deriving from an immediate response to the scenes they depict, the simple means of execution being suddenly raised to their intensity of effect by the conviction and enthusiasm." Thus, in true primitive art both form and content are an unmediated response to stimuli. The artistic means themselves are direct and uncomplicated but not impoverished because of the internal qualifiers, such as sincerity and energy. As in his first article, Pach insisted on the value of this art as the "precious . . . instinctive rendering of things seen." And because the Pueblo artists were frank and literal in their artistic statements, he read the lyric, epic, or humorous content in the work as a reflection of the unconscious. These "children of nature" achieved, instinctually, color effects of which "any 'civilized' artist might be proud." Comparing its colors to those of Persian miniatures, Pach celebrated the "Oriental" richness of the Pueblo painting, even as he declared it unique and "nearer to us: it is American!"[98]

Holger Cahill

Remembered best as director of the Federal Art Project of the Works Progress Administration (1935–1943), which sponsored mural projects and gave employment to more than four thousand artists, Cahill began his institutional involvement with American art under the forward-thinking John Cotton Dana at the Newark Museum in 1921. During his long association with the Museum of Modern Art, which began in 1932, he organized exhibitions and wrote and edited catalogues, including *American Painting and Sculpture, 1862–1932* (1932). One of the most important of these was the influential survey of pre-Columbian art, *American Sources of Modern Art* (1933), in which he attempted to show an affinity between modern, Aztec, Maya, and Inca art. The New York's World Fair of 1938–1940 featured an exhibition of American painting which Cahill had or

ganized. Following World War II he continued to live in New York, devoting most of his time to writing fiction. Nevertheless, a recognized authority on New Mexican folk art, Cahill was described at the time of his death in 1960 as an ardent supporter of American avant-garde art.[99]

Coinciding with the third presentation of Pueblo watercolors at the Society of Independent Artists exhibit in New York in 1922, Cahill published an article in the *International Studio* entitled, "America Has Its Primitives," in which he observed that the popular conception of the Indian as a violent savage (i.e., the bad half of the dichotomous Indian) was being replaced by a "relatively peaceful, industrious figure." According to Cahill, this "child of nature" hunted wild animals, wrested his living from the soil with a rough hoe, and lived among his people "in a free democratic association." He insisted that the "shrewd materialist culture" of the West had taken much from Indian civilization, but not its higher elements, such as philosophy, poetry, and art. Indeed, he wrote, and rightly so for his time, that much of the public still rejected the notion of an Indian *art*.[100]

Cahill patronized the painters by describing them, as Hewett, Henderson, and others had, as "these Pueblo Indian boys," despite the fact that all of those exhibited were adults: Crescencio Martinez, Awa Tsireh, Fred Kabotie, Velino Herrera, *and* Tonita Peña, a woman and one of the most accomplished painters of her generation. Nevertheless, Cahill saw these "boys" as the "pioneers of a new race of American primitives . . . by virtue of a child-like vision and a delight in things seen, and not in any sophisticated or consciously cultivated naivete." By integrating a European art technique—watercolor—with their lavish ceremonial life, Pueblo artists had created an instinctive, expressive aesthetic dimension that marked "the birth of a new art in America."[101]

Cahill shared with his primitivist colleagues a belief that the Pueblo watercolors were examples of a timeless art more than a specific ethnographic record. His appreciation of the formalism of the Pueblo watercolors, especially their lack of naturalism and their flatness, was no doubt conditioned by his familiarity with and appreciation of modernist aesthetics. Cahill also praised the Pueblo artist's conceptual treatment of the dance ceremonies, which served as the primary subject matter of the works on display at the Independents' exhibit: "An American or European painter . . . would paint the phenomenon. The Indian concentrates on the thing itself. The European would record his visual sensations. The Indian records what he knows, emending his vision by his knowledge and his intuitive understanding—and art is usually in proportion as the artist does this."[102]

Although Cahill associated, in this instance, American and European art with a recording of sensory perception, I assume he meant older styles (e.g., Impressionism) and not the then-current styles of the avant-garde, whose search for the noumenon involved amending with memory and intuition the phenomenon of the object. I suspect also that this metaphysical aspect of modernism—its critique of cognition as defined as facts verifiable by sensation (e.g., positivism)—informed and sustained Cahill's attraction to Indian art's search for "the thing itself." However, he found the culture of modernity, as distinguished from modernism, to be the antithesis of Pueblo culture, which he characterized as permeated with "aestheticism and a deeply religious feeling." In his view, although modern Western culture claimed to find joy in beauty, as did the Indian, it had erected, in fact, a "sordid industrial Babel." Thus, he advised, "We great Machine People, who have carried ugliness well-nigh to apotheosis in the fairest lands of earth, may well forego the conqueror's pride and learn wisdom from our humble brother of the Pueblos, who has made the desert bloom with beauty."[103]

Marsden Hartley

Hartley's avant-garde credentials, so to speak, were firmly established when his first solo exhibition opened at Alfred Stieglitz's "291" Gallery in New York in 1909. He was already familiar with the art of Cézanne, Matisse, and

Picasso when he went to Paris in 1912, where he met Mabel Dodge (Luhan) through the Americans Gertrude and Leo Stein.[104] In order to know better the personnel of an art association known as Der Blaue Reiter, whose art and publications he was already aware of, Hartley spent time in both Munich and Berlin in 1913. Der Blaue Reiter's interest in the spiritual attributes of primitive art encouraged him to study the collections at the Museum für Völkerkunde in Berlin and the Trocadero in Paris. This exposure, in turn, contributed to Hartley's compelling *Amerika* series, abstractions relating to Native America.[105]

Hartley also knew the primitivistic paintings of his Stieglitz circle associate, Max Weber, as well as the latter's enthusiasm for pre-Columbian and Native American art, as expressed in the journal *Camera Work*. So by the time he traveled to the American Southwest, Hartley had already been introduced to primitive art, in general, and "New World" art, in particular—indeed, had already responded pictorially to Indian art. He arrived in Santa Fe from New York on 12 June 1918 and was greeted by Mabel Dodge (Luhan) and her third husband, Maurice Sterne. After a two-day rest they traveled on to Taos, where Hartley stayed until 6 November, when he was motivated, overtly at least, by an outbreak of influenza to return to Santa Fe. In truth, he was never comfortable in Taos, a town whose name he later equated with "chaos." During the winter of 1919 he visited California and met the artist and teacher Arthur Wesley Dow, who was likewise interested in indigenous art of the Americas. Then, in June 1919, Hartley returned once again to Santa Fe, remaining there until November, when he journeyed back to New York, via Chicago.[106]

Although Hartley wrote poetry as early as 1902, his first essay was written in 1915, and from 1917 until 1923 he was an active writer, often reaching a national audience with publications in *Art and Archaeology*, *The Dial*, *Nation*, and *Poetry*. During his stay in New Mexico Hartley contributed two essays to the journal of the Museum of New Mexico, *El Palacio*, which also reprinted essays he had published else-

where. His five essays focusing on Native American culture were written during or after his stay in the Southwest, and they are critical documents in the history of early twentieth-century American art and culture. Not only do they chart the emergence of Hartley's own personal aesthetic, but they also testify to the importance given Native art and culture by a preeminent avant-garde artist/critic in his search for distinctly *native* American values out of which the nation might generate an aesthetic consciousness.

In "Tribal Esthetics," which appeared in *The Dial* in November 1918, Hartley established the religious dances of the Pueblos as the leitmotiv of his textual primitivism. In June of that year Hartley witnessed "the dance of the young corn," and on the evening of the Fourth of July he saw "the dance of mercy," which, he wrote, was seldom performed and, in this case, had been offered as an act of patriotism to the Red Cross.[107] For Hartley, these dances were the unifying force of Indian culture, and he was disappointed that they had been characterized as barbaric, explaining, "The dance is not to these people a form of gay exercise; it is wholly a bodily conception of a beautifully lofty spiritual idea." Here, as in all of Hartley's other accounts of Pueblo dances, he stressed the link between the body and the spirit and celebrated the dance as an art form made manifest through the sensuous movements of the body: "It is an organized rhythmic conception and esthetic composition, spirit and body harmonized to symbolize . . . their so ardent desires."[108]

Not only did Hartley experience at the dances a "precise beauty" for which he found language insufficient, but he also recognized that these "episodes in the history of a great people" could not be understood, owing to a lack of knowledge about the language and the symbolism. And, like Luhan, Hartley believed the Indian to be "the discoverer . . . and the keeper of the secret." He, too, saw Native American culture as being "complete" in its historic and aesthetic evolution, and thus, about to disappear: "There was the glimpse of this little spectacle of a great civilization, probably one of

the finest in history, and soon, or comparatively soon, to pass out of existence, out of ken of the visible world forever into a religious silence, the dignity of which would be little appreciated in the new years to come."[109]

Hartley's primitivism comprised a romantic yearning for unification with nature and a concomitant modernist anxiety about the artifice of civilization. The Indian race, which he equated with the rising and setting of the sun, lived in harmony with the universe, "wanting little or nothing from a world of invented subterfuge." By its very existence indigenous culture constituted a critique of the newer Euro-American civilization, which, according to Hartley, befooled itself with a host of vulgarities. He found it pitiable that the West, which had too much civilization, could not begin again along some "such simple lines as they have evolved so beautifully." Despite this lament, Hartley knew that a fresh start was impossible because of knowledge of the world. For example, even as he proclaimed the ineffable beauty and certainty of the dance's aesthetic effects, he also knew that "it would be an idle heresy for us to really think of the corn as a being who can be assisted to fruition by the offering of a dance." Speaking of ritual as a gift, he observed that modernity was powerless to celebrate the simple experiences of life. Even from this distance, Hartley's final statement is deeply moving in its emptiness, sadness, and longing: "We have no ceremony for our vision."[110]

A pair of Hartley's essays, "Aesthetic Sincerity" and "America as Landscape," appeared in *El Palacio* in December 1918. Together they are emblematic of his struggle to free himself from the dictates of European modernism. They also embody, covertly, his dissatisfaction with the Taos Society of Artists' attempts to designate their art colony the home of *American* art. In the first of these, Hartley defined "Aesthetic Sincerity" as a universal standard: "Genuineness, authenticity, are qualities we demand of ancient objects and pictures in the museums of art anywhere in the world." However, he conceived of temporal and geographical determinants of authenticity in art, and borrowing the

style of another time or place was tantamount to laying on a pictorial veneer: "There is no use in attempting to copy the convention of Paris or Munich or Dresden to the redman, or to the incredibly beautiful landscape of the Southwest." Furthermore, Hartley believed that if one were going to respond with aesthetic sincerity to the landscape and to Native American culture in the Southwest, it would be necessary to embody the region's primordial character.[111]

Hartley also returned once again in this essay to the theme of unity between Pueblo art and nature. The beauty of Pueblo architecture, he wrote, was the beauty of the earth, from whose forms it was derived. The decoration of these earthen houses was "kept within the strictest bounds of elemental emotions." Hartley warned his fellow artists in New Mexico, many of whom were trained in European academies, that they "would never arrive at the primal significance of the southwest . . . or of painting as a means of expression" until they eliminated from their art the artificial, the rococo. For Hartley, authenticity in art was inextricably bound up with a sincere emotional response to the landscape. Breathing the spiritually and aesthetically rarefied air of Pueblo country he was moved to announce, "America extends the superb invitation to the American painter to be for once original."[112]

In "America as Landscape" Hartley continued to develop an idea about Indian art and culture which he first expressed in "Tribal Esthetics" when he wrote that experiencing Pueblo dances was akin to seeing the "history of your native land . . . written in the very language of the sun and the moon."[113] For an artist to come to terms with the idea of "America as landscape, as a country capable of inspiring and producing any type of greatness," Hartley thought it necessary to shed the "impetuosity, nervous haste and peevishness" that typified non-Indians. Instead, an artist needed "the calm of the redman," whose education came from nature itself.[114]

In this essay Hartley also continued his critique of the Taos Society of Artists. For ex-

ample, he stated, "I heard the remark once this summer as being a stout conviction on the part of certain painters who have essayed to devote themselves to redman subjects, that the art of America would spring from their given spot. It is at least a pleasing and convenient bit of egotism. It is hardly true however, for merely following the Indian around, applying Parisian literary poses to him, attaching redman titles, is not a sufficient guarantee."[115] The Taos Society of Artists failed to establish the "art of America," in Hartley's eyes at least, because they lacked an original American aesthetic. Native American art, however, was another matter altogether, and Pueblo ceramics, dances, songs, and weavings demonstrated to Hartley that "races have always invented their own esthetics as a racial necessity." The Indian's aesthetic, according to Hartley, was of primary importance because it was his own creation, born of his persistent need for self-expression. Quite to the contrary, "whites," he wrote, "had to borrow quickly because we have no tradition and no racial background." And, although Americans had depended too much on "the fetish of Paris," World War I had actually served to liberate serious painters and poets (i.e., Hartley himself) from such conventional aesthetics. Freed from the grip of European aesthetics, these returning exiles were obliged to draw on Native traditions.[116]

Hartley's essay "Red Man Ceremonials: An American Plea for an American Esthetics," which appeared in *Art and Archaeology* in January 1920, was a continuation of themes on which he had previously written—national aesthetic consciousness, identification with the landscape, the primitive, and Native American rights. He began his call for an "American aesthetic" by listing reasons artists should heed the Native American model: Indian art, particularly the dances, had made the name "America" memorable in world history; the Indian alone had provided America with its claim to cultural development; and in Indian art there were lasting symbolic equivalents for the beauty of the American landscape. I must emphasize the significance of this last point, for Hartley insisted that "it was our geography that makes us

American of the present." Equating the idea of "America" with the American landscape had become, at this point in Hartley's career, the centerpiece of his conception of an American aesthetic.[117] Euro-American visual arts had a long tradition of regarding nature as landscape, and certainly Hartley followed this tradition.[118] He valued Indian art so highly precisely because he saw a spiritual celebration of nature in it, the symbolic equivalent of the landscape. For example, he wrote of *the* Indian: "He is the one man who has shown us the significance of the poetic aspects of our original land. . . . He has indicated for all time the symbolic splendor of our plains, canyons, mountains, lakes, mesas and ravines, our forests and our native skies, with their animal inhabitants. . . . He has learned throughout the centuries the nature of our soil and has symbolized for his own religious and esthetic satisfaction all the various forms that have become benefactors to him."[119] Based on these artistic achievements, and what he described as the wide discrepancy between ancient and contemporary American art, Hartley designated the Indian artist "the one truly indigenous religionist and esthete of America." He urged all those "loving the name" America to cherish the Indian, because only through intimacy with America's first artist would Americans present and future know anything "of their spacious land."[120]

In discussing "redman" ceremonials Hartley also commented on racial character, evolution, and their relationship to an American aesthetic. It is significant, he wrote, that races in general, and primitive peoples in particular, have a desire "to inscribe their racial autograph before they depart." The racial autograph of the southwestern "redman" that so impressed Hartley was, of course, "the beautiful gesture of his body in the form of the symbolic dance." However, Hartley again stressed the fact that "universal understanding" or "universal adaption" of this aesthetic was not possible because, like all primitives, Indians invented "modes of expression for themselves according to their own specific psychological needs." This lack of universality was not, for Hartley at least,

a dysfunctional hermeticism but represented instead a use of symbols that the racially younger Euro-Americans were simply not prepared to understand.[121]

Hartley's opposition to government suppression of Native traditions was based, in part, on evolutionist theory. Equating the Indian's "racial gesture" (i.e., religious dances) with "the artery of racial instinct," he used organic growth as a metaphor for cultural/artistic evolution in arguing against interfering with the dances: "Those familiar with human psychology understand perfectly that the one necessary element for individual growth is freedom to act according to personal needs. Once an opposition of any sort is interposed, you get a blocked aspect of evolution, you get a withered branch, and it may even be a dead root."[122] It was "simply unthinkable" to Hartley that the "enduring consciousness" of Native America could survive without its ritual life, and he promised that such a deprivation would result in racial death. In issuing these warnings, Hartley likened Indian peoples to animals *in the wild*: "It is as if you clipped the wing of the eagle, and then asked him to soar to the sun . . . or as if you asked the deer to roam the wood with its cloven hoofs removed." The Native American race, therefore, was like a precious natural resource not to be squandered foolishly: "We have lost the buffalo and the beaver and we are losing the redman, also, and all these are fine symbols of our native richness and austerity."[123]

Hartley's plea in this essay was prompted by his recognition that American culture lacked "a national esthetic consciousness." In an apparent reference to the appropriation of African art by the European avant-garde, he noted that "other nations . . . have long since accepted the Congo originality." He added that even though black Americans had contributed the only native elements in American music, their dark color was a stumbling block to their acceptance by the "intelligent race." However, according to color scale, as Hartley perceived it, the "redman" ought to receive dispensation from such prejudice: "We have no qualms about yellow and white and the oriental intermediate hues. We

may therefore accept the redman without any of the prejudices peculiar to the other types of skin, and we may accept his contribution to our culture as a most significant and important one."[124]

It was not enough, Hartley explained, to have a scientific curiosity about the archaeology of Native America, and it was fortunate, he believed, that instead of seeing "him" as a phenomenon, perceptive artists and poets were coming forward to recognize the contemporary Indian artist as a "spiritual expresser of very vital issues." And this was as it should be, for the nation needed to "accept the one American genius" it possessed. Hartley was explicit about the goal of his (romantic, florid) description of Native American ceremonials: "I want merely, then, esthetic recognition in full of the contribution of the redman as artist, as one of the finest artists of time; the poetic redman ceremonialist, celebrant of the universe as he sees it, and master among masters of the art of symbolic gesture."[125]

Hartley's essay, "The Scientific Esthetic of the Redman," published in *Art and Archaeology* in 1922, was his response to the Corn Dances he had seen at Santo Domingo. In the past, he wrote, everyone learned "the science of his specific racial esthetic," so that all art issued from the racial consciousness. Thus, he described Native American aesthetics as "the science of the redman" because it had been developed to satisfy racial needs. Hartley made, in this regard, two important revelations about the lessons of his southwestern experience—one about himself and his art, the other about the psychology of races: "It is from the redman I have verified my own personal significance. I have learned that originality is the sole medium for creation. I have learned that what is true for races is true for individuals. That art is a logical necessity to the development of human beings as long as they retain the psychology typical of them." A critical lesson learned by Hartley from the "redman" was that all primitives related to their religion in a sensuous way, and the Indian, in particular, had proven that for religious experience to matter at all it must in-

clude the body and it "must be pleasurable." On the other hand, Hartley explained that at best, the Christian tradition had given the world fine paintings and cathedrals, while its worst lesson was an "abnegation of the body," which led to Puritanism.[126] Embracing Native American cosmology, he believed, meant embracing the principles of paganism: "The red understanding of the universe . . . will have taught [us] that everything that is worth caring for is worth celebration. That nothing in art shall endure or in life for that matter, without the explicit inclusion of the body. Complete understanding includes the clear conception of the beauty of the body even in its sensuous frankness."[127]

In Hartley's explanation of the Corn Dance as a path to mental, spiritual, and physical well-being, I also identify important aspects of his definition of artists and their concerns. For example, of these three reasons for the dance, Hartley asks, "What else then shall the primal preoccupation of the artist be?" The artist is part priest, part actor, whose primal instincts are "the power for reverence, and the power for representation." However, according to Hartley, the modern artist had the misfortune to live in a secular world. When compared to the importance of the engineer, the chemist, and the inventor in the prevailing system, the artist was the "excrescence." The modern artist was blocked from the "primal preoccupation"— spiritual holism—by two barriers, his irreligious attitude and his superficiality. More than the scientist, he wrote, the Euro-American artist needed to realize how the Indian artist's devotion to "the principle of conscious unity in all things" had led to "race achievement." And, in the Native American unification of the arts he saw how "the spiritual universe" could be signified by "esthetic consciousness." If all this were not reason enough for modern artists to study the scientific aesthetic of Native America, there were lessons to be learned about the "fine moralities of nature" as well. Hartley had been persuaded that Indian art demonstrated with finality the two essential components of nature: "The sense of order, and the sense of immateriality."[128]

Conclusion

My analysis of these primitivist texts on Native American art reveals a concern, indeed, a fear, shared by many of the writers about the increasing secularization of modern American life. Their sustained physical presence in the Southwest was itself a critique of urbanism and its attendant psychic dislocations. But more than just establishing individual alternative lifestyles and collective outposts of avant-garde culture, the colonists were attempting to regain a lost sense of community and social intimacy that they saw still extant in Pueblo life. In their efforts to preserve ceramic, basketry, and textile traditions—that is, objects made by hand from natural materials—Austin, Sloan, and others were rejecting the anonymous and sterile products that the industrial revolution had made commonplace in Euro-American society. Similarly, the stress in these texts on the Indian's "Otherness," as seen in the ubiquitous obsession with the Pueblo Corn Dance (i.e., the ritual propitiation of nature), establishes the question of nature versus culture as one of the dichotomous tensions of early modernism. Furthermore, implicit in the primitivist's fixation on the perceived primal, exotic, and vital aspects of Pueblo life was an assertion of the moribund quality of Western traditions, especially in art and religion. And yet, even as these texts make manifest a critique of positivism, rationalism, and materialism, they promote the idea of a "racial consciousness," which corresponds to a particular (primitive) stage of evolution. Thus, the Indian "race" is conceptualized within a linear, temporal construct that grounds it and assigns it value, and at the same time it is conceptualized as essential and ahistorical.

More important than the fact that their collective commentary could contain both thesis and antithesis is the fact that both ideas— Indian as specific to history (of biology) and Indian as perpetual (like the rhythms of nature)— are representations. As representations, "Indians" and "Indian art" supported beliefs about time, race, and history that were external

to them. Witness the fact that the one voice never articulated in these texts or through the preservationist projects is that of any specific Native American artist. I am compelled, therefore, to observe that despite their philanthropic and moral imperatives, revival movements such as those of the Indian Arts Fund constituted a paternalistic speaking about and for Indian artists. The artists neither speak for themselves nor operate autonomously regarding the criteria for collecting, marketing, and preserving (i.e., controlling) the products of their labor and imagination. In many ways the aesthetic aspects of the revived/preserved arts, as well as the new Pueblo painting, were responses to market forces existing outside the native community.[129]

The call, frequently heard in these texts, for a unique American (national) aesthetic based on Indian art is but one of many examples of nation states which, in the period following rapid industrialization and urbanization, sought to salvage the traditions of their rural folk cultures.[130] Such salvage projects had (have) at least three components. The first related to a romantic need to preserve—as with endangered species—a primitive state of cultural development, usually associated with agrarian life, which had not been tainted by the ill-effects of capitalism and secularization. The second component was a function of the first—a desire to provide a new, more stable economic base that would halt the disintegration of these traditional cultures. Thus, it was important to develop markets and marketing techniques that would create a need for the objects outside the community in which they were created. In this stage of interaction between native artists and their patrons, the out-group consumer actually functions as a "form-creator."[131] And thirdly, the folk or primitive culture, in this case Native American, and their aesthetic creations were appropriated and used as emblems of the nation state itself.[132]

Pictorial Responses to Native America: Primitivist Painting, 1910–1940

In an article on the Taos Society of Artists that appeared in *Scribner's Magazine* in 1916, Ernest Peixotto complained that "few American painters of note have given serious study to the American Indian."[1] After a favorable review of paintings made by the various members of the society, Peixotto expressed his earnest hope that more American painters, "with their fine technical equipment, their virile natures and American spirit, will accept the lure of the West and go out to New Mexico." Other artists, he wrote, should be influenced and encouraged by the successful pictures of Indians made by Ernest Bluemenschein, Bert Phillips, and the other artists in the society. He wondered why American modernists, with their penchant for "vigor and vitality" and their "fondness for primitive color and pattern and the naive crudities of aboriginal art," had not yet discovered the inspirational mysteries of the Pueblos. Peixotto recommended that instead of going off to Polynesia and Malaysia, American artists should study the ancient pictographs at Frijoles Canyon, the symbolism of Pueblo pottery, and "the crude graces of the Hopi dancers."[2]

"Few American painters" was the important qualifier in Peixotto's article, since by 1916 some members of the avant-garde had, in fact, already made the trek to the Taos and Santa Fe art colonies (Paul Burlin and Robert Henri). But going to the Southwest was a prerequisite neither for studying Indian art and culture nor for making primitivist art. Some artists, notably those connected with the Stieglitz Circle and the Armory Show, such as Max Weber and Marsden Hartley, had already used their museum studies to initiate the kind of involvement with Native American art and culture that Peixotto sought. For some of the "advanced" artists examined in this chapter, Native Americans and their art were an intense but fleeting infatuation, while others had their notions about art—both theory and practice—irrevocably transformed by the encounter. The perceived "Otherness" of Native America, expressed in a variety of ways, and a belief in the universal validity of (primitive) abstraction were features common to many of the diverse responses made to Indian art/culture by the New York avant-garde during a period beginning just prior to the Armory Show and extending, roughly, to 1940. I take the latter as a point of demarcation, because even though some of the artists examined in this chapter had careers that extended well beyond 1940, their mature styles were all formulated by that time. Thus, despite their longevity, in terms of age, aesthetic solutions, and intellectual milieu there is a clear generational difference between them and the artists whose Indian-inspired primitivism is associated with the 1940s—the Abstract Expressionists and the Indian Space painters (see Chapter 5). Similarly, the stylistic diversity that characterizes primitivist painting between the Armory Show and 1941 (when Adolph Gottlieb, Jackson Pollock, and Richard Pousette-Dart began their pictographic paintings) also distinguishes it from that of the 1940s, which was far more unitary and homologous.

Arthur Wesley Dow

Although much of Dow's distinguished career as an artist and teacher lies outside the historical parameters of this study, his ideas about non-Western, and especially Native American, art were an important aspect of the artistic environment in New York, in which American modernism developed.[3] Among those in the Stieglitz Circle, Charles H. Caffin, Arthur Dove, Georgia O'Keeffe, and Max Weber, in particular, were influenced by Dow's lectures and writings. As early as 1891 Dow had studied Aztec art and ornament as part of his search to define indigenous Native American principles of design. His interest in nonwestern arts was enhanced by his friendships with Ernest F. Fenollosa, a scholar of Japanese art and culture, and Frank Hamilton Cushing, noted ethnologist and specialist on Zuni art and culture.[4]

Fenollosa, who became a Tendai Buddhist during his stay in Japan, no doubt shared with Dow his belief that a new style of American art would issue from a Hegelian synthesis of eastern and western traditions.[5] Similarly, Cushing, who had been initiated into the Zuni Order of the Bow, believed in a "cosmic uniformity of art expression . . . that inexorably bound oriental,

occidental, and primitive cultures." Cushing was convinced that the methodology of ethnographic history must be based on both scientific and mystical lines of investigation. According to Frederick C. Moffatt, Dow incorporated the ideas of both Fenollosa and Cushing into his teaching experiments at the Summer School of Art, which he founded in Ipswich, Massachusetts, in 1900. In particular, Dow used his so-called natural method, derived from Cushing's idiosyncratic ethnology, to test a version of recapitulation theory known as the "cultural epoch theory." This theory, Moffatt explained, "held that the individual reexperiences the developmental stages of the human race in acquiring motor skills."[6]

As Sylvester Baxter indicated in his 1903 essay, "Handicraft, and Its Extension, at Ipswich," Dow used Indian baskets and Zuni, Navajo, and Peruvian textiles as materials for teaching the natural method.[7] Baxter confirmed the derivation of the natural method from Cushing's experiences at Zuni and noted that the cardinal purpose of such teaching was to take the students, most of whom were themselves art teachers, directly back to "the root of things," which was the "nature within us." Baxter's explanation of the Ipswich experience is a classic example of recapitulation theory as lay text. He wrote that once the signs marking the way were revealed, the students found their way back to the primitive beginnings of art. By following their primal instincts for art, the students traversed once again "old channels long since covered up." Typically, he perceived the relationship between the "primitive state of mind and feeling" and modernity as that of child and adult: "While from our twentieth-century civilization we may not return to the childhood of the race, we can in great measure bring into play the primitive springs of thought, impulse and action that exist in every human being, and so put ourselves *en rapport* with the primitive state of mind and the primitive view of things, just as the adult can bring himself into sympathetic relations with the child." Dow's chief tools in liberating these primitive springs of thought, as Baxter pointed out, were examples of primitive

textiles and baskets and Cushing's method of identifying and then emulating the ancient production processes.[8]

Dow's book *Composition*, first published in 1899, was a codification of the synthetic exercises he employed at Ipswich and later at Columbia University. Among the illustrations for *Composition* were shards of Indian pottery that had been found at Ipswich.[9] In the second edition (1912) Dow wrote at length about "Repetition," which he described as probably being the oldest form of design and the one most commonly used in creating compositional harmony. Music and poetry, he explained, derived from the earliest forms of art, in which "the figures march or dance round the vases, pots and baskets." The sacred dances of the savages he associated with drums and "other primitive instruments for marking rhythm" and with "the chant and mystic song." As more specific examples of repetition in the art of "barbaric peoples," Dow cited "the rude patterns marked with sticks on Indian bowls and pots, or painted in earth colors on wigwam and belt, or woven on blanket."[10]

There is other evidence as well of Dow's interest in Native American and other "primitive" arts. Students who took his course in "Art Appreciation and Art History" at Columbia University were introduced to a variety of nonwestern and archaic arts, with special attention given to the indigenous arts of North America. Dow developed this aspect of the curriculum in cooperation with the American Museum of Natural History. Perhaps these were the students who provided Dow with the sixty colored designs based on Native American symbols that he lent for exhibition at the "Panama-Pacific International Exposition" held in San Francisco in 1915. According to Moffatt, this donation reflected Dow's support for efforts by the exposition's art exhibition committee "to promote a new national style derived from prehistoric Indian art." Dow had instructed his students to find "new qualities of line and color through using these strange, mysterious and elemental motifs." In particular, he was fascinated by the fylfot, or swastika, which had been stud-

ied previously by Cushing. Dow himself included the swastika in his 1915 essay on "Designs from Primitive American Motifs." As a final testament to his use of Indian designs and symbols, the swastika was chosen to decorate the boulder marking Dow's tomb.[11]

Max Weber

Max Weber's memories of the folk, Byzantine, and synagogue art of his early childhood in Russia made him both susceptible and responsive to the teachings of Dow, with whom he studied at the Pratt Institute in New York from 1898 to 1901. Indeed, Holger Cahill, whom Weber considered a close personal friend, noted that in teaching Weber, Dow was sowing seeds on fertile ground, and in his later years Weber himself recalled the lasting impact of Dow's lessons.[12] Since Weber was Dow's student after the latter began employing his "natural method" of teaching, it is inconceivable that he would not have conveyed to him his enthusiasm for Native American art. And, in all likelihood, it must have been Dow who first drew Weber's attention to the collections of ancient American art at the American Museum of Natural History. These exposures to art outside the Euro-American tradition helped prepare Weber for his role as a preeminent member of that first generation of American modernists who simultaneously established an American artistic identity and radically transformed artistic conventions.[13] The evidence for this exists in Weber's own definition (c. 1913) of modernism: "An eclecticism peculiar to modern civilization produced this modern-art child which happened to be born in the city of Paris. Its genealogy is Italian, Spanish, Oriental, primitive. . . . [Its] simplification of form is derived from African, Mexican, and other primitive sculpture."[14]

While he was in Europe, from October 1905 until January 1908, Weber enhanced his knowledge of primitive art by studying the tribal arts on display in the Ethnographic Section of the Palais du Trocadero in Paris. He also saw primitivist paintings by Picasso, Braque, and Matisse

which, according to Alfred H. Barr, made manifest ideas that had been implied in Dow's teachings.[15] Thus, it was logical that Weber arranged for Matisse to teach a class that included fellow Americans Walter Pach and Maurice Sterne. In his appraisal of Weber's artistic development, Cahill wrote that it was characteristic of Weber to "seek out Matisse." In explaining this aspect of Weber's artistic temperament, Cahill relied on the *logic* of cultural primitivism. Matisse, according to Cahill, sought through his art and teaching a "renewal" predicated on the belief "that it is the art of primitives and of children that strikes most deeply into the heart of things." Weber's own background and personality, Cahill observed, made him immediately qualified to understand this point of view and its correlate, "that the innocent eye sees clearly and joyfully."[16] Cahill was not, however, the first critic to make these kinds of observations about Weber. As early as 1926, in the introduction to *Primitives*, a book of Weber's prints and poems, Benjamin De Casseres had described him as a "veritable primitive" whose mind was "innocent of the stupefying complications and complexities of civilization." De Casseres defined Weber as "a curious reversion to the beginnings," whose poems "have a strange, infantile, untutored flavor." In these poems, many of which were inspired by, and written in the presence of, Native American sculptures at the American Museum of Natural History, De Casseres found the "crude simplicity [of] the very essence of First Speech."[17]

In his monograph on Weber (1930), Cahill noted that upon returning to America in 1909 the artist was constantly studying the aboriginal American art at the American Museum of Natural History, and that his fascination with its collection of Northwest Coast totemic art was translated into the woodcut prints and poems in *Primitives*.[18] Joy S. Weber, the artist's daughter, who has devoted much of her energy to maintaining her father's archives and estate, observed that Cahill's book was written in close cooperation with her father and that "the comments pertaining to the primitives—especially American Indians—are about as factual as can be found."[19] Although Weber's European so-

journ no doubt intensified his interest in non-western art, the claim that he "haunted the galleries of the American Museum of Natural History" as a result of "having been exposed to the Parisian rage for primitive art" is inaccurate.[20] Rather, his predilection for tribal arts had its origins in Dow's teachings, which enabled him to see the ancient American objects in the museum as art and not merely as artifact.[21] In fact, years later Weber ranked the Museum of Natural History with the Louvre in Paris and the National Gallery in Washington and added with regret that "in spite of its marvelous collection" it had been "regarded [by others] as a collection of examples of anthropological value only." Clearly, for him it was much more than that, a place where, by his own admission, he "gained an ever increasing understanding of the art of the primitives and the art of the Western continent."[22]

An integral part of Weber's method for continually increasing his understanding of the Native American art at the Museum of Natural History included sketching the ancient and historic Pueblo pottery on display there. Three such sketches from Weber's notebooks (c. 1910), previously unpublished, which include his notations about the color schemes, reveal his interest in both the shapes of the ceramics and their geometric decorations, including zigzag, step-fret, and spiral-scroll motifs (Figs. 3-1, 3-2, 3-3). In two of these sketches Weber drew the designs independent of their ceramic picture support, indicating his attraction to the inherent value of such stylized nature motifs (Figs. 3-2, 3-3). Furthermore, two of these sketches indicate his intention to incorporate these Pueblo objects and their geometric decorations into his own work. At the upper and lower right of Fig. 3-2 are two still-life studies that either include or entirely consist of Pueblo pottery. The sketch illustrated in Fig. 3-3 has at the far left a small study for an interior scene with an abstracted figure and still-life objects. Beneath this study, a sketch of a horizontal band of pottery decoration shows the careful balancing of stylized forms. Immediately to the left of the interior study, running along the left margin of the page,

a notation reads: "Invent geometric beauty—to give direction for unity through combination and relation."

Given the weight of this documentary evidence, I expected to find in Weber's finished oil paintings numerous and overt traces of this fascination with Indian art. But in fact, the legacy of his appreciation and close study of Indian art was subtly merged with lessons learned from African, pre-Columbian, and Asian art, the Old Masters, and early modernism, especially Cubism. Perhaps the sublimation of Weber's primitivist impulse was related, at least in part, to the severe negative criticism of his early work, which affected him deeply.[23] On the occasion of Weber's first one-person show at Alfred Stieglitz's "291" Gallery in January 1911, V. E. Chamberlain gave the following report in the *New York Evening Mail*, later reprinted in *Camera Work*: "Here is an artist who has shown some very strong work indeed but who has reverted to a rude sort of Aztec symbolism which seems to be without significance to any soul but himself. Grotesque profiles, enormous eyes, bodies joined like dolls, barbaric patterns in the landscapes—these are the elements of Mr. Weber's pictures and their ugliness is appalling."[24]

If, in fact, after 1913 Weber was sublimating his admiration for Pueblo and Northwest Coast sculpture into the larger whole of his art, and if we assume that what he took from these traditions was related to Dow's teachings, then it follows that we should look for proof of these assumptions in design and decoration, as opposed to specific imagery. Indeed, as early as 1910 Weber had written in *Camera Work* of seeing "Indian quilts and baskets, and other work of savages, much finer in color than the works of the modern painter-colorists."[25] Paradoxically, Weber incorporated Native American and other such designs into an incipient abstract vocabulary with which he intended to represent the dynamism of the new century. I am thinking in particular of a series of paintings that Percy North described as translating "the image of New York City into a potent symbol of a new era of technological progress."[26] But I must admit that my approach to Weber's "city"

Figure 3-1
MAX WEBER
page from a sketchbook
(c. 1910).

Collection of Joy S. Weber,
Santa Fe.

Figure 3-2
MAX WEBER
page from a sketchbook
(c. 1910).

Collection of Joy S. Weber,
Santa Fe.

Figure 3-3
MAX WEBER
page from a sketchbook
(c. 1910).

Collection of Joy S. Weber,
Santa Fe.

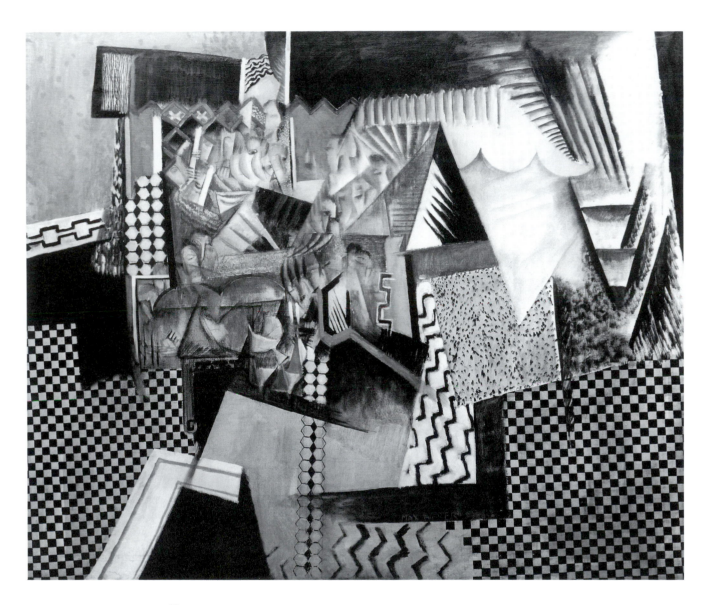

Figure 3-4
MAX WEBER
Chinese Restaurant
(1915).

Oil/canvas, 40" x 48".
Collection of Whitney Museum
of American Art, purchase, 31.382.
Photograph by Geoffrey Clements Photography.

paintings is not as revisionist as it might seem on the surface. As long ago as 1930 Cahill wrote cogently about Weber's ability to use modernism to make manifest the nexus between the two- and three-dimensional structures of Native American art and the kinetic and architectonic quality of modern urban life. According to Cahill, Weber's "discipline in modern art" enabled him to juxtapose, in the city paintings, Pueblo and Northwest Coast Indian art with the geometric forms of skyscrapers, bridges, and the elevated train.[27]

Among the pictures Cahill discussed in this context are three from 1915 that suggest Weber's cognizance of Pueblo and Northwest Coast art: *Chinese Restaurant*, *Grand Central Terminal*, and *New York at Night*. The dynamic and complex interplay of geometric elements that characterizes the overall composition in *Chinese Restaurant* (Fig. 3-4), for example, suggests the formal qualities of Awatovi polychrome from northeastern Arizona (Pueblo IV, c. A.D. 1300–1598). More specifically, the black-and-white checkerboard patterns at the extreme lower left and right are typical of designs on Mesa Verde pottery from the Four Corners region (Pueblo III, c. A.D. 1000–1300), as well as on Classic Mimbres period (A.D. 1000–1130) pottery from southwestern New Mexico. The wavy or saw-tooth pattern right of center, which extends from the lower edge of the canvas roughly to the middle, although reminiscent of Cubist decoration, is also found on literally thousands of black-and-white pots from a variety of Kayenta, Mesa Verde, and Chaco Canyon sites ranging from Late Basketmaker III (c. A.D. 700) through Pueblo IV (A.D. 1500). Similarly, in *Grand Central Terminal*, the repeated interlocking rectilinear forms, especially the step-fret motif (Greek key), and the hatched and cross-hatched planes that energize the composition, are typical features in many examples of Pueblo pottery. Furthermore, in his notebook sketches of Pueblo pottery from the Museum of Natural History, Weber drew examples of the ceramic shapes and designs of all these pottery traditions. In addition, innumerable examples of Pueblo pottery could share Cahill's characterization of these paintings: "There is a clash of dynamic forces as expressed in the opposition of geometric shapes, cones and hemispheres, the round and the triangular, the vertical, the horizontal, the oblique."[28]

The claustrophobic clustering and interpenetration of rectilinear planes in *New York at Night* share with Northwest Coast art what appears to be a *horror vacuii*. The insistent verticality of the picture also strives for a monumentality to equal that of the great totem poles that make a cluttered forest of the Northwest Coast room at the Museum of Natural History (Figs. 3-5, 3-6).[29] Perhaps standing in Manhattan, amidst a forest of new skyscrapers, Weber felt a distortion of scale and perspective similar to that prompted by his encounter with "The Totem Pole Man," about whom he wrote, "the vagaries of space he frights away."[30] Furthermore, the architectonic quality of *New York at Night* corresponds to North's assertion that "tall buildings formed the framework and scaffolding for Weber's vision of urban grandeur."[31] But, bearing in mind Cahill's juxtaposition of Pueblo art and the thrust of skyscrapers, it is useful to note that the "scaffolding" of *New York at Night* is not dissimilar to the architectonic headgear (*tablitas*) worn by Hopi kachinas (Fig. 3-7), which Weber had referred to in *Camera Work*. As further evidence of Weber's awareness of Hopi kachinas, there is North's comment that he included one in a watercolor (c. 1910).[32] Certainly he used this *tablita*-like scaffolding as a decorative element in the upper left of *Interior with Women* (c. 1917).

Besides admiring the plastic (constructive) power of the form-language of Native American sculpture, Weber also must have been drawn to its *Americanness*. It is true, of course, that several of Weber's early modernist pictures reflect the impress of Picasso's Cubism and that he shared the French avant-garde's interest in African sculpture. And it seems likely that he would have perceived the geometric order of Indian design as being comparable, in many respects, with the geometry of Parisian modernism. He nevertheless consciously avoided being associated too closely with a specifically European style, choosing not to call his compositions Cubist, but rather, "form in the crystal."[33] Furthermore,

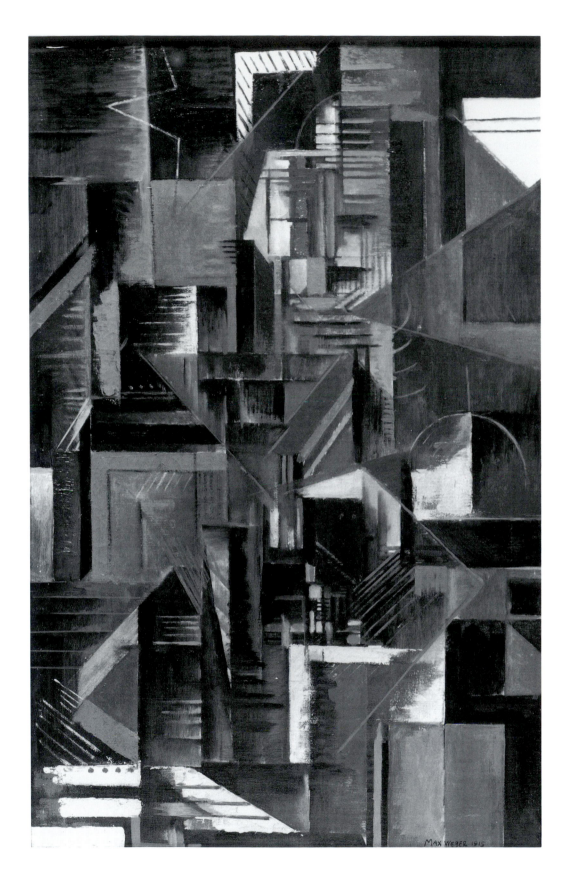

Figure 3-5
MAX WEBER
New York at Night
(1915).

Oil/canvas, 33" x 20".
Archer M. Huntington
Gallery, The University
of Texas at Austin.
Gift of James and Mari
Michener, 1991.
Photograph by George
Holmes.

Weber disavowed responsibility for the title of his first book, *Cubist Poems* (1914).[34] Cahill, who recognized in Weber's paintings of this period an affinity between Native American art and the design of the modern city, also realized that despite what Weber's art had in common with Parisian modernism, it had an overridingly American context and content: "There is something so specifically American in Weber's experience that it seems to me accurate, now [1949] as it did then, to speak of Weber as having lived the history of modern art in America. His work finds its deepest meanings in relation to this American world and its original bent was shaped by American teaching."[35] As I noted previously, Dow's *American* teaching, with its debt to Cushing's experiences among the Zuni, often focused on Indian art, in both the theoretical and the practical sense. Keeping in mind Cahill's statement about Weber's American experience and the relationship between the American world and the deepest meaning of his art, we must remember that Weber's encounter with Indian art had to have been significantly different from that of the American-born artists discussed in this chapter, such as Marsden Hartley and Robert Henri. For Weber, the immigrant artist, Indian art was not only a part of "this American world" but was also simultaneously an essential element of *his* new world, the "New World," and the dynamic new world of the twentieth century.

Paul Burlin

Paul Burlin was an important early modernist whose long life in American art ranged from the Armory Show to Abstract Expressionism.[36] Born in New York in 1886 of Russian and English parents, Burlin spent his early childhood in England and returned to America at the age of twelve. By the time William Glackens invited him to exhibit four drawings in the Armory Show in 1913, Burlin had studied at the National Academy of Design, worked as a commercial illustrator, and traveled in Europe (1910), where he became aware of Post-Impressionism.[37] Following the Armory Show, he became the first of its participants to travel

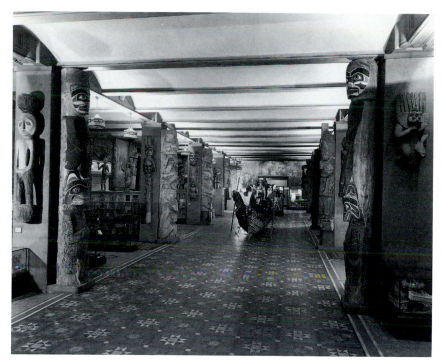

Figure 3-6
General view of the Northwest Coast Indian Hall at the American Museum of Natural History, New York.
Courtesy American Museum of Natural History, neg. #318931.
Photograph by T. L. Bierwert.

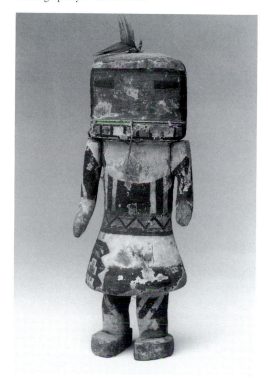

Figure 3-7
Hopi, kachina
(before 1930).

Wood, pigment, feathers,
7 3/4" high.
Collection of Joy S. Weber,
Santa Fe.

to New Mexico, where he introduced Fauvist/ Expressionist styles of painting.[38] Throughout Burlin's New Mexican period (1913–1920) he exhibited his work periodically at the Daniel Gallery in New York, which allowed him to follow the development of modernism. Although Native American art and culture had a demonstrable impact on Burlin's art in these years, the evidence for this is largely documentary since, unfortunately, most of these paintings are now lost and are known only through existing black-and-white photographs.

As a modernist, Burlin was not atypical for his intense preoccupation with primitive art, which actually had begun before his move to New Mexico when he saw in New York the collection of African sculpture assembled by Marius de Zayas. However, as Irving Sandler rightly observed, Burlin was not fully appreciative of the inherent power of primitive art "until he encountered the forceful geometry and brilliant color of American Indian decoration."[39] Upon his arrival in Santa Fe, Burlin was deeply moved by what he described as the "primeval, erosive, forbidding character of the landscape." He recalled being entranced by Indian "witch doctors and [by] the whole aspect of the metaphysical propitiation of the forces of nature." But Burlin was more than merely impressed by this encounter with Native American ecology-as-ritual, for as he stated, "I wished to understand these configurations that were indigenous to the character of the land."[40] Assistance in achieving that understanding came from the noted ethnomusicologist Natalie Curtis, whom Burlin met in Santa Fe and married in 1917.

A New Yorker, Natalie Curtis's first visit to the Southwest in 1900 deflected her from a promising career as a musician. She began instead a fieldwork project among the American Indians that took her from Maine in the Northeast, across the Plains states to British Columbia, and back down to California, Arizona, and New Mexico.[41] From this she produced *The Indians' Book* (1905), a monumental anthology of songs, poems, myths, folktales, and drawings which she had collected from eighteen different tribes, including the Navajo and five of the

Pueblos. Because Curtis provided Burlin with a firsthand introduction to, and commentary on, Native life in New Mexico and Arizona (he often accompanied her as she attended a variety of social ceremonies and religious rituals), her published comments about Indian art and culture provide some context for his artistic primitivism.

Like the other writers at the Santa Fe and Taos colonies, Curtis, not surprisingly, was a cultural primitivist. She explained in the original introduction to *The Indians' Book*—she insisted they were the authors—that the volume reflected "the soul of one of the noblest types of primitive man—the North American Indian." Collectively, the contributors were revealing "the inner life of a primitive race" that "looks out with reverence upon the world of nature." Curtis also revealed an evolutionist bias, writing that the primitive races, such as the American Indian, were "child races" who might make a "contribution to humanity when they are grown." She hoped that *The Indians' Book* might hasten "the day when adult races wisely shall guide the child races."[42]

Curtis's comments in *The Indians' Book* about Indian art must have been especially provocative to Burlin. She observed that with its inborn sense of color and form, Indian art "is not a luxury of the cultured few [within Native society], but the unconscious striving of the many to make beautiful the things of daily living." She was particularly concerned that America, the modern nation, should value Indian art: "What other nation has in its midst a like opportunity for inspiration? Let us pause in the stress of our modern life to listen to the ancient lore of our own land. . . . And if there is truth in the theory that the American continent was the first to emerge, then are the Indians, indeed, perhaps the most ancient of peoples and their spiritual conceptions should be of interest and value to the whole human race." Furthermore, because of an essential difference between the "races," Curtis believed Indian art could provide some relief for the "stress of modern life." And at this turn she added to her primitivism an element of nationalism:

We [Anglo-Saxons] are a people of great mechanical and inventive genius, but we are not naturally song-makers, poets, or designers. Can we afford to lose from our country any sincere and spontaneous art impulse, however crude? The undeveloped talents native to the aboriginal American are precisely those in which the Anglo-Saxon American is deficient. Far ahead of Europe are we [Americans] in labor-saving devices, but far behind in all art industries. Our patterns and designs are largely imported from France. And yet, here among us, down-trodden and by us debauched, is a people of real creative artistic genius—the first Americans and possibly the oldest race on earth. [43]

Similarly, in an article entitled "The Perpetuating of Indian Art" (1913), Curtis stated that Americans needed to realize that education of native peoples ought to "include a reciprocal interchange of ideas." While the Indians might be provided with the means of adapting to modernity, especially industry and the "mechanical processes of self-expression," the dominant culture should "recognize the inborn racial ideals and inherited art impulses" of Native America. Concerning art, Curtis wrote, "white people" had little to teach the Indians, but much to learn.[44]

Indeed, Burlin himself felt there was much of value to know and understand about Indian art, informing Mabel Luhan on occasion that "an Art Form like this should be known to the world."[45] In particular, he wondered about the impetus for the abstract decorations on Pueblo bowls and noted that in contrast "all other picture-making seemed like story-telling trivia."[46] Not surprisingly, Burlin found his realizations about Indian abstraction leading him toward changes in his own art. He recalled that these discoveries, "none of which had anything to do with 'representation,'" were "the vague beginnings of an esthetic credo."[47] His new aesthetic, which tended toward abstraction, revealed itself in portraits and figure studies of Indians and Hispanics made in the years following his arrival in New Mexico. From the scant pictorial

evidence available, and the more detailed documentary evidence, it is obvious that two mutually reinforcing characteristics must have typified these paintings. On the one hand, Burlin adapted Fauvist and Cubist styles to the "traditional" picturesque subjects of New Mexico, treating them—for the first time ever—in an expressionistic fashion. On the other hand, having studied the abstract elements of Native art in the Southwest, he sought to use the lessons learned from the nonobjective forms he admired to simplify his own compositions.[48]

Burlin's *Apache Braves* (c. 1915, Fig. 3-8) is hardly radical for its subject matter—an Indian idyll not dissimilar to the romantic images created by the members of the Taos Society of Artists, such as Martin Hennings's *Passing By* (1924).[49] But Burlin's technique is far more innovative, if somewhat derivative. The broad and broken brushwork, the suppression of perspective space, the figural distortions, and the insistent geometry of the forms all suggest an artist informed by Post-Impressionism, Fauvism, and to a lesser extent, Cubism. His *Nomad Girl* (1913–1922) is a pretty young Navajo in traditional dress, set off with silver jewelry (Fig. 3-9). Despite the delicate interior modeling of her heart-shaped face, the overall tone of the painting is solid, heavy, and archaic. Burlin has treated her body as a series of simplified, lithic volumes, not unlike the geometric rocks upon which she rests. Her upper body is contiguous with the background space; her right hand, both legs, and the lap they create merge almost imperceptibly with the flattened foreground space. Thus, the *Nomad Girl* is rendered as one with the earth. Burlin's simplification of the subject observed in nature was an essentializing process designed to produce an archaic form equivalent to her perceived autochthonous state. Or, as Curtis explained, "Burlin's sketches of the Navajos (a people still as richly suggestive to the painter as any in the world) strike deeply and instantly far below the surface to the essential mood-values, as it were, of the life of a nomad shepherd folk adrift on the Arizona desert."[50]

Figure 3-8
PAUL BURLIN
Apache Braves
(c. 1915).

Oil/canvas, 40" x 30".
Courtesy of The Anschutz
Collection.
Photograph by James O.
Milmoe.

In describing the monumentality and massive sculptural form of the *Nomad Girl*, Sharyn Udall noted the influence of both Matisse and Gauguin on Burlin's flattened, simplified figure.[51] This is certainly an accurate assessment, and yet I suspect that Curtis must have had such a painting in mind when she wrote in 1917 that her husband's Indian portraits were "as archaic in quality as the redman himself." Curtis believed that Burlin's subject matter insisted on a pictorial simplification distinct from that of modernism: "Simplification in art, which with the Moderns is something of an abstract and intellectual problem, should become in our West the logical and inevitable thing, intuitive in process, and charged with an emotional reality."[52] And, indeed, critics in the East agreed that Burlin's work in the West had that real emotional charge. Guy Pene Du Bois, an Armory Show organizer, was the editor of *Arts and Decoration* when he wrote in 1917, in reference to the Indian portraits, that Burlin was a "straight from the shoulder" painter who dealt with "primitive force as a religious precept."[53]

Along with the essentializing Indian portraits, Burlin made southwestern paintings that were even more abstract and that show more directly the influence of the "nonobjective" forms of Pueblo pottery designs. One such work, *Forces in Motion* (c. 1916, now lost), was shown in New York in 1917 at the annual exhibition of the Society of Independent Artists and also at the Anderson Gallery (Fig. 3-10). *Forces in Motion* was one in a series of paintings that represented Burlin's response to what he described as "the force and smooth beauty and terror" of the heavy machinery he had observed in Pueblo, Colorado.[54] Along with his other "machine" paintings, it was later included in an exhibition at the Pennsylvania Academy of the Fine Arts, which was cocurated by Alfred Stieglitz.[55] In considering this painting I want to correct what I perceive as an imbalance in the recent literature on Burlin concerning the relative importance of Cubism to his abstractions.

According to Udall, *Forces in Motion* "expresses in vehement terms the aggressive power

of machine forms." And she is correct in seeing in the painting certain general similarities to the futurist spirit of Joseph Stella and the "kinetic cubism" of Francis Picabia and Max Weber. More specifically, Udall finds a thematic precedent for Burlin's work in Marsden Hartley's prewar "Berlin" abstractions.[56] I agree with her observation, but along with Cubism and its variants, Indian art also played an important role in the development of Burlin's machine abstractions. First of all, as Sandler has observed, although the Armory Show had a significant impact on Burlin, he was not immediately prepared to make a commitment, aesthetically speaking, to Cubism.[57] And, as I noted previously, Burlin admitted that his own aesthetic, which was moving increasingly away from representation, was stimulated by Pueblo abstraction. While there can be little doubt that Burlin and Hartley must have discussed their mutual interest in Cubism and Indian abstraction when, by way of Mabel Luhan, they renewed their friendship in 1918, that was well after Burlin had painted *Forces in Motion*.[58] Thus, if initially Burlin was tentative about adapting Cubist techniques, exposure to Native American design was a liberating force, enabling him, as he put it, to depart "into the abstract, dynamic power of machine shapes."[59] For Burlin as for Weber, Cubism and Native American design were interactive and mutually reinforcing.

Forces in Motion supports Curtis's assertion that Burlin had discovered "in our Southwest" an artistic "inspiration directly in line with the whole trend of modern art." In her essay on the new southwestern art, Curtis explained that before World War I, because Euro-American civilization had hyperextended, young artists had sought in African sculpture a primitive influence that would show the way back to an elemental art. But now, she wrote, Burlin had discovered that same kind of artistic inspiration in Native American art. Moreover, the value of the thing discovered was that, like myth, it bridged the unspannable distance between genesis and the present: "Here [in the Southwest] is the vital stimulus of a land and a people still at the dawn period, still close to the roots of things, and *alive*—not belonging to an alien soil, not to a

Figure 3-9
PAUL BURLIN
Nomad Girl
(c. 1913–1922).

Oil/canvas, dimensions and present location unknown. Courtesy Museum of New Mexico, neg. #20512.

Figure 3-10
PAUL BURLIN
Forces in Motion
(c. 1916).

Oil/canvas, dimensions and
present location unknown.
Courtesy Museum of
New Mexico,
neg. #20510.

vanished past whose culture has been part of our art-inheritance since Egypt's time, but co-existent with ourselves to-day, and a part of the actual contemporary history of this continent." The West, Curtis wrote, had a "savage beauty" and "ancient aboriginal peoples" and there, according to Burlin, *a new kind of painting might arise.*[60]

Marsden Hartley

Hartley's southwestern sojourn, and the primitivist essays that issued from it, had been preceded by primitivist paintings made in Europe, 1912–1914. These works combined a modernist technique with Native American motifs which Hartley had seen at the Trocadero in Paris and at the Museum für Völkerkunde in Berlin, although he may have seen Native American objects at the Museum of Natural History in New York as early as 1900.[61] Several factors must have encouraged Hartley to seek out primitive art, including Weber's work and the primitivist sculptures of Jacob Epstein, *Der Blaue Reiter Almanac,* and an article describing Kandinsky's "primitive and savage art," which Hartley mentioned in a letter to his patron, Stieglitz.[62] In the same letter Hartley also informed Stieglitz that the primitive art at the Trocadero was the "real thing" and had been "created out of spiritual necessity."[63] In yet another letter to Stieglitz he described the impact of these primitive obejcts: "One can no longer remain the same in the presence of these mighty children who get so close to the universal idea in their mud-baking."[64] Although a confluence of stimuli motivated Hartley to visit ethnographic collections in Paris and Berlin, the results were singular—only references to Indians and Indian art appear in his European-period primitivist canvases. If, on these museum visits, Hartley was particularly moved by African or other tribal arts, there is no visible legacy of it in his work.

Hartley's first significant pictorial response to his museum studies was a brushy, hauntingly expressive still life from 1912 entitled *Indian Pottery (Jar and Idol)* (Fig. 3-11).[65] Neither the style nor the technique of this painting relates it to Indian art. Dominant in the picture is a large, centrally placed Acoma Pueblo pottery jar decorated with floral motifs and a stylized representation of a bird. At the extreme lower right, almost submerged in the murky darkness of the background, is a double-mouthed black Pueblo jar with a stirrup handle. In the lower left corner Hartley painted a small figurative sculpture, which Gail Levin has identified as being Kwakiutl in origin.[66] What strikes me as important about this work is the way that Hartley, like the keeper of a curiosity cabinet, has deracinated culture-specific objects and mixed them together, along with the image of a book, without any indication of original context. By using the pottery jars and the totem as signs of his longing for the primitive and the natural, Hartley has stripped them of their primary meaning. And yet, there is no evidence that Hartley *intended* to evoke the original meaning of the objects. As an example of painting, the work is compelling, especially its brooding palette, which recalls Cézanne's late pictures of Mont Saint Victoire. But it does not describe, nor was it intended to connote, a specifically Native American content. It does em-

Figure 3-11
MARSDEN HARTLEY
Indian Pottery (Jar and Idol)
(1912).

Oil/canvas, 20 1/4" x 20 1/4". Photograph courtesy of Gerald Peters Gallery, Santa Fe, New Mexico. Photograph © Robert Nugent.

Figure 3-12
MARSDEN HARTLEY
Indian Fantasy
(1914).

Oil/canvas, 47" x 39 1/2".
North Carolina Museum
of Art, Raleigh.
Purchased with funds from
the State of North Carolina.

body, however, in its aching sadness, the "content" of Hartley, the rootless American wanderer viewing in European museums a mélange of dislocated Indian objects.

After a trip to America, Hartley returned to Berlin in April 1914 and began a group of paintings that he called the *Amerika* series. These works combined the flatness of Synthetic Cubism with Indian subject matter. The *Amerika* paintings, according to Gail Scott, issued from Hartley's desire to "reaffirm his Americanness."[67] No doubt, Hartley's trip home to America and subsequent return to Berlin must have encouraged him to find an American theme on which to focus his paintings. It is

not surprising then that he selected the one subject which, in early twentieth-century Germany, was identified as being quintessentially American. In fact, German fascination with Native Americans had been an important aspect of nineteenth-century romanticism, as typified by the popularity of Karl May's fantastic "Indian" novels. Important collections of American Indian material had been on display in Berlin since 1829, and by 1914 there were almost thirty thousand examples of Native art on display in the Museum für Völkerkunde.[68] Furthermore, Hartley was aware of August Macke's *Mounted Red Indians* (1911) and his essay on "Masks" in *Der Blaue Reiter Almanac*, in which

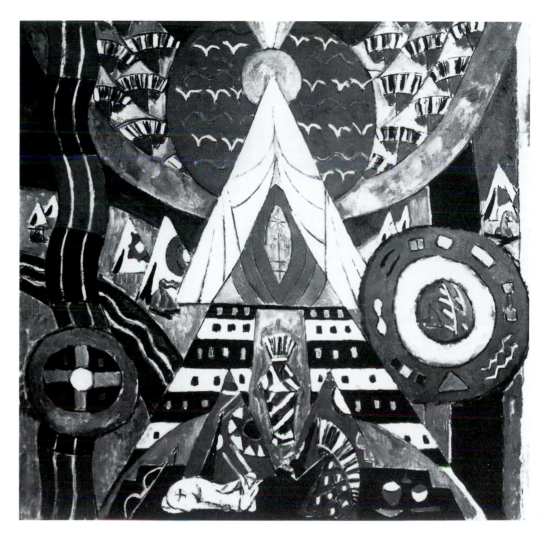

Figure 3-13
MARSDEN HARTLEY
Indian Composition
(1914).

Oil/canvas, 47 4/16" x 47 1/16".
Vassar College Art Gallery,
Poughkeepsie, New York.
Gift of Paul Rosenfeld, 50.1.5.

he wrote of Indian war paint and an Alaskan chieftain's cape.[69]

Based on her research in Paris and Berlin, Levin has written authoritatively on the presence and the sources of Indian motifs in Hartley's *Amerika* paintings, and some of the comments here follow hers. *Indian Fantasy* (1914, Fig. 3-12) is exactly that, a fantastic combination of images derived from Hartley's trips to the Völkerkunde collections: Chippewa miniature canoes; a carved eagle from the Northwest Coast; Plains tepees; and painted Pueblo pottery. The palette, the abstract organization of the figurative elements, the mandorla inscribed with a pictographic figure, and the

circles inscribed with eight-pointed stars all relate to a Hopi kachina (Sio Hemis) in the museum's collection. Similarly, *Indian Composition* (1914, Fig.3-13) uses patterns and designs inspired by Plains Indian beadwork (cross within a circle) and Hopi symbols for corn, as well as repeating the pictographic figure in a mandorla motif.[70] The small horse resting in front of the tepee, however, is surely borrowed from Franz Marc. Both of these paintings, along with *Indian Symbols* (1914) and *Pyramid and Cross* (1914), respond to a common feature of many Native American designs: symmetrically arranged geometric forms. Although the *Amerika* series was short lived, Hartley also in-

corporated the symmetry, emblematic forms, and geometric patterns of Native American art into his German military pictures, such as *Berlin Ante-War* (1914) and *Portrait of German Officer* (1914).

Robert Henri

Robert Henri, the Philadelphia/New York painter and teacher around whom the so-called Ashcan School of urban realists formed in the early years of the twentieth century, made a practice of finding exotic summer painting locations in which he might encounter a wide range of human "types." In addition to Ireland, the spot Henri frequented most often was Santa Fe, where he worked in the summers of 1916, 1917, and 1922, painting, according to William I. Homer, "picturesque types chosen from the local Indian and Mexican populace."[71] Henri was drawn to New Mexico partly as a result of the proselytizing of the indefatigable Edgar L. Hewett, whom he met in 1914 while summering in La Jolla, California. Hewett was in San Diego that summer preparing the Indian art and ethnology exhibits for the "Panama-Pacific International Exposition," which opened in 1915. In a letter written from La Jolla to a former student in July 1914, Henri bemoaned the way that progress had changed the Indian but expressed great enthusiasm over Hewett's exhibition plans: "The Exposition here will be beautiful. Through Dr. Hewett there will be a perfectly presented idea of the great art history of America—not that part of it that has come since Columbus—but that greater American part that came before. . . . The Indian village is going to be a fine incident too."[72]

Hewett, in turn, exhibited some of the Indian portraits Henri made that summer in La Jolla in the exposition's Gallery of Fine and Applied Arts in 1915. Through Hewett, Henri came to know and admire Pueblo art and ritual life, and like Hewett, he collected "specimens," as he called them, of the new Pueblo painting.[73] In the years following his first meeting with Hewett, Henri commented often in his letters,

articles, and reminiscences about the quality and importance of Native American art. And in terms of his own painting style, the use of Puebloans as subject matter precipitated a dramatic shift in Henri's palette. Thus, I want to examine, first of all, Henri's perceptions of Native American art and culture, and secondly, the context and content of his remarkable series of Indian portraits.

During their summers in Santa Fe, Henri, his wife Marjorie, and their artist friends were introduced by Hewett to the Indians at various Pueblos, and Henri was particularly impressed by the ceremonials he witnessed at Taos and Acoma.[74] In a letter written from New Mexico, he noted that despite being a "crushed out race" in the material sense, the Puebloans possessed a spiritual life that the dominant culture, with all its goods and material comforts, could envy. He marveled at the mystery and beauty of the ceramics and textiles still being made in New Mexico, commenting in particular on the ability of the objects to express "some great life principle."[75] Henri never doubted the validity of these objects as "high art," even though they were not oil paintings—a mistake he criticized others for making. Indian artists, he explained, expressed themselves and their race through decoration and design. As a result, he wrote, "the work of art is . . . a matter of course."[76] In 1923, the year following his last summer in Santa Fe, Henri speculated on the place in the history of American art of the "truly decorative and significant work of the Indian." In that context, he stressed the antiquity, the purity, and the Pacific origins of Native American art.[77]

Given Henri's commitment to an art reflective of real life, to democratizing the "art world" by adjusting the relationship between individuals and institutions, and to a search for an art spirit that expressed national values, it is not surprising that these same issues informed his writing about Indian art and culture. He explained that among the "ancient Indian race," art was "the reality of their lives." Each Indian, Henri wrote, "lived and expressed his life according to his strength; was a spiritual existence, a genius, an artist to his fullest extent." He saw in Indian society a definition of the art-

ist that contrasted with that of his own society: "They have art as part of each one's life. The whole pueblo manifests itself in a piece of pottery. With us, so far, the artist works alone. Our neighbor who does not paint does not feel himself an artist. We allot to some the gift of genius; to all the rest practical business." And yet, although individuals made works of art, each object expressed the spirituality and "communal greatness" of the Pueblo. The lesson in this, for Henri, was that America would never achieve greatness in art by displaying "canvases in palatial museums." Instead, this greatness would occur when America, like Native America, allowed the art spirit to enter "into the very life of the people, not as a thing apart, but as the greatest essential of life to each one."[78]

Although Henri complained in the summer of 1914 that Indian models were sufficient but not plentiful in La Jolla and that perhaps more were coming (from New Mexico), it appears he painted eight portraits of Tewa Indians there.[79] The evidence for this conclusion is a letter written from Hewett to Henri in October 1914, which provided both English and Spanish translations of Tewa names.[80] Since two of those named, Water Eagle and Water of Antelope Lake, are individuals whose portraits Henri exhibited at the exposition in San Diego the following year, I assume all eight names represent models whose portraits he painted in the summer of 1914. The portrait of Water of Antelope Lake (Tom Po Qui), whom Henri knew by her Spanish name, Romancita, indicates how dramatically his sense of color was affected by Indian life in the American Southwest (Plate 4). Henri's painterly style and approach to color was derived from his admiration for a European painting tradition embodied in the works of Rembrandt, Velásquez, Goya, and Manet. Generally speaking, then, his style had been predicated on the use of a dark or neutral ground and a relatively muted palette. He was certainly not insensitive to color before visiting the Southwest, but rather, he relied more on the tonal effects of blacks, browns, and greys to create a sense of mood in his portraits, such as *Viv (New York)* (1915). By comparison, the whole of *Romancita* is shot full of an airy light, the result of wet white impastos that model—in a loose, fluid fashion—the figure. The background, divided into two flat zones by a horizontal slash of lemon yellow, is rendered im-pressionistically. The upper zone is a brushy field of color: sand, faded lilac, pale blue, rose, and tart yellow. The lower zone is a reflection, lower in value, of the bright, luscious colors of Romancita's Native dress: turquoise blue, Mexican lime green, strawberry/rose, and blood red. Her face, modeled with bits of bronze, brown, and yellow, is the color of sunlit adobe. The light reflected from Romancita's jet black hair is a deep, lustrous purple. The sheer sensuous indulgence and revelry in color that *Romancita* represents marks a complete departure from Henri's earlier work and later works not associated with Indian life in the Southwest. His other Tewa portraits, discussed below, show this same richness of color.

This sudden exploration of ripe color was not coincidental to Henri's feelings about his Tewa subjects. In a contemporaneous review of the paintings, including *Romancita*, exhibited at the exposition in 1915, it was noted that Henri "believes he must invent an exact and specific technique for each idea he wishes to express." The Indian portraits, the reviewer explained, illustrated "this attitude of Mr. Henri toward life." According to the article, not only did Henri capture the "brilliancy and splendor" of the Tewa environment, but also in his rendering of native costume he revealed "their reaction toward the free and primitive things."[81] Furthermore, the reviewer saw them as the most complete portraits imaginable: "He is expressing to you not only his conception of the man and woman as members of a race . . . [but] at the same time he indicates the national characteristics of reserve and impassivity. He sees in them the type of Indian of the particular tribe to which they belong, and he also expresses his personal conception of the abstract human being."[82]

In the summer of 1916 Henri painted in a studio (provided by Hewett) located in the Pal-

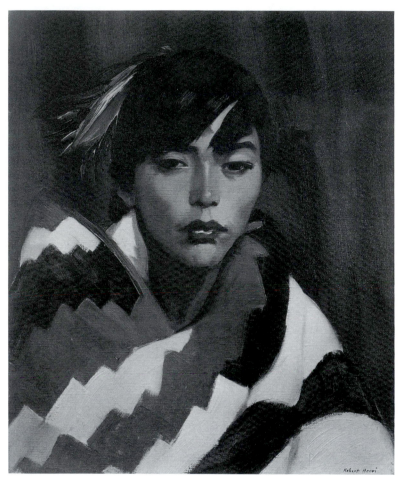

Figure 3-14
ROBERT HENRI
Ricardo
(1916).

Oil/canvas, 61 cm x 50 cm.
University of New Mexico
Art Museum, Albuquerque.
Anonymous gift.

ace of Governors on the plaza in Santa Fe.
Having met Indians in Santa Fe and at the various Pueblo ceremonials he attended, Henri
painted several portraits, including those of
Ricardo and *Dieguito Roybal* (Figs. 3-14, 3-15).
In *Ricardo*, Henri portrayed the sloe-eyed
young man wrapped in a bright red-and-black-
striped blanket, the zigzag patterns of which
rise up at the corners like mountain peaks.
Ricardo's head, decorated with yellow, blue,
and red feathers, appears to rise out of this
"blanket mountain." As William H. Truettner
observed, in *Ricardo* Henri "exploits the potential of boldly patterned blanket in . . . [a] forceful way, repeating the motifs in the planar
structure of the subject's face and in the angle
of the forelock that falls across his left eyebrow."[83] Henri has implied then a tripartite

unity consisting of Ricardo and his "equivalents": the geometry of Indian design and the
landscape forms it evokes.

Dieguito Roybal, whom Henri mistakenly
identified as being from Tesuque, was an active
participant in the ritual life at San Ildefonso.
He also served for many years as Hewett's
guide and ethnographic informant. A Navajo by
birth, Roybal was an important figure in the interaction between the Pueblos and the artists,
literati, and anthropologists that constituted the
avant-garde of the Santa Fe colony. In 1923 a
photograph of him as "Tewa Rain Priest" appeared on the cover of *El Palacio*, the official
journal of the Museum of New Mexico.[84]
Henri's portrait of Roybal had been exhibited
in that institution in 1917 and entered its permanent collection as a gift from the artist.
Roybal was, in fact, a drummer and rain priest
for the Summer People of San Ildefonso, the
moiety responsible for both the Rain and Eagle
Dances. Henri portrayed Roybal in this role,
with drum placed between his legs and drumstick upraised. Roybal is presented in a formal,
completely frontal, that is, hieratic fashion, as
befits the solemnity and sacral nature of the
occasion.

Even in the context of Henri's southwestern
paintings, his portrait of Roybal is startling for
its exciting but sharply dissonant arrangement
of colors, as an energetic struggle takes place
between the lemon yellow hair wraps, the chartreuse leggings, and the red-orange blanket
spread across Roybal's lap. In a letter written to
Hewett from New York in November 1916,
Henri expressed some concern that the painting
was "a little raw in color from the top of the
drum down." However, he felt this would be
easy to correct, and, once done, the portrait
would be one of his "top Knotch canvases." He
also noted that the portrait had made both
friends and enemies among the New York critics, some of whom objected to the bright colors
and some of whom, he wrote, "object to Indians
at all."[85] Even so, Henri expressed great personal satisfaction with the portrait and wrote in
1920 that Roybal felt likewise: "The painting of
the drummer chief Diegito [*sic*] gave so much

pleasure to the old warrior that when I presented it to the Museum he would sit by it for hours every day enjoying without a smile or a sense of awareness the attention of the visitor in the Gallery."[86]

In several of Henri's portraits of Tewa women, he included Indian art to establish both a southwestern ambience and a genuine ethnicity, or in Henri's terms, "racial spirit." In *Gregorita with the Santa Clara Bowl* (1917, Fig. 3-16), a beautiful young woman with piercing dark eyes wraps her arm casually around a large black bowl. The picture, easily one of Henri's finest portraits, is suffused with the clean, arid light of the Southwest, and the rich sky blue of Gregorita's dress glints off the hard sheen of the bowl. Given the strength of her gaze, her relaxed but formal posture, and the great sense of dignity and composure that she exudes, Gregorita represents Henri's belief that "the North American Indian has nobility of poise and gesture."[87] Furthermore, he uses the bowl to establish Gregorita's identity as an autochthon, implying that she draws sustenance and inner strength from this bowl, which was shaped from the earth in the traditional way of her ancestors.

Henri also used textiles, perhaps Navajo in origin, as both a backdrop and an ordering device that frames the sitter and acts as a stable counterpoint to his rather expressive application of thick impastos. In these portraits, such as *Gregorita* (c. 1917), *Indian Girl of Santa Clara* (1917), and *Julianita* (c. 1917, Fig. 3-17), not only do the geometric textile designs provide "racial" authenticity, but they also repeat, on a larger scale, some shape, pattern, or color manifest in the sitter. Thus, a unity is established between racial identity and indigenous art forms. Nearly all of these portraits follow an almost iconic formula. A single figure, usually a beshawled young woman, is set close to the front of the picture plane, and a very shallow space behind her is indicated by a draped blanket. The lack of narrative elements squeezes time out of these pictures, situating the sitters in that perpetual ethnic time known as the "ethnographic present." The complete stillness of the sitters and the reduction of genre props to a

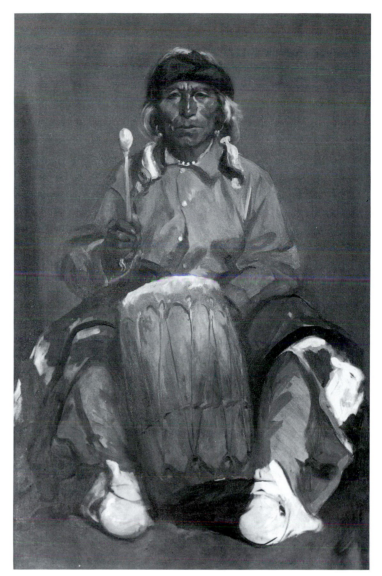

Figure 3-15
ROBERT HENRI
Dieguito Roybal
(1916).

Oil/canvas, 65" x 40 1/8".
Courtesy Museum of
New Mexico, neg. #20797.

minimum—jewelry, blanket, bowl, drum—suggests a people outside the flow of time. According to Truettner, the prototype for this kind of portraiture by Henri and others, including Andrew Dasburg and Victor Higgins, was late nineteenth-century ethnophotography in the Southwest, typified by John K. Hillers's *Zuni Maiden* (1879, Fig. 3-18).[88] Like Hillers's photographs, Henri's portraits have, on the surface, the look of objective realism about them. And yet, they are much more than the pictorial documentation of an ethnic life observed. *Gregorita, Julianita,* and the other Tewa portraits are high art versions of souvenir snapshots of the exotic life in a romantic, faraway place. Henri stressed this himself, writing, in reference to the Tewa portraits, "The picture is the trace of the adventure and to me that is the only

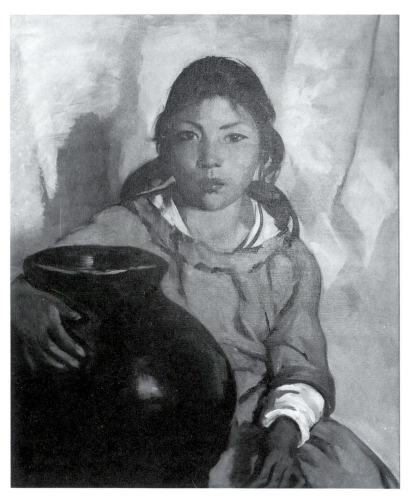

Figure 3-16
ROBERT HENRI
*Gregorita with the Santa Clara
Bowl*
(1917).

Oil/canvas, 32" x 26".
Edwin Ulrich Museum
of Art, The Wichita
State University,
Endowment Association
Art Collection.

ethnicity and continued to represent "a meeting of art and life." Mediating between these two opinions is Truettner's, which interprets Henri's escape from urbanism—and subsequent immersion in Indian art and ritual life—as part of a plan to "express freely and spontaneously in his work a new sense of national purpose."[90]

But the debate over the intention and meaning of Henri's Indian portraits is certainly not new. As early as 1915 he expressed astonishment that his southwestern paintings had been criticized for their lack of context. He defended the artfully neutral spaces in which his sitters appeared, stating that "their lives are in their expressions, in their eyes, their movements, or they are not worth translating into art." What attracted him to ethnic subjects—"my people," he called them—was that in some way they were "expressing themselves naturally along the lines that Nature intended for them." His sense of evolutionary determinacy was the basis of Henri's refusal to use his portraits to sentimentalize Indian peoples or to mourn the loss of their traditional way of life. After all, he explained, "every race, every individual in the race must develop as Nature intended or become extinct." Yet another reason for having focused so intently on the sitter at the expense of the surrounding social context was Henri's conviction that the race was expressed in the individual. The beauty of the human body, he wrote, was that it symbolized great spirituality, and he wanted his portraits of individual Tewas to capture "whatever of the great spirit there is in the Southwest." Henri did always have a *national* art spirit in mind, however, and finding the spiritual greatness of the Southwest was related to his desire to democratize American art: "I am looking at each [Tewa] individual with the eager hope of finding there something of the dignity of life, the humor, the humanity, the kindness, something of the order that will rescue the race and the nation."[91]

John Sloan

Responding to Henri's glowing reports about Santa Fe, John Sloan and his first wife, Dolly, journeyed there in the summer of 1919, and

reason for valuing a portrait or of its being of interest in any way to others."[89]

The ideological context, or the *apparent* lack of one, of Henri's Tewa portraits has been interpreted in conflicting ways. J. J. Brody observed that while Henri's eastern paintings had confronted the gritty reality of urban subject matter, in the Southwest he did not seek out the "tensions, poverty, or any other theme that could have made Indian subject matter more than just an exotic attraction." In contrast, Patricia Janis Broder explained the portraits as a continuation of the class consciousness manifest in his East Coast paintings, which had explored the relationship between individuals of all social classes and the environment. Henri's southwestern paintings, she noted, were focused on

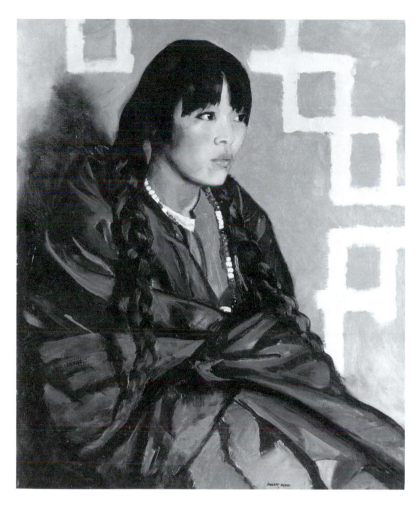

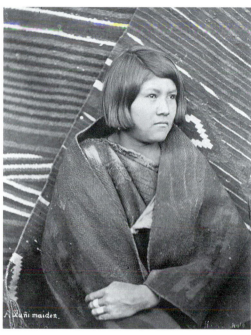

Figure 3-17
ROBERT HENRI
Julianita
(c. 1917).

Oil/canvas 32" x 26".
© 1992 Indianapolis
Museum of Art.
Gift of Mrs. John N. Carey.

Figure 3-18
JOHN K. HILLERS
Zuni Maiden
(1879).

Albumen silver print,
9 7/16" x 7 1/8".
Amon Carter Museum,
Fort Worth, Texas.

with the exception of 1933, he was a summer colonist for the next thirty-one years. According to the artist's second wife, Helen Farr Sloan, neither Sloan nor Dolly were interested in Indian art prior to their first trip to the Southwest. In addition to his fascination with Pueblo ceremonial dances, Sloan developed a great admiration for a variety of traditional and transitional Indian art forms, and over the years he kept scrapbooks that included articles on Indian life, especially those on decorative designs and southwestern ethnology.[92]

Sloan speculated that perhaps his attention was attracted by the evidence of vision and memory that he saw in Native American art. He also found the standard definitions of art and artist challenged by his encounter with In-

dian art: "The work of the American Indians is a perfect demonstration that things not generally regarded as works of graphic or plastic art, are indeed the works of artists. Their pots, blankets, paintings are so evidently inspired by a consciousness of life, plus a thing we have not got—a great tradition." Sloan also questioned whether there was "any real traditional art in the world today" other than Indian art. The art of modern nation states, he wrote, did not have that sense of community possessed by Indian artists. And rediscovering that spirit of unity, which is shared by artists, would require a change in the "social relations of men."[93] He testified to the strength of his convictions about Indian art by assembling an outstanding collection that included paintings and blankets. Among the paintings from Sloan's collection

Figure 3-19
JOHN SLOAN
Nude on a Navajo Blanket
(1929).

Tempera/oil-varnish
glazes/panel, 24" x 48".
Courtesy Kraushaar Galleries,
New York.

now in the collection of the Montclair Art Museum are watercolors by several important Indian painters active between 1919 and 1950, the year of Sloan's last summer in Santa Fe: Harrison Begay (Navajo); Velino Herrera (Ma-Pe-Pi) of Zia; Otis Polelonema (Hopi); and Abel Sanchez (Oqwa Pi) of San Ildefonso. Some of these paintings were exhibited at the "Exposition of Indian Tribal Arts" in New York in 1931, of which Sloan was a principal organizer. Now in the collection of the Hampton University Art Museum are a watercolor depicting a costumed dancer by Velino Herrera, which was probably exhibited at the 1931 exposition; a print from the *Tewa Series* by Harrison Begay; a group of watercolors painted by western Pueblo artists and acquired at the Gallup Intertribal Ceremonial in 1932; and thirteen Navajo textiles.[94]

Some of the Navajo textiles that Sloan collected appear as studio props in his paintings. In *Brunette Nude, Striped Blanket* (1928–1930), the rectilinear geometry of the blanket contrasts with (even as it emphasizes) the undulant and abundant curves of the model. Similarly, in *Nude on a Navajo Blanket* (1929), the sharp, vertical, linear elements of the blanket design serve to measure, balance, and support the roundness, horizontal movement, and softness of the model's body (Fig. 3-19). In *Nude and Chief Blanket* (1932), a Third Phase chief's blanket hangs on the wall behind the model, where its darker colors and the visual "weight" of its design balance the left side of the picture. Thus, in all these works Sloan has conceived of the Navajo textiles as providing structure to the pictorial design. Indeed, he admired Indian art for its "fine sense of geometrical decoration."[95] And yet, I am tempted to read into these pictures a desire on Sloan's part to link a freely expressed and natural sexuality with a "primitive" art form associated with an intuitive oneness with nature. However, such a reading is called into question by his *Self Portrait, Indian Blanket* (1929) where it is the artist himself, wearing his wire-rim spectacles and posing soberly in front of one of his own canvases, who wears a blanket

draped over his shoulder. In this case the Indian blanket does, in fact, seem appropriated for symbolic as well as decorative and structural purposes. All self-portraits provide bits of information, consciously or otherwise, about the artist's self-image. Sloan identifies himself as a man of the West, reinforcing his stern, almost Calvinist visage, his legendary antiestablishment stance, and his iconoclastic personality. Furthermore, clothes, costumes, insignia, religious emblems, and other symbolic apparel allow a member of one group (Santa Fe art colonists) to distinguish themselves from another (the effete eastern establishment). Similarly, such symbols allow members of one group or class to recognize each other. As such, Sloan signals his membership in the group of Indian art cognoscenti who wanted to revive and preserve aboriginal culture.

His encounter with Pueblo ceremonials, which he subsequently sought so vigorously to protect and preserve, provided Sloan with a perfect painting theme. Because he felt that, where religious subject matter was concerned, he had been fitted with blinders by Henri's teaching, paintings such as *The Eagle Dance* and *Ancestral Spirits*, both done during the summer of 1919, his first in Santa Fe, allowed him to pictorialize religious experience and still be true to Henri's dictum about painting real life (Figs. 3-20, 3-21).[96] In fact, Indian ceremonials were for Sloan the consummate example of the intertwining of art and life. He described the Eagle Dance, which he had seen performed at Tesuque, as "an unforgettable ceremonial which displays at its best the Indian's deep harmony with all nature," and he found the performance of the Eagle dancers "simple, unimitative, but profound."[97] *Ancestral Spirits*, now in the collection of the Museum of Fine Arts in Santa Fe, was formerly in Hewett's collection and was originally published in Sloan's *Gist of Art* (1939) as *Koshare*, which is the Keresan name for the figures who appear first in the Corn Dance. An animated group of Koshares are shown emerging from a kiva or underground ceremonial chamber. Given

Sloan's association in Santa Fe with ethnologists such as Hewett, it is hardly surprising that his comments that accompanied the illustration of this painting in *Gist of Art* are quite accurate in describing the Koshare's initial activities: "A preliminary of the Corn Dance at Santo Domingo is the reenactment of an ancient ceremony in which the ancestral spirits consult on the coming dance, scouting the points of the compass for enemies. Assured on this point the Koshare proceed slowly through the Plaza and return to the kiva and the dancers come forth for the ceremony." Sloan later painted a somewhat more abstract version of this same theme, entitled *Koshare in the Dust* (1930), which he noted was done from memory, since "drawing, much less painting is not permitted during the dances."[98]

Sloan's style was not particularly affected by an awareness of Indian art and life. His palette did become brighter in the Southwest, but this tendency is seen in landscape paintings as well as in genre scenes of Hispanic and cowboy life. The change, then, seems a natural response to the pageantry, local color, open sky, and hot sun of the Southwest. Therefore, the dance scenes he painted, such as *Eagles of Tesuque* (1921) and *Dance at Cochiti Pueblo* (1922), are loosely rendered impressionistic canvases, marked by a simplicity of drawing that verges on crudeness. Like the images of non-Indian subjects, such as *The Plaza, Evening, Santa Fe* (1920) or *Bleeker Street Saturday Night* (1918), the Indian dance scenes were meant to be honest and accurate documents of real moments in time. And yet, Sloan's hierarchical notions about primitive life are obvious, at times, in his account of these scenes. For example, *Eagles of Tesuque*, which is a rather straightforward depiction of the dancers on the plaza, was published with his comment that for three hundred years "the little Pueblo of Tesuque has made a noble fight against . . . civilization."[99] The lack of pretentiousness in the images themselves may be attributed, no doubt, to Sloan's own lack of pretentions. In particular, despite his great affection for Pueblo peoples and their documented affection for him, and despite his

Figure 3-20
JOHN SLOAN
Eagle Dance
(1919).

Media, dimensions, and
current location unknown.
Formerly collection of
Frank Osborne.
Courtesy Delaware
Museum of Art.

Figure 3-21
JOHN SLOAN
Ancestral Spirits
(1919).

Oil/canvas, 24" x 20".
Courtesy Museum of
New Mexico, neg. #108649.

sincere appreciation of their art as a ritualized expression of spiritual experience, Sloan never claimed to know the real meaning of the dances he so admired. Contrary to what has been written in recent years, he thought it presumptuous to assume an understanding of their religious values.[100]

However, unlike Henri, Sloan did inject an element of social criticism into his paintings of Pueblo life. In 1923 he painted *Grotesques at Santo Domingo* (Fig. 3-22), which portrays a group of tourists in the foreground watching the Koshares dance across the plaza. When this work was published in *Gist of Art* Sloan provided the following caption: "I think I am in a position to inform the reader that the grotesques in the picture are in the immediate foreground." *Grotesque*, he wrote, is hardly the word to describe the Koshares, "whose actions and chant and dress make them more than humanly

natural."[101] Similarly, in 1927 Sloan made a pair of etchings that mock the curiosity seekers for whom the Pueblo ceremonials were but a momentary flirtation with "real primitives." In *Knees and Aborigines* (Fig. 3-23) he satirizes a group of flappers and their dandies who lounge comfortably, smoking cigarettes while a solemn and sacred event takes place before them. Likewise, in *Indian Detour* (Fig. 3-24) a small group of dancers in the center is encircled and dwarfed by an army of tourist buses. In the foreground the tourists make a spectacle of themselves, largely ignoring the age-old ritual taking place as they chat, dance, and flirt. Prior to this, in *Traveling Carnival, Santa Fe*, an oil painting from 1924, Sloan included a small group of Indians, who are barely visible at the far right. In a telling reversal, Sloan represents them as marginal figures on the edge of the crowd, observing, but alienated from the spectacle.

Figure 3-22
JOHN SLOAN
Grotesques at Santo Domingo
(1923).

Oil/canvas, 30" x 36".
Courtesy Kraushaar Galleries,
New York.

Figure 3-23
JOHN SLOAN
Knees and Aborigines
(1927).

Etching, 7" x 6",
Courtesy Kraushaar Galleries,
New York.
Photograph by Geoffrey
Clements Photography.

Figure 3-24
JOHN SLOAN
Indian Detour
(1927).

Etching, 6" x 7 1/4".
Courtesy Kraushaar Galleries,
New York.
Photograph by Geoffrey
Clements Photography.

Jan Matulka

Although the Czech-born artist Jan Matulka had studied in Prague, he was not aware of the modern movement in European art until he emigrated to America in 1907 at the age of sixteen. After studying at the National Academy of Design in New York from 1911 to 1916, Matulka was awarded the first Joseph Pulitzer Traveling Scholarship, which he used to fund a year in the Southwest, 1917–1918. In addition to his achievements as a painter and printmaker, Matulka established a place for himself in the history of American art as an influential instructor at the Art Students League in New York (1929–1932), where he taught the principles of modernism to several young Americans, including the sculptor David Smith.[102] There is little documentary evidence concerning Matulka's trip through the Southwest, and only a few works of art from that period are extant. Nevertheless, even without any supporting primary documents, these surviving objects are significant in the history of American modernism as they represent the first effort to use the twentieth century's new pictorial language to embody the abstract rhythms of Pueblo ceremonials. Even if both Henri and Sloan represented the presence in the Southwest of an artistic and cultural avant-garde, they were not *modernists*, in a stylistic sense, and their representations of Native American life were exactly that—representations and not abstract equivalents. Their works never departed from an essentially romanticized realism. Hartley, on the other hand, had mastered the vocabulary of modernism before arriving in Santa Fe but chose not to use his firsthand observations of Indian art and life as subject matter. Burlin's more radical works, although they drew strength from Pueblo designs, were abstractions of machine power. Matulka, then, was the first artist to use a semiabstract modernist style not only to represent but also to embody and to evoke what he saw as the essential, that is, rhythmic, elements of Pueblo dances.

Along with a cognizance of Cubism, Matulka brought to the Southwest both an awareness of primitive art and an interest in exotic "types." As such, he was much less interested in mingling with the art colonists in Santa Fe and Taos than in observing Indians, Hispanics, and rodeo cowboys.[103] Throughout the summer of 1917 his interest in Pueblo art and artifacts increased, in part because of his explorations with the modernist idiom. He recognized in the stylized geometric designs of Pueblo culture and its forerunner, the ancient Anasazi, America's original abstract art. According to Broder, Matulka's fondness for jazz and classical music made him predisposed to use Pueblo dances, with their drummers, choruses, and intricate cadences, as subject matter.[104] Because these rituals involved the simultaneous interaction between color, movement, and complex musical rhythms, Matulka found them the perfect theme for his experiments with abstraction. In fact, the relationship must have been a mutually reinforcing one— only a modernist style could generate the pictorial equivalent of experiencing Pueblo dances.

All of the works on paper which Matulka made in response to the ceremonial dances he saw at the Rio Grande Pueblos in New Mexico were either lost or destroyed, probably by the early 1920s.[105] However, two mixed media works on paper depicting the Hopi Snake Dance, which Matulka must have seen as he traveled through Arizona in August 1917, have survived: *Hopi Snake Dance, Number I* (1917–1918) and *Hopi Snake Dance, Number II* (1917–1918). In these two works (Figs. 3-25, 3-26), the figure-to-ground relationship is made ambiguous as the dancers (Snake Priests) and the earth are unified into a single, highly stylized geometric configuration. Hard-edged zigzags and rectilinear elements, suggesting an architecture of form, are fused with concentric arcs and serpentine movements to make a composition that is both structural and fluid. The use of strong linear designs invokes the order of the dance, while the geometric patterns refer to the rhythmic beat of the music. The relative abstraction of the representation allowed Matulka to find pictorial equivalents for the stylized and metered motions of the dancers. The abstract

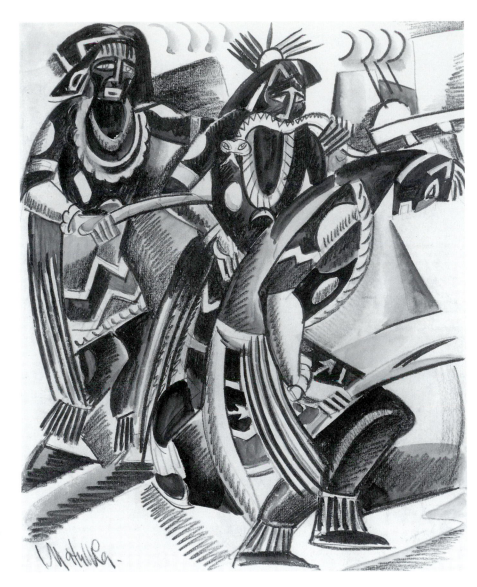

Figure 3-25
JAN MATULKA
Hopi Snake Dance, Number I
(1917–1918).

Crayon, watercolor, and
pencil/paper, 15" x 12".
Collection of Whitney
Museum of American Art.
Gift of Gertrude W. Dennis,
79.38.
Photograph by Geoffrey
Clements Photography.

unity of music, dancer, and symbolic costume is
revealed by the fact that all of Matulka's lines,
shapes, and rhythms are interactive and interde-
pendent: every linear movement causes, is re-
lated to, or is balanced by, another movement.
Only an incipient abstraction—influenced by
Cubism and the stylized geometry of Pueblo
pottery and the dance itself—would have suf-
ficed to generate something of the experience,
as opposed to a picture, of the Snake Dance. In
short, these are quintessential examples of early
modernist primitivism. In terms of style,
Matulka welds together and demonstrates the
compatability of a "primitive" and a "modern"
form-language predicated on an abstract geom-
etry. In terms of content, he takes as his *modern*
subject the affirmation of primitive man's abso-
lute (spiritual) unity with nature. Matulka's

Snake Dance images, therefore, make manifest
the dualistic notion that primitive life is natural
and that nature has an essential order and har-
mony that cannot be pictured per se, but can be
signified by abstraction.

Given his interest in music, it is not surpris-
ing that when he returned to New York
Matulka experimented with Synchromism as a
way of pictorializing the abstract rhythms—of
color and music—of Pueblo dances.
Synchromism, which had been developed by
Stanton MacDonald-Wright and Morgan
Russell in Paris, sought to explore the musical
aspects of color, creating form and orchestrat-
ing space through color triads, dominants, and
tonics.[106] Thus, it was the perfect technique for
Matulka, who wanted to present the dance as an

70

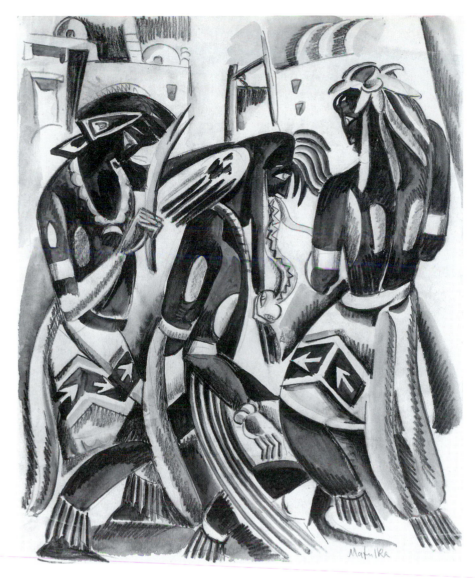

Figure 3-26
JAN MATULKA
Hopi Snake Dance, Number II
(1917–1918).

Crayon, watercolor and
pencil/paper, 15" x 12".
Collection of Whitney
Museum of American Art.
Gift of Gertrude W. Dennis,
79.39.
Photograph by Geoffrey
Clements Photography.

abstract composition of color, movement, and music. *Indian Dancers* (after 1918), based on a hunting ceremonial called the Mixed Animal Dance, was both more ambitious and less successful than the dance scenes he made in Arizona (Fig. 3-27). As with the Synchromism of MacDonald-Wright and Russell, Matulka exploits and exaggerates the color patches of Cézanne. In doing so, he suppressed the illusion of space, allowing background, figures, and foreground to fuse into a single assemblage of mostly wedge-shaped segments of color. However, his attempts to create color harmonics and his sensitivity to the interplay between sharp, high-key, and more melancholy color tones are offset somewhat by the coarse, almost clumsy brushwork. A recently discovered and previously unpublished oil-on-paper study for this painting (c. 1918, Fig. 3-28) is fresher and brighter in color, more dynamic, and in terms of relative naturalism, more tightly defined. In the study, black is given a more subordinate structural function, delineating the edges of forms in space, whereas in the finished oil painting, heavy black smudges "mute" the interpenetration of forms, and thus, Matulka's desire for the modernist sense of simultaneity (of movement, music, and color) is unfulfilled.

As I noted in Chapter 2, paintings by Matulka, probably those discussed above and others relating to his year in the Southwest, were exhibited in Chicago in 1920 alongside works by Awa Tsireh and Ananda Coomaraswamy. Both Coomaraswamy and the organizer of the exhibition, Alice Corbin

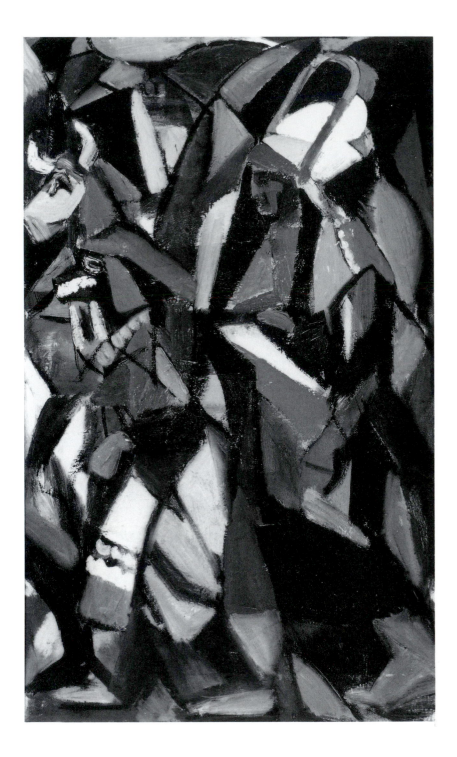

Figure 3-27
JAN MATULKA
Indian Dancers
(after 1918).

Oil/canvas, 26" x 16".
Courtesy of The Anschutz
Collection.
Photograph by
James O. Milmoe.

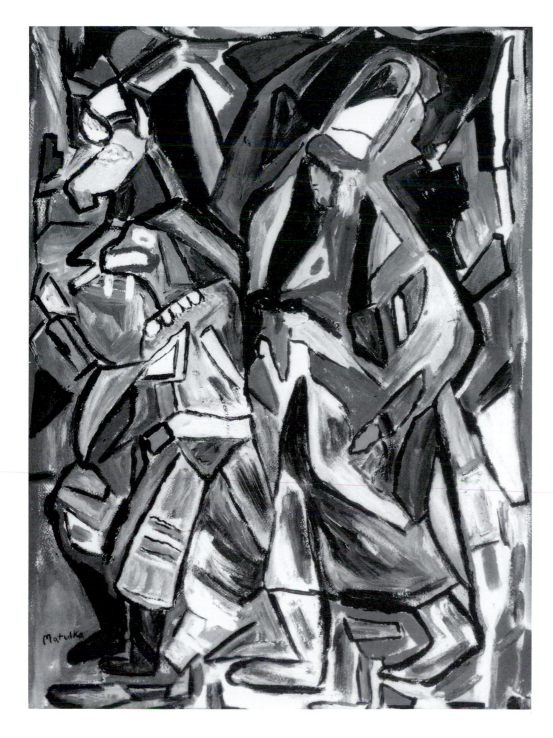

Figure 3-28
JAN MATULKA
study for *Indian Dancer*
(c. 1918).

Oil/paper 24" x 18".
Private collection.
Courtesy Owings-Dewey
Fine Art, Santa Fe.

Henderson, had collected watercolors by Awa Tsireh and it seems likely that Henderson must have met Matulka in the Southwest and admired his modernist primitivism. In any case, the few remaining images of Indian ceremonials by Matulka indicate that before 1920 he had come to terms with modernism and had seen in Native American art and culture a fertile confluence of the primitive and the modern.

John Marin

John Marin's interest in the Southwest might have originated in the vivid descriptions of it given by Hartley and Sloan. However, it was at the suggestion of Georgia O'Keeffe and Rebecca Strand [James] that Mabel Luhan invited Marin to visit Taos, which he did in in the summers of 1929 and 1930.[107] Initially, Marin was unsure about life in Taos, and after a few weeks, described himself as "this poor innocent Critter, . . . away out here on the prairie . . .

amidst Indians and Mexicans who have black eyed daughters."[108] A month later, though, he admitted that in the Southwest one was "forced to *respect* the elements." And it was a "great thing," he wrote, "to be forced to *respect* something."[109] In these two summers of work Marin produced at least sixty-four watercolor paintings, mostly landscapes and scenes of village churches.[110] Unlike most of his contemporaries, however, he was relatively unconcerned with either the history or the ethnography of Pueblo life. But he did admire the abstract designs of Indian blankets and jewelry, examples of which he collected. And yet, as he explained to Alfred Stieglitz and Georgia O'Keeffe, when he got home to New Jersey with his souvenirs, they seemed out of place.[111]

Since Marin's Realist-Cubist vision of the New Mexican landscape was predicated on what Van Deren Coke described as an "underlying quasi-geometric structuring," it was logical for him to incorporate the strong linear designs of

Figure 3-29
JOHN MARIN
Taos Canyon, New Mexico
(1929).

Watercolor, 16 1/2" x 22".
Collection of Irwin Goldstein, M.D.

southwestern Indian art into such works as *Taos Canyon, New Mexico* (1929) and *Storm, Taos Mountain, New Mexico* (1930). In the former (Fig. 3-29), Marin used the step-fret motif to suggest interlocking landscape forms (as seen from a distance), while in the latter (Fig. 3-30), a zigzag or lightning design incises itself along the edge of a mountain just left of center and then grounds itself to the earth. Beneath the stormy landscape, acting as a framing device, is a decorative sawtooth pattern which, in southwestern Indian art, often symbolizes mountain peaks. These designs and patterns, according to Coke, were not part of Marin's phenomenal experience of the landscape, but rather, were taken directly from Navajo textiles and jewelry. Furthermore, Coke has explained that Marin introduced these Indian designs in order to make his chosen landscape subjects more recognizable and to enhance the inner resonance generated in the audience by landscape forms. Apparently this was a successful pictorial strat-

egy. As evidence of this, the painter Ward Lockwood once informed Marin that he could recognize every place in the Taos Valley Marin had painted and that Marin's landscapes did not seem abstract to him. Marin replied that they were not and added, "That's just the way the places look to me."[112]

Shortly after his arrival in early June 1929, Marin, who thought of the out-of-doors as his studio, happened upon some Taos Indians on a rabbit hunt. Describing the incident to Paul Strand, he wrote, "*Yours truly* stumbled luckily right into the midst of it, almost taken for a rabbit."[113] The watercolor that issued from this serendipitous encounter, *Taos Indian Rabbit Hunt* (1929), has a prismatic quality characteristic of Marin's work in general, which resulted from a Cubist/Futurist-inspired fracturing of the surface with aggressive diagonal movements (Fig. 3-31). This linear flux is held together with a superimposed geometric order constructed of cloud, lightning, and mountain de-

Figure 3-30
JOHN MARIN
Storm, Taos Mountain, New Mexico
(1930).

Watercolor, 16 3/4" x 21 5/8".
Metropolitan Museum
of Art, New York,
Alfred Stieglitz Collection.

Figure 3-31
JOHN MARIN
Taos Indian Rabbit Hunt
(1929).

Watercolor, 19 1/2" x 14 3/8".
University of Maine,
Machias.
Photograph by O. E. Nelson.

signs taken from Navajo and Pueblo art. Marin suppressed all sense of spatial perspective in this work so that everything—scrub brush, riders, trail, rabbits, and mountain peaks—exists on a single pictorial plane. Certainly Marin had employed this quintessential formal principle of modernism—flatness—before going to the Southwest. However, in the context of this painting it is instructive to recall the following statement. Marin writes, "As I grow older I find that I cannot accept—without a doubting most of the old masters. I would rather base [my art]—on those archaic peoples and our own American Indians in their concept of what an art work must possess which is mostly an im-

printing of their concepts on flat surfaces which surface they do not kill."[114]

Even if Marin was not as studious as some of his colleagues in his approach to Native American art and culture, he, too, was overwhelmed by the artistry and primitive authenticity of Pueblo ceremonials. On 4 August 1929 he saw the Corn Dance at Santo Domingo—the same ritual that had inspired deep passions in both Hartley and Sloan. Marin was no less moved by this dramatic, communal celebration and ritual propitiation of nature, for he exclaimed in a letter written shortly thereafter, "A big Indian dance I attended—I feel my greatest human Experience—the barbaric Splendor of it was magnificent."[115] It was only natural that Marin's "greatest human Experience" was the source of his most ambitious and complex New Mexican picture, *Dance of the San Domingo Indians* (1929). Since photography was forbidden, with only his memory or quick sketches perhaps, Marin created his elaborate vision of the dance in his studio, working on it much longer than his plein-air landscapes (Fig. 3-32). Because it was a studio painting, Marin relied on design, as opposed to finesse with the brush, to achieve his ends.[116] Marin's reliance on complexity of design over surface facility was demanded by his perception of the subject matter itself: "Certain passages in the dance itself are so beautiful that to produce a something having seen it—becomes well nigh worthless—it's like grafting on to perfection—it's like rewriting Bach. To out brilliant the diamond—to out red the ruby. But man will always continue it seems to try and do just that."[117]

Marin's painting records the beginning of the dance and shows the chorus in the right center, gathered around a lone drummer. The beat of the drum is evoked synesthetically by the "sound rays" or "futurist force lines" that emanate from the center of the drum. In one collective body the dancers wind their way around the plaza, with two larger-than-life Koshares, one at the lower center and another to the left center, as the source of two interacting circular rhythms. As if to echo the beat of

Figure 3-32
JOHN MARIN
*Dance of the San Domingo
Indians*
(1929).

Watercolor, 22" x 30 3/4".
Metropolitan Museum of Art,
New York, Alfred Stieglitz
Collection.

the drum and the intervening measure of silence, a balanced pattern of light and dark pulses through the communal body—indeed, through the whole picture. The sense of cadence and order is also suggested by Marin's emphasis on the geometry of the costumes, and in the background he used a series of diagonals and the opened planes of buildings to turn a visual analysis of architecture into an image that recalls his own architectonic southwestern landscapes. Furthermore, according to Coke, Marin fractured the adobe walls and used the angles of the roofs "to set up reverberations that echo the cadence of the dance."[118]

The idea of *Dance of the San Domingo Indians* as an architectonic construction is further enhanced by Marin's use of structural devices that contain and frame the image. At the top, a pair of flat-topped mesas in the distance, which are represented on the same pictorial plane as the adobe buildings, serve to limit the expansion of visual energy. At the same time, this pair of mesas reinforces the bilateral division of the dance into two interactive concentric rhythms. The "framing" at the bottom is done by "the jagged snake-lightning symbol for water, the terraced cloud symbol, and geometric structural forms."[119] At the bottom, in the left and right corner, some of these "structural forms"—flat,

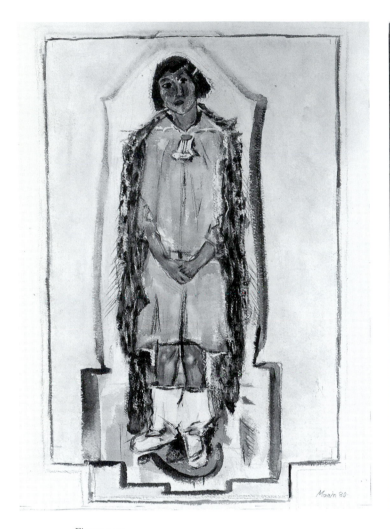

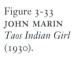

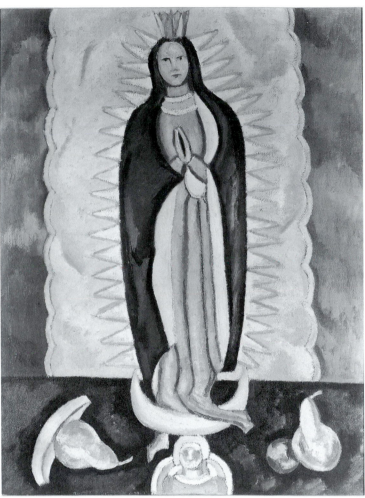

Figure 3-33
JOHN MARIN
Taos Indian Girl
(1930).

Watercolor, 27" x 20".
Private collection.
Courtesy Kennedy Galleries,
Inc., New York.

Figure 3-34
MARSDEN HARTLEY
Virgin of Guadalupe
(1919).

Oil/composition board,
31" x 23 7/8".
All rights reserved.
Metropolitan Museum
of Art, New York,
Alfred Stieglitz Collection.

interpenetrating, geometric planes—are intersected by sharp, diagonal force lines. The result is a kind of scaffolding of lines and planes that supports the internal rhythms generated by the dancers. As this scaffolding builds up the left side, it becomes a columnar form supporting a pottery bowl on which rests another columnar form that terminates in blossoming leaves. A slight variation of this design appears at the right, where the columnar form is decorated with snake-lightning. These vertical, architectonic members that terminate in flowering forms must be stylized corn plants, which are the staff of life, so to speak, of Pueblo culture and the motivation for the dance. Curiously, these corn plants extending up the sides of the picture are highly reminiscent of a framing device provided by a graphic designer to watercolors by Awa Tsireh when they were published as illustrations for an article by Holger Cahill in 1922. Perhaps this is only coincidental or perhaps both Cahill and Marin had seen some New Mexican prototype for this decorative device.

Not only did Marin add certain elements to the dance he witnessed (symbols as framing device), but he also removed certain elements, namely the spectators, Indians and non-Indians alike, who never fail to appear at this most important ritual event. In fact, Marin had observed that for some the Corn Dance was more spectacle than ceremony. In a letter to Stieglitz he wrote, "The Harvey company is big here. They run the hotels along the Santa Fe route and send bus lines all over. They take loads of visitors to see the Indians at the Pueblos. How do the Indians like it? They have no say in the matter. Some [non-Indians] say, beautiful. Others say, we must change and remedy all this. The only stray hope being that those who say, beautiful, may in some way increase their fold."[120] Thus, Marin makes his picture tidier—in the ethnographic sense—by removing the tourists and relocating the dance in that more "authentic" time: pre-Harvey bus tour. Unlike Sloan, whose etchings *Indian Detour* and *Knees and Aborigines* are explicit, if critical, about cultural interaction, Marin, as one who collects culture by way of ethnographically oriented, but nevertheless constructed, images, wants

only to collect authentic culture. Establishing the authenticity of the collected culture clarifies and focuses Marin's primitivism. When the time of the dance is situated in a primitive past, Marin's own modernity is thrown into sharp relief, thus allowing the painting to function as a culture-salvaging paradigm.[121] At the heart of this paradigm is a duality described by a variety of oppositions, but especially by the following pairs: us/not us, static past/dynamic present, traditional/modern, and vanishing authenticity/emergent inauthenticity.[122] For the Corn Dance to be worthy of being collected/salvaged and used as a metonym for the whole of Pueblo culture, its purity and authenticity had to be established.[123]

Marin saw the Corn Dance performed at Santo Domingo again in the summer of 1930, but he chose not to paint a second version of it. Indeed, he expressed reservations about the one painted in 1929, suggesting to Stieglitz that he might even destroy it.[124] He did paint, that second summer in Taos, a watercolor entitled *Taos Indian Girl* (1929), which suggests an awareness of Hartley's *Virgin of Guadalupe* (1919), an oil painting based on a New Mexican *santo*, or devotional object (Figs. 3-33, 3-34). Broder noted that Marin's Indian girl is set against an "altarlike backdrop, and the central form is enclosed within a harmonious geometric frame." This encouraged her to speculate that to Marin "the Pueblo girl was a contemporary icon—the symbol of the Indian in twentieth-century America."[125] If indeed she symbolizes Native American experience in the twentieth century, we should note that she is passive, static, and dehumanized—constrained by the altar, which makes this not a portrait but a picture of an (religious) *object*. Safely on her pedestal, she (Pueblo culture) has been salvaged, but the price of this redemption is a cluster of loss: of temporality, (cultural) mobility, and, ultimately, humanity.

Raymond Jonson

Raymond Jonson first visited Santa Fe in the summer of 1922 and settled there permanently in 1924. From then until his retirement in

1978, as a painter, theorist, teacher, and curator, he consistently championed, in sophisticated works and erudite essays, the values of modernism.[126] The inevitable characterization of Jonson as a *southwestern* modernist, however, diminishes his position as a first-generation *American* modernist who was never hampered by parochial ideas or trite regional subject matter. Many of the same stimuli—aesthetic, intellectual, and spiritual—that history associates with the art and theory of such preeminent figures as Dow, Arthur Dove, and Wassily Kandinsky also animated Jonson's modernism. And at critical points in his career, he had significant encounters with the personnel of the avant-garde and the institutions associated with them in both New York and Chicago.

Jonson's first encounter with the principles of modernism must have come when he enrolled in the Art School of the Portland Museum in 1909, where his teacher was Kate Cameron Simmons, one of Dow's former students.[127] Between 1910 and 1912 he studied at the Chicago Academy of Fine Arts and the Art Institute of Chicago, and he had the good fortune to see the Armory Show when it came to Chicago in 1913, the year he began working for the Chicago Little Theatre. In 1917 one of Johnson's paintings hung in the first exhibition of the Society of Independent Artists in New York, while a private gallery there showed his stage designs and models. A fellowship enabled him to spend the summer of 1919 at the MacDowell Colony in New Hampshire, and following its closing for the year, he spent part of the fall visiting museums and galleries in New York. He was in New York for an extended stay again in 1920 when he designed the sets and costumes for a production of Euripides' *Medea* at the Garrick Theatre. After Jonson settled in New Mexico in 1924, he continued over the years to exhibit his works in one-person and group shows in New York and numerous other American cities. In 1931 he was in New York for an extended period in conjunction with a show of his work at the Delphic Studio, which included various abstractions and his *Grand Canyon Trilogy* (1927).[128] In 1936 he exhibited at the Rockefeller Center in

New York, and in 1940 his work was included in an exhibition at the Guggenheim Museum of the Transcendental Painting Group.

When Jonson first traveled in the Southwest in 1922 he knew immediately that the combined effect of landscape forms and "Indian atmosphere" would stimulate his painting.[129] In a letter written in July of that year he observed that the people were "decorative and somewhat primitive." Later, after a dozen years of New Mexican residence, he announced, "In truth, this is the site of the real American—the original one."[130] His choice of the word *site*, associated with archaeology, as opposed to location, place, or birth, was a telling one, as southwestern Indian art and architectural ruins were inextricably linked in his mind with landscape and the rhythms of nature. Indeed, on occasion he would point out the fact that Indian symbols echoed the forms of mountains.[131] Like his contemporaries, Jonson made many visits, beginning in 1922, to the Pueblos to see the ceremonial dances. His sensitivity to this ritual art form and the emotions it stirred in him were revealed in a letter written to Dane Rudhyar in 1937. Commenting on a dance at Santo Domingo, he indicated his familiarity with the ceremony—as he recognized new dancers—and noted its exciting magnificence and perfect rhythmic movements.[132]

Forty years after settling in Santa Fe, Jonson recalled that Indian art had no immediate bearing on his painting, but added that later, as a result of "working with certain landscape motifs," he was drawn to the abstract designs of Indians. He remembered sensing "a connection between the landscape and certain aspects of Indian designs."[133] The legacy of that discovery is visible in the *Earth Rhythm Series* (1923–1927), such as *Earth Rhythm No. 6* (1925), in which the landscape forms are rendered with the precise geometry of blanket and pottery designs (Fig. 3-35). Based on the landscape near Chimayo, New Mexico, many of the forms in the central configuration bear such a striking resemblance to Pueblo architecture (cliff dwellings) that the image seems one of a mountain designed by primordial architects. According to Ann

McCauley, the *Earth Rhythm Series* was not merely about the rhythms of geological time. In support of this she cited Jonson's statement, "I feel that the purity or virginity of this wild country is being corrupted by a later civilization." The original American, he wrote, "is becoming extinct."[134]

Seriality was central to Jonson's working method, and two of his series were concerned with the unity of southwestern Indians with nature: the *Cliff Dwellings Series* (1926–1928) and the *Pueblo Series* (1926–1928). In *Cliff Dwelling No. 3* (1927) Jonson seriated the mesa wall as if it were an excavation, carving away the layers as they ascend toward the central mass of the landscape configuration, which is also the center of the painting (Fig. 3-36). There, tucked away as if it had grown inside the womb of the earth, only to be covered over by layers of geo-

logical time, are the pristine rectilinear forms of Anasazi architecture. Similarly, in *Pueblo Series—Taos* (1926) the adobe buildings—indicated by small, hard-edged rectilinear forms—are merged into the overarching architectural geometry of the Sangre de Christo mountains, stressing the unification of human structures and the natural environment (Fig. 3-37).[135]

In 1964 Jonson recalled that in 1933 he had intentionally used Indian elements in a few paintings.[136] The best-known painting in this series, which Jonson designated the *Indian Design Motifs*, is *Southwest Arrangement* (1933), which demonstrates the inherent power of southwestern Indian designs to signify landscape and nature (Fig. 3-38). That we recognize mountain peaks, mesas, the arc of the sun over the horizon, and stylized parrot feathers in the

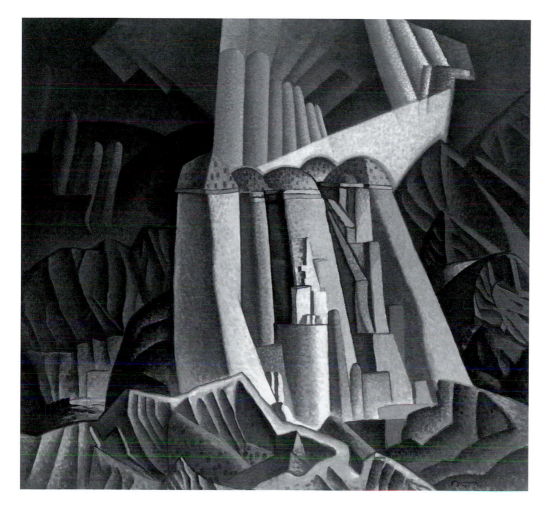

Figure 3-35
RAYMOND JONSON
Earth Rhythm No. 6
(1925).

Oil/canvas, 37" x 40".
Collection of Jonson Gallery,
University of New Mexico
Art Museum, Albuquerque.

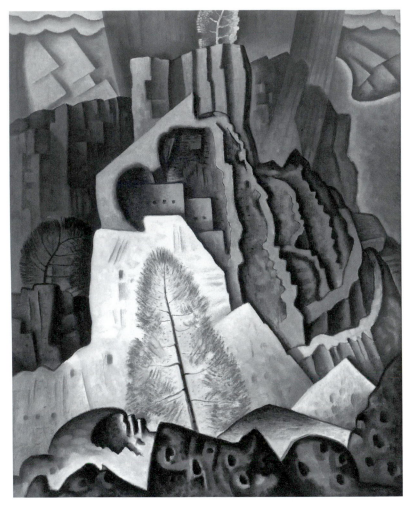

painting suggests that Pueblo and Navajo designs constitute an *abstract pictorial language* capable of creating the visual equivalent of an *essential, abstract nature*. Jonson probably appropriated the forms and shapes for this arrangement from examples of Pueblo art in the collection assembled by his wife, Vera (Fig. 3-39). Indeed, one of Jonson's students, the renowned Cochiti painter Joe H. Herrera, confirmed that Jonson had baskets, pottery, and Pueblo weavings that he used in developing designs.[137] It seems likely that Vera Jonson acquired these objects while she was employed by the Spanish and Indian Trading Post, where she began working in 1927.[138] Included in this collection, which Jonson gave to the Maxwell Museum of Anthropology at the University of New Mexico after his wife's death in 1965, were a variety of Pueblo ceramics, Pima and Papago baskets, Navajo rugs, Ute beadwork, a Hopi kachina, and numerous examples of Hopi, Zuni, and Navajo silver jewelry.[139] In an unpublished letter accompanying the gift, Jonson explained that the material was "a part of Vera's collection which she assembled many years ago." These examples

Figure 3-36
RAYMOND JONSON
Cliff Dwelling No. 3
(1927).

Oil/canvas, 48" x 38".
Collection of Jonson Gallery,
University of New Mexico
Art Museum, Albuquerque.

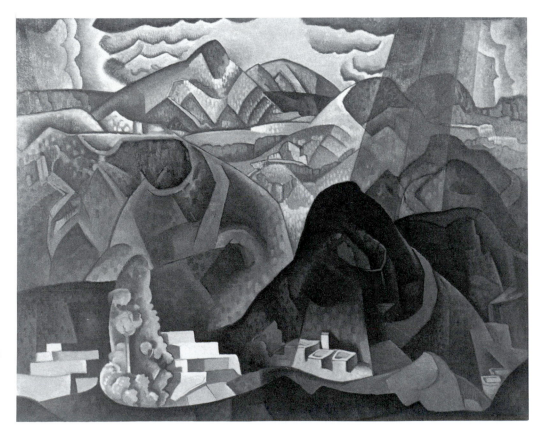

Figure 3-37
RAYMOND JONSON
Pueblo Series—Taos
(1926).

Oil/canvas, 38" x 48".
Albuquerque Museum.
Gift of George P. Pulakos and
Katherine C. Hunt in honor
of Samuel H. Spitz, M.D.

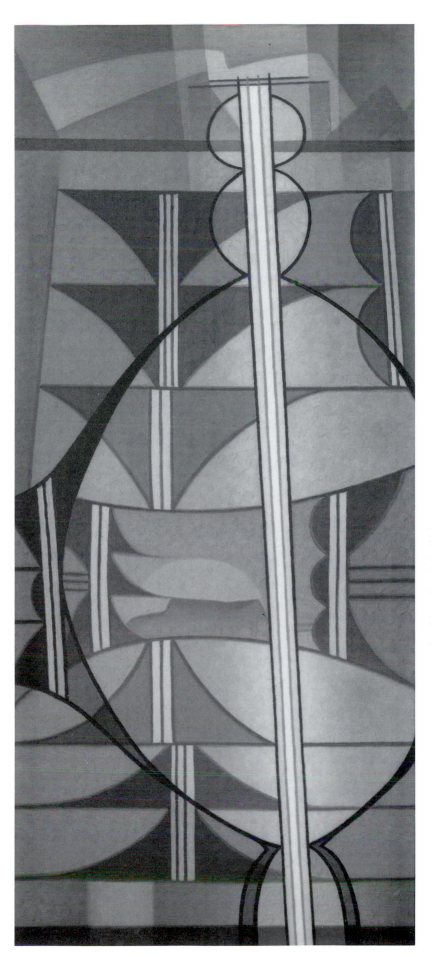

Figure 3-38
RAYMOND JONSON
Southwest Arrangement
(1933).

Oil/canvas,
45" x 20".
Collection of Jonson Gallery,
University of New Mexico
Art Museum, Albuquerque.

of Indian art, he wrote, "have been a part of our daily environment and have been personal and precious to us."[140]

Some of the objects that beautified Jonson's daily environment may well have provided the inspiration for such works as *Southwest Arrangement*. Included in the collection is a large Zia olla, an Acoma jar, and a bowl from San Ildefonso. All of the works are polychrome, and all have, like *Southwest Arrangement*, both stylized bird and pyramid-mountain forms. And, like its ceramic prototypes, *Southwest Arrangement* is the record of a remarkable adjustment of hard-edged, stylized forms, both curvilinear and geometric, to a flat surface. Finally, both the painting and the pots have a decorative quality that transcends mere design to arrive at a plastic logic which allows for both abstract complexity and refined clarity. Another object in Vera Jonson's collection that may have served as a design source for the painting is a Navajo rug (c. 1930), which shares with it a world-mountain motif, as well as strong linear patterns.

Figure 3-39
Raymond and Vera Jonson with their collection of Pueblo pottery. Collection of Jonson Gallery, University of New Mexico Art Museum, Albuquerque.

In 1946–1947 Jonson once again made Native American art the focus of an extended series of paintings entitled *Pictographical Compositions*. Despite the importance of this series to the artist's oeuvre—there were seventeen such paintings—it has received relatively little attention in the literature.[141] One of the major tasks of future Jonson scholarship will be to establish the whereabouts of, and subsequently, to publish, these important missing works so that their place in his overall production can be evaluated. Jonson described the works, such as *Pictographical Composition No. 7 (Oil No. 17)* (1946), as "an emotional organization established in *design* terms upon thinking of pictographs and petroglyphs in general" (Fig. 3-40). The connection, in a literal sense, between the *Pictographical Compositions* and their Indian rock art predecessors, he explained, was the "use of the incised line and the admixture of sand with the paint in certain shapes."[142] This reference to "certain shapes" contradicts Ed Garman's assertion that the *Pictographical Compositions* do not use "motifs or shapes of Indian rock wall painting or carving."[143] Furthermore, I am hard-pressed not to read abstract figuration into the linear design that activates the surface of *Pictographical Composition No. 7*. In fact, not only does the painting recall incised rock surfaces, but the image also evokes the notion of a Mimbres linear design that has been "liberated" from the circular confines of the bowl it decorates (Fig. 3-41).

In 1973 Jonson was asked by Bertha Dutton, then the director of the Museum of Navaho Ceremonial Art (now the Wheelwright Museum of the American Indian), to donate an appropriate example of his work to the permanent collection. After careful consideration his choice was *Pictographical Composition No. 6* (1946, now lost). Jonson explained his selection in a letter published here for the first time: "Because these works were painted in a spirit of sympathy with primitive Indian design, while not at all copying it, I feel perhaps this work will feel at home in the environment of the Museum." After noting that the painting was one

Figure 3-40
RAYMOND JONSON
Pictographical Composition No. 7
(*Oil No. 17*)
(1946).

Oil/canvas, 28" x 36".
Collection of Jonson Gallery,
University of New Mexico Art
Museum, Albuquerque.

in a series of seventeen, Jonson discussed both the impetus and the method of the series: "Let me explain that these works arose from my admiration for and contemplation of Indian pictographs and petroglyphs. The paintings are neither copies nor attempts at imitating any primitive Indian art though at times there may be a feeling of an influence to some degree of Indian design. The format in general is a painting into which lines have been incised. However, since they are in fact paintings, I did not use the term petroglyph but rather pictograph." Despite the fact that the series was based on an "admiration and contemplation" of southwestern Indian rock art, the artist felt he had fully internalized the inspiration, insisting that they "are Jonson pictographs, not Indian."[144]

Figure 3-41
Mimbres Culture, pottery bowl depicting two stylized mountain sheep (Mimbres Archive No. 4263). 4 1/8" high, 9 1/4" in diameter. Maxwell Museum of Anthropology, University of New Mexico, Albuquerque.

Emil Bisttram

Emil Bisttram, born in Hungary in 1895, was a naturalized American who grew up on New York's Lower East Side. As a very young man

Figure 3-42
EMIL BISTTRAM
Koshares
(1933).

Watercolor, 22 1/2" x 16 3/4".
Courtesy Museum of
New Mexico, neg. #110809.
Gift of Mrs. Johnson McNutt.

tions in several American museums (Dallas, Houston, Santa Fe, San Francisco).[147] Likewise, he participated in numerous group exhibitions: the Whitney Museum of American Art (1931, 1951); the Chicago Art Institute (1931); the Corcoran Gallery, Washington, D.C. (1937); the Guggenheim Museum (1940, 1945–1950); and the Metropolitan Museum of Art (1951). And like Jonson, with whom he co-founded the Transcendental Painting Group, Bisttram was an eloquent and learned spokesperson for the spiritual philosophy that underpinned his nonobjective painting.[148]

Bisttram, who had spent three months in New Mexico in 1930, was in Mexico on a Guggenheim Fellowship in 1931, where he studied mural techniques with Diego Rivera. In 1932 he settled in Taos and promptly opened the town's first commercial art gallery, the Heptagon Gallery, and the Taos School of Art. Some of Bisttram's early southwestern works, such as the Rivera-like *Two Indian Women* (1935), which was made for the Federal Art Project, are representational images that emphasize abstract form, clarity of drawing, and strength of design. The sculptural monumentality of the two Indian women, and the elegant simplification of linear movements that contain solid, stable forms, also recall Picasso's earthy, neoclassical women of the 1920s.[149] Not unlike Picasso, Bisttram often moved back and forth between representational and more abstract styles of painting. Indeed, he observed on occasion that when he finished an abstract work he always painted a figurative one. By not copying himself, he explained, he avoided becoming an academician.[150] This accounts, perhaps, for the fact that *Two Indian Women* is quite different, stylistically, from the seventeen watercolors collectively known as the *Dancing Gods Series*.

In 1933 Bisttram exhibited the *Dancing Gods Series* at, among other institutions, the Museum of Fine Arts, Santa Fe, and the Delphic Studio in New York. The watercolors that constituted the series depicted the ceremonial dances of the Hopi, Zuni, Santo Domingo, and, perhaps, other Pueblo Indian peoples. One of the works in this group, *Koshares* (1933, Fig. 3-42), is a

he established a successful commercial art agency in New York, which he abandoned to study, successively, at the National Academy of Design, Cooper Union, the Art Students League, and the New York School of Fine and Applied Art (now the Parsons School of Design), where he was an associate instructor (1920–1925). In 1923 he organized the art department at the Master Institute of the Nicholas Roerich Museum in New York, where he taught until 1931.[145] Roerich, who had visited Santa Fe in 1921, may have first made Bisttram aware of the art colonies in New Mexico.[146] However, one of his teachers at the Art Students League, Leon Kroll, had been in Santa Fe as early as the summer of 1917.

Like Jonson, because he settled permanently in the Southwest at a relatively early point in his career, Bisttram has largely been left out of the history of modern art in America, in spite of the fact that in his lifetime he had solo exhibi-

mesmerizing visual essay on decorative pat-terns. The clowns' black-and-white body paint, the black dashes indicating their tassles, and the dots that stand for seeds in the watermelon slices they carry all shift back and forth between representation and abstract decoration. And there are other sign-games being played as well. For example, the tongue of the Koshare at the far left becomes a black stripe on the body of another. Similarly, the top of the cap of the clown in the middle becomes the tongue of the one just above. The visual punning implied in such shifts is related, no doubt, to the playful antics of the Koshares themselves.

Koshares shows that, like Matulka, Bisttram understood that only a highly stylized design which meshed curvilinear and geometric forms could convey the experience of the abstract rhythms created by the dancers' costumes and their movements. Bisttram's *Koshares*, however, is a much less architectonic image than Matulka's *Hopi Snake Dance* pictures (see Figs. 3-25, 3-26), as the shapes in the former are uni-fied into one flat design—taut like the skin of the drum—which clings to the picture plane. This single planar picture space, as well as the cut-and-pasted look of the hard-edged shapes and the playful decorative patterns, suggests Bisttram's assimilation of the Synthetic Cubist aesthetic. Similarly, *Abstracted Mudhead Figures* (1933, Plate 5) echoes Picasso's *Three Musicians* (1921) in its use of variable patterns, bold juxta-positions of color, and jigsaw approach to figu-ration. In *Domingo Chorus* (1936), a gouache related to the *Dancing Gods Series*, Bisttram re-lied again on a Synthetic Cubist design: flat, hard-edged shapes are fitted together like pieces of pasted paper in a seamless unity.

When the *Dancing Gods Series* was exhibited in Santa Fe, the reviewer for *The Santa Fe New Mexican* observed that one of Bisttram's kachinas had a dynamism comparable to the "abstract quality of movement" seen in the In-dian dances "in their pure state." The reviewer was especially moved by one of Bisttram's Hopi Snake Dance figures because it captured the "same deep-seated Orientalism" that one often sensed in Indian dances. But another kachina image was disappointing for being too reminis-cent of Leon Bakst's designs for the Russian Imperial Ballet, and thus it seemed to have a "sophisticated rather than primitive Orientalism." Overall, however, the verdict was that Bisttram's *Dancing Gods* were the first southwestern paintings with a Native American subject matter to achieve real importance.[151]

Perhaps more important to the history of modernist primitivism than a "regional" review written on what was essentially Bisttram's home turf was the brief essay written by Leo Katz that introduced the catalogue accompanying the ex-hibition of Bisttram's works at the Delphic Stu-dio in New York. Not only did Katz reveal a ubiquitous longing for a lost unity with nature, but in the process he also associated Bisttram's primitivism with the search for a higher con-sciousness. Katz insisted that Native American ceremonials are not a show but rather a method for maintaining "an intimate contact with the secret forces of nature." He also stressed the mind/body duality on which the efficacy of the dance depends. Katz explained that by com-muning with these higher powers outside in na-ture, "the powers of the subconscious, inside" were awakened. In tandem with the "rhythmical physical movements" of the dance, the dancers thus achieved a "higher—a superreality." Ac-cording to Katz, this accounted for the fact that the masks and ritual designs associated with ceremonial dances are "never naturalistic but are 'magic abstractions' of age-old tradition."[152]

Katz also questioned how anyone interested in the "spirit of modern art" could ignore the relationship between "American aboriginal art" and Surrealism and the various modern styles of abstraction. One possible answer, he wrote, was the superstitious belief that all abstract art was a "French importation." In fact, Katz argued, "there was never a language less local, more universal, than the language of abstract ele-ments." Thus, Katz, like so many of the writers at the New Mexican colonies, testified to the essential and universal quality of Native Ameri-can (abstract) art. He bemoaned the fact—as he saw it—that until Bisttram embarked on his "mission," no one had tried to fertilize Ameri-can modern art with Native American tradi-

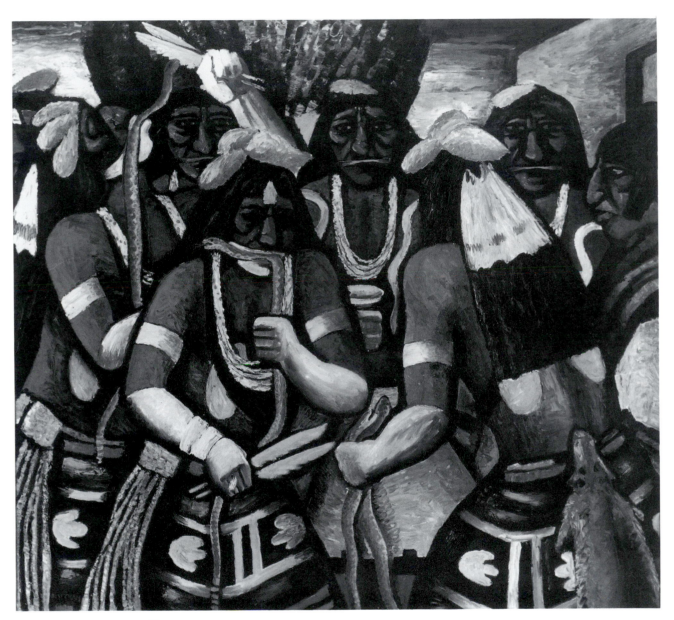

Figure 3-43
EMIL BISTTRAM
Hopi Snake Dance
(1933).

Oil/canvas, 41" x 45".
Courtesy Museum of New Mexico,
neg. #110805.

tions. Bisttram's efforts in this direction were a "courageous and valuable service," because Indian traditions were "so quickly and inevitably moving towards degeneration due to the increasing contact with our fatal superficiality." Once again, the potential contribution of Native American art to modernity was predicated on the belief in its being a cultural expression which, if unadulterated, was authentic and not superficial, like Euro-American culture. Katz noted that, unlike Bisttram, artists who used sentimental Indian themes for calendar and mantlepiece pictures were not addressing the real problem, which was a spiritual and intellectual one. Katz writes, "I see a great modern abstract movement born from the pains of intellectual isolation, longing for a higher reality in life—and the great old magic abstraction of the Indian, grown out of the powers of the soil and sun, and saturated with deep meaning.—The two had to meet.—There had to be an attempt for an interpenetration where there was so much for us to envy and to learn."[153]

In addition to the watercolor version of the *Hopi Snake Dance* (1933) in the *Dancing Gods Series*, Bisttram also made in 1933 two oil-on-canvas renditions of the same theme (Fig. 3-43). Both are titled *Hopi Snake Dance* and are so remarkably similar that a description of one suffices for the other. Both show a broad, linear simplification of form and lack of interior modeling probably derived from Rivera's figure painting. Similarly, both are thickly painted and, in terms of color, are exuberantly expressive. There are sensuous coral pinks, bold juxtapositions of white and jet black, lemony greens, and azure blues. The faces of the dancers have a brute earthiness, intended to suggest, perhaps, their primitive and autochthonous quality. Indeed, both works have an unfettered vigor about them, characteristics that Bisttram, no doubt, associated with Hopi life in general, and with the Snake Dance, in particular.

Despite the success of these intentionally archaic, vibrantly colored images, Bisttram was deciding that representational painting was not his métier. His wife, Mayrion, observed that he had decided "that any 'realistic copy,' no matter how true to life, would not express the spirit of this interesting people." As such, he consciously shifted his attention away from images of Indian people to the symbolism of Indian culture. Writing in retrospect about this period, Bisttram noted that he found himself "experimenting with symbolism in abstraction, all Indian in origin." Commenting on this, Mayrion Bisttram explained that by studying "kachinas, decorations, and sandpaintings," the artist was finally convinced that "in the Indian's own approach to the problem, that of giving their religious symbolism an understandable form, lay the answer." Bisttram was especially drawn to the "abstract concept of Nature" and deity embodied in such symbolism. Thus, after studious research into what aboriginal American artists had tried to symbolize in their work, he created a series of designs that he called *Indian Symbolism Abstracted*. According to his wife, the Indians who saw the abstractions approved of them, as they "recognized their own abstract approach to the story of Indian life and belief." Given the lack of corroborating evidence for this statement, it is more informative to note the role in his own development that Bisttram assigned to these works: "From this level of thought [the Indians' abstract concept of nature] I moved into the non-objective approach."[154] The significance of this statement must not be underestimated, since it establishes a direct relationship between Bisttram's *Indian Symbolism Abstracted* and the cosmic, transcendent abstractions that constituted his mature style.

Bisttram probably included some of the paintings that constituted *Indian Symbolism Abstracted* in an exhibition of abstract and nonobjective art at the Museum of Fine Art in Santa Fe in 1938. Alfred Morang, who later would serve as the publicist for the Transcendental Painting Group, noted that the Bisttram paintings on display took an abstract approach to Indian subject matter. In doing so, Morang wrote, Bisttram revealed "an amazing grasp of the emotional side of a race that most painters have been content to portray in its postcard-tourist phases." Bisttram's textures reminded Morang of the earth itself, and he observed that "his colors are crude with the crudeness of a primitive people."[155]

Although the search is still ongoing to locate and identify the works that constituted *Indian Symbolism Abstracted*, two late paintings may give some indication of what the earlier paintings must have looked like. The reason for this assumption is that Bisttram often returned, sometimes even decades later, to earlier motifs and styles. Thus, *Indian Legend* (1954), a casein painting, may relate to Bisttram's primitivistic works of the 1930s and early 1940s.[156] *Indian Legend* is dominated by a large mask form in the middle. Dispersed around the central mask motif are feather motifs, animal paw prints, and glyphs that suggest the pre-Columbian art of Mexico. A fluid, white serpentine form winds its way across the surface from left to right. With its Meso-American designs and the combination of biomorphic and geometric shapes suggesting Northwest Coast art, this work is best described as having a hybrid nature. In addition to the evocations of indigenous art traditions, there is also a certain Surrealist sensibility in the free play of the shapes. Likewise, a late acrylic painting, *Mosaic of the Past* (1974), seems to refer to the art of the Northwest Coast as much as to southwestern Indian art. Certainly some of its geometric designs are probably Pueblo and Navajo in origin, but in its insistent verticality, rigid compartmentalization of biomorphic and geometric shapes, totemic figuration, and *horror vacuii*, it actively appropriates the Northwest Coast aesthetic.

As I already noted, delineating Bisttram's oeuvre and its absolute chronology remains an important unfinished aspect of the history of a spirit-oriented modernism in the Southwest. However, the centrality of Indian art in Bisttram's evolution is now established, as the evidence here demonstrates that his encounter with Native American art and religious thought was the impetus for his move into nonobjective abstraction.

George L. K. Morris

As a cofounder of the American Abstract Artists (1936), George L. K. Morris was both a principal figure in the development of abstract art in America and a prominent member of the New York avant-garde whose teachers at the Art Students League (fall of 1929, 1930) included two Native American art enthusiasts—Sloan and Matulka. In addition to producing his abstract paintings, Morris was an articulate defender of modernism as critic and editor of *Miscellany* (New York, 1929–1931), *Plastique* (Paris, 1937–1939), and the *Partisan Review* (New York, 1937–1943).[157]

Morris's primitivism—he made more than a dozen works of art on the theme of the American Indian—had both nationalist and internationalist contexts. As early as 1928 he referred to Native Americans in his assessment of America's need for a national tradition in art: "Ours has been the first era to boast a civilized land without its own civilization. . . . The creative artist . . . has no background . . . upon which to draw; the only remote past this country knows is one of forest and Indians, and all the artist's materials he must deliberately create. . . . Many writers . . . endeavor to overcome the lack of national background by mingling European tradition with the fruits of their direct observation, and they have found much about them that the last century could not see."[158] Morris must have felt truly inhibited by this lack of a national tradition, for he speculated that "perhaps when we have a fixed genuine accent the artist will again be free to raise his voice."[159] To acquire this "American voice" it would be necessary, Morris believed, to make a retrospective search for the primary elements of an American aesthetic: "The essential impulse in the search for an authentic culture must be a movement backward. . . , until the artist can find a place to rest his feet securely. All the past civilizations have begun this way. If an authentic American culture is to arise, we must go back to a beginning. My work . . . is an attempt to find such a beginning."[160] As he searched for the authentic America, Morris was moved to write on more than one occasion that only "primitive" American art represented a genuinely American aesthetic, adding that even

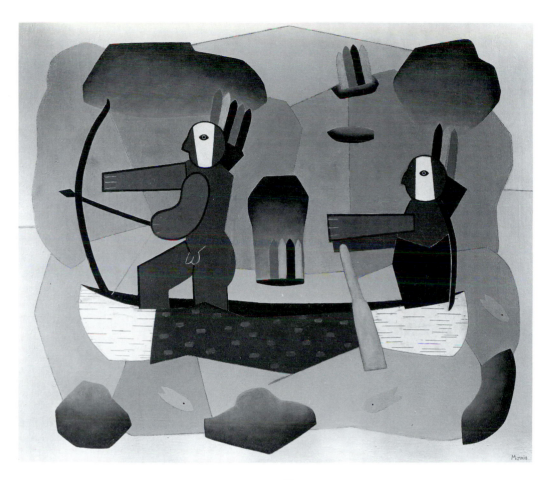

Figure 3-44
GEORGE L. K. MORRIS
Indians Hunting No. 1
(1932).

Oil/canvas, 76.2 cm x 91.4 cm. Courtesy John P. Axelrod, Boston, MA. Photograph by Helga Photo Studio.

"from the earliest times the nature of American art was abstract in feeling."[161]

As for international contexts, Morris and most of the other members of the American Abstract Artists were committed to a universal, utopian abstract art that was devoid of historical and temporal elements. Thus, as Melinda Lorenz has explained, he conceived of Indian subject matter as an element of the international language of modernist primitivism. According to Lorenz, Morris's primitivism was a distinctly formal one that "avoided nineteenth-century exoticism and symbolism." Morris was attracted, therefore, to the primitivism of Henri Rousseau because the latter had restored "purely plastic qualities to painting."[162] As such, Morris's first painting on the theme of the American Indian, *Battle of Indians* (1929), has more to do with the fantasies of Rousseau, the Italian primitive Pollaiuolo, and European images of the "New World" than with any factual aspect of Native American culture or history.[163] Yet another example of the internationalist

context of Morris's primitivism was his belief that early modernism (Cézanne and Cubism) had returned art "to its bare bones where it had been left in the caves of Altimara [*sic*]."[164]

A certain *evolutionist* strain also ran through Morris's perception of modernist primitivism. His insistence on associating primitivism in art with a stripping down to the essential elements of artmaking was an aspect of his generation's *cultural* primitivism. For example, according to Morris, modernism returned "to the more primitive conception—to the basic qualities for which any untutored mind is receptive." The fundamental appeal of these basic elements, he

noted, was tactile, but "over-civilization had dulled the [Euro-American] race to any such basic, tactile reactions."[165] By assigning the primitive a universal responsiveness to tactile experience, Morris could avoid recourse to extra-artistic explanations (subconscious, archetypal) of abstract art. As Morris's works indicate, his idea of going forward by journeying backward, as he described it, was a matter of using the essential language of modernism to pictorialize authentic American (Indian) themes.[166] His first collage, *Indians Hunting No. 1* (1932, Fig. 3-44), is a product of this kind of artistic enterprise. The simplification of

Figure 3-45
GEORGE L. K. MORRIS
Indians Hunting No. 4
(1936).

Oil/canvas, 35" x 40".
University of New Mexico
Art Museum, Albuquerque.

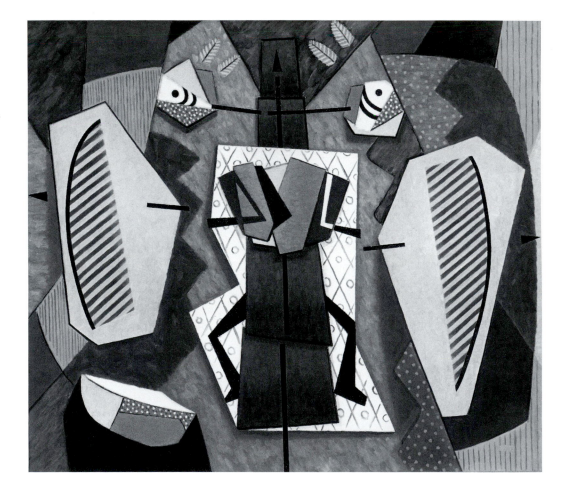

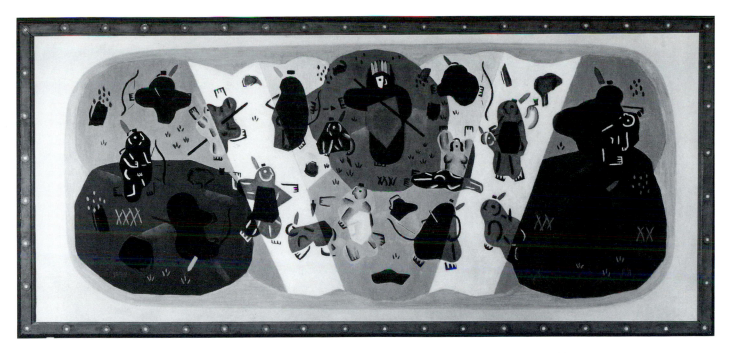

Figure 3-46
GEORGE L. K. MORRIS
Battle of Indians No. 2
(1933).

Oil/canvas, 28" x 64".
George L. K. Morris and
Suzy Frelinghuysen
Foundation, Lenox,
Massachussetts. Photograph
by Nicholas Whitman.

form, no doubt, relates to the influence of his Parisian teacher Fernand Léger, whom Morris described as "the real primitive" whose art arrived at "the core of the primitive impulse."[167] However, the flat, linear, and static quality of the figures may also reflect the influence of contemporaneous Pueblo painting that Morris would have seen in New York at the "Exposition of Indian Tribal Arts in 1931" (see Fig. 4-1), of which his former teacher Sloan had been a principal organizer. If this is so, it would explain why the "Indian" figures in Morris's collage have an illustrative character, although he felt modern artists needed to take "the long road back . . . to a simplicity untrammeled by the thousand complexities of illustration that enchain the issue."[168] But the examples of contemporary Pueblo painting exhibited in New York in 1931 *were* illustrative (and decorative) in nature, and yet they were *authentic* in that the artists who made them were being responsive to specific historical conditions: the marketplace, preservationist patronage, and nontraditional art education. Morris may have unwittingly "primitivized" his figurative images on the basis of an Indian art that did not have the pure, primitive authenticity he sought.

A review of the literature on *Indians Hunting No. 1* and the other works in this series is in order here. Nicolai Cikovsky, for example, observed that the subject of *Indians Hunting No. 1* was an explicitly American one, "with its doll-like figures, their heads modelled after Indian masks, and birch bark canoe, for which, in a flagrant Americanism, Morris applied a collage of actual bark."[169] However, it is not so much a matter of the figures being "doll-like" as it is their suggestion of the simple figuration of Plains Indian pictographs. Furthermore, Cikovsky does not specify—and it is not clear—just what Native American mask tradition influenced Morris in making such an image. And, if there is a "flagrant Americanism," it was the selection of the subject itself, for as Lorenz points out, the birchbark operates quite logically, in a semiotic sense, as a sign for the indigenous material of canoes made by peoples of the Woodland tradition. However, I find problematic Lorenz's assertion that in the *Indians Hunting* series, such as *Indians Hunting No. 4* (1936, Fig. 3-45), Morris used Indian designs "because of their inherent primitive authenticity and structural strength."[170] While it is true that the work in question has a roughly symmetrical design consisting of flat geometric planes, really nothing beyond a general primitivism suggests a close observation of Native American designs.

Cikovsky, too, sees a strong influence of Indian art in *Indians Hunting No. 4*, especially "the kachina-like character of its central motif" and "the resemblance of the poses of the back-to-back hunters to those in pueblo ceremonial dances."[171] Certainly the central totemic figure

Figure 3-47
GEORGE L. K. MORRIS
Indians Fighting
(1935).

Watercolor, torn paper, and
birchbark/paper collage,
17" x 13". Collection of
Cornelia and Meredith Long.

does recall pre-1900 kachina effigies, but unfortunately, the illustration of Pueblo painting used by Cikovksy to demonstrate back-to-back ceremonial dancers does not feature any kachinas.[172] However, the desire to find the influence of Indian art in this painting is explained, no doubt, by Morris's own recollection of it. As he observed in a letter written to Van Deren Coke in 1975:

> I spent some time in Santa Fe in the thirties, and explored Indian pueblos between San Ildefonso and Acoma, all the while filling notebooks with sketches of design-fragments which interested me. However, I also noted the designs of Northwest Indians and even those (less sophisticated) in the East. I selected those which seemed to fit into the plastic scheme of the work on which I was engaged. As the painting came shortly after my trip to New Mexico, the chances are the influence was that of the Southwest. But of course I can't be sure, as the work was executed in my New York studio on my return—where all my notebooks were at my disposal.[173]

The one thing that is certain about *Indians Hunting No. 4* (and the others that comprise the series) is that Morris continued his exploration of Léger's purist version of Synthetic Cubism. Morris's commitment to Cubist abstraction and decoration in the context of the Indian themes is typified by the relationship between *Battle of Indians No. 2* (1933) and *Indians Fighting* (1935) (Figs. 3-46, 3-47). The oil painting *Battle of Indians No. 2* is far more abstract, in almost every way, than his earlier Rousseau-like version. Cikovsky suggested Eskimo art as a possible source for the figurative style of the later version, but the simplified figuration and the active, almost random dispersal of the figures over the whole flattened space, again, are more likely related to Plains Indian pictographic accounts of war.[174] And yet, the flat space and simplified (i.e., essentialized) decorative forms are perfectly consistent with Synthetic Cubist design. Certainly the modernist part of this

equation dominates in *Indians Fighting*, a water-color, torn paper, and birchbark collage. In this later work Morris was concerned with Synthetic Cubism's ability to make abstract signs via textures (birchbark) and fragmentary bits of symbols (arrowhead, glimpse of a spear) that refer metonymically to the idea of Indians fighting. Even the amoeboid shapes (primitive biological forms), derived from Joan Miró, were probably used by Morris, according to Lorenz, to signify "the natural, primitive state of American culture."[175]

Morris continued these biomorphic references, along with Hans Arp's technique of chance construction with which he had experimented earlier, in *Indian Composition* (1939), an oil painting to which he attached nails and bits of birchbark that refer, synthetically, to Indian canoes.[176] However, a later oil painting of *Indian Composition* (1942–1945, Fig. 3-48) relies far more overtly on southwestern Indian art and culture. The central figurative image, an abstraction on the kachina motif, is surrounded by the planar geometry of ceramic and textile designs.[177] In this instance Morris really does appropriate fragments of Indian design, which are then woven into a complex Cubist construction. Likewise, *Arizona Altar* (1949–1951, Fig. 3-49), perhaps the last of Morris's works to incorporate Indian referents, is an extremely ambitious one, compositionally speaking, made with oil and pencil on an umprimed, loose-weave cotton canvas. The decorative scroll forms that twist like snakes across the surface are not unlike the site-and-path motifs found in southwestern Indian ceramics and rock art. Similarly, the small abstract symbols and primitive animals immediately to the right and left of the central configuration also may be an effort to evoke the images of rock art. However, many of the other "signs," such as crosses, candles, and the stylized central *santo* figure wearing a crown, are based on Morris's visit to San Xavier del Bac, a Spanish mission church near Tucson, which he described as being a mixture of "bastard baroque" and "Indian textures."[178]

Figure 3-48
GEORGE L. K. MORRIS
Indian Composition
(c. 1942–1945).

Oil/canvas, 63 1/4" x 49 1/4".
Collection of Corcoran
Gallery of Art.
Gift of the Friends of the
Corcoran, 65.21.

Figure 3-49
GEORGE L. K. MORRIS
Arizona Altar
(1949–1951).

Mixed media/canvas, 53" x 40 1/2".
Hunter Museum of Art,
Chattanooga, Tennessee.
Gift of Ruth S. Holmberg.

Conclusion

Because "The Indian" was/is a conceptual category, its malleability was reflected in the works analyzed in this chapter. Just as the representation of Native peoples in such diverse forms as popular literature and ethnological reports varied according to the current needs of the ethnocentric representers, so too was the variability of "Indians" and "Indian art" made manifest in the art of the avant-garde from 1910 through the 1940s. Indeed, the pluralistic nature of the methodology of this chapter was demanded by the pluralistic nature of the responses to Native America being examined. The constructed Indian (art) seen in the paintings discussed above, although often based on close contact with, and admiration for, Native Americans—Pueblo Indians, almost exclusively—generally had much to do with the personality and intellectual and spiritual concerns of the observer. Henri and Sloan, for example, were interested in the "real nature of things," the correlate of which was an art based on observing the model (the sitter, genre activity, etc.). Nevertheless, they were also fascinated with (exotic) human types, especially Henri. As a result, their images of Pueblo peoples and their lives can be characterized as a kind of exotic realism that was predicated on "racial" difference.

The modernists, no less than Henri and Sloan, were seeking the "real nature of things," but for them, this meant some absolute, essential order in nature. It was quite natural, then, that they would be drawn to what they saw as the unity between Pueblo ritual, nature worship, and the abstract designs of pottery and blankets. For artists such as Hartley, Jonson, and Bisttram, that relationship symbolized a cosmic abstract order to be emulated in nonrepresentational art. Thus, one of the most significant aspects of this chapter is its revelation of the way that Native American art, and its attendant notions about landscape, self, and consciousness, as perceived by the modernists, provided a powerful justification for finding spiritual value in abstraction.

Native American Art in New York, 1931–1941

The Abstract Expressionists and Indian Space painters, whose art and art theories are the subjects of Chapters 5 and 6, paid studious attention to Native American art in response to two interrelated trends in American intellectual life that had gained strength throughout the 1930s and found full expression in the early 1940s. Artistic interest in Native American art and culture was stimulated by the belief that the vitality and spirituality of Indian life, as embodied in its art, could make a positive contribution to the America of the future. The second of these trends was the widely held belief that primitive art was a manifestation of a universal stage of primordial consciousness that still existed as the contents of the unconscious mind. The New York avant-garde's awareness of C. G. Jung's concept of a collective unconscious that included early humankind's symbolic mode of thinking prompted a study of the mythic and ceremonial nature of primitive art. Young artists, such as Jackson Pollock, Adolph Gottlieb, and Richard Pousette-Dart, were encouraged in this endeavor by John D. Graham, the Russian emigré artist and critic. These two aspects of American intellectual life in the 1930s and 1940s established the context for the artistic primitivism of Pollock and his generation.

This chapter focuses on the first of these intellectual currents. Running parallel to the broad interest in primitive art just described was the ever-growing recognition of the contribution Native American cultures could make to a specifically American national identity. The need for a revitalized America, as a nation with unique cultural resources, originated in part in the economic depression of the thirties. That the strengths and values of Native Americans were incorporated into the nation's cultural identity was also due in part to the liberal policies of the Bureau of Indian Affairs during the New Deal. But the greatest impetus, perhaps, for appropriating and "nationalizing" Native America was the aggressive activity of New York museums, as well as the increased number of books and articles about Indians and their art that appeared in the thirties, a decade bounded by two important exhibitions of Indian art.

Beginning with the "Exposition of Indian Tribal Arts," which opened at New York's Grand Central Galleries in 1931, the awareness of Native American civilizations as a spiritual and aesthetic resource for modernity grew exponentially through the 1930s. By 1941 the idea had such validity in American artistic, intellectual, and political life that when the Museum of Modern Art hosted the now-legendary exhibition "Indian Art of the United States," it was making concrete a set of values that were fully anticipated by the audience—the American public, in general, and the New York art world, in particular. "Indian Art of the United States" was literally a cultural happening that set in motion in New York waves of artistic and intellectual activity that rippled throughout the 1940s. To understand what forces brought this exhibition about and why its impact was so monumental, it is necessary to examine the chain of events that began in 1931.

The Exposition of Indian Tribal Arts

On 30 November 1931, the exposition's first day at the Grand Central Galleries, more than three thousand visitors viewed some 650 objects, including excellent examples of ancient and historic arts and crafts from dozens of Indian tribes, as well as contemporary paintings by Plains and Pueblo Indian artists (Fig. 4-1).[1] After it closed in New York in December, the exposition began a two-year tour arranged by the College Art Association of America to fourteen cities, including the District of Columbia, where it was installed at the Corcoran Gallery in 1933 as part of the Washington Bicentennial. The exposition was sponsored by a private, nonprofit organization with regional committees in New York, Boston, Chicago, Philadelphia, Santa Fe, Los Angeles, San Francisco, and Seattle. Painter and Indian art patron John Sloan was president of the Board of Directors, which included Indian art collector Amelia Elizabeth White (chairman of the Executive Committee); Frederick W. Hodge of the Museum of the American Indian; Oliver La Farge, anthropologist and author of the Pulitzer Prize–winning "Indian" novel *Laughing Boy*

Figure 4-1
TONITA PEÑA
(Quah Ah, San Ildefonso
Pueblo)
Eagle Dance
(n.d.).

Tempera/paper,
12 1/2" x 16 1/2".
Courtesy Museum of New
Mexico, neg. #130768.

(1929); Abby Aldrich Rockefeller; publisher and tribal art collector Frank Crowninshield; and Dr. Herbert J. Spinden, curator of the Department of Ethnology at the Brooklyn Museum, the exposition's final venue. Similarly, the exposition's advisory committee was an illustrious and eclectic group, indicating the broad base of interest and patronage that already existed for Native American art by 1931: Mary Austin; Alfred H. Barr, Jr., of the Museum of Modern Art; the painter Andrew Dasburg; Frederic H. Douglas of the Denver Museum; Alice Corbin Henderson; the anthropologist Alfred L. Kroeber; Walter Pach; the poet Carl Sandburg; and the linguist Edward Sapir, among many others.

According to the exposition's own records, in the summer of 1930 a group of Indian art supporters met in Santa Fe to discuss plans for "an important exhibition of Indian art, both ancient and modern, to be shown as art—not ethnology."[2] The bylaws of the organization stated that its goal was to "win the aesthetic appraisal of Indian art, as a means of awakening public appreciation, so as to encourage the Indians to continue to develop their art, and create an enlarged market for same."[3] The organizing com-

mittee determined that to achieve these goals, each regional committee (none of which included Indian artists) "should attend to the censorship of material before it reaches New York in order to set a high standard of excellence." Native artists were thus excluded from the critical audience that would establish the criteria for aesthetic excellence in Indian art, continuing a pattern set in the Southwest in the 1920s. Furthermore, the organizers agreed that in the catalogue "mention of Indian problems would be out of place," ensuring therefore that the colonial-tourist-salvage contexts attendant to the social formation of the work, especially Plains and Pueblo watercolors, would have a ghostly absence in the discourse.[4]

In a *Prospectus*, probably written by Sloan, which was sent to potential supporters, the organizers of the exposition expressed concern that most Americans thought of "Indian art as belonging to the remote past, to be seen in museums along with other relics of antiquity." Few Americans, he observed, realized that Native arts had entered the "machine age" in spite of centuries of pressure and vast changes wrought by "an alien civilization." The exposition's in-

tention, therefore, was unequivocal. Referring to "our native first Americans," Sloan stated that "the aim is to present Indian art as *art*; and to win for it the appreciation . . . which has been so generously accorded the primitive and folk art of every other race and country."[5]

Similarly, a letter written to Spinden in April 1931 by Liston M. Oak, who was at that time executive secretary of the exposition, outlined the motivations and ambitions of the organizers, including their desire to provide the American people with "their first opportunity to see really fine Indian things, and to estimate the cultural contribution the Indian can make."[6] The *Prospectus* noted also that a successful exposition would increase the market demand for high-quality Indian art, thus encouraging Indian creativity. In fact, many of the exhibits, which the committee was to acquire directly from the artists whenever possible, were to be for sale. However, there was once again the assurance that "careful censoring of things submitted will ensure a high standard of beauty and excellence."[7]

The organizers were determined that the exposition "be as smart as possible," and that in management, publicity, and installation, it would emphasize "great beauty and good taste." With the guidance of the (non-Indian) artists and architects on the advisory committee, and "by handsome display, clever lighting, and generous use of space, the maximum artistic and dramatic effect" was to be obtained for the Indian objects on display.[8] For example, Oliver La Farge, coeditor of the catalogue, proposed that each example of pottery, sculpture, masks, and beadwork "should be illustrated alone, as an *object of art*, and that groups would be ruinous to the lesson we wish to teach."[9] Because the exposition was to be both "educational and cultural," it would be necessary, the organizers thought, to maintain a "dignified publicity campaign."[10] Furthermore, because they wanted the exposition to have a national impact—to educate even that portion of the audience who would not be able to see the traveling exhibition—the committee understood that it had to open in New York, even though it was "far

from the western country where most of the Indians live today." The *Prospectus* explained that because the New York press influenced "profoundly the press of the entire nation, . . . a successful exhibition in New York commands the attention of the whole country."[11]

In addition to sponsoring a series of lectures in conjunction with the exhibition and arranging for classes of students to visit the show, the exposition published a book-length illustrated catalogue, entitled *Introduction to American Indian Art*, which was edited by three anthropologists who served on the Board of Directors: F. W. Hodge, La Farge, and Spinden. In the introductory essay, La Farge and Sloan explained that the contemporary watercolors on display in the exposition were "at once classic and modern." The works of Awa Tsireh and others were "old, yet alive and dynamic." The modernism of these artists, according to La Farge and Sloan, was "an expression of a continuing vigor seeking new outlets and not, like ours, a search for release from exhaustion." The authors noted that along with several appropriately modernist formal qualities—"simplicity, balance, rhythm, abstraction"—the new Indian painting was characterized by its virility. This art, they wrote, resists "meaningless geometric design," has natural symbolism, and a "primitive directness and strength, yet at the same time it possesses sophistication and subtlety." Writing more generally about the wide range of objects in the exposition, La Farge and Sloan noted that "the American Indian race possesses an innate talent in the fine and applied arts." Indians, according to this interpretation, were born with a "capacity for discipline and careful work, and a fine sense of line and rhythm, which seems to be inherent in Mongoloid peoples."[12]

Besides La Farge and Sloan's introduction, several essays by preeminent (non-Indian) authorities on Indian art were included. Rather than scrutinize these in detail, I want to examine only briefly those comments that focused on the modernness, the Americanness, the collective nature, or the (psychological) universality of Native arts, since these were the principal elements of the constructed Indian (art) in the

years 1931–1941. For example, in his article on "Fine Art and the First Americans," Spinden observed that an American art and culture could be predicated on Indian traditions. Just as the English never failed to find inspiration in the Arthurian romance, Americans would come to realize "the epic grandeur in the song sequences and world stories of the first Americans." Specific art forms, such as the Navajo Night Chant, were going to become a part of "our national literature as mysterious and beautiful dramas which somehow prefigure the American ideal." No less than the Arthurian legends, Native America represented for Spinden the persistence of a romantic golden age, the spirit of which could vivify modern America: "We have in our Indians a reality of Arcady that is not dead, a spirit that may be transformed into a potent leaven of our own times." Both the transforming power of Native art and its collective quality were central to Spinden's perception of its value to America. He wrote, for example, that "Indian art is filled with social purpose and in its normal development conscious individualism has had little play." Furthermore, he had witnessed how both Mexican and Peruvian society were "acquiring new social personalities" as a result of their incorporation of Indian "traditions and capabilities."[13] Thus, a lesson was to be learned from these other "New World" nations about the relationship between indigenous culture, modernity, and the collective nature of society: "In a similar way our own aborigines must supply an ingredient to the national character of the United States. We may safely trust these first Americans with a mandate of beauty. In a world which grows mechanical they seem able to keep contact with the great illusions. This is well, because these great illusions enrich the oversoul of society and fix the interdependence of individuals in patterns of collective efficiency."[14]

Mary Austin's essay on "Indian Poetry" was concerned, although she never stated it overtly, with the modernness of the art form, as her interpretation was heavily indebted to the modernist notion of abstraction as an essentializing process. Native American poetry, as with all primitive poetry, was like the painted decorations on ceramics— "the abstraction of an experience sketched upon the audience with the poet's self as the tool." Furthermore, like modern art, Indian poetry and painting sought not to represent something but rather to express something. For example, she writes that "even when a picture is introduced, as it often is in Pueblo pottery, it is not the picture as portrait which interests the Indian, but the picture as idea." Thus, the forms of Indian painting, according to Austin, are equivalent to the ideas and experiences of the "tribal mind," such as "food, vitality, summer, good hunting, fecundity, [and] spiritual power." She ascribed this particular quality to the mingling of "Oriental" and "New World" traditions, stressing the need to remember that "all Indian art . . . is racially akin to the art of the Chinese, and that the local influences are all American."[15]

Not surprisingly, given her role in the emergence of the new Indian painting some years earlier, the essay on "Modern Indian Painting" was written by Alice Corbin Henderson, who continued to emphasize the "tribal conception of life and art, as . . . something possessed in common." According to Henderson, "this primitive (and perhaps enlightened) point of view" allowed everyone to share equally in conceiving the function of art, which was "another form of language." The "spirit of Indian art," she noted, issued from "the living matrix of Indian life and culture," which was a "whole body of myth and philosophy," and thus was "different from our modern individualistic conception of art." And, although Henderson stressed the freshness, spontaneity, and "unspoiled vision of these native American artists," she cautioned against seeing these qualities as new or surprising. Rather, the work shown in the exposition was "merely a continuance of an age-old tradition."[16] Finally, because two of the Abstract Expressionists discussed later, Richard Pousette-Dart and Jackson Pollock, were influenced by Navajo sand painting, it is instructive to reproduce here Henderson's comments on this art form, particularly her stress on its archetypal and ritual aspects: "The design, and every smallest part of it, is wholly symbolic. It

has an archetypal, elemental significance. However intrinsically beautiful, its beauty to the Indian is in its meaning. It represents a philosophic conception of life. Its purpose is to convey this philosophy, and, once it has been used in the ceremonial ritual that follows, the painting is entirely erased and destroyed with the same ceremonial precision with which it was made."[17]

Laura Adams Armer's essay on "Sand-Painting of the Navaho Indians" presented a more detailed discussion of the subject. An artist, photographer, and author, Armer recorded hundreds of sand paintings between 1924 and 1942 and made the first film of a Navajo ceremonial, *The Night Chant* (1928).[18] Her comments, too, are useful in the context of modernist primitivism because of the kind of information they might have provided Pollock, in particular, about sand painting. Early in her essay she established the importance to the Navajo culture of "shamans who sing the myths of an ancient people and an ancient land, who conduct ceremonial dances, and who supervise the making of the sacred sand-paintings." These ancient myths, she wrote, were "born of heroic living in a land whose physical features challenge the imagination, [and] are blended with historical facts in the songs and the paintings." Because sand paintings "are the most ephemeral of all art," Armer thought that "it would be a valuable gift to American culture to save these age-old symbols." She also valued sand paintings as the artistic expression of spirituality and cultural authenticity: "The sand-paintings, representing very old traditional art, are a direct outgrowth of religious emotion. They are the only uninfluenced examples of aboriginal American art produced today. While they are highly stylized designs which must be made perfect according to the shaman's knowledge, there was a time in the remote past when they were spontaneous productions of artist priests. They link religion and esthetics to such an interesting degree that artist and ethnological student each finds in them a rich field of research." In sand paintings, Armer wrote, "mystery, faith, and beauty reign supreme while the multicolored symbols breathe out divinity."[19]

Because ceremonial masks and the myths associated with them, especially those of Northwest Coast and Eskimo origin, were of particular interest to many Abstract Expressionists, including Pollock and Sloan's students, Adolph Gottlieb and Barnett Newman, I want to review briefly the comments made about these traditions in Charles C. Willoughby's essay "Indian Masks." He explained, for example, that on the Northwest Coast "practically all of the masks were ceremonial." Clan masks represented totemic ancestors who founded the clans, and in addition to having a clan totem, "each man could acquire a personal totem which also was his guardian spirit." Among the Kwakiutl, Willoughby noted, certain individuals inherited the right to be initiated into "secret societies established by a guardian spirit of the clan," such as the Hamatsa, or Cannibal, Society. After a lengthy discussion of the myth of the "Cannibal Raven" and the initiation rites associated with the Hamatsa Society, he observed that the ceremonial dance "is really a dramatic performance of the myth relating to this spirit." Willoughby also reported the importance of masks in the practice of shamanic medicine: "While wearing a mask the shaman is transformed into the animal or spirit which it represented, thus imparting to him superhuman powers over the disease." And, concerning an Eskimo mask from Anvik, on the Yukon River in Alaska, he stated that these ceremonial masks "take the forms of the human face, often with one or more features grotesquely distorted . . . and the imaginary faces of spirits and mythical monsters." Totemic animal masks were also worn in Eskimo ceremonies, he wrote, and "the wearers believe themselves to be transformed into these animals, or at least endowed with their spiritual essence."[20]

Thus, the scholarly essays in the catalogue documented one of the most important exhibitions of the 1930s. Indeed, when the exposition opened, the press reported that "it is unquestionably the most representative and beautifully presented collection of Indian art that has been assembled."[21] According to Sloan, the exhibition was significant for presenting contempo-

rary art that was both "beautiful" and rooted in history: "Throughout the United States there are Indian artists and craftsmen who are producing today work of great intrinsic beauty, conforming to an unbroken aesthetic tradition that had its origins in pre-Columbian times. This extraordinary persistence of an ancient art is perhaps unique in history."[22]

In other words, an authentic art form created in the "racial" past was alive in the present and available for absorption by modern artists. In fact, in reviewing the exposition for *Creative Art* Sloan wrote, "On account of the geographical position, I believe that Amer-Ind art will have more influence in America than the appreciation of African art has had in Europe. . . . We want to help American consciousness to include this American art."[23]

The *Americanness* of Native American art was one of its most important components in Sloan's regard, and his appreciation of it was based on no small amount of chauvinism. He felt that a deeper awareness of Indian art by modern artists and their patrons could only enrich the culture and make it more specifically American.[24] He was not alone, of course, in perceiving this potential. On the contrary, his position typified the response of many critics to the exposition. Walter Pach, previewing the exhibition in the *New York Times*, wrote that "the art of the Indians, so eloquent of this land, is American art, and of the most important kind." Europeans, Pach explained, already understood that Americans "have only to draw on the resources immediately behind them or around them to give their art a background of the primitive, such as is found in every one of the great schools of the past."[25] Similarly, the *Brooklyn Eagle* observed, "We accepted Europe's dictum in regard to the inspirational quality of Negro, Mayan, and New Guinian [*sic*] art. But we disregarded the art of our own aborigines. The Tribal Art Exhibition should do much to bring about a revision of opinion nationwide."[26] Edward Alden Jewell, the art critic for the *New York Times*, also drew the same analogy about European modernism and African art as did Sloan and others. In his review

Jewell speculated as to whether "we are about to witness an enthusiastic borrowing of Indian motif and technique on the part of artists in this country, so alive just now to the American heritage."[27] The *Christian Science Monitor* cited "a distinguished art critic" who speculated that the exposition might generate a "swerving of American taste from French interiors to those inspired by Indian ornament."[28] Likewise, the *Brooklyn Eagle* noted that "the exhibition is especially timely, coming as it does in a year when we are searching for the quality of our own cultural tradition."[29] Not only was the *discovery* of Indian art perfectly timed with the search for an American identity based on non-European values, but it may, in fact, have provoked this chauvinism. In support of this idea a critic for the *Art Digest* noted, "Perhaps the 'American Wave'—the movement launched by artists and art lovers to save American art from inundation by the so-called 'alien flood'—had something to do with the commotion caused in New York by the opening of the Exposition of Indian Tribal Arts . . . probably never before has an exhibition been given so much space in the newspaper and periodicals."[30]

Although New York, and of course, Santa Fe and Taos, were centers of this interest in Native American art, it was in every sense a national phenomenon. When the exposition opened, the reviewer for *Connoisseur* felt that it would "express the very tangible interest in the Indian arts which has been growing quietly in the last few years and has now spread over every part of the country."[31] Spinden, discussing the merits of Indian art in *Parnassus*, stated that the Indians of the United States were "prepared to accept a mandate of beauty and administer it for the national good." He called the Indians our national artists who, having maintained their spirituality in an increasingly mechanical world, would help enrich America's spirit and "establish the interdependence of individuals in a social organism." Spinden was timely in his observation that there must be an "Indian ingredient in the formation of that special and characteristic expression which will constitute American art of the future." Like Sloan and later John Graham, Spinden also recognized

the continuity from ancient times to the present of ceremonial traditions that were still being tapped by Indian artists as "a source of inspiration for their work."[32]

John Collier and the "New Deal" for Native Artists

Although the 1941 exhibition "Indian Art of the United States" received a complete commitment of resources from the Museum of Modern Art, its staging would have been impossible except for the liberal Indian affairs policies of President Franklin D. Roosevelt's New Deal. "Indian Art of the United States" was organized by René d'Harnoncourt, general manager of the newly created Indian Arts and Crafts Board, a federal agency established by Roosevelt's new commissioner of Indian Affairs, John Collier.[33] Collier's appointment in 1933 was urged by various Southwest Indian groups for whom he had been an advocate during a decade as the secretary of the American Indian Defense Association.[34] His faith in Indian values was a mystical one, and he was determined to protect Indian ceremonial traditions while promoting their arts and crafts. One avowed mode for accomplishing this was to have the Department of the Interior's Indian Arts and Crafts Board (hereafter, referred to as IACB) discover and integrate into the mainstream of American life "viable elements" of the Indian's aesthetic life.[35] The political mandate for Collier's reversal of the old government policy of forcing the Indian onto the "White Man's Road" was the Indian Reorganization Act (Wheeler-Howard Bill, Act of 18 June 1934).[36] La Farge, writing in *New Republic*, recognized that this law alone would mark Roosevelt's administration as a turning point in Indian history.[37]

Since Collier's perceptions of Native American art and "religion" affected government policy, it is particularly important to examine them here because of their remarkable similarity to Sloan's views and to John Graham's Jungian emphasis on continuity with the racial past and on ritual as a transformer of consciousness (see Chap. 5). At a symposium on government involvement in the arts in America,

Collier described contemporary Indian peoples as "ancient social orders, organisms of communal life from thousands of years ago . . . all-embracing in the experience of its members, and striving at this hour to make profound adaptions to the demands of necessity while keeping alive ancient values."[38] Just as Graham wrote later in 1937 that primitive art brought to consciousness the collective wisdom of past generations, Collier saw the various forms of Indian art as expressions of the "tribal will that the past shall be incarnate in living men." Collier also believed that anyone who entered into the racial past, which he called the "racial own," had his or her life deepened by the transcending of individuality. Echoing Jung's description of primitive religion as an attempt at spiritual transformation, Collier recognized the Indian belief that individuals could and did expand their consciousness through ritual art. Jung's assessment of modern man's need for spiritual transformation was echoed in Collier's diagnosis of Euro-American culture in the twentieth century as being religiously and aesthetically shattered. He suggested, however, that if modern man would only pay attention, Native Americans were capable of presenting "to the modern world a gift of beauty, of idealism, and of art forms and art genius."[39]

This sense that modernity, and especially European civilization, had been sapped of spirituality was reflected in the perception that the then-current vitality of Mexico was the result of the incorporation of pre-Columbian values. In urging the acceptance of American Indian art, Spinden wrote in 1931 that Americans should observe the example of Mexico, which was enriching its social personality by integrating indigenous traits and potentials. Similarly, Sloan's fondness for Mexican tribal art and his ardent enthusiasm for the art of Diego Rivera were well known in the thirties.[40] In a 1939 editorial in the *Magazine of Art* entitled "The New World Is Still New," F. A. Whiting, Jr., wrote that although the Thames and the Seine were already charted in our intellectual geographies, there was currently an air of adventurous discovery concerning the unexplored aesthetic resources of the Americas. He went on to suggest

that a desire for isolation from Europe's war or the influence of the "Mexican Renaissance" could be helping to promote this "stirring of American imagination."[41]

The 1940 exhibition "Twenty Centuries of Mexican Art" at the Museum of Modern Art (MOMA) only served to affirm the existing idea that an innovative modernist style of painting had been generated out of indigenous roots by the Mexican muralists. In a review of this exhibition for *View*, the American Surrealist journal, Nicolas Calas encouraged artists to take a lesson from it, because it presented the signs of the unknown that western artists had been searching for with uncertainty. The magic to be found in the Mexican art could, he wrote, lead to a "new form of art which will enable us to solve some of the major cultural problems of the twentieth century."[42]

The obvious lesson for New York artists was that to create an original, native American art they had to begin, as had the Mexicans, by examining indigenous Indian art. Transforming these art roots by subjecting them to the language of modern art could allow American artists to create a radically new national art without being overly indebted to European principles. The best work of José Clemente Orozco and Rivera seemed to exemplify this paradigm. In fact, as Robert Hobbs has observed, by 1940 there was a sense that the "triumph of North American painting had already occurred—but in Mexico, not the United States." According to Hobbs, MOMA's exhibit of Mexican art underscored the sources of Mexican modernism, which was demonstrably more advanced, aesthetically, than painting in New York.[43]

The perceived "triumph" in 1940 of an Indian-inspired Mexican modernism made the American art world more keenly aware, more self-consciously interested in the art of "United States Indians." The atmosphere had been intensified in 1939 when Dr. George Vaillant, director of the American Museum of Natural History, published *Indian Arts in North America*, the first attempt at a genuinely comprehensive, scholarly treatment of the topic. Vaillant's book was comparable to John Graham's discussions

of primitive art in that it continually stressed the idea that ritual art expressed the spiritual yearnings of the group mind. Noting the recent development of a Mexican national style and the lack of comparable "Old World" equivalents to the achievements of American Indian art, Vaillant stressed the latter's anonymous, collective, and spiritual quality. Because a modern technical age required such harmonious cooperation for peace and survival, he found the underlying principles of Native American art perfectly attuned to contemporary needs. Vaillant assumed that such a ceremonial art of pure design and infinite variety was a "conceivable point of departure for a national art."[44]

As curator of the American Museum of Natural History's 1939 exhibit "Ubiquitous Primitive Art," Vaillant had selected ceremonial masks and examples of totemic art from the Pacific Northwest Coast and Alaska to accompany examples of pre-Columbian, African, and Oceanic art.[45] And following this, Spinden presented a collection of Indian paintings and sculptures from Arizona and New Mexico at the Brooklyn Museum in 1940.[46] Thus, the decade preceding 1941 was rich with exhibitions, books, catalogues, and a body of art criticism focused on Native American art that set the stage for the Museum of Modern Art's dramatic and conceptually innovative presentation of Indian art.

René d'Harnoncourt and "Indian Art of the United States"

On 22 January 1941, New York's Museum of Modern Art unveiled "Indian Art of the United States," one of the most provocative and acclaimed exhibitions in the young life of that powerful institution. Organized for the museum by the IACB under the direction of its general manager René d'Harnoncourt, the exhibition was a watershed event in the history of Euro-American interaction with Native American art in the twentieth century. The exhibition was the fruition of two years of intensely focused work by d'Harnoncourt, his collaborator Frederic H. Douglas, curator of Indian Art at

the Denver Museum, and architect Henry Klumb, who worked for the IACB. But in fact, d'Harnoncourt had been refining both the theory and the practice of preserving, promoting, and displaying primitive art and contemporary Native arts and crafts since the late 1920s. The museum, in turn, made a complete commitment of its physical resources, allowing Klumb to convert all three floors into the installation spaces designed by d'Harnoncourt for his selection of objects. More than a thousand high-quality ancient, historic, and contemporary works of art from the continental United States, Alaska, and parts of Canada were exhibited to illustrate d'Harnoncourt's premise that Indian art, which belonged "solely to this country," was "meeting the impact of the twentieth century with the resourcefulness and vitality that have always been among its outstanding characteristics."[47]

Reviewing even a brief sampling of the art chosen by d'Harnoncourt provides a tantalizing glimpse of the audience's aesthetic experience. On display, for example, was a legendary male effigy pipe (Adena Culture, c. A.D. 100), which was excavated at Chillicothe, Ohio in 1901 and lent for exhibition by the Ohio Historical Center (Plate 6). The American Museum of Natural History lent a well-known and outstanding example of Nootka painting on wood, which had been made on Vancouver Island about 1850 and was collected by George T. Emmons in 1929 (Fig. 4-2). Obviously, there was a great temporal breadth in d'Harnoncourt's choice of materials. From the University of Pennsylvania Museum in Philadelphia he borrowed a rare wooden deer maskette (c. A.D. 800–1400), which had been excavated from the shell mounds at Key Marco in southeastern Florida by Frank Hamilton Cushing in 1895 (Fig. 4-3). In sharp contrast to objects such as this—prehistoric and probably ritualistic in nature—viewers saw relatively new works of art, such as a gouache painting depicting the *Green Corn Ceremony* by Awa Tsireh of San Ildefonso Pueblo (Fig. 4-4). Done around 1922, this painting was from MOMA's own collection, courtesy of Abby Aldrich Rockefeller, who was one of the museum's founders. Indeed, the scope of the exhibition was so vast and d'Harnoncourt's installation designs so innova-

tive that the reviewer for *Newsweek* magazine wrote that MOMA, with the most elaborate and ambitious exhibition in its history, surpassed itself again by placing Indian art "among the American fine arts."[48]

As profoundly important as "Indian Art of the United States" proved to be, it was hardly the first time, nor would it be the last, that art of the "Other" was exhibited at the Museum of Modern Art. Its 1933 exhibition, "American Sources of Modern Art," had attempted to show an affinity between modern, Aztec, Maya, and Inca art. Following this, MOMA exhibited "African Negro Art" in 1935, "Prehistoric Rock Pictures in Europe and Africa" in 1937, and as noted above, "Twenty Centuries of Mexican Art" in 1940, which was organized by Nelson Rockefeller with assistance from Roberto Montenegro. In recalling "Indian Art of the United States," Alfred H. Barr, Jr., MOMA's founding director and a master of installation design, noted that despite the high quality of the exhibitions of primitive art held at the museum in the 1930s, they seemed "primitive themselves by comparison with René's magnificent later achievement."[49] D'Harnoncourt himself organized the 1946 exhibition "Art of the South Seas," which, according to Monroe Wheeler, revealed "the aesthetic value of the cultural materials of Polynesia, Micronesia, and Australia, which had been considered in the past only as anthropological data."[50] In 1954 d'Harnoncourt collaborated with Wendell C. Bennett on an important presentation at MOMA of "Ancient Art of the Andes." More recently, tribal art from Africa, Oceania, and the Americas was included in William Rubin's controversial 1985 exhibition "'Primitivism' in 20th Century Art."[51] However, none of these exhibitions radically altered the public's perception of a non-Western art tradition as did "Indian Art of the United States."[52]

To understand why this exhibition was so immensely popular with the art-going public, the critical press, and d'Harnoncourt's peers in the museum world, it is instructive to contrast it with the "Exposition of Indian Tribal Arts," which had been a critical success but which had

Figure 4-2
Nootka, painted wooden
house board from Vancouver
Island (n.d.). 298.5 cm long,
173.1 cm wide. Courtesy
American Museum of
Natural History, neg.
#31386.

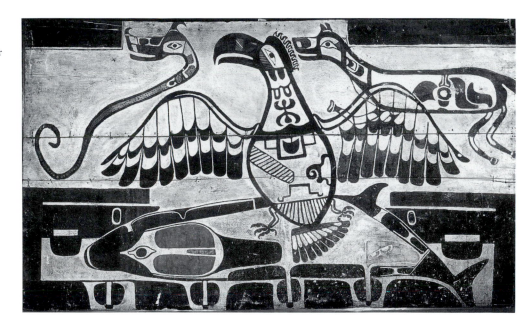

lacked the authoritative force and persuasive power that MOMA's institutional credibility was able to provide in 1941. In a review of "Indian Art of the United States" in the *New Republic*, La Farge himself credited the "cachet of the museum" with preparing the public's mind.[53] D'Harnoncourt, too, emphasized this fact when he commented in 1939 on MOMA's offer to sponsor the exhibition: "The importance of this offer lies . . . in the ability of the Museum of Modern Art to draw popular attention to the various subjects with which they are dealing."[54] Furthermore, according to La Farge, while the exposition in 1931 had received rather tepid government support, federal resources made possible "the gathering of a magnificent selection" of Indian art at MOMA.[55] Indeed, d'Harnoncourt's efforts relating to "Indian Art of the United States" were supported vigorously by Collier, Roosevelt's commissioner of Indian Affairs. Collier had received a New Deal mandate from Roosevelt's Department of the Interior to "promote the economic welfare of the Indian tribes . . . through the development of Indian arts and crafts and the expansion of the market for the products of Indian art and craftsmanship."[56] And finally, d'Harnoncourt was able to augment federal patronage of the exhibition

with financial support and political influence issuing from his close personal relationships with such men as Rockefeller and Dr. Frederick P. Keppel, president of the Carnegie Corporation.[57]

It was, however, d'Harnoncourt's infectious enthusiasm, skill at organization, and most of all, his brilliant exhibition designs that always managed to be both educational and entertaining, that made "Indian Art of the United States" an unparalleled success. In evaluating the exhibition, I cannot overstress the importance of d'Harnoncourt's meticulous attention to detail, his consideration of each object in relation to the whole, and his genuine concern for the visitor's experience.[58] By all accounts, the results of his vision and energy were spectacular. This conclusion is supported by the critical reviews of the exhibition, most of which were effusively enthusiastic.[59] Almost all commented on the effectiveness of the unique installations. For example, writing in *Art News*, Jeanette Lowe described the exhibition as a brilliant dramatization of Indian artistic and spiritual values.[60] *Design Magazine* noted that "brilliantly colored backgrounds and ingenious methods of display are being used to present the thousand or more items of the exhibition."[61] Barr, who in

1941 was both director of the museum and director of the Department of Painting and Sculpture, later recalled of d'Harnoncourt's exhibits: "He avoided both the purely aesthetic isolation and the waxworks of the habitat group. . . . The varied galleries seemed informal at first glance, but were calculated in size, perspective, sequence, color, light level, sometimes dramatic but never theatrical, and functional rather than decorative. The presentation of the works of art achieved both aesthetic and intellectual delight."[62] Even *Women's Wear Daily*, in a preview of the exhibition, commented on "d'Harnoncourt's sympathetic magic."[63]

In planning the spaces and settings in which to work his "sympathetic magic," d'Harnoncourt made a conscious decision to classify the objects and the installations for them in two

Figure 4-3
Wooden deer masketle (Key Marco, Florida, A.D. 800–1400). Wood/pigment, 8.5 cm high, 8 cm wide, 16 cm deep. University Museum, University of Pennsylvania, neg. #S8-13256.

Figure 4-4
AWA TSIREH (Alfonso Roybal, San Ildefonso Pueblo), *Green Corn Ceremony* (1922).

Gouache/paper, 27 3/4" x 19 1/2". Collection of Museum of Modern Art, New York. Abby Aldrich Rockefeller Fund. Photograph courtesy Museum of Modern Art, New York.

distinctly different categories. In the first category he included "the great Indian traditions of the past, including moundbuilder material, Bering Strait culture, and other Indian civilizations now dead." These objects were "to be shown only as art for art's sake."[64] The second category consisted of historic materials, which d'Harnoncourt considered the art of living Indian culture. In contrast to the prehistoric material, every effort would be made to provide the historic objects with an authentic aboriginal ambience. As he explained to George Heye, founder of the Museum of the American Indian, "Since we are interested in showing Indian culture through Indian art, and not Indian art as an end in itself, we can never forget the place of each specimen in its native civilization and must consider many points that would be insignificant in an art-for-art's-sake display."[65] The contemporary art was to be contextualized also, but because the goal in this case was to show the potential contribution of Native arts and crafts to modern decorative arts, d'Harnoncourt found himself facing "an entirely new installation problem." Since it was necessary to "emphasize the contemporary quality in both the Indian work and the display apparatus," the installations themselves "should be very contemporary and Fifth Avenue in the best sense of the word."[66] This would make it possible to stress (the new) functional value and aesthetic qualities, as opposed to the original cultural connotations, of contemporary Native crafts.

All these aspects of d'Harnoncourt's exhibition strategy—decontextualization of ancient art, contextualization of historic art, and recontextualization/aestheticization of contemporary art—are discussed at length below. However, I must point out that d'Harnoncourt's presentation of ancient art *as art* and not ethnographic material was, generally speaking, a continuation of the precedent established by the "Exposition of Indian Tribal Arts" and by Spinden at the Brooklyn Museum in the early 1930s.[67] More specifically, his unified plan for the entire exhibition was the mature formulation of (*a*) strategies for merchandising contemporary Native arts and crafts that he had developed over a period of years, first in Mexico and then later at the IACB; and (*b*) the successful exhibition techniques employed by the IACB under his direction in its presentation of Indian arts and crafts at the "San Francisco Golden Gate International Exposition" in 1939.[68]

In September 1939, d'Harnoncourt reported to the directors of the IACB that of the invitations given by eastern institutions to follow up the San Francisco exposition, the most important had come from the Museum of Modern Art. In addition, museums in various other cities, including Worcester, Buffalo, and Chicago, had offered to finance a traveling exhibition of Indian art organized by the IACB. He felt it was logical to combine these opportunities and present an exhibition at MOMA that would then circulate throughout the United States. Along with MOMA's ability to provide an *art* audience, the value of this set-up was the fact that it would allow the IACB to focus for a period of up to three years on the problems of production and merchandising, since MOMA would have assumed the responsibility of showcasing Native arts and crafts as "valuable and desirable contemporary products."[69]

The Exhibition

When the exposition in San Francisco closed on 29 October 1939, approximately 1.5 million people had seen the IACB's Indian exhibits and d'Harnoncourt had been at work for over a month organizing "Indian Art of the United States." Object files and photographs were being generated, fieldwork on the reservations was underway, and Douglas was assisting d'Harnoncourt in his planning efforts.[70] D'Harnoncourt had already informed Douglas that the scope of the exhibition was going to be beyond what he had imagined was possible: "The Museum is willing to turn over to us not only one floor, as I had hoped, but the entire building and its large court, for three or possibly four months next fall."[71]

The potential for a monumental exhibition,

which MOMA's building and garden presented d'Harnoncourt, when coupled with the current political climate, encouraged him to think of the exhibition as an opportunity to highlight the essential Americanness of Indian art. He was encouraged in this sentiment by Francis Henry Taylor, director of the Worcester Art Museum, who wrote to him, concerning plans for "Indian Art of the United States," "It might be a great relief and extremely popular to promote the Indian at this time when everyone is pretty well appalled and fed with up Europe."[72] D'Harnoncourt himself had claimed Indian art solely for the United States,[73] and this reference to the nation as "owner" of Indian art helps explain why the title of the exhibition shifted from "Indian Art in North America," as d'Harnon-court originally called it, to "Indian Art of the United States."[74] In that time of intense prewar searching for national values, d'Harnoncourt was a sensitive instrument for Roosevelt's New Deal policies, which had stressed freedom for the arts. More than once, d'Harnoncourt used a not-so-latent nationalism as justification for celebrating the aesthetic achievements of Native America.[75] For example, in material he prepared for MOMA's Publicity Department he announced that his goal was to "create a new appreciation and a deeper understanding of a much-neglected art form that is nationwide in its scope and truly American in style and concept." He was certain that the exhibition, with its tremendous variety of materials, techniques, and designs, would "demonstrate that American Indian art is as diversified as American landscape."[76] In his foreword to the catalogue, to which Eleanor Roosevelt signed her name,[77] he explained, "At this time, when America is reviewing its cultural resources, this book and the exhibit on which it is based open up to us age-old sources of ideas and forms that have never been fully appreciated." He went on to say in the foreword that Indian art "constitutes part of the artistic and spiritual wealth of this country."[78] This message was not lost on the critics, especially George Vaillant, who wrote that visitors to the show became highly conscious of their American heritage.[79]

The audience encountered the first of the many "aesthetic and intellectual delights" recalled by Barr at the front door of the museum, where d'Harnoncourt had placed, flush against the facade, a thirty-foot totem pole carved in 1939 by Haida artist John Wallace. This striking juxtaposition of the so-called primitive with the modern prompted one critic to observe, "Other totem poles rise like a surrealist forest inside the museum."[80] Jeanette Lowe also observed of this pole, "The carved raven, killer-whale and devil fish may strike that eye, more accustomed to such fauna in the world of Surrealism, as symbols of the unconscious mind."[81] Thus, the exhibition's linkage of Native American art, Surrealism, and other modern movements, which was also a common feature of many critical reviews of the show, actually began in the rarefied air of West Fifty-third Street.

The exhibition began on the third floor in a series of galleries devoted to the ancient civilizations of North America wherein d'Harnoncourt displayed painting, sculpture, and ceramics selected "for their aesthetic value only."[82] The displays for these objects were minimal, lending to the artwork "the type of dignity usually associated with the work of the 'Classics.'" D'Harnoncourt made it a point to install these objects "as one would install any gallery of small sculpture using simple pedestals and cases standing before plain walls."[83] For example, the displays for the selection of Mimbres pottery (Fig. 4-5) were marked by neutrality, austerity, and a lack of textual information that encouraged a purely aesthetic encounter with the ceremonial bowls. Today, of course, museum-goers are acclimated to such reductive displays of Indian art, but not so the audience in 1941. Lowe, therefore, explained that because there was an inherent difficulty in evaluating new art forms outside their cultural context, the museum (i.e., d'Harnoncourt), "by its own arrangement . . . helped the spectator to grasp some of the essentials of the abstract pattern which are intrinsically Indian."[84] She had observed, no doubt, that enlarged Mimbres de-

109

Figure 4-5
Installation of Mimbres pottery at the exhibition "Indian Art of the United States" (1941). Photograph courtesy Museum of Modern Art, New York.

Figure 4-6
Fred Kabotie, Charles Loloma, Herbert Komoyousie, and Victor Cootswytewa (Hopi Pueblo), replica of Kiva mural excavated at Awatovi, Arizona; at the exhibition "Indian Art of the United States" (1941). 120" long, 50" high. Denver Art Museum, #1953.435abc.

signs, liberated from their original surfaces, were reproduced on the wall behind the bowls. The only cultural signifier—the word Mimbres—painterly and cursive, was isolated within a free-floating biomorphic shape, reminiscent of Miró, which referred, once again, to the affinity of the primitive and the modern.

The only exceptions on the third floor to d'Harnoncourt's decontextualization of ancient Indian art were the introductory gallery, which had maps and other didactic materials, and a gallery that consisted of a series of kivalike spaces, lit only by a hole in the top of the chamber. As visitors moved through these darkened chambers, they saw reproduced on adobe panels a set of prehistoric Pueblo murals that had been excavated at Awatovi in northeastern Arizona by J.O. Brew of Harvard's Peabody Museum in 1938 (Fig. 4-6). In this instance d'Harnoncourt's design provided a compelling ambience that amplified the encounter with the murals. Lowe reported in *Art News*, for example, that "the showing of murals in small, low rooms, dimly lighted, gives an idea of the caves in which they originally were."[85] The murals had been re-created at the Haskell Institute in Lawrence, Kansas, by three high-school-age

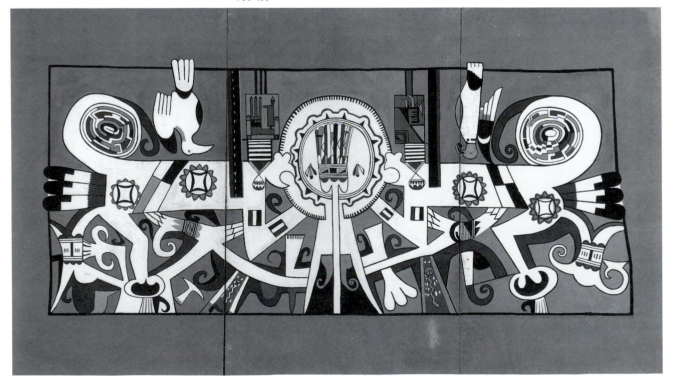

(and now distinguished) Hopi artists—
Charles Loloma, Herbert Komoyousie, and
Victor Cootswytewa —under the supervision
of Fred Kabotie, the highly acclaimed Hopi
painter who was at that time an Indian Service
employee.[86] One of the more memorable
moments of the exhibition came when Kabotie
posed with Eleanor Roosevelt in front of a
mural (Fig. 4-7).

Upon leaving these midtown kivas, the visi-
tor entered an expansive space lit by natural
light, in which d'Harnoncourt installed one of
the exhibition's most dramatic objects: a full-
scale (twelve and a half by sixty feet) canvas mu-
ral reproduction of Basketmaker pictographs
from Barrier Canyon in Utah (Fig. 4-8). A pho-
tograph of the original site was included in the
catalogue. In contrast to the intimacy of the
kivas, the giant mural, according to Vaillant,
cast the viewer "into the infinite expanse of
time and space."[87] Discussed favorably in al-
most every review of the exhibition, the picto-
graph replica was unique in being the only
object on display not made by Native American
artists. Instead, it had been commissioned by
the IACB—that is to say, by d'Harnoncourt—
and made by artists working for the Federal Art
Project of the Works Progress Administration
(WPA). Funding for the special photographic
expedition to Barrier Canyon, which was per-
haps the single most expensive aspect of the ex-
hibition, had been terribly complicated. The
logistics, both bureaucratic and topographical,
had proved even more problematic. And yet,
d'Harnoncourt had maintained a steadfast com-
mitment to the importance of this display,
insisting that the wealth of design in Indian
pictographs warranted serious attention. As
he wrote, "Pictographs constitute a phase of
Indian art that has so far been very much
neglected both by the scientists and by the art
world, in spite of the fact that a survey of the
field shows that they compare favorably in qual-
ity and scope with those widely publicized rock
paintings from Africa or Australia." After much
research d'Harnoncourt selected the picto-
graphs at Barrier Canyon because they were

"important aesthetically." Exhibiting this art
form, he believed, was "a matter of nation-wide
interest."[88]

On the second floor d'Harnoncourt exhib-
ited the art of historic Native American peoples
under the heading "Living Traditions." Using a
format similar to one used in the San Francisco
exposition, he sought in these displays to create
the "atmosphere" of the cultural background
of the objects and to direct the audience
"from vista to vista" through a variety of im-
pressions.[89] For example, as photographs of
the Northwest Coast exhibits demonstrate,
d'Harnoncourt used intensely dramatic lighting
to emphasize the plastic qualities of the sculp-
ture and to suggest the dark forest interiors
from whence they originally came (Figs. 4-9,
4-10). Some of the masks, however, were given
their own singular space and lit from below,
thus indicating their status as individual *master-
pieces*. Vaillant must have had these in mind
when he wrote in the *Art Bulletin*, "This impos-
ing aesthetic expression was cunningly shown,
the spotlighted sculpture being the only illumi-
nation in an otherwise dark room. The super-
natural forces, with whom the Indian has always
been in such intimate contact, seemed dramati-

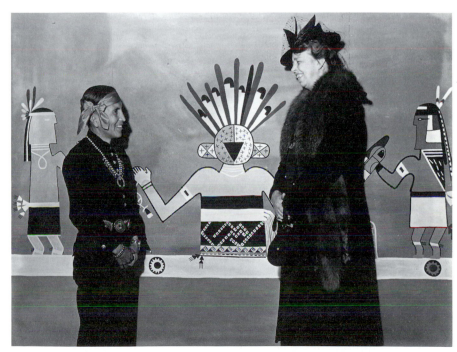

Figure 4-7
Fred Kabotie and Eleanor
Roosevelt at the exhibition
"Indian Art of the United
States" (1941). Photograph
courtesy Museum of Modern
Art, New York.

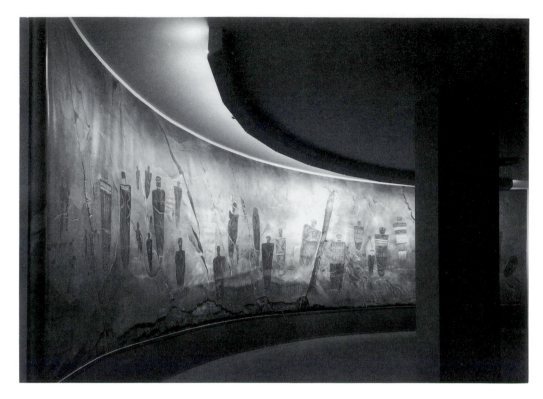

Figure 4-8
WPA mural replica of
Basketmaker-Period picto-
graphs from Barrier Canyon,
Utah, installed at the exhibition
"Indian Art of the United
States" (1941).
Photograph courtesy Museum
of Modern Art, New York.

Figure 4-9
Installation of Northwest Coast
Indian sculpture at the
exhibition "Indian Art of the
United States"(1941).
Photograph courtesy Museum
of Modern Art, New York.

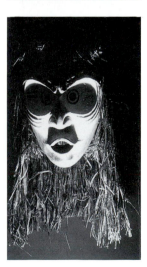

cally concentrated here, overawing even the case-hardened New Yorker."[90] That Vaillant responded to the mysterious and dramatic lighting of this particular installation is an indication of d'Harnoncourt's success in establishing the ritualistic (read instinctual, premodern) context for the masks on display. Evidence of d'Harnoncourt's desire to focus on the "intimate contact" between Indians and "supernatural forces" may be found in his description in the catalogue of the Northwest Coast tradition: "Beside the dark sea and forest there developed an art in which men, animals, and gods were inextricably mingled in strange, intricate carvings and paintings. Religion and mythology found their outlet in vast ceremonies in which fantastically masked figures enacted tense wild dramas."[91]

Even though it was d'Harnoncourt's intention to contextualize the historic art, some of the displays on the second floor reflected the clean, streamlined look of contemporary design. For example, visible in the photo are kachinas and pots (Fig. 4-11). One is struck by the generous spacing of the objects, the lack of textual clutter, and the *moderne* look of the backdrop, with its pristine white geometric shapes. What a contrast it must have been for those who had seen the cramped cases uptown at George Heye's Museum of the American Indian.

The first floor, devoted to "Indian Art for Modern Living," was divided into three galleries: contemporary painting and sculpture, "Indian art as an object for study," and "Indian contributions to modern decorative arts."[92] D'Harnoncourt felt that the gallery of painting and sculpture was a matter of aesthetic experience and needed no other justification. He was convinced that in and of itself the gallery of painting and sculpture would be the final element required to generate a sincere new interest in Indian art in both museums and schools. Furthermore, he believed that "some of the down-town galleries will swing into line and accompany our exhibit with sales exhibits that should create a new steady market for Indian paintings in the east."[93] Among the artists represented in this section were Fred Kabotie, Oscar Howe (Dakota), Harrison Begay (Navajo), and Monroe Tsatoke (Kiowa).

The study gallery, however, focused on contemporary Indian art's "abstract contribution" to modern life and was a combination of objects, pictorial charts, and texts.[94] This "abstract contribution" had two components that d'Harnoncourt wanted to point out. The first was that Indian and other so-called primitive art

112

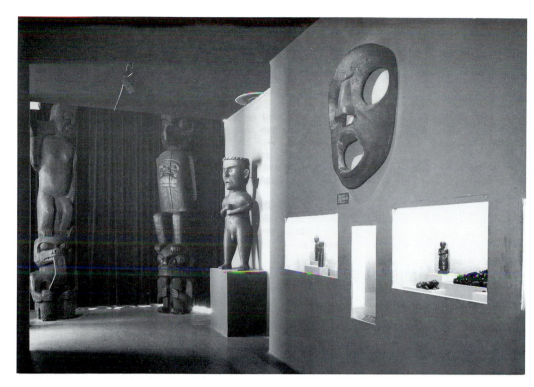

Figure 4-10
Installation of Northwest
Coast Indian art at the
exhibition "Indian Art of the
United States" (1941).
Photograph courtesy
Museum of Modern Art,
New York.

Figure 4-11
Installation of historic Pueblo
art at the exhibition "Indian
Art of the United States"
(1941). Photograph courtesy
Museum of Modern Art, New
York.

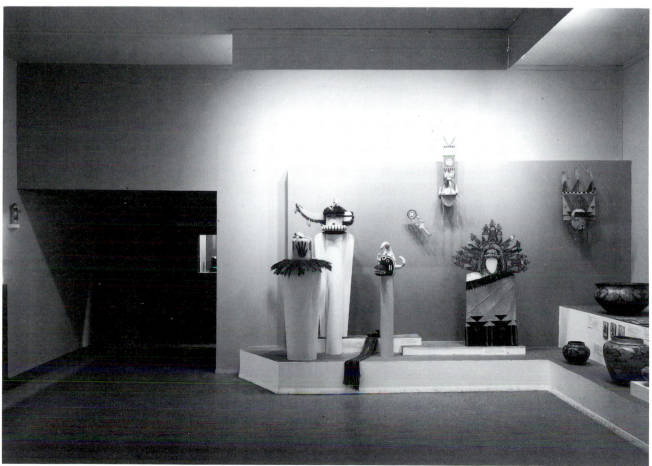

provided the best opportunity for studying the role of art in the economic, social, and religious life of a community. The second was the unity of technique, raw material, and form in a work of art. D'Harnoncourt felt this was an issue of public concern, and yet it was one "very difficult to grasp in the machine age, when the majority of the people are unfamiliar with the original raw material used and with the complicated production methods employed."[95]

The section that focused on Indian contributions to modern decorative arts was, according to d'Harnoncourt, the single most important and vital part of the entire exhibition.[96] To him, the enrichment of contemporary culture was Indian art's "concrete contribution."[97] He was convinced that the public would realize the value of contemporary Indian art when shown that it harmonized with the artistic concepts of modernism.[98] Thus, the objects and displays were coordinated to demonstrate that "the modern Indian . . . can produce artistic things whose beauty and utility are keyed to modern life," and d'Harnoncourt designed model interiors which showed that Navajo rugs and blankets, Pueblo pottery, Eskimo carvings, recent Indian painting, and even Cherokee wastepaper baskets "fit perfectly into the contemporary scene." Some of these objects, he explained, "find a place in our houses and wardrobes simply because of their decorative value, but many combine utility with aesthetic merit."[99]

Along with displays promoting the use of Indian art as home furnishings, d'Harnoncourt's exhibits also suggested its use as personal adornment and as fashion accessory. The former was easily accomplished with an outstanding selection of Navajo silver jewelry, but d'Harnoncourt's solution to the latter was far more innovative. He supplied Swiss fashion designer Fred Picard with articles of Indian manufacture to be used in Picard's line of women's wear, which was featured at the exhibition.[100] Picard responded by using an Osage beaded and braided belt made in Oklahoma as trimming on a short evening cape. Also exhibited was an after-skiing suit designed by Picard that incorpo-

rated Seminole cotton patchwork and Navajo buttons of hammered silver.[101]

D'Harnoncourt did not believe it necessary to insist on the functional value of all the art exhibited. In one portion of the first floor he displayed works of "such high aesthetic quality that they could be used as objets d'art, even though they were not intended for this purpose by their makers."[102] Thus, "Indian Art for Modern Living" was both contextualized, stressing function and adaptability, and aestheticized, making contemplative objects of material that originally had utilitarian or, perhaps, ceremonial function. And despite all these creative efforts to generate a market demand for contemporary Indian art, "Indian Art of the United States" (unlike the exposition in San Francisco) did not offer retail sales of contemporary Indian arts and crafts. D'Harnoncourt felt that more long-term benefits would be derived by introducing Native arts and crafts into New York stores—which would continue to carry the merchandise after the exhibition closed—than by a temporary sales room at MOMA. By July 1940, well in advance of the opening of the exhibit, he had secured promises from private individuals allowing IACB-sponsored Indian organizations to use office space on Fifth Avenue for a wholesale center. He intended to use the interest sparked by "Indian Art of the United States" to develop "permanent business contracts with established New York firms."[103]

The Catalogue: The Critical Reception

The critics, including those who wrote for the popular press as well as for art magazines, agreed without exception that "Indian Art of the United States" was an unqualified success. According to *Newsweek*, the "fashionable opening-night throng which . . . wedged itself four-deep around the dramatically lit showcases testified to the brilliance of the exhibit." Frank Caspers, writing in *Art Digest*, called the exhibition "the most significant recognition to date of the aesthetic gift of American Indian artists." La Farge noted in the *New York Times* that it

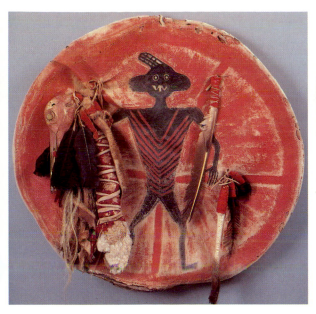

Plate 1.
Arapoosh, Absaroke (Crow), buffalo hide shield,
Montana
(c. 1800–1834).

Mixed media, 22" in diameter.
National Museum of the American Indian,
Smithsonian Institution (11/7680).

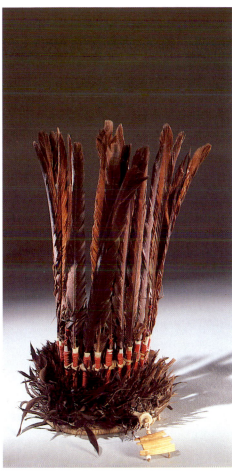

Plate 2.
BILLY PREACHER
(Maidu), feather headdress
(collected 1908).

Magpie feathers, red-shafted flicker
quills, goose quills, clamshell beads,
glass beads, cotton cord, plant-fiber
twine, and willow rod, 12" high, 7"
wide, 8 1/2" in diameter.
Brooklyn Museum, 08.491.8693,
Museum Expedition 1908,
Museum Collection Fund.

Plate 3.
Tlingit, shaman's dancing headdress
(collected by George Thornton
Emmons, 1882–1887).

Mixed media, 22 cm long, 15 cm high.
Tr. #3817 (2).
*Courtesy American Museum
of Natural History.*

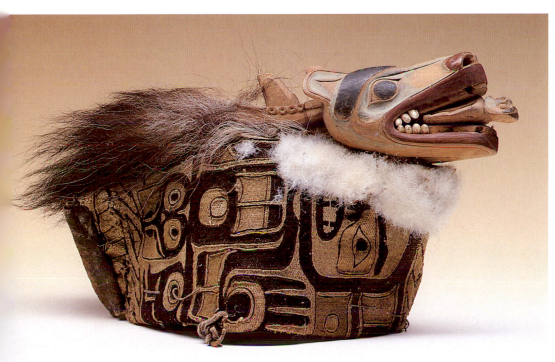

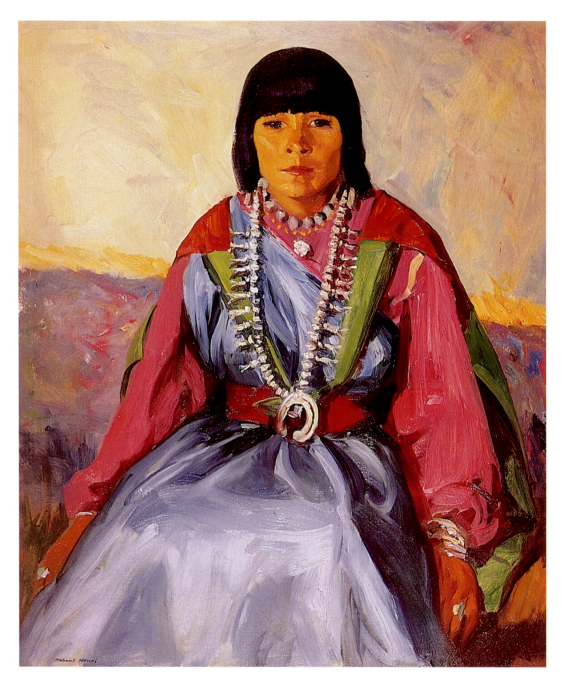

Plate 4.
ROBERT HENRI
Romancita
(1914).

Oil/canvas, 41" x 33".
The Harmsen Collection.

Plate 5.
EMIL BISTTRAM
Abstracted Mudhead Figures
(1933).

Watercolor, 21 3/4" x 16 1/2".
Private collection.
Courtesy Owings-Dewey Fine Art,
Santa Fe.

Plate 6.
Adena Culture, male effigy pipe
(C. A.D. 100).

Pipestone, 20 cm high.
Ohio Historical Society.

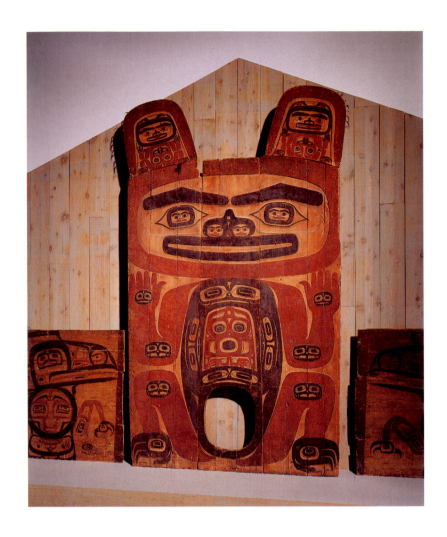

Plate 7.
House screen of Chief Shakes
(Tlingit house partition),
Wrangell Village, Alaska (c. 1840).

Cedar, native paint, human hair,
179 15/16" high, 107 7/8" wide.
Denver Art Museum, #1953.315.

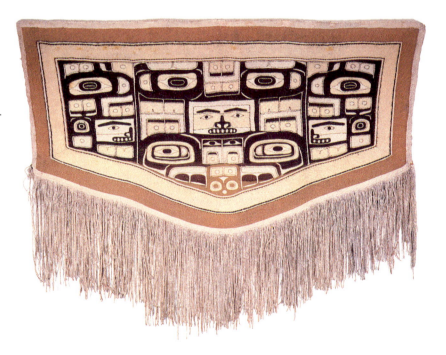

Plate 8.
Tlingit, Chilkat blanket
(Alaska, nineteenth century).

Dyed wool and cedar-bark fibers,
69" high.
Brooklyn Museum, #1989.51.63,
Adolph and Esther Gottlieb Collection.

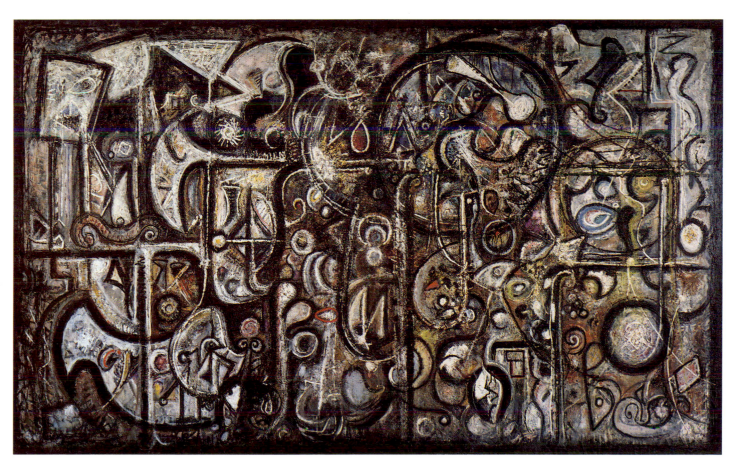

Plate 9.
RICHARD POUSETTE-DART
Symphony Number 1, The Transcendental
(c. 1941–1942).

Oil/linen, 90" x 120".
Estate of the artist.
Photograph courtesy Indianapolis Museum of Art.

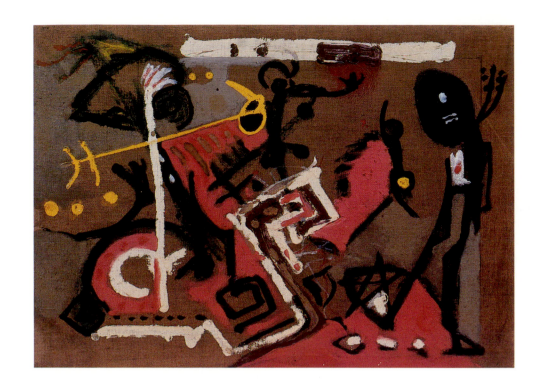

Plate 10.
JACKSON POLLOCK
Composition on Brown
(c. 1945).

Oil/brown canvas,
15 1/8" x 21 1/8".
Courtesy Jason McCoy, Inc. © 1993
Pollock-Krasner Foundation/ARS,
New York.

Plate 11.
JACKSON POLLOCK
The Child Proceeds
(1946).

Oil/canvas, 43" x 22".
Courtesy Jason McCoy, Inc. © 1993
Pollock-Krasner Foundation/ARS,
New York.

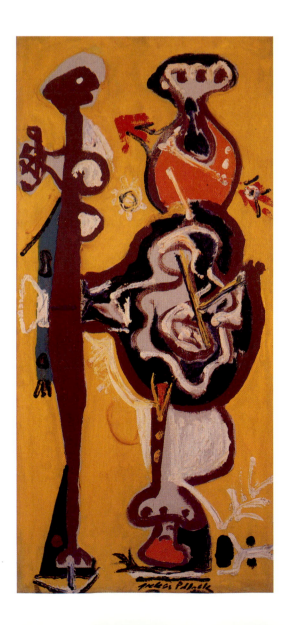

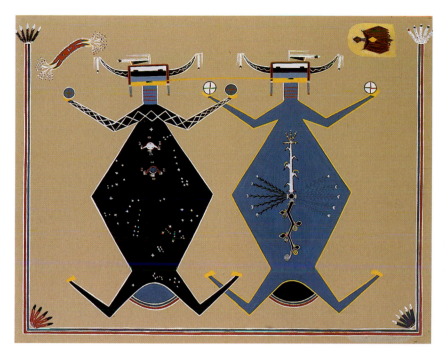

Plate 12.
Navajo, replica of a sand painting depicting "The Blue Mother Earth and the Black Father Sky" from the Male Shootingway ceremony (1920s).

Gouache/illustration board, 28 3/4" x 22 5/8".
Photograph by Herb Lotz.
Courtesy of the Wheelwright Museum of the American Indian, no. P4-#4a.

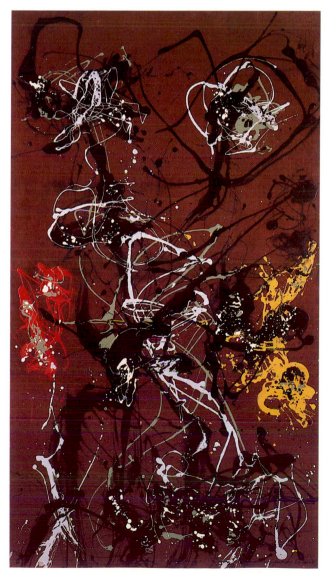

Plate 13.
JACKSON POLLOCK
Number 10
(1950).

Oil/canvas mounted on masonite, 66" x 36 1/2".
Vassar College Art Gallery, Poughkeepsie, New York.
From the collection of the late Katherine Sanford Deutsch '40.
© 1993 Pollock-Krasner Foundation/ ARS, New York.

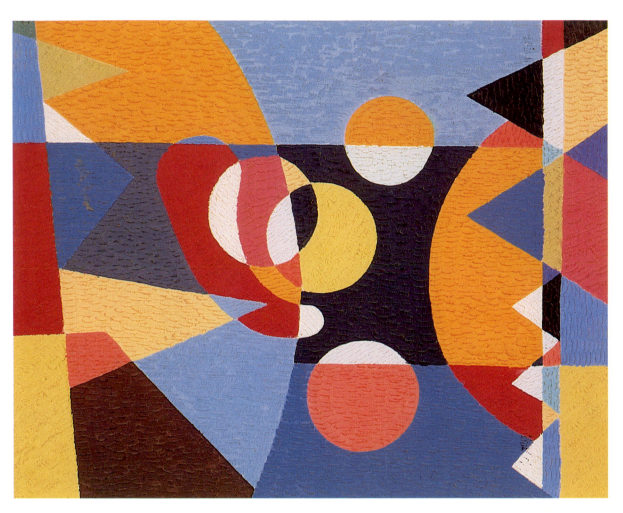

Plate 14.
JOE HERRERA
(Cochiti Pueblo)
Untitled
(1951).

Oil/canvas, 16" x 20".
Collection of Jonson Gallery,
University of New Mexico
Art Museum, Albuquerque.

was "a new chance for the real Indian—and a chance at last for the East to discover the realities of Indian civilization." In *Parnassus*, a publication of the College Art Association, the show was described as the "largest and most representative exhibition of its kind ever assembled." Similarly, *Art News* also understood it to be the "definitive exhibition of Indian arts and crafts."[104]

In reviewing the book-length catalogue of the exhibition, which was written primarily by d'Harnoncourt,[105] Florence Berryman noted in the *Magazine of Art* that it was a superb exhibition, the most comprehensive revelation ever of Indian art. She rightly observed that more than merely accompanying the exhibit, the book helped to prove the exhibition's thesis that Indian art was both vital and adaptable to modern life.[106] Caspers, too, felt that the book, *Indian Art of the United States*, was the "most complete on its subject ever written." For him, it was a "compact, vital and absorbing record of America's indigenous civilization."[107] Thus, the book was itself an effective instrument for changing the public's perception of Native American art. So, too, was the abundant critical discourse that flowed like a textual river around *Indian Art of the United States*—exhibition and book—reinforcing and extending d'Harnoncourt's ideas. Therefore, the book and the critical response to the show must be examined together.

Since America was struggling in 1941 to emerge from a crippling economic depression and at the same time was being drawn inexorably into a European war, it is hardly surprising that d'Harnoncourt and the critics saw Native America's vital strength, resilience to adversity, and ability to adapt to change as a resource for the nation's future. Indeed, there were undeniable ideological and political rewards to be reaped from making Indian art generically American. To that end, d'Harnoncourt sought to link, in the public's mind, the power and *élan vital* of ancient America and the nation-state known as the United States of America. Thus, he wrote, "This publication, as well as the exhibition on which it is based, aims to show

that the Indian artist of today, drawing on the strength of his tribal tradition and utilizing the resources of the present, offers a contribution that should become an important factor in building the America of the future."[108] Neither d'Harnoncourt's genuine appreciation of Indian art nor his commitment to the Indian's cultural rehabilitation and right to self-determination are denigrated by recognition of the fact that the qualities of Indian art that he stressed in the book could be described as quintessentially *American*: basic soundness, vigor, strength of tradition, unexplored wealth, and close relationship to the land. Indian art was used, therefore, to remind the American public that what had made and would continue to make the nation strong was a constant ability to renew itself in the face of challenge by exploiting untapped resources with new technologies. D'Harnoncourt cited, for example, Navajo silversmithing and Plains horsemanship as evidence of the Indian's willingness to seize the opportunity to transform traditional culture. He found it only "natural that a new appreciation of these values by the authorities and by part of the American public is now bringing to light in many places traditional customs and traditional thinking."[109]

While reflecting on the success of "Indian Art of the United States" relative to the "Exposition of Indian Tribal Arts" of 1931, La Farge extended d'Harnoncourt's idea of associating the values of Indian art with the United States. La Farge believed that the public's response to the earlier show was diluted by the fact that unlike African art, Indian art in 1931 had not yet been endorsed by Paris.[110] Likewise, he wrote that if the Awatovi murals had been discovered in the Old World, they would already be well-known in America because the French would have valued them; thus, "it would have been aesthetically respectable, even necessary, to appreciate them." It was important for La Farge to devalue Europe as a standard of cultural achievement, for he insisted that there were aspects of Indian civilization, "some material, some intangible, . . . that can stand comparison with skyscrapers or the present apex of white civilization in Europe." Furthermore, he recognized that Indian art was "the only art original

115

to this land" and that its abstract forms equaled those of European art.[111] In contrast to the exposition of 1931, the "double pleasure" of d'Harnoncourt's exhibition for La Farge was in seeing that Indian art was "still vigorous, still evolving" and that the public was finally waking up to the gifts of Indian art and culture. He noted that the great strength of Indian art was its ability to change and that this was its relevance for contemporary America.[112]

The *American* aspect of the exhibition was also noted by Jean Charlot, who wrote in *The Nation* that the patriotic atmosphere then current in the United States would encourage recognition of Indian artists. In fact, he called them the "hundred-per-centers of American art, beside whom even Thomas Craven's roster of Americans acquires an immigrant flavor."[113] Similarly, Vaillant, in his review of the exhibition, wrote chauvinistically about "the art of our own Indians." And yet, he also described experiencing the exhibition as being in the presence of a "truly continental American art, one which we may hope some day to rival." As American art moves into the future, Vaillant wrote, it must seek its roots in the native environment of which Indian culture is such an important part.[114]

In the book, just as in the exhibition, d'Harnoncourt tried to synthesize contextualization, recontextualization, and aestheticization of the objects. In the first case, he explained that art-for-art's-sake was an unknown concept in Indian cultures and that "the close relationship between aesthetic and technical perfection gives the work of most Indian artists a basic unity rarely found in the products of an urban civilization."[115] Likewise, he found the term *primitive*—in both its literal and popular usage—unacceptable as a description of Indian art. Instead, manifesting an understanding of folk art consistent with the anthropological literature of the 1940s, he stated, "Traditional Indian art can best be considered as folk art because it is always an inextricable part of all social, economic and ceremonial activities of a given society."[116]

This emphasis by d'Harnoncourt on the complete integration of art and culture in Indian society underscores the fact that in the catalogue

and in many critical reviews of the exhibition one often encounters a mass culture version of C. G. Jung's idea of a consciousness, both collective and archaic, still manifest in primitive art and folk traditions. This is hardly surprising, since Jungian interpretations of primitive and primitivist art were commonplace in the early 1940s. For example, d'Harnoncourt stated in the catalogue that Indian art was created "within a collectively established scope of forms and patterns and always serves . . . a spiritual purpose accepted by the entire group." Pueblo art, in particular, was cited as an art tradition determined by centuries of collective activities and concepts. Indeed, the concepts of the individual Pueblo artist were said to be identical to those of the group. Even contemporary Indian arts and crafts, d'Harnoncourt wrote, continued to fulfill a variety of collective needs, especially economic and religious ones.[117]

Ideas similar to these were expressed in various reviews. Lowe, who saw in totem poles symbols of the unconscious mind, wrote that traditional Indian art "always served a definite utilitarian or spiritual purpose accepted by the entire group of which it was an expression." Furthermore, she stated that because tribal groups used repeatedly the same combinations of form elements, it was "possible to define their collective concepts and art styles." One of the most poignant aspects of the exhibition for Lowe was the display of Northwest Coast masks. The contemporary audience, she wrote, could relate to the collective concepts and psychological implications of such objects.[118] In his review Charlot expressed the hope that contemporary artists would see the spiritual content of Indian art as a balance between the subjective needs of the individual artist and the constraints of the tradition in which that artist worked: "The Indian artist manages to assert his greatness within an accepted frame of his tribal norms."[119]

La Farge, too, revealed an awareness of certain aspects of modern psychology in his comments about the exhibition in the *New York Times*. For example, he felt that d'Harnoncourt's show was bringing Indian art "to the surface of

our reluctant consciousness in a new and compelling way." And his description of Indian art as the result of the evolutionary process was perfectly compatible with the evolutionist component inherent to Jungian psychology. He explained that "it took a long while to develop the culture that produced" the objects on display, and he assigned "the rich complexity of pueblo life as we know it today" to a long, smooth evolutionary process. One result of such an evaluation was that America acquired a cultural antiquity, previously lacking, comparable to that of Europe, for as La Farge noted of the works exhibited, "The America out of which they came is 20,000 years old."[120]

The process of aestheticization—that is, the authoritative validation of the objects as intrinsically fine works of American art worthy of modern consideration—actually began with their placement in what Caspers referred to as "Manhattan's sleek Museum of Modern Art."[121] As for decontextualization, influenced, no doubt, by formalist theories of modernism, d'Harnoncourt insisted that one could conduct "an aesthetic evaluation of the art of any group without being much concerned with its cultural background." He further stated that a "satisfactory organization of lines, spaces, forms, shades and colors should be self-evident wherever we find it." But in the catalogue no less than in the exhibition, d'Harnoncourt sought to modify this decontextualization by offering a variety of contexts—religious, utilitarian, technical, and social—for the objects. In a certain sense, however, his insistence on contextualization emphasized the audience's *aesthetic* experience: "Yet we know that increased familiarity with the background of an object not only satisfies intellectual curiosity but actually heightens appreciation of its aesthetic values."[122] And, although he admitted that the art on display issued from regional cultures, this knowledge apparently served as a defense of the catalogue's overt refusal to interpret specific symbols. Indeed, while Douglas's lengthy captions for the illustrations provide a plethora of information about the history, function, style, composition, materials, and techniques associated with objects, there is al-

most nothing that could be construed as iconography, let alone iconology.

Like his installations on the first floor, d'Harnoncourt's discussion in the catalogue of contemporary Indian art was clearly intended to stress that art's compatibility with modernism. He characterized the best of the new work as having an "economy rather than complexity of design." Echoing the modernist dictum that form follows function, he wrote that "the close relationship between function and form are what bring Indian work so near to the aims of most contemporary artists and make it blend with any surroundings that are truly of the twentieth century." In particular, he saw the new Indian painting as being closer to the concepts of modernism than traditional art because it "replaced functional value with aesthetic ones."[123]

Although it was perhaps not intentional, reviews of the show also contributed to the aestheticization of the objects by evaluating and praising them with the principles and language of modernism. Lowe, who found parallels between Surrealism and the totemic art of the Northwest Coast, claimed that the ancient Woodland banner stones exhibited were "as bold in shape and as simplified as any form that ever entered the head of Brancusi." She described the Nootka house painting (Fig. 4-2) as a "fascinating abstraction on the essentials of form." Similarly, she found some Indian masks "almost a pure abstraction of form," while others were reduced to an essential form, making them comparable to much contemporary sculpture.[124] In his review, Caspers spoke of a spirit as modern as Paul Klee, which "designers are adapting to the demands of present-day fashion needs."[125]

Several critics, including Charlot, compared Surrealist, Eskimo, and Northwest Coast art. For example, Charlot reported that "orthodox surrealists" praised "the distorted spirit masks of the Eskimos," which were made under the influence of drugs or the stimulation of fasting. Max Weber, one of the very first modern American artists to appreciate Native art, wrote to Alfred

H. Barr that the magnificent exhibition proved that "we have the *real* Sur-realists right here in America." Vaillant, who knew well the important collections of Eskimo and Northwest Coast art at the American Museum of Natural History, wrote that the small Eskimo masks chosen by d'Harnoncourt embodied "the imaginative concentrate of *surrealisme.*" Before the exhibition opened, d'Harnoncourt had himself wondered how modern artists who had seen Eskimo art could go on exhibiting: "There is really very little that the good Eskimo leaves unsaid in the line of whimsical conventionalization."[126]

Charlot was not surprised that MOMA would host such an exhibition, since "Indian crafts are one of the sources of our own modern style." Indeed, he claimed that it was "a fact that Chilkat blankets were admired by early Cubists as the living tradition on to which their own plastic inventions were grafted." He also quoted French painter and theorist Amédée Ozenfant, who playfully exclaimed that the Indians were imitating Picasso. And Charlot credited Indian artists with the "amphibian gift of moving at ease among abstract as well as realistic pursuits" comparable to the swings between abstraction and realism that had characterized twentieth-century Euro-American art. In spite of this, he realized that "the deepest thrust of the Indian mind, the language it chooses to exalt its clan pride, wield magic power, or address the gods, is the language of abstract art."[127]

Charlot also explained that even though each generation of avant-garde modernists might "flirt with what in the vast and complex body of aboriginal art approximates its fancy," the best Indian art always transcended "such modish standards."[128] Concerning this relationship between modern and aboriginal art, the *Washington Star* quoted d'Harnoncourt as saying that because the affinity between traditional Indian art and modern art could not be explained by actual contacts, "we must concede the existence of human concepts that find expression in specific art forms." Modernism, he explained, had rediscovered forms that the Indian artist had never discarded. Thus, the interviewer concluded that in some aspects modern art was completing a cycle begun by Indian artists.[129]

Conclusion

There was, then, in the exhibition, the catalogue, and the accompanying criticism, a lack of resolution between what appear to be conflicting conceptions of Native American art as either universal and understood aesthetically or as culture-specific and functionally responsive to societal needs. In retrospect, the weight of the evidence proves that d'Harnoncourt actually sought the rich provocation inherent in this paradox. If "Indian Art of the United States" could demonstrate that these conceptions were not mutually exclusive, then the potential audience for, and commercial consumption of, Native arts and crafts would increase. Furthermore, the complexity of the exhibition as an experience and of the catalogue's content was in direct proportion to the intensity of d'Harnoncourt's belief that the rehabilitation of the Indian artist was a national moral responsibility. He was equally convinced that the slow and delicate process involved in staging such an exhibition was warranted by the enrichment of American life that it would engender.[130]

Partially because of the elaborate interplay of contexts, including decontextualization, recontextualization, and aestheticization, the exhibition was extremely well received at all levels. One of the strongest indications of the exhibition's success is the fact that it helped shape artistic practice. Indeed, "Indian Art of the United States" had a profound and immediate impact on the development of avant-garde art in New York. The show was particularly popular with several incipient Abstract Expressionists, such as Jackson Pollock, who visited the exhibition often and expressed his fascination with the display of Navajo sand paintings (Fig. 4-12). Partially as a result of seeing the exhibition, he incorporated into his paintings specific Indian images, such as the semiabstract figures of Pueblo pottery, as well as dramatic Northwest Coast masks. Perhaps more importantly, his revolutionary drip paintings of the late 1940s owe much to the ideas, processes, and purposes associated with Navajo sand painting. Like Pollock, Adolph Gottlieb and Richard Pousette-

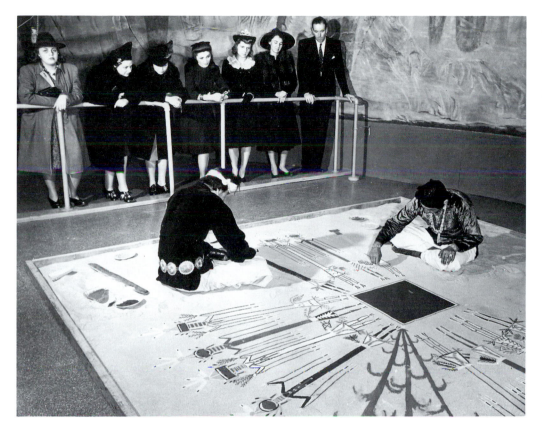

Figure 4-12
Navajo sand painters working at the exhibition "Indian Art of the United States" (1941). Photograph courtesy Museum of Modern Art, New York.

Dart also made paintings in the early 1940s that responded to d'Harnoncourt's displays of pictographs and totemic sculpture.

There can be little doubt that the quality of d'Harnoncourt's installations, the depth of the catalogue, and the stature of the Museum of Modern Art were integral to the final results: at that point in time, "Indian Art of the United States" was the most outstanding and unquestionably the most popular exhibition of Native art in American history. And yet, the positive reception of the exhibition is inseparable from d'Harnoncourt's anticipation of the audience's "horizon of expectations." That is to say, "in its moment of historical appearance," the exhibition demonstrated an awareness of the audience's previous cultural, ethical, and aesthetic experience vis-à-vis Native America.[131] D'Harnoncourt's acute awareness of the audience's "current expectations"—their readiness to have certain themes explored, certain questions answered, and certain beliefs re-

vised—was an essential, if somewhat less tangible, element in his remarkable achievement. Vaillant's final comment on the exhibition typifies the critical consensus that d'Harnoncourt had successfully visualized the audience's horizon of expectations: "We have preserved the work of the Indians as ethnology, let us also enjoy it as art."[132]

I would be remiss, however, not to mention once again the political and cultural rewards that were to be obtained from associating Indian art with the United States. More than ever, it seemed, the nation needed to find the taproot of its cultural strength. Certainly it had occurred to Charlot that the exhibition came at a time when Americans found themselves "stranded on their own continent in recoil from a beset world."[133] And La Farge observed that at "this time when we are restudying America, restudying our resources, may be the day of its [Indian art] acceptance."[134] According to d'Harnoncourt, one of America's great cultural strengths was its sense of tradition. For ex-

119

ample, he wrote, "To rob a people of tradition is to rob it of inborn strength and identity. To rob a people of opportunity to grow through invention or through acquisition of values from other races is to rob it of its future."[135] This statement's polyvalence reflects both the exhibition and the catalogue. For although he was speaking ostensibly about Native American peoples, he was thinking, perhaps, about the racial oppression then occurring under totalitarian regimes in Europe. And since the future of the United States of America just then was clouded by the darkness of fascist violence, it is plausible, even likely, that d'Harnoncourt was speaking about America itself, urging its people to find in Native American values a sense of inborn strength and identity.

Finally, when considered as an ideological construct, "Indian Art of the United States" is necessarily understood as a manifestation of cultural primitivism. The call for a national aesthetic based on Native American art, frequently heard in the critical responses to the exhibition, underscores the fact that the exhibition was organized by a government agency and funded by powerful corporations. Collectively, the design and discourse of the exhibition transformed Indian art, and the cultural traditions thus represented, into a signifier of national spirit. In this context, d'Harnoncourt's statement that denying a people the "opportunity to grow . . . through the acquisition of values from other races is to rob it of its future" may be seen as a defense of the political instrumentality inherent in the nation's colonial appropriation in 1941 of Native American art.

Primitivism, 1940–1950: Theory, Criticism, Painting

In the late 1930s and early 1940s the "myth-makers" of the New York avant-garde, including Adolph Gottlieb, Barnett Newman, Jackson Pollock, Richard Pousette-Dart, and Mark Rothko, made paintings that referred to atavistic myth, primordial origins, and primitive rituals and symbols, especially those of Native American cultures.[1] These artists shared a general tendency to depict ritual violence or inherently violent myths, as well as an archaism exemplified by biomorphic forms and, often, coarse surfaces. This self-conscious primitivism of early Abstract Expressionism, which included totemic imagery and pictographic writing derived from Native American art, differed in essence from the primitivism of the earlier European avant-garde in that it was "an intellectualized primitivism."[2] Indeed, if the primitivism of Picasso and Matisse, for example, was a decontextualization of the plastic form of African sculpture, then the works of art examined in this chapter and the following one on Pollock's primitivism represent the willful recontextualization by the New York avant-garde of forms and myths appropriated from Indian art.

This conscious manipulation of Native American art was a psychological and aesthetic response to recent history. As I stated in Chapter 4, two aspects of American intellectual life in the 1930s worked to heighten artists' awareness of Indian art. The first was a nationalistic recognition of the essential Americanness of Indian art. The second, conversely, was the perception that Indian art sprang from deeply rooted ancient traditions that made manifest a universal collective unconscious. The confluence of these two trends with the spiritual crisis created by the failure of modernism to generate a social and political utopia, and intensified by the rise of fascism, instilled in the "myth-makers" of the New York avant-garde a desire to transcend the particulars of history and search out universal values. And because they were seeking universals, these "first generation" Abstract Expressionists were attracted to C. G. Jung's concept of a collective unconscious that included early humankind's symbolic mode of thinking. Such a theory prompted their serious—in some

cases scholarly—study of the mythic and ceremonial nature of Native American art. Furthermore, because it had continued unbroken from ancient times up to the present, Indian art was perceived as being different from other prehistoric or primitive arts. Perceived as a cultural continuum bridging the gap between primordial and modern peoples, Native American art was seen as having special relevance for modern art and life.

As I have demonstrated in the previous chapters, there was never a scarcity of interest in Indian art in twentieth-century America. And yet, as the evidence in Chapter 4 showed so clearly, an "Indian fever" raged in the 1930s, a decade that saw a dramatic increase in the number of exhibitions, books, and articles about Native art and culture. In addition to "Indian Art of the United States" and other popular exhibitions, the fine permanent collections at the Museum of the American Indian, the American Museum of Natural History, and the Brooklyn Museum provided both the Abstract Expressionists and the Indian Space painters with sources of imagery and ethnographic information that shaped their perceptions of the vitality, Americanness, and spiritual and aesthetic values of Indian art. And within the New York avant-garde, painters who also functioned as critics, theorists, and curators contributed in these roles to the integration of Indian art into modernist painting. For example, John D. Graham, Wolfgang Paalen, and Barnett Newman were important for stressing the spiritual quality inherent in Indian art. Essential to their theories and criticism of Native American (and other primitive) arts was an understanding of myth, totem, and ritual that relates to Jung's ideas, as well as others, and reveals these artists as the advocates of a new, transformed consciousness for modernity.

John D. Graham and the "Primordial Racial Past"

During the late 1930s in America, the Russian-born Graham was perhaps the single most credible purveyor of the idea that atavistic myth and primitive art are an avenue to the unconscious

mind and primordial past.[3] The artist Peter Busa, for example, recalled that Graham was a "great proselytizer of ideas and was more intellectual than most painters."[4] When Graham arrived in New York in 1920 he was a devotee of both modern and primitive art and had an excellent knowledge of art history. In addition to what he may have known about American Indian art when he first arrived in the United States, his enthusiasm for it was surely strengthened by his association at the Art Students League with John Sloan, whose teaching, Graham insisted, was always the basis of his work.[5] Indeed, by the early 1940s Graham was able to announce, "I am an expert on Prehistoric, African, Oceanic, Mexican-Precolumbian [sic], and North American Indian, as well as Modern and Antique art in general."[6]

The young artists whom Graham met in New York found him mature, worldly, and by all descriptions, charismatic. In addition to Pollock, Gottlieb, Newman, and Pousette-Dart, his friends and acquaintances included, among numerous others, the incipient Abstract Expressionists Fritz Bultman, Arshile Gorky, and Willem de Kooning. Gottlieb, who was one of the first of this group to meet Graham at the Art Students League in the early 1920s, later sponsored him for United States citizenship.[7] Graham had seen examples of Parisian modernism in Moscow as early as 1905 or 1906, and by traveling to Europe in the twenties and thirties, and by sharing issues of *Cahiers d'Art* with Gottlieb and others, he kept them apace of European interest in primitive and ancient art.[8] Gottlieb, for example, shared Graham's enthusiasm for Native American, pre-Columbian, and Egyptian art, and under Graham's advisement he began to collect Indian art in 1935.[9]

Graham's critical writings were central to the New York avant-garde's understanding of and interest in primitive art, including Native American. His *System and Dialectics of Art* (1937) was first published in Paris, and a second edition of one thousand copies appeared the same year in New York.[10] This book was a germinal text in the history of modern art for many reasons, including the fact that it was replete with the ideas and language of Jungian psychology, in particu-

lar the theory of a collective unconscious as revealed in archetype and myth.[11] As Eleanor Green has observed, *System and Dialectics of Art* captured the imagination of an intelligentsia concerned with advanced art, and immediately following its publication, and for several years thereafter, it was widely discussed in avant-garde circles.[12] Indeed, Gottlieb, Pollock, and Pousette-Dart all owned copies of this critical text, which Graham had written (as he noted in the preface to the original edition) between 1926–1936, in Paris and New York.

System and Dialectics of Art reflects the tenor of the times in its revelation of a connoisseur's aesthetic and psychological, not purely ethnological, appreciation of primitive art.[13] Inherent, if unstated, in Graham's thinking is the rejection of ethnocentricity that necessarily precedes a genuine and complete understanding—if such a thing is possible—of primitive art: "[It is] a highly developed art as a result of great civilizations based on principles different from those of the white man's civilization." Graham contrasted the "great Negro civilization" with that of the white man, which was "based on the expansion of consciousness." Black civilization, he wrote, "is based on the expansion of the unconscious, on a direct contact with his own soul and reactions to nature and its mysteries." But in a primitivist leveling of historical and cultural difference, he stated, "At present the term 'Negro art' loosely embraces the Oceanic, Eskimo, Precolombian [sic] and North American arts." These same traditions form part of Graham's list of the finest examples of abstract art, which included, among others, Picasso's art. Since at the time the United States seemed to be on its way to realizing the importance of America's indigenous civilizations, young New York artists who sought to create an original native American art must have found highly provocative Graham's statement that "races and nations develop culture in proportion as they have free access to their racial past afforded by the folklore, by going through the succession of tedious accumulations of experiences . . . summing them up . . . retracing their own steps." Just as timely was

Graham's assertion: "Creation is the production of new authentic values by delving into memories of immemorial past and expressing them in terms of pure form (in space and matter) in order to project them into the clarities of the future. Creative images are circumscribed by the ability to evoke the experiences of primordial past, by physical limitations and the extent of one's consciousness."[14]

Throughout *System and Dialectics of Art* Graham repeatedly insisted on several distinctly Jungian points, a few examples of which will suffice as illustration. In response to his own rhetorical question concerning the origins of art, Graham wrote, "Our unconscious mind contains the record of all our past experiences—individual and racial, from the first cell germination to the present day." Similarly, he explained, "The purpose of art in *particular* is to re-establish a lost contact with the unconscious (actively by producing works of art), with the primordial racial past and to keep and develop this contact in order to bring to the conscious mind the throbbing events of the unconscious mind."[15] The reason for bringing the events of the unconscious into the conscious mind is related to Jung's belief that the emergence of the basic elements of the unconscious, the primitive stages of civilization, into waking consciousness could help modern man meet his need for spiritual transformation.[16] There are other spiritual and psychological echoes of Jungian theory in the remainder of Graham's description of the purpose of art: "The abstract purpose of art is to arrest the eternal motion and thus establish personal contact with static eternity . . . the concrete purpose of art is to lift repressions (and not to impose them)."[17] Although Graham's definition of the stages of art is simplified, it is analogous to the process of psychotherapy by which one would ideally achieve an integration of the self: "a) analysis or penetration; b) discovery or revelation; c) organization."[18]

System and Dialectics of Art proposed to the young New York modernists in Graham's circle of friends that art was a mode of penetrating and analyzing the primordial past because it offered "an almost unlimited access to one's uncon-

scious." Prehistoric art, according to Graham, is especially potent in this regard because it is "an art of pungent directness that thrusts one into the canyons of the past back to the first cell formation." More than just using the "first cell" germination of the "racial past" as a poetic metaphor (for recapitulation theory), Graham specifically described the organic relationship between culture, consciousness, and art when he wrote, "The history of civilization (or history of evolution for that matter) is the development of Form and the development of Form is the record of evolution of consciousness." This meant that forms representing the early stages of civilization (i.e., prehistoric, primitive, and archaic art) were the visual record of a primordial consciousness still extant in Euro-American civilization as the "throbbing events of the unconscious mind." And because Jung had identified primitive religious rites with primordial attempts at achieving spiritual transformation, it is appropriate to note here that Graham, once again, cited pre-Columbian, prehistoric, and archaic art as examples of the fact that "all great art is ceremonial."[19]

Even if the language of *System and Dialectics of Art* was simplified, and, admittedly, the text is redundant, it was without question a sympathetic presentation of many of Jung's important ideas about art and primitive consciousness. Furthermore, Graham's presentation of primitive art as a universal aesthetic category only made Pollock and other avant-garde readers more susceptible to an appreciation of Indian art. For example, he characterized primitive art as "monumental; taken roots in deep unconscious; abstract; awesome; sensuous; direct."[20] There can be no doubt that the "myth-makers" would be drawn to such an art; after all, Graham's description could easily be applied to their Abstract Expressionist paintings as well. In particular, he made numerous references to "Precolumbian" (which clearly subsumed "Indian") and especially Eskimo art, in which he saw sensitive, poetic reminders of prehistory. Pollock, who was responsive to Eskimo masks, must have noted these passages carefully.[21]

In 1937 Graham also published an article entitled "Primitive Art and Picasso," which was a more explicit analysis both of primitive art as an expression of the unconscious mind and of the ramifications for modern art of this relationship. At its core was a discussion of primitive art as an expression of the racial past and the influence of such art on the plastic development in Picasso's paintings. Of principal importance in the text is Graham's continued emphasis on Jung's dichotomy between conscious and unconscious mind and between modern and primitive culture. Graham wrote that "primitive races and primitive genius have readier access to their unconscious mind than so-called civilized people." The importance of this concept for Graham and the avant-garde was that the unconscious was, in his words, "the creative factor and the storehouse of power and of all knowledge, past and future." Furthermore, he explicitly stated the therapeutic importance of probing the unconscious, referring directly to Native American art: "The Eskimos and the North American Indian masks with features shifted around or multiplied, and the Tlingit, Kwakuitl, and Haida carvings in ivory and wood of human beings and animals, these also satisfied their particular totemism and exteriorized their prohibitions (taboos) in order to understand them better and consequently to deal with them more successfully."[22]

"Primitive Art and Picasso" also continued Graham's important analogy between primitive experience and the evolution of consciousness and culture; he wrote that "access to the unconscious permitted primitive people to comprehend the origin of the species and the evolution of forms eons ago." Graham favorably compared Picasso to primitive artists who, while "on the road to elucidation of their plastic problems, similarly reached deep into their primordial memories."[23] As I demonstrate in Chapter 6, ideas like these profoundly animated Pollock's art, encouraging him to study carefully the plastic qualities and subject matter of Indian art. After examining the relationship of primitive art to evolution, psychology, and plastic form, Graham concluded: "The art of the primitive races

has a highly evocative quality which allows it to bring to our consciousness the clarities of the unconscious mind, stored with all the individual and collective wisdom of past generations and forms. . . . An evocative art is the means and result of getting in touch with the powers of our unconscious."[24] This passage emphasized that primitive art, such as Eskimo masks and Northwest Coast Indian carvings, had a powerful and purposive role to play in a spiritual transformation of modern experience through the merging of the conscious and unconscious mind. As well as validating their appreciation of Native American art, such words may have encouraged Pollock, Gottlieb, and Pousette-Dart, all of whom knew Graham well, to make painterly reference to the unconscious.

The New York avant-garde's fascination with Native American art was reinforced also by the activities of various Surrealist emigré artists who arrived in New York in 1941.[25] Some of the Surrealists, including André Breton, Yves Tanguy, the Chilean Matta, Kurt Seligmann, and Max Ernst, acquired from George Heye's Museum of the American Indian (with the dealer Julius Carlebach acting as an intermediary) rare Eskimo masks from the Kuskowim River region of Alaska.[26] Among the Surrealists, Ernst, along with Seligmann and Wolfgang Paalen, had the most sustained interest in Native art. During his stay in America Ernst assembled a high-quality collection of Northwest Coast and Pueblo Indian objects. In her autobiography, the art dealer and patron Peggy Guggenheim stated that during her marriage to Ernst he kept a totem pole in the house and passionately acquired Hopi kachina dolls and totemic masks from the Northwest Coast.[27] The interest in Northwest Coast art, however, was spread by the Austrian-born Surrealist Wolfgang Paalen more than by Graham or anyone else, including Ernst.[28]

Wolfgang Paalen

Paalen had studied with Hans Hofmann in Germany and had been associated with Breton's circle in Paris. When he left Paris in May 1939, Paalen, like his fellow Surrealist Seligmann,

went directly to the Pacific Northwest Coast (Canada and Alaska), where he collected several masterpieces of Indian art, including the house screen of Chief Shakes (Tlingit, c. 1840, Plate 7). But Paalen was more than a mere collector of primitive art; even anthropologists were impressed by his writings on the totemic underpinnings of Northwest Coast art.[29]

Although he resided in Mexico, Paalen was frequently in New York in the early and mid-1940s. Beginning in the spring of 1942 he published in Mexico the art journal *DYN*, which was distributed primarily in New York at the Gotham Book Mart, a regular meeting place for artists.[30] Paalen's paintings were exhibited at Julien Levy's gallery in 1940, and both he and Pollock exhibited in the spring of 1945 at Guggenheim's Art of This Century Gallery.[31] Thus, Paalen, his journal, and his ideas were readily available to New York artists who were interested in Native American art. In "Le Paysage totemique," published in three installments of *DYN* in 1942, he effectively conveyed the complexity and the mythological basis of Northwest Coast art.[32] In December 1943 Paalen published a special double issue of *DYN* entitled the "Amerindian Number" (Fig. 5-1), which contained articles, illustrations, and book reviews dealing with Northwest Coast art and a variety of other Native American topics. In an editorial preface, sounding very much like Graham, Paalen announced, "Art can reunite us with our prehistoric past and thus only certain carved and painted images enable us to grasp the memories of unfathomable ages." Occidental art, he observed, had experienced an osmosis with Asia, Africa, and Oceania, and "now it has become possible to understand why a universal osmosis is necessary, why this is the moment to integrate the enormous treasure of Amerindian forms into the consciousness of modern art. . . . To a science already universal but by definition incapable of doing justice to our emotional needs, there must be added as its complement, a universal art: these two will help in the shaping of the new, the indispensable world-consciousness." Paalen ended his editorial by announcing

the role *DYN* might play in developing the new consciousness through universal art: "Nothing could be more important for an art review than its contribution, howsoever small this may be, toward such a consciousness. And that is why *DYN* hopes, in this number, to open the way toward a better understanding of Amerindian art."[33]

In "Totem Art," Paalen's essay contribution to the "Amerindian Number," he writes, "Many of the achievements of their [Northwest Coast Indians] arts and crafts that cannot be enumerated here have not been surpassed in any other culture." In particular he was struck by the magnificent power of totem poles, counting them "among the greatest sculptural achievements of all times." Paalen also observed, as did critics of "Indian Art of the United States," that only in modern sculpture could "one find analogies to their surprising spatial conception."[34]

As early as 1941, Paalen had shown an awareness of Jungian theory.[35] And indeed, his analysis of Northwest Coast sculpture reflected this interest in Jung: "Their great art . . . was of an entirely collective purpose: an art for consummation and not individual possession." As with Graham's Jungian conception of primitive art, Paalen understood

> that it was necessary to consider totemic systems . . . as corresponding to a certain developmental stage of archaic mentality, the vestiges of which can be found throughout mankind. For we can ascertain successive stages of consciousness: in order to pass from emotion to abstraction, man is obliged, in the maturation of each individual to pass through the ancestral stratifications of thought, analogously to the evolutionary stages of the species that must be traversed in the maternal womb. And that is why we can find in everyone's childhood an attitude toward the world that is similar to that of the totemic mind.[36]

Pollock, who read *DYN* and would have known Paalen through their dealer Guggenheim, or their mutual friend, Robert Motherwell, was deeply involved with the idea

Figure 5-1
Cover of the "Amerindian Number," *DYN*, nos. 4–5 (December 1943), with drawing of a killer whale by Kwakiutl artist James Speck.

of passing from "emotion to abstraction," "ancestral stratifications," and "evolutionary stages of the species."[37] Likewise, these same issues played a vital role in the art of Newman, Gottlieb, and Rothko. Newman, in fact, knew Paalen, had received an autographed copy of "Form and Sense" from him, and shared his and Ernst's interest in the totemic art of the Northwest Coast.[38] Newman also shared Paalen's conviction that primitive art gave modern man a deeper sense of the primordial roots of the unconscious mind and that understanding and even adopting primitive art values would create a more universal art in the present. The evidence for this view is in Newman's activities as a curator and critic of primitive and primitivist art from 1944 to 1947, and in his paintings as well.

Barnett Newman

Newman was one of the "myth-makers" of early Abstract Expressionism, and around 1944 he began to make fluid, biomorphic abstractions with pictorial debts to both Surrealism and primitive art. He was also influential as a theorist and indefatigable promoter of the new New York abstraction. Furthermore, the exhibitions of ancient and historic "New World" art that Newman organized helped create the intellectual and artistic climate in which he and his contemporaries made their "ideographic pictures."

In 1944, with the assistance of the American Museum of Natural History, Newman organized the exhibition "Pre-Columbian Stone Sculpture" for the Wakefield Gallery in New York. Lenders to the exhibition included Graham and publisher Frank Crowninshield, whose collection of primitive art Graham helped assemble.[39] In his brief introductory comments to the catalogue, Newman, like Sloan (with whom he studied), Graham, Vaillant, and d'Harnoncourt, insisted that pre-Columbian art be judged and appreciated as art "rather than works of history or ethnology [so] that we can grasp their inner significance." For Newman, a new inter-American consciousness based on an aesthetic appreciation of pre-Columbian art

would result in the comprehension of "the spiritual aspirations of human beings" and the building of permanent bonds. Experiencing this ancient American art is a way, Newman wrote, of "transcending time and place to participate in the spiritual life of a forgotten people." But he believed that ancient American art was more than an avenue to the past, stating that it has a "reciprocal power" that "illuminates the work of our time" and "gives meaning to the strivings of our artists."[40]

In 1946 Newman organized an important exhibition, "Northwest Coast Indian Painting," for the Betty Parsons Gallery. He was assisted once again by the American Museum of Natural History, and Graham once again lent objects, as did Ernst. The Abstract Expressionist painter Fritz Bultman, who was close to both Graham and Pollock, recalled that this was a very popular exhibition, which Pollock and "everybody" attended.[41] In the catalogue (which Dore Ashton read as an adaptation of Wilhelm Worringer's theory of primitive abstraction), Newman described the ritualistic paintings on display as "a valid tradition that is one of the richest of human expressions."[42] In explaining how these Indians "depicted their mythological gods and totemic monsters in abstract symbols, using organic shapes," Newman established the grounds for defending abstract art: "There is answer in these works to all those who assume that modern abstract art is the esoteric exercise of a snobbish elite, for among these simple peoples, abstract art was the normal, well-understood, dominant tradition." Also, as in his comments on pre-Columbian art, Newman stressed that an awareness of Northwest Coast art illuminates "the works of those of our modern American abstract artists who, working with the pure plastic language we call abstract, are infusing it with intellectual and emotional content, and who . . . are creating a living myth for us in our own time."[43]

Newman focused so intently on Northwest Coast Indian ritual art because he perceived it as a parallel to his own art and to that of his contemporaries.[44] In fact, "Northwest Coast Indian Painting" may be thought of as a prolegomenon

to "The Ideographic Picture," an exhibition he organized for the Betty Parsons Gallery in January 1947. Fewer than ninety days separated the two shows, which suggests that the premise of "The Ideographic Picture" (paintings about ideas) was already established in Newman's mind when he insisted that Northwest Coast Indian painting "illuminated" the "pure plastic" abstractions of New York's modern "myth-makers."[45] "The Ideographic Picture" featured paintings by Hans Hofmann, Rothko, Clyfford Still, Theodoros Stamos, Newman himself, and others that were the "modern American counterpart to the primitive impulse."[46] Newman had originally intended to include works by Pollock and Pousette-Dart, but contractual obligations prevented that.[47] Newman began his essay for the catalogue *The Ideographic Picture* by invoking the image of "the Kwakiutl artist painting on a hide," an aesthetic act that represents the "pure idea."[48] The Kwakiutl painter's abstract shapes, Newman explained, were "directed by a ritualistic will toward a metaphysical understanding."[49] By calling up such an image Newman hoped to "make clear the community of intention" that motivated New York's ideographic painters.[50] The "myth-making" of this community often consisted of taking old myths—notably Greek and Northwest Coast Indian—and recasting them according to the function of myth as defined by aspects of the early philosophy of Friedrich Nietzsche and the psychological theories of C. G. Jung.[51]

Admittedly, the influence of both Nietzsche and Jung on the New York avant-garde in the 1940s has been treated elsewhere.[52] Yet the interrelatedness of their ideas, and their connections to those of Wilhelm Worringer (whose *Abstraction and Empathy* was an important text for Newman), as well as to contemporary anthropological texts, such as Ruth Benedict's *Patterns of Culture* (1934), has not been thoroughly examined. It is now clear that Newman's awareness of ethnological texts on primitive art and culture, anthropological theory, and various exhibits of Indian art interacted with his understanding of the theories of Nietzsche, Jung, and Worringer about consciousness and the spiritual function of art, myth, and ritual. The remainder

of this section on Newman, then, explores the way in which his knowledge of primitive art and cultures, particularly Native American, coincided with and affirmed those European intellectual theories, resulting in a view of the world as tragic, but redeemable through art. This theme is a central aspect of the pictorial content of Newman's Abstract Expressionist paintings, which are also discussed below.

In *The Birth of Tragedy Out of the Spirit of Music* (1871) Nietzsche stressed the primacy of the Archaic period in his search for the origins of the tragedy as an art form. The essential paradigm through which Nietzsche argued his thesis was the Apollinian/Dionysian duality, which he conceived "as the separate art-worlds of *dreamland* and *drunkness*."[53] The Greeks synthesized these opposing creative forces into "the equally Dionysian and Apollinian art work of Attic tragedy." Nietzsche explained that the Dionysian vision is not only a recognition of the "terrors and horrors of existence," but also a "drunken reality [that] seeks to destroy the individual and redeem him by a mystic feeling of Oneness." Dionysian experience is simultaneously an ecstatic union with the "mysterious Primordial Unity" and a cognizance of the world as fundamentally lacking in any objective meaning. Furthermore, he saw Dionysian revelry as a universal stage of experience: "From all quarters of the Ancient World—to say nothing of the modern . . . we can prove the existence of Dionysian festivals [in which] the very wildest beasts of nature were let loose."[54]

Nietzsche associated the Apollinian mode with repression of the barbarism and ecstasy of Dionysian vision, with the beautiful illusion of the dream world, and with the search for an absolute truth to mask the constant flux and subjectivity of genuine reality. Instead of the *mystic oneness*, the Apollinian vision maintains the illusion of the *principium individuationis*. And yet, Nietzsche insists, the Apollinian Greek had to realize that "his entire existence, with all its beauty and moderation, rested on a hidden substratum of suffering and knowledge, which was disclosed to him by the Dionysian."[55] Moreover, as noted above, Nietzsche perceived the

Apollinian as essential to the creation of tragic art.

Concerning the origins of the tragic form, Nietzsche had much to say about myth that no doubt rang true to Newman's generation. Nietzsche writes that it is through tragedy—the dialectical synthesis of the Apollinian and Dionysian modes—that "the myth attains its profoundest significance, its most expressive form." Warning of the limitations of science (associated with the order and logic of the Apollinian), Nietzsche states that where reason is insufficient "to make existence appear to be comprehensible," then "*myth* also must be used." Particularly poignant for Newman and the other "myth-makers" was Nietzsche's insistence that "it is only a horizon encompassed with myths which rounds off to unity a social movement."[56]

Nietzsche discovered that the more he came to understand the human need to redeem the horror of existence, the more he felt "driven to the metaphysical assumption that the Verily-Existent and Primordial Unity, as the Eternally Suffering and Self-Contradictory, requires the rapturous vision, the joyful appearance for its continuous salvation." One could, however, respond with affirmation to the existential texture of life, could embrace both barbarism and the illusion of beauty, if one simply realized that "only as an *aesthetic phenomenon* is existence and the world eternally *justified*." In the closing pages of *The Birth of Tragedy*, Nietzsche offered to "lead the sympathizing and attentive friend to an elevated position of lonesome contemplation," where the treacherous path could be traversed if only we "hold fast to our shining guides, the Greeks."[57]

Jung took Nietzsche's advice to heart: he began his *Psychology of the Unconscious* (1916) by referring to "the simple greatness of the Oedipus tragedy—that never extinguished light of the Grecian theatre"—and by noting that even today "that which affected the Greeks with horror remains true." Like Nietzsche, Jung located his thesis in a paradigm of duality, positing two kinds of thinking, "directed and dream or phantasy thinking," and observed that the latter "sets free subjective wishes." Fantastic thinking,

which he associated with the unconscious, is also remarkably Dionysian in nature. For example, Jung wrote that fantastic thinking "corresponds to the thought of the centuries of antiquity and barbarism." And, where Nietzsche stressed the relationship between Dionysian vision and the tragic content of the myth, Jung noted that fantastic thinking, which flowed automatically from an "inner course," constantly rejuvenated myths "in the Grecian sphere of culture."[58]

Of prime importance to the primitivist art theory of the "myth-makers" were the parallels Jung drew between the myths of antiquity, the primitive mind, dreams, and the thoughts of children.[59] He explained that although "the Dionysian mysteries of classical Athens . . . have disappeared," in childhood we repeat these archaic tendencies.[60] As I indicated in Chapter 1, this is an idea widespread in both nineteenth- and twentieth-century social sciences: ontogeny recapitulates philogeny, or in its development the individual (organism) recapitulates the evolutionary stages of the species.[61] Jung summarized it succinctly: "Our minds . . . bear the marks of evolution passed through."[62] And concerning the dream, Jung quoted Nietzsche: "The dream carries us back into earlier states of human culture, and affords us a means of understanding it better." Likewise, it is not surprising that Jung writes, "The supposition is justified that ontogenesis corresponds in psychology to phylogenesis. Consequently, it would be true, as well, that the state of infantile thinking in the child's psychic life, as well as in dreams is nothing but a re-echo of the prehistoric and the ancient."[63] Artists in search of access to the unconscious would have observed that Jung, by way of Nietzsche, was suggesting that like dreams, the myths of antiquity and primitive art (as the product of the primitive mind) can transport us back into the primordial stage of consciousness.

Many of the ideas found in Wilhelm Worringer's *Abstraction and Empathy* (1908) resemble those of Nietzsche and Jung mentioned above. Worringer, too, used a post-Hegelian paradigm, insisting on the importance of synthesizing the two elements of a duality; for

Worringer, the urge to abstraction and the urge to empathy in art form the "shape of a comprehensive aesthetic system." He, too, noted that the content of modern culture is founded on the classical tradition and warns that our dependence on Aristotelian concepts blinds us to the "true psychic values . . . of all artistic creation." And most important of all, Worringer recognized that "there is one great ultimate criterion for mankind's relation to the cosmos: its need for redemption."[64]

Newman, as I intend to argue, was fascinated by the Dionysian tendencies Worringer identified in the abstract art of primitive peoples. Therefore, it is necessary to establish how and when he became aware of the theoretical section of *Abstraction and Empathy*. By the time the first English edition appeared in 1953, Newman was already well aware of the central trope of Worringer's argument. When Newman read Worringer's *Form in Gothic* in 1944, he first read, no doubt, Herbert Read's introduction, which included in its entirety T .E. Hulme's synopsis of the theoretical section of *Abstraction and Empathy*. Hulme's accurate account in English of Worringer's theory about primitive man's "tendency towards abstraction" was part of an essay on "Modern Art" published in his *Speculations* (1924). Furthermore, in 1945 the *Sewanee Review* published in three parts a seminal essay by Joseph Frank on "Spatial Form in Modern Literature," which likewise featured a detailed synopsis of *Abstraction and Empathy*, focusing on the relationship between "abstract styles" and the "incomprehensible chaos" of the primitive world.[65] Although he disagreed with certain aspects of Frank's argument, the essay fired Newman's imagination, and he grappled with Frank's material in a series of notes and drafts and in one finished essay, "Painting and Prose," which remained unpublished in his lifetime. Indeed, according to Mollie McNickle, "Newman's most fruitful confrontation of 1945 was his rumination" on Frank's three-part essay.[66] Responding to what he described as "one of the most valuable analyses of modern literature to appear in recent times," Newman noted that what united "the abstract art of the Northwest Coast Indian and the archaic Greek" was

the "fact that they were able to transcend appearance and make contact with absolutes."[67]

Newman playfully titled one of his responses "Frankenstein," and this essay, as McNickle has observed, indicates that Newman realized the "portent and the promise of the weighty ideas with which he was grappling for the future of his own work."[68] In fact, it is here that Newman reveals an understanding of Worringer's *Abstraction and Empathy*, for one must possess knowledge of an idea in order to enter into a discourse with it. For example, Newman wrote that "Worringer is not correct in his oversimplification of the polarity that exists between naturalism and abstraction" and that the facts broke down "Worringer's and Frank's secondary argument that style is the result of a people's general attitude toward nature." Noting that an "ambivalence between naturalism and abstraction existed in . . . primitive cultures," Newman concluded—at least in this unpublished work—that "Worringer's explanation . . . that man's art is a reflection of his attitude toward the universe . . . has no substance."[69] And yet, responding to the Museum of Modern Art's 1946 exhibition, "Art of the South Seas," Newman published an essay, "Las formas artisticas del Pacifico," in which he insisted that the "distinguishing character of Negro African art is that it is an art of terror . . . before nature" and that "Mexican art can be said to contain a terror of power." Oceanic art, Newman explained, was distinguished by a sense of magic based on a "terror before nature's meaning." He elaborated, writing that in "Oceania, terror is indefinable flux rather than tangible image." As the Oceanic artist struggled to explain his world, Newman wrote, he "found himself involved in an epistemology of intangibles" that led to a "pictorial art that contained an extravagant drama."[70] Although he does not invoke Worringer by name, inscribed in Newman's analysis of Negro African, Mexican, and especially Oceanic art is the Worringerian idea that style (i.e., a pictorial art of extravagant drama) embodies an attitude toward the universe (i.e., "terror before nature's meaning" that is an "indefinable flux").[71]

Similarly, Worringer wrote that primitive man, "is spiritually helpless . . . because he experiences only obscurity and caprice in the . . . flux of the phenomena of the external world." Worringer explained abstraction as primitive man's response to the transcendental forces of nature. Furthermore, he linked such abstraction to a metaphysics—beyond beauty—that expressed the dialectical struggle "between instinct and understanding." Worringer's theory pits primitive man, with his transcendental experience of nature, tendency to abstraction, and preponderance of instinct, against postclassical man, characterized by his perception of immanence in nature, urge to empathy in art, and emphasis on understanding.[72]

Because Newman was a theorist and curator as well as a painter, and because he, of all the New York avant-garde, demonstrated the most overt interest (as a collector, curator, and critic) in Northwest Coast Indian art, it is not surprising that his writings register most fully the impact of the theories of Nietzsche, Jung, and Worringer.[73] The Nietzschean conception of tragedy underlies Newman's essay "The Object and the Image," which appeared in the third issue of *Tiger's Eye* (March 1948), an avant-garde journal with which Newman was associated. For example, Newman wrote, "Greece named both form and content; the ideal form—beauty, the ideal content—tragedy." He also noted that when the "Greek dream" (Apollinian vision) prevailed in contemporary art, it was accompanied by a "nostalgia for ancient forms" and "self-pity over the loss of the elegant column and the beautiful profile." Newman decried this refined agonizing over Greek objects: "Everything is so highly civilized." According to Newman, the American artists, who were barbarians without refined sensibilities, now had the opportunity to "be free of the ancient paraphernalia" and to "come closer to the sources of the tragic emotion."[74] Clearly this was a reference to the new American painting that dealt with the wellspring of tragedy. Concerning the tragic emotion, Newman asked, "Shall we not, as artists, search out the new objects for its image?"[75]

In that same issue of *Tiger's Eye*, the avant-garde indicated its interest in Nietzsche's Apollinian/Dionysian paradigm. The following passage from *The Birth of Tragedy*, selected perhaps by Newman, was juxtaposed with a drawing by Theodoros Stamos: "I shall keep my eyes fixed on the two artistic deities of the Greeks, Apollo and Dionysus, and recognize in them the living and conspicuous representatives of two worlds of art differing in their intrinsic essence and in their highest aims. I see Apollo as the transfiguring genius of the *principium individuationis* through which alone the redemption in appearance is truly to be obtained: which by the mystical triumphant cry of Dionysus the spell of individuation is broken, and the way lies open to the mothers of being, to the innermost heart of things."[76]

Even if it remains unresolved whether Newman himself chose this passage from Nietzsche, it does further confirm, because of his association with *Tiger's Eye*, his awareness of the central thesis of Nietzsche's *Birth of Tragedy*.[77] Furthermore, an almost existential poetry, reminiscent of Nietzsche, is evident in Newman's introduction to "The Ideographic Picture," in which he explained the "artist's problem" as "the idea complex that makes contact with mystery—of life, of men, of nature, of the hard, black chaos that is death, or the grayer, softer chaos that is tragedy."[78] And confronting chaos, Newman believed, linked men across the ages: "All artists whether primitive or sophisticated have been involved in the handling of chaos."[79]

Likewise, Newman's brief essay for "The Ideographic Picture" bears evidence that he knew well Worringer's *Abstraction and Empathy*. For example, as noted above, Newman saw Kwakiutl abstraction in the context of a "ritualistic will" and a "metaphysical understanding." According to Newman, for the Kwakiutl artist, shapes were "a vehicle for an abstract thought-complex, a carrier of the awesome feelings he felt before the terror of the unknowable."[80] These ideas are comparable to Worringer's assertion of a metaphysics higher than that of beauty, which is documented by primitive and archaic art, and to his description of primitive

man's spiritual helplessness in the face of the flux of nature.[81] A few months earlier, in his essay for the exhibition of "Northwest Coast Indian Painting," Newman wrote what reads like a paraphrase of Worringer. Whereas Worringer had written that "the urge to abstraction stands at the beginning of every art and in the case of certain peoples at a high level of culture remains the dominant tendency,"[82] Newman explained, concerning Kwakiutl, Tlingit, and Haida Indians, that "among a group of several peoples the dominant aesthetic tradition was abstract," and "among these simple peoples, abstract art was the normal, well-understood tradition."[83] Furthermore, just as Worringer had asserted that the theory of empathy (with nature) does not explicate "that vast complex of works that pass beyond the narrow framework of Graeco-Roman and modern Occidental art,"[84] Newman stated: "It is becoming more and more apparent that to understand modern art, one must have an appreciation of the primitive arts, for just as modern art stands as an island in the narrow stream of Western European aesthetics, the many primitive art treasures stand apart as authentic accomplishments that flourished without benefit of European history."[85] And, recalling both Worringer and Nietzsche, Newman noted that the Northwest Coast Indian painters were not concerned with "decorative devices" but "with the metaphysical pattern of life."[86]

As for Newman's knowledge of Jungian theory, he stated that he could communicate with Jungians but that there might be disagreements about terminology.[87] And like his contemporaries, Gottlieb and Rothko, Newman also made specific reference to antique myths and primitive art, which Jung had explained as relics of primordial consciousness. In addition to Surrealism,[88] the automatic-biomorphic qualities of such works as *Gea* (1944–1945) seem to reflect both Jung's notion of a stream of consciousness (fantastic thinking) that takes place when directed thinking ceases and his use of organic growth as a metaphor for the evolution of consciousness. The flowing hand evident in Newman's works on paper from about 1945 is surely the physical counterpart of the random, spontaneous, and poetic looping of the unconscious mind, as well as a reflection of his interest in the natural sciences.[89] Finally, concerning Newman and Jungian theory, it is instructive to recall the words of Bultman, the "missing irascible": "Jung was available in the air, the absolute texts were not necessary, there was general talk among painters."[90]

Newman's interest in Native American art may well date from his days in the early 1920s as a student of John Sloan at the Art Students League. At the time Newman would have met Sloan, the latter, as a critic, collector, and curator, was actively promoting both old and new Indian art. Newman, no doubt, must have had many discussions about Indian art with Gottlieb, with whom he visited the Northwest Coast Hall at the Museum of Natural History in the late 1930s.[91] And, as I have already indicated, he also knew Graham, who lent pre-Columbian and Northwest Coast Indian objects to the exhibitions he organized.[92] Sometime in the 1940s Newman collected four museum-quality argillite totem poles (probably Haida) and a painted shield (probably Chiricahau Apache), which are still a part of his estate.[93] In addition, the fourteen titles in Newman's library that treat North American Indian art and culture are testimony to his devotion to this subject. Of these, five are exclusively or significantly focused on Northwest Coast art and society; three deal with Aztec art; and the rest are general studies of primitive art, culture, and anthropology. Among the fourteen are three books by Northwest Coast specialist Franz Boas: *Anthropology and Modern Life* (1928), *The Mind of Primitive Man* (1943), and *Primitive Art* (1955); one rather mystical treatment, *Indians of the Americas* (1947), by the Native Rights advocate and former commissioner of Indian Affairs, John Collier; and the *Thirty-Fifth Annual Report of the BAE*, part 2 (1921), which consists of a lengthy report on Boas's fieldwork with the Kwakiutl Indians. Five of the books were publications of the American Museum of Natural History, an institution whose collections of Northwest Coast art Newman knew intimately.

Conspicuous for its absence from Newman's library as it exists today is Ruth Benedict's *Patterns of Culture* (1934), which he had read and which was a profoundly influential text in avant-garde circles in the late 1930s and 1940s.[94] Benedict used as the focus of her argument Nietzsche's discussion of Dionysian and Apollinian modes of experience. According to Ann Gibson, *Patterns of Culture* made the Dionysian-Apollinian distinction "part of the intellectual apparatus of the period."[95] Newman must have been impressed by this book, which brought Nietzsche's analysis of the opposing elements of Greek tragedy to bear on the Kwakiutl Indians of the Northwest Coast and the Zuni Indians of the Southwest; on at least two occasions Newman found it useful to incorporate its title in his own writing. In a letter to Harry Shapiro, dated 1 August 1944, Newman stated, "There is every reason for art and anthropology to go together for the objects that form the basis for the scientific study of the patterns of culture are the same objects that form the aesthetic study of the soul of man." Shapiro was at that time the chairman of the Department of Anthropology at the American Museum of Natural History and had assisted Newman in organizing the "Pre-Columbian Stone Sculpture" exhibition some months earlier. In this letter, Newman announced his "conviction that the best audience for anthropology, outside of anthropologists themselves, is the art public." As a result of this conviction, he asked, "Why cannot the Museum do the converse of the Pre-Columbian exhibition by putting on exhibits of outstanding examples of modern art?"[96]

Later, in a passage from his unpublished essay "The New Sense of Fate," Newman alluded to Benedict's book in discussing his preference for primitive, as opposed to Greek, plastic art: "All we know concretely of the primitive life are its objects. Its culture patterns are not normally experienced, certainly not easily. Yet these objects excite us and we feel a bond of understanding with the primitive artists' intentions, problems, and sensibility, whereas the Grecian form is so foreign to our present interests that it virtually has no inspirational use. One might say that it has lost its culture factor."[97]

Benedict's *Patterns of Culture* was surely the prototype of that marriage of Nietzschean archaism (violent myth) and Northwest Coast art, myth, and ritual which was a distinctive feature of much avant-garde art, literature, and criticism in the forties. She took her cue, however, from her mentor Franz Boas, who compared, in a book owned by Newman, the similarities between the Phaeton legend of the ancient Greeks and the Northwest Coast Indians.[98] *Patterns of Culture* no doubt inspired the editors of *Tiger's Eye* (or perhaps Newman himself) to select from Boas's report on the Kwakiutl Indians a shaman's song that appeared in a special section devoted to the sea in *Tiger's Eye* (no, 2 [December 1947]). Not surprisingly, the first part of this song recounts the acquisition of shamanic power by way of a Dionysian experience involving a totemic animal (Killer Whale) and descent into the underworld (sea): "I was carried under the sea by the supernatural power, the supernatural power."[99] Newman would have found in the texts of Benedict, Boas, and others ethnological confirmation, so to speak, of Nietzsche's thesis. *Patterns of Culture*, in particular, probably mediated between Nietzsche's interpretation of archaic tragedy and Newman's own study of Northwest Coast art and ritual.

The keystone of Kwakiutl spiritual life is the *Tsetseka*—a round of winter ceremonies that takes place from November to March.[100] The winter ceremonials are, to use Nietzsche's words, a time of "festivals of world-redemption and days of transfiguration."[101] During this period everything in the whole of society is indeed transformed: people shed their summer names and take Tsetseka names; new songs and new forms of protocol arise based not on secular wealth but on clan-ceremonial rank. Broadly speaking, Tsetseka is the time when the spirits come into the village to initiate the novices into one of the four principal dancing societies. The most important of these is the Hamatsa, whose ceremony is held under the auspices of Bakbakwalanooksiwae, a powerful human-eating spirit who lives in the sky (or at the north

end of the woods/world). The Hamatsa novice fasts in the woods until he goes into an ecstatic trance, during which he meets the Cannibal Spirit, from whom he derives power and whose protégé he becomes. Benedict noted, "The experience of meeting the supernatural spirit was closely related to that of the vision." She went on to say, "The whole Winter Ceremonial, the great Kwakiutl series of religious rites, was given to 'tame' the initiate who returned full of the 'power that destroys man's reason' and whom it was necessary to bring back to the level of secular existence. . . . The initiation of the Cannibal Dancer was peculiarly calculated to express the Dionysian purport of Northwest Coast culture. Among the Kwakiutl the Cannibal Society outranked all others."[102]

And, in another passage, Benedict stressed the Dionysian aspect of the Kwakiutl ritual enactment of cannibalism:

> Like most of the American Indians, except those of the Southwest Pueblos, the tribes of the Northwest Coast were Dionysian. In their religious ceremonies the final thing they strove for was ecstasy. The chief dancer, at least in the high point of his performance, should lose normal control of himself and be rapt into another state of existence. He should froth at the mouth, tremble violently and abnormally, do deeds which would be terrible in a normal state. . . . The very repugnance which the Kwakiutl felt toward the act of eating human flesh made it for them a fitting expression of the Dionysian virtue that lies in the terrible and the forbidden.[103]

Under the spell of the supernatural, the Hamatsa dancer moves in a frenzy through the winter house crying *haap* (eat) and occasionally trying to bite the spectators. They, in turn, surreptitiously encourage him by whispering under their breath such words as *eat* and *body*, which only intensifies the dancer's madness.[104] And then, like Nietzsche's Dionysian cultist, "in this extremest danger to the will, *art* approaches, as a saving and healing enchantress."[105] That is, the taming of the Hamatsa dancer is a highly structured ritual perfor-

mance. The whole ceremony, in fact, is a supreme artifice with a script (oral tradition), prescribed sequence of events (ritual), stage hands (cult members), and stage props (works of art). The art objects involved, the likes of which Newman included in the "Northwest Coast Indian Painting" exhibition, include masks, drums, dance blankets, rattles, and shaman's robes (Fig. 5-2). For the Kwakiutl, the theatrical nature of the ritual does not diminish its transforming power. Again, Nietzsche explained this aspect of art: "In the dithyramb we have before us a community of actors, who mutually regard themselves as transformed among one another. . . . This enchantment is the prerequisite of all dramatic art."[106]

The method by which the Hamatsa dancer is recivilized indicates that, like the rites of Dionysus, the Winter Ceremonial deals with the cycles of nature. As Benedict explained: "Perhaps the most striking Dionysian technique of the Winter Ceremonial is that which finally tames the Cannibal and ushers in his four-month period of tabu. According to ideas that are current in their culture it expresses in the most extreme manner the supernatural power that lies in the horrible and the forbidden. . . . The final exorcism . . . was that which was performed with menstrual blood. Upon the Northwest Coast menstrual blood was polluting to a degree hardly excelled in the world."[107]

Dealing as it does with starvation, ritual death, and rebirth, Tsetseka is an attempt to make a symbolic spiritual defense against the death of nature during the long darkness of the winter months. Newman would have surely recognized this aspect of the Hamatsa dancer. For example, writing in *The Golden Bough*, James Frazer linked Dionysus to Adonis, Attis, and Osiris as fertility gods who symbolize the death of nature in winter and its rebirth in spring: "Like other gods of vegetation Dionysus was believed to have died a violent death, but to have been brought back to life again; and his sufferings, death, and resurrection were enacted in his sacred rites."[108]

Nietzsche also linked the ecstatic behavior of the Dionysian cult to rites of spring: "It is either

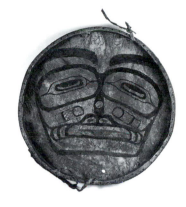

Figure 5-2
Kwaikutl drum
(n.d.).

6 cm high, 49 cm in diameter.
Courtesy American Museum of Natural History, New York, neg. #2A 13414.
Photograph by P. Hollenbeak/ O. Bauer.

under the influence of the narcotic draught, of which the hymns of all primitive men and peoples tell us, or by the powerful approach of spring penetrating all nature with joy, that those Dionysian emotions awake, in the augmentation of which the subjective vanishes to complete self-forgetfulness."[109] And his description of the Dionysian's ecstasy is not unlike the image of the Hamatsa dancer presented by Benedict: "Even as the animals now talk . . . so also something supernatural sounds forth from him: he feels himself a god, he himself now walks about enchanted and elated even as the gods whom he saw walking about in his dreams." In his state of bestial desire, the Hamatsa dancer reenacts the primordial myth-time. Thus, he is akin to Nietzsche's satyr, who "is the offspring of a longing after the Primitive and the Natural." Concerning the chorus as the origin of tragedy, Nietzsche observed, "The satyr, as being the Dionysian chorist, lives in a religiously acknowledged reality under the sanction of the myth and cult."[110] No description of the Hamatsa initiate could be more precise than this. His self-induced madness occurs during a clearly defined period of societal transformation; his barbarism is sanctioned by the secret society that sponsors him; and his society as a whole recognizes the validity of the sustaining myth (encounter with the Cannibal Spirit). Indeed, even the spectators in the house are full participants in the ritual performance.

With the Nietzschean analysis as model, Benedict and Newman would have perceived the Kwakiutl Hamatsa ceremony as a Northwest Coast tragedy. The savagery of the Hamatsa dancer, which represents primal experience or Dionysian content, was redeemed by a total illusion, or *Gesamtkunstwerk*, which is the supreme Apollinian form. It cannot be coincidental that shortly after a time of violence and unprecedented brutality—World War II—Newman chose to exhibit ceremonial painting from the Northwest Coast, which he called "a valid tradition that is one of the richest human expressions." Furthermore, Newman, in discussing this "pure painting," warned against appreciating it only for its Apollinian qualities: "It is our hope that these great works of art,

whether on house walls, ceremonial shaman frocks and aprons, or as ceremonial blankets, will be enjoyed for their own sake, but it is not inappropriate to emphasize that it would be a mistake to consider these paintings as mere decorative devices. . . . These paintings are ritualistic."[111] Newman was drawn to this art because, like that of his contemporaries, it was an "expression of the mythological beliefs" of artists who "depicted their mythological gods and totemic monsters in abstract symbols, using organic shapes."[112]

Beyond shaping his art theory and informing his criticism, the idea of tragedy as the artistic redemption of chaos was also given form by Newman in his own paintings. Beginning in 1944, he made a series of relatively small, expressionistic works on paper, characterized by biomorphic images that signify both the creative act and the organic evolution of consciousness. One such untitled work from 1944 features (at the bottom center-to-left) a hybrid "totemic monster" of Northwest Coast derivation. On top of its extended neck (a series of linked, skinless vertebrae) is a head featuring a long, pointed snout and exaggerated eye that recalls, in a general way, Kwakiutl wolf masks of the type Newman borrowed from the American Museum of Natural History for his Northwest Coast show at the Parsons Gallery. Its curved horns and coiled tongues, however, are reminiscent also of Sisiutl, a serpent monster with the power to transform itself into a fish. One of Newman's books, Pliny Goddard's *Indians of the Northwest Coast* (1934), featured numerous illustrations of composite mythological animals, including a horned water monster.[113] In the center of the picture is another horned or feathered canine, and floating, swimming, and flying around this animal are several birds and insects.

The natural freedom of the forms in the biomorphic, totemic world of this untitled work (and the related works of 1944) demonstrates that Newman shared with the Kwakiutl painter a concern "with the nature of organism."[114] Moreover, these are pictures of the subconscious mind's fantasy landscapes, created by the hand automatically, when, as Jung stated,

directed thinking ceases. Newman's choice of fast mediums—chalks, oil crayons, ink, watercolors—reveals his desire to connect his hand directly to the bank of primeval images stored in his (individual portion of the collective) unconscious, enabling him to produce images free of rational dictates. He spoke later of the liberation inherent in such a mode of drawing: "How it went . . . that's how it was . . . my idea was that with an automatic move, you could create a world."[115] The sensuous, hothouse growth and fluid movement of the organic forms in this created world relates to Newman's conception of the freedom common to primitive and modern experience. Betty Parsons, who described Newman as "a great authority on the primitive," recalled that "he gave me the idea that the primitive world was a free world and [that] this world that I was in now was a free world." According to Parsons, she was influenced by Newman's idea "that there was a relationship between the primitive world and the present world."[116]

In two of these primitivistic works from 1944–1945, *The Song of Orpheus* and *The Slaying of Osiris*, Newman used organic forms suggestive of the unconscious to pictorialize the tragic content of two ancient myths, both of which share numerous traits with the myth of Dionysus. Orpheus, a Thracian poet of Greek legend, used his divinely inspired music to secure the return of his wife Eurydice from the underworld of the dead (i.e., she was redeemed by art). But Orpheus ignored the warnings of Hades, and just before he set foot on earth, he looked back into the underworld and Eurydice disappeared. The women of Thrace were so angered at Orpheus's prolonged mourning that during one of their Dionysian orgies they tore his body to pieces. Despite Orpheus's power to restore the dead through his music, on account of his fallibility his story ends in his tragic dismemberment. Newman's selection of the divine musician as subject matter *cannot* be coincidental to his concern with tragedy. Tragedy, Nietzsche argues, is born out of the spirit of music, and "the essence of tragedy . . . can only be explained . . . as the visible symbolisation of music, as the dream-world of Dionysian ec-

stasy." Like the Dionysian musician, Orpheus symbolizes "primordial pain" and its "primordial re-echoing." Furthermore, according to Nietzsche, "the pictures of the lyrist [Dionysian musician] . . . are nothing but *his very self* . . . the only verily existent and eternal self resting at the basis of things."[117] Similarly, and with a tragic elegance, Newman wrote, "The self, terrible and constant, is for me the subject of painting."[118]

In the myth and ritual associated with the Egyptian deity Osiris, Newman may have seen parallels to the Hamatsa Society. For instance, not only is Osiris a "personification of the great yearly vicissitudes of nature," but according to Frazer, he redeemed the Egyptians from the savagery of cannibalism.[119] And Osiris, like Dionysus, is associated with the origin of wine, suffers dismemberment, is resurrected, and is celebrated with elaborate ritual. In giving form to this myth, Newman again eschewed a narrative transcription, focusing instead on abstract forms that signify growth.

Newman's treatment of these mythic subjects, and others such as *Gea* and *Pagan Void* (1946), represents his willingness to confront the Dionysian content of tragic modernity. The deprivations of the Great Depression and the brutality of World War II had demonstrated to Newman and his contemporaries that modern and primitive experience—as Nietzsche, Jung, and Worringer had suggested—were essentially the same.[120] Furthermore, the war, Newman explained, turned the terror of the unknown into the tragedy of the known: "We now know the terror to expect. Hiroshima showed it to us. We are no longer in the face of a mystery. After all wasn't it an American boy who did it? The terror has indeed become as real as life. What we have is a tragic situation rather than a terror situation. After more than two thousand years we have finally arrived at the tragic position of the Greeks and we have achieved this Greek state of tragedy because we have at last ourselves invented a new sense of all-pervading fate."[121]

Although he continued to reject the ideal form of Greek plastic art because it overempha-

Figure 5-3
BARNETT NEWMAN
Onement II
(1949).

Oil/canvas, 60" x 36".
Wadsworth Atheneum,
Hartford, Connecticut.
Gift of Anthony Smith.

existent unity.[124] But now, true to the idea of tragedy as an artform, the primordial expression, as given form by the zip, is secured and made to take its place in a logical order—an artifice of Newman's making. Despite the fiery passion of the painterly zip in *Onement I*, its iconic centrality, balance, and monumental repose speak of exaltation and of the sublime. Less than one year after Newman applied the zip in *Onement I*—thus beginning a mature articulation of the abstract sublime—his essay "The Sublime Is Now" appeared in *Tiger's Eye* (no. 6 [15 December 1948]).[125] Not only does this essay provide insight into Newman's artistic intentions, but it also reveals the link between those intentions and Nietzsche's view of "the *sublime* as the artistic subjugation of the awful."[126] For example, Newman begins by announcing that the legacy of the Greek ideal of beauty (Apollinian form) is the European artist's "moral struggle between notions of beauty and the desire for sublimity."[127] In this context, and with the paintings as witness, the desire for sublimity may be read as a desire for a tragic art: subjecting Dionysian content to Apollinian form.[128] Even the modernist revolution, Newman explains, represented "the rhetoric of exaltation" and not "the realization of a new experience." The result, according to Newman, was a modern art without a sublime content. He believed, however, that some of the American avant-garde, by refusing to capitulate to "the problem of beauty" at the expense of myth, exaltation, and abstraction, were making sublime art out of their own feelings.[129]

There is a sense of triumph over resignation in Newman's pronouncement that the sublime is now. Indeed, Newman was confident enough in 1949 to title a painting *Dionysus*. In keeping with his solution to the question of how to make sublime art, *Dionysus* is painting as an expansive theater of emotion, embodied in color and space. And yet, Newman's artistic will imposes the beauty of order on the orgy of emotion associated with Dionysus. From *Dionysus* issues that metaphysical comfort which Nietzsche assigns to all tragic art: "In spite of the perpetual

sized the Apollinian, his titles bear out his belief that "we can accept Greek literature, which by its unequivocal preoccupation with tragedy is still the fountainhead of art."[122] But the "tragic perception," according to Nietzsche, "even to be endured, requires art as a safeguard and remedy."[123] Thus, Newman's desire to make an art that would heal, transform, and redeem modernity was an essential element in his complex conception of the sublime. Furthermore, this desire for the sublime contributed to the drama, clarity, and even purity that first came into his art with the creation of *Onement I* (1948) and was fully articulated in *Onement II* (1948, Fig. 5-3). In these two paintings, the expressive "zip" (as he called it) that articulates the surface, which Newman had already begun to clarify in such works as *Moment* (1946), becomes an ideograph of Newman's "first man," who experiences, albeit in a tortured way, the primal

change of phenomena, life at bottom is inde-structibly powerful and pleasurable."[130] In the heroic *Dionysus* Newman locates the idea of redemption in the abstract sublime.

Indian Space Painting

Besides the myth-makers of Abstract Expressionism, the "Other" style of New York primitivism in the 1940s was Indian Space painting.[131] Responding to the highly stylized art of Northwest Coast, Pueblo, Inuit, and Inca Indians, the goal of the Indian Space painters, according to Ann Gibson, was to "draw the net of a seamless picture space as flat as a drum, [and] yet to base the referents within it on the *real* structures offered by concepts in the physical and anthropological sciences."[132] The resultant paintings are characterized by flat, all-over designs that balance organic and geometric forms; the incorporation of Native pictography; and an investigation of what might be described as the metaphysical vitality of a line in space (Figs. 5-4, 5-5). The term *Indian Space*, which referred to the nonillusionistic pictorial structures of aboriginal American art, was coined by Howard Daum, although he later regretted that it singled out exclusively the indigenous sources of the style.[133] In fact the work tended to be a highly syncretic fusion of "New World" forms, symbols, and structures and "Old World" modernism as taught by Hans Hofmann.

The progenitors of the style—Steve Wheeler, Robert Barrell, and Peter Busa—had been at the Art Students League and in Hofmann's classes together, and the Indian Space style issued from their desire "to equal or even surpass Picasso's Cubism by developing a new pictorial space . . . inspired by Native . . . art from both Americas."[134] In the early 1940s their work inspired a slightly younger group of artists, several of whom, including Daum, Gertrude Barrer, and Ruth Lewin, also studied at the Art Students League, where they were students of Will Barnet during a time when he stressed in his classes the spatial structures of Northwest Coast Indian art. This second group was associated with Kenneth Beaudoin's journal

Iconograph, which reproduced Indian Space paintings, and with his Galerie Neuf, which hosted an exhibition of their work in 1946: "Semeiology or 8 and a Totem Pole." *Semeiology* (as in Charles Peirce's "semeiotics") was the alternate term for Indian Space, preferred by some of the artists because it emphasized their interest in exploring the language of symbols.[135]

Like Paalen's *DYN*, Beaudoin's *Iconograph* was an important instrument for encouraging an awareness in New York of Native American art and for promoting an avant-garde primitivism derived from indigenous sources. In the first issue of the New York series of *Iconograph* (1946), Beaudoin observed, "We are looking at new runes this year: we are covering ourselves with strange magic devices, with strange, fantastic intellectual clothes." The "new runes" to which Beaudoin referred were the Indian Space paintings then on display at his gallery: "In New York this spring Wheeler, Barrell, Busa, Collier, Barrer, [Helen] DeMott, Sekula, [Ruth] Lewin, [Lily] Orloff, Daum, [Angus] Smith are painting a new magic out of old star-driven symbols rooted in an understanding of pre-columbian American Indian art, using it (not historically but) as a competent vehicle for current representational art. (For critical purposes I have referred to this group of painters as semeiologists . . . connoting the roots of the method to be in ancient runic-Amer-Indian art.)"[136] That same issue of *Iconograph* featured an article on "Typography," in which James Dolan, the journal's art director, used examples of Northwest Coast and pre-Columbian art to illustrate his premise that "alphabetic writing evolved only after the limited communication by oral language, gesture-sign, and picture riting [*sic*] became insufficient to express and record thoughts." Like Newman, Dolan was concerned with the relationship between "primitive art forms" and contemporary efforts at "forming a *picture* of an idea." Similar, too, was Dolan's belief that historically an "ideographic language" was the "primary measuring device by which man has oriented himself to the elements of time and space, that he might create order out of chaos."[137] However, in fairness to Dolan, and to

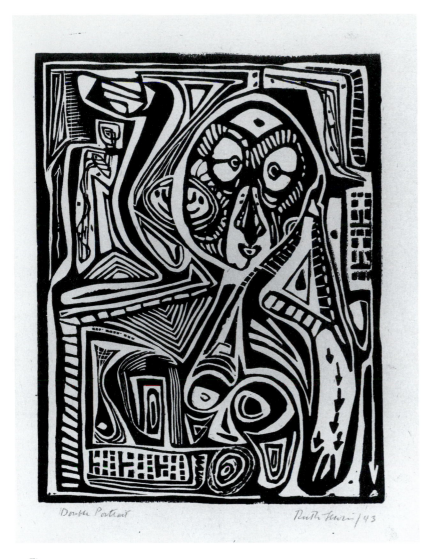

Figure 5-4
RUTH LEWIN
Double Portrait
(1943).

Woodcut, 9 1/2" x 7 1/2".
Private collection.
Photograph courtesy
Sidney Mishkin Gallery,
Baruch College,
City University of New York.

original art by Barrer, Jackson Pollock, Mark Rothko, and Stanley William Hayter. Furthermore, Beaudoin made the following editorial pronouncement in *Iconograph* (no. 4):

> It has occurred to the staff of *Iconograph* that they may have cause to feel proud that they were the first art magazine in America to recognize the influence which Indian art has had on a whole group of young American painters and to attempt to chart some of the directions in which it has carried them. We do not overlook Wolfgang Paalen's interest in Indian art and the influence *DYN* has had in America; but we did not overlook the importance of being in New York in 1946 where we were in a focal point to gauge the effect of his influence in terms of artistic results. We are proud to have been able to present to our audience the spoken literature of the Haida Indians (as recorded by eminent anthropologists) and to have printed art . . . which shows the terms in which Indian art has been introduced into the work of the young American painter.[139]

Gibson carefully and thoughtfully noted both the differences and similarities between Indian Space painting and the "myth-making" phase of early Abstract Expressionism. Barnet, Barrell, Busa, and Wheeler, for example, created works that "display two-dimensionality and all-over composition—awareness eventually demonstrated also in . . . the New York School." She observed also that these two groups shared the belief (which was commonplace in this period) that "the art of early cultures exhibited formal power and profound insights." However, the Indian Space painters, Gibson explained, although not indifferent to the idea that tribal art provides access to the unconscious mind, were more interested in the idea that the structure, as opposed to the process, of primitive art might "describe in a universal way man's perception of his environment." Thus, Indian Space represented a "less reductive, more linear, and specific aspect of abstract art" than that of the "myth-makers." Moreover, as she has made

Beaudoin, who was interested in the art of both Newman and Gottlieb, the exhibition "Semeiology or 8 and a Totem Pole" took place, and the first issue of *Iconograph* appeared, six months in advance of Newman's "Northwest Coast Indian Painting" exhibit and nearly ten months in advance of "The Ideographic Picture."[138]

Other issues of Iconograph continued this quintessentially 1940s' mixture of primitive and primitivist art. Northwest Coast art was a prominent element in *Iconograph* (no. 3 [Fall 1946]), with the inclusion of "The Girl Who Fed a Raven," a Haida folktale that was accompanied by a reproduction of *The Hunter* (c. 1946) by Gertrude Barrer, who was an art director for *Iconograph*. Likewise, *Iconograph* (no. 4 [Winter, 1946]) featured three Haida folktales collected by Franz Boas, and reproductions of

Figure 5-5
GERTRUDE BARRER,
Untitled I
(1946).

Oil/canvas, 15" x 14 1/4".
Collection of the artist and
Aurora Russell.
Photograph courtesy
Sidney Mishkin Gallery,
Baruch College,
City University of New York.

clear, some of the Indian Space painters differed from the "myth-makers" in their desire to make "real" abstractions based on hard-edged, planar geometry and on information about time and space gleaned from readings in twentieth-century physics and Bergsonian philosophy that reinforced their understanding of Northwest Coast art and myth.[140]

Steve Wheeler

Although Wheeler did not participate in the "Semeiology" exhibition at Galerie Neuf in 1946, and although his attitude toward the public discourse on Indian Space painting was always complex and contentious, it is generally agreed that he was the progenitor of the style, a point first made by Beaudoin in 1946 and reiterated by Clement Greenberg in 1947.[141]

Wheeler himself recalled that in about 1939–1940 he discovered in Northwest Coast Indian art "a striking confirmation of the universality of a style" he was then developing.[142] Indeed, such works as *Oedipus at Hoboken* (c. 1944–1946, Fig. 5-6) do appear to have strong debts not only to Northwest Coast but also to Pueblo Indian art. Like Northwest Coast carved chests and Chilkat blankets, *Oedipus at Hoboken* is marked by a severe *horror vacuii*, or in forties terminology, an all-over composition. Masks, birds, and other biomorphic, zoomorphic, and totemic forms are spread across the surface in a taut, hard-edged design. In several places the "space" between representational images is filled in with decorative patterns associated with Pueblo pottery designs: checkerboard, diamonds, and sawtooth forms. Thus, space as

Figure 5-6
STEVE WHEELER
Oedipus at Hoboken
(c. 1944–1946).

Tempera/paper, mounted on
board, 20" x 12".
Collection of Jeffrey S.
Podell.
Photograph courtesy Gallery
Schlesinger, New York.

Figure 5-7
STEVE WHEELER
Laughing Boy Rolling
(1946).

Oil/canvas, 36" × 45".
Collection of Whitney
Museum of American Art,
purchase, 47.3.
Photograph by Geoffrey
Clements Photography.

such is actually denied by Wheeler's use of flat patterns, and a single planar surface is defined. His *Laughing Boy Rolling* (1946, Fig. 5-7) is an almost archetypal example of modernist primitivism, synthesizing as it does Hofmann's push and pull of high-key color, a cognizance of Cubist structure and space, Wheeler's own ironic sense of humor, and Inuit, Inca, and other aboriginal designs and motifs. According to Sandra Kraskin, the imagery of this painting—tongues, mouths, and orifices—as well as its insistence on the "process of generation," is reflective of Northwest Coast Indian art's iconography of metamorphosis.[143]

But Wheeler resisted attempts to locate the stimulus for his work in Native American art, and with the exception of *Path of the Osages*, which he exhibited at the Feragil Galleries in New York in 1944, the titles of his paintings and prints generally do not refer to indigenous art or culture: *Good Morning Cézanne* (1940–1941), *Girl Whistling* (1946), and *Little Joe Picking His Nose* (1947). After a negative review by Clement Greenberg in 1947 in which he criticized Wheeler and the Galerie Neuf artists for being too derivative of Northwest Coast art, Wheeler circulated an open letter insisting that Greenberg's view of his art was at least "the result of a basic misconception." Wheeler informed Greenberg: "It would be of little use here to retrace the origin of this naive idea which you picked up and repeated. . . . That there are individuals and groups who insist and labor hard to convince others that their efforts have a relation to Indian art is a matter of record. These people have done everything to make this clear but despite the lack of evidence, I think we should believe them. Especially since

141

they seem to enjoy looking for a ruler by which they can measure each other's wampum." Wheeler also noted that his forthcoming artist's book, *"Hello Steve,"* would identify the basis of his work.[144]

Although Wheeler stated in 1947 that *"Hello Steve"* was forthcoming, advertisements for it appeared in numerous issues of the Surrealist journal *View* beginning as early as March 1945, where the images reproduced in the book were described as "pictographs." Similarly, the "Tropical America" issue of *View* (1945) also ran an advertisement for *"Hello Steve,"* which again referred to the "pictographs" and called the book "a salute to the new world."[145] The limited edition book, which was remarkably inventive and beautifully crafted, included thirteen photo silk-screen facsimiles of original "pictographs" and an essay by "Adam Gates," Wheeler's pseudonym.[146] The prints in *"Hello Steve,"* such as the frontispiece, *Ticket Please* (c. 1945–1947), do little to dispel Beaudoin's and Greenberg's belief that Native American art contributed to the development of Wheeler's "pictographs." Indeed, the critic who reviewed Wheeler's 1944 exhibition at the Feragil Gallery could easily have been describing *Ticket Please* when (s)he noted that they are "essentially crazy-quilts whose patches are borrowed from American Indian art, oriental prints, cubism, and abstractionism."[147] The linearity, compartmentalization of biomorphic forms, and organic unity of *Ticket Please* all suggest a cognizance of Northwest Coast designs, just as the continued presence of various decorative patterns used as a space-filler is probably an adaptation of Pueblo pottery decorations. Furthermore, the "liquidity" and almost magical transformation of one form into another is similar to the metamorphoses that take place in the Northwest Coast conception of "reality," wherein the relationships between humans and nature, and between myth-time and present-time, are fluid and dynamic.

Wheeler's texts, including *"Hello Steve"* and other related writing, are poetic and compelling explanations of his intentions. And, as he promised Greenberg, the basis of his work *is* illuminated by these texts, although they tend to support the idea that Wheeler was building on Indian art. In particular, the intellectual and spiritual motivations behind the linearity and transformative quality of the images is underscored by these texts. In "A Close Up of *'Hello Steve,'*" which first appeared in the *League Quarterly* and was later reproduced as a pamphlet promoting the book, Wheeler explained that he was altering and adapting "natural forms" according to the "humor or terror" that inspired him while painting. Not atypical of his generation, Wheeler had a rather romantic notion of the artist, who "alone has the real self-strong unflinching courage" to face "the taut line of reality." Also typical of the 1940s was Wheeler's existential reduction of ideas to black and white: "Experience in the in-between sense does not exist here. All of life, every little facet, each act, every little gesture is the big thing." He saw a clear distinction, too, between his work and "abstractionism," which he thought imposed limitations on reality: "If the motion of things in my pictures only existed on a local plane, how then would it be possible for me to show water turning into air, a smile into an umbrella, anger into heat into light, a nose into a fish."[148] This statement reveals the kinship between Wheeler's art and the transformative imagery of Northwest Coast art, both of which move playfully, almost magically along the continuum between representation and abstraction.

Writing as Adam Gates, Wheeler made similar statements in the text of *"Hello Steve"* itself. For example, although he was describing his own work, he might well have been thinking of Northwest Coast art when he observed that "the shapes become humanized into signs and symbols, projecting a code that constructs a living meaning" and that "the image constantly transforms itself." Furthermore, "Gates" explained that "by giving reality fullness and depth, Wheeler creates a morphological totem whose principal structure is the very process of consciousness." His conviction that "ecstasy Is The Beginning OF ALL ART" was a Dionysian one, and it had a remarkably existen-

tial, even Nietzschean basis: "Ecstasy, plus the shadow of misery, engages desire and is imprisoned in a work of art."[149] In the preface to *"Hello Steve,"* Wheeler made statements remarkably similar in content to ones made by Gottlieb discussed later in this chapter. He described his painting as "a fluid drama pushing the spectator into the substance of a world completely strange." His description of contemporary life, with its reference to violence and ritual, was similar also to Gottlieb's: "The present is here in all its tenderness and brutality. We cannot go back. Today life is turning the soul of man inside out. . . . Its essence is the spirit of discovery pushing hope, despair, violence—precision to the utmost. Out of this ritual of necessity our image is created."[150]

Peter Busa

Peter Busa's Indian Space paintings, like those of Wheeler, serve as a reminder of how New York primitivism in the late 1930s and 1940s developed in part as a response to museum anthropology. Like the myth-makers of Abstract Expressionism, the Indian Space artists were devoted students of the collections of Native American art in various New York institutions, including, among others, the American Museum of Natural History and the Museum of the American Indian. Barrell, for example, worked at the Hayden Planetarium adjacent to the Museum of Natural History, and like Barnet, Busa, and others, including Newman and Pollock, he collected the museum's publications on primitive art as well as the annual reports of the Smithsonian Institution's Bureau of American Ethnology. As for Busa, the "story" of his primitivism suffices as a description, generally speaking, of those of his colleagues as well. He read all the standard material of the period, including Graham's influential essay "Primitive Art and Picasso" (1937), Robert Goldwater's *Primitivism in Modern Art* (1938), and especially Franz Boas's *Primitive Art* (1928), which he studied carefully in the late 1930s. Boas's text, predicated on objects assembled by museum anthropology, discusses

primitive art as a collective category, thus allowing a single chapter to "feature reproductions of a Northwest Coast painted box, a Zuni jar, a New Guinea house, and several Peruvian textiles."[151]

Busa must have recognized an anthropologizing of form implicit in *Primitive Art*, since his work subsequently drew on Boas's illustrations of Peruvian textiles, Inuit masks, and Northwest Coast designs, as well as Surrealist notions of transformation. In *Children's Hour* (c. 1948, Fig. 5-8) he conjoins flat, abstract space (which modernist painting shared with Northwest Coast two-dimensional art), primitivist geometry, Inuit mask forms (the face of the cat at right center), and figuration derived from Peruvian textile designs (the slit eye and elongated nose of the profile face at the top).[152] The tight arrangement of large, flat, hard-edged forms suggests a child's jigsaw puzzle, and the playful gestalt of the painting references both Miró and Inuit art. *Children's Hour* is thus an icon of primitivism linking the freedom of childhood to both the "authenticity" of primitive culture and the liberation in

Figure 5-8
PETER BUSA
Children's Hour
(c. 1948).

Oil/canvas, 72" × 52".
Collection of Christopher Busa.
Photograph courtesy Sidney
Mishkin Gallery, Baruch College,
City University of New York.

143

Figure 5-9
Advertisement in *Iconograph*,
no. 1, for Peter Busa
exhibition at Art of This
Century Gallery
(Spring 1946).
Photograph courtesy
Peter Busa.

Figure 5-10
PETER BUSA
Original Sin
(1946).

Oil and enamel/canvas, 37" × 31".
Jane Voorhees Zimmerli Art Museum,
Rutgers State University of New Jersey.
Gift of the artist.
Photograph by Victor's Photography.

Figure 5-11
PETER BUSA
Figures
(c. 1947–1948).

Ink/paper, 18" x 24".
Collection of
Christopher Busa.

herent in modernism's willful subversion of traditional modes of representation. Such a painting exists as palpable proof that for Busa and the other Indian Space artists, the Museum of Natural History and its textual counterpart, Boas's *Primitive Art*, functioned as a "Bakhtinian" chronotope. According to James Clifford, "the term chronotope, as used by [Mikhail] Bakhtin, denotes a setting where (and when) certain activities and stories take place."[153] As the artistic double of Clifford's "anthropological *flâneur*,"[154] Busa's response was to create pictorial fictions that use "Indian spaces" and signs of "primitive times" to tell a specific story about the culture of modernity and a set of beliefs it held about preindustrial non-Western cultures, the evolution of consciousness, and the history of human artifacts.

In addition to sharing with Barrell and Wheeler the genesis of the Indian Space style, Busa was also linked to the Abstract Expressionists. Besides sharing the Abstract Expressionists' interest in Northwest Coast art, he participated, along with Pollock, Gerome Kamrowski, William Baziotes, and Robert Motherwell, in a short-lived group that formed around the Chilean Surrealist Matta in New York in the winter of 1941–1942.[155] In the spring of 1946, besides showing in the "Semeiology" exhibition, Busa had his first one-person show at Peggy Guggenheim's Art of This Century Gallery, where Pollock had his first solo exhibition in 1943. An advertisement for Busa's exhibition in *Iconograph* (no. 1 [Spring 1946]) reproduced a painting that features the biomorphic automatism associated with Surrealism (Fig. 5-9). However, the open-work linearity, the graphic whimsy, and the mobilelike appendages of the untitled image are also highly reflective of Inuit art.

Busa must have had a work such as *Original Sin* (1946, Fig. 5-10) in mind when he recalled that Pollock had seen his "drip works."[156] But more suggests a similarity with Pollock's painting than just the drip technique and the tangled linear web swirling around the central form.

145

For example, the jagged white form(s) at the lower left are reminiscent, in a general way, of certain passages in Pollock's *Birth* (Fig. 6-1) (c. 1938–1941). Pollock, of course, had experimented with dripped or poured paintings well before 1946, and as Busa himself pointed out, others were experimenting with this technique also.[157] Given the present lack of corroborating evidence, it would be premature to assume that *Original Sin* reflects Pollock's influence on Busa; but clearly they were going to the same well, so to speak. In reference to his drip works Busa spoke of "the Surrealist dictum . . . that there is a free agent,"[158] and he insisted later that his painting was "characterized by a blatancy that is very close to all primitive expression, such as . . . the American Indians."[159]

Despite the provocative title and use of biomorphic shapes in *Original Sin*, in Busa's opinion a clear distinction could be made between the contrived psychic aberrations of Surrealism and the images of the new post-Surrealist art in New York. In an interview in 1946, noting that the "history of painting is the history of ideas," he announced that "the last generation used to worry about how to go mad," while "our fight is to keep from going crazy."[160] This explains, perhaps, the sense of order and control that is present in much of his art, including works that drew on Northwest Coast and Eskimo art. For example, his *Figures* (c. 1947–1948, Fig. 5-11) shows two fantastic semiabstract, biomorphic/zoomorphic figures whose internal organs are seen via the so-called X-ray technique of the Northwest Coast. Furthermore, both the viscera of the figure on the left and the head of the figure on the right recall Inuit masks. And even though—or perhaps because—these imaginary creatures relate to primitive art and to Surrealist biomorphism, the forms don't "go crazy." The fluid shapes are sharply defined, as with Miró's Surrealism or Northwest Coast painting, suggesting that what Busa took from these traditions was a febrile image of poetic transformation that was controlled, in the Apollinian sense, within a restrained graphic order.

Both before and after his biomorphic works of 1946 Busa made flat, hard-edged, geometric abstractions (e.g., *Children's Hour*) which, according to Gibson, were cognizant of Piet Mondrian's "all positive" space and which sought "to overcome even the residual distinction between figure and ground that he saw in Cubism."[161] Some of these works, such as *Kachina* (n.d.), which Busa exhibited in the show "New Paintings" at the Bertha Schaefer Gallery in New York in 1951, make overt reference to Native American art, while others, such as *Horizontal after the Half Moon* (1952, Fig. 5-12), draw on the formal structures of Northwest Coast art. This latter painting, which was exhibited in the Whitney Museum's annual show of contemporary American painting in the win-

Figure 5-12
PETER BUSA
Horizontal after the Half Moon
(1951).

Oil/canvas, 64" x 43".
National Museum of
American Art, Smithsonian
Institution.
Gift of Emil J. Arnold.

ter of 1952–1953, maintains a latent sense of totemic figuration. And as in the compositions of Northwest Coast carved chests, Busa has fitted rectilinear and softly rounded geometric forms together in a taut design that exists on a single surface without any overlapping. In its linear clarity, latent (abstract, totemic) figuration, and squeezing out of illusionism, Busa's work in the late forties and early fifties is very close in style to paintings made in this period by Will Barnet.

Will Barnet

Although Barnet did not exhibit in the "Semeiology" exhibition at Galerie Neuf, he had a direct impact on the development of the style when he took his Art Students League classes to various New York museums, where he pointed out the abstraction of form and flattening of space in Northwest Coast art, as well as the cultural vitality that prompted such work. He was drawn to the "tension-laden relationships" of Northwest Coast art because they suggested the strength necessary to contain dynamic conflicts[162] and because he saw distinct parallels between "the dynamism of Indian society" and the dynamism of American society of the 1940s.[163] Starting in the late 1940s Barnet began to incorporate the aesthetic principles of various Native American traditions in his own work, and by the early 1950s he was producing works such as *Fourth of July* (1954, Fig. 5-13), which, although indebted to the totemic forms and spatial concepts of Northwest Coast art, are very much his own. The figuration in *Fourth of July* is a fully abstracted one, and the clarity and visual logic of the internal structure are compelling. According to one critic, the images in this work "have been reduced to their most essential structures and rearranged and merged to create a larger ideographic whole"[164]—essential structure and ideographic unity being precisely the kinds of aesthetic values that Barnet admired in Native American art.

Barnet's interest in Native American art began during his childhood when he saw the collections of the Peabody Museum at Harvard. Like his contemporaries, he collected and read a variety of ethnographic publications, including the writings of Franz Boas and especially the *Annual Report of the Bureau of American Ethnology* (hereafter cited as *BAE Report*), which featured Indian pictographs that had a marked influence on his creation of abstract symbols. As a result of these varied sources Barnet came to appreciate not just Northwest Coast and southwestern Indian art but "all the Indian cultures." His fascination with Native American art resulted from three interactive kinds of needs—sociological, aesthetic, and psychological—that were made manifest in his paintings and prints.

Boy in Corn (1945, Fig. 5-14) was one of his first painterly responses to the aboriginal culture on which he was focused in the forties. The child, rendered in broad, simplified forms, is locked into space by various geometric patterns contiguous to his body that are taken from Pueblo pottery. At the right are two large ears of corn, the food around which many Indian cultures were organized. Barnet had seen

Figure 5-13
WILL BARNET
Fourth of July
(1954).

Oil/canvas, 52" x 38".
Courtesy of Will Barnet.

Figure 5-14
WILL BARNET
Boy in Corn
(1945).

Oil/canvas, 22" x 26".
Current location unknown.
Photograph courtesy
Will Barnet.

the geometric motifs of early Hopi pottery illustrated in the *BAE Reports* he owned and was impressed by the fact that "the Hopis were selecting objects to express nature symbolically." The choice of corn—the quintessential (Native) American food—relates to Barnet's desire to create "a real, a true American painting." In fact, he recalls emphatically that he "did not want to be a European" and that in his "search for American values," he used Indian art/designs to establish his identity as an *American* artist.[165]

In at least two works from 1947 Barnet continued aesthetic experiments that merged modernist formalism with Indian designs, which, in his understanding, were signs for emotional responses to the complexity of nature. He describes *Woodland Lore* (1947, Fig. 5-15) as a

watershed painting in his effort to assimilate modernism: "A finalizing of my cubistic experiments, . . . it has large, vertical, planar divisions and a complexity of space." The angular facets, decorative geometry, and feather shapes are taken, perhaps, from Indian designs, but the title itself refers to the plethora of insects, birds, and animals that populate both the picture and "the primitive countryside," as Barnet described the setting in upstate New York where he was then living. In symbolizing "small things against the mass of nature," Barnet uses an architecture of skewed and intersecting geometric forms to convey what he called the "rising and falling levels of nature." In *Strange Birds* (1947), a lithograph that relates thematically to *Woodland Lore*, Barnet uses decorative patterns, zig-

zag, and feather motifs inspired by Hopi pottery to imply the primordial nature of these enigmatic birds. The more angular, totemic bird at the left, with its abstract rectilinear head, is an example of Barnet's commitment to "a combination of geometry and imagery," a phrase that aptly describes many examples of both Hopi and Northwest Coast art.[166]

Summer Family (1948, Fig. 5-16) and *The Awakening* (1949, Fig. 5-17) are examples of works in which Barnet evokes the forms and structures of Northwest Coast art in an effort to achieve a composition that "went beyond Cubism in some of its spatial aspects." Although he lectured on Juan Gris at the Art Students League in the late 1920s and the 1930s and admits that Gris's work exerted a "planar influence" on him, as "an American painter" he "wanted to break away from Cubism." In both of these primitivistic paintings, abstract linear design and totemic verticality are greatly emphasized, and each of the figures has a simplified, masklike face. In particular, the totemic figure in the middle of *Summer Family* and the one at the far left of *The Awakening* feature biomorphic shapes contained within rectangular compartments and are clearly derived from Northwest Coast totem poles or carved house posts. However, Barnet has always seen these works, and others related to them, as representing something more than the borrowing of Indian symbols. Rather, he was responding to the "sophisticated structures" Native American artists had "for interpreting their emotions." Incorporating Northwest Coast and Pueblo designs was a way, therefore, for Barnet to develop a personal, yet American, form language through which to relate his own emotional experiences.[167] However, even though *Summer Family* and *The Awakening* have a provocative spatial ambiguity, the "all-positive" space that Barnet admired in geometric abstractions from the Northwest Coast was not realized in his own work until the representational elements were transformed into abstract symbols (e.g., *Fourth of July*).

As Barnet explained it, *The Awakening* represented the elimination of "realistic space" and the substitution of "a painting space based

purely on the rectangle: the vertical and horizontal expansion of forms."[168] It is this seemingly organic expansion of abstract forms around the figures that compresses the space within the picture. This sense of compression was intensified in several paintings and prints Barnet made after 1949, in which latent figuration evolved into symbolic forms derived from Northwest Coast art. For example, in *The Cave* (1950–1951, Fig. 5-18), Barnet "was searching for an immediate structure" that he could keep "right on the surface, compressing it."[169] In this key painting, which initiated a whole series of abstractions, including *Janus and the White Vertebra* (1955, Fig. 5-19), organic shapes breathe, swell, and push against each other in a tight, flat design that is contained claustrophobically by the hard rectangle of the picture support. The tension between the two lingering remnants of primitive figuration was described by Barnet as a psychological relationship "between the child and the man in a cave." In this portrait of Barnet and his son he "tried to use every inch of canvas as a shape, every form was to be responded to as being an image." Here, he felt, was the "all-positive" space he had been searching for, and furthermore, the relationship between the forms symbolized the "inner struggle of people where the cave idea sometimes dominates a certain period."[170] In discussing *The Cave* and other works from this period, Barnet compares the environment of the city and personal compression with the compressed pictorial space in the work. Because he wanted to pictorialize with "honesty and feeling" the very real emotions of living in the modern cave, it was logical for Barnet to create abstract symbols based on Indian art. Hopi artists, he explained, "caught the overwhelming dynamism of fear and fright about thunder and lightning," and he, too, needed a comparable form language for such emotions.[171]

Barnet's abstractions from the late 1940s "evolved from the subconscious to some extent." But he saw his use of this primal material as being quite different from Abstract Expressionism: "It was formalized into painting—Pollock and Gottlieb left it in a raw state, and I

Figure 5-15
WILL BARNET
Woodland Lore
(1947).

Oil/canvas, 22" x 26".
Current location unknown.
Photograph courtesy
Will Barnet.
Photograph by Helga Photo
Studio.

Figure 5-16
WILL BARNET
Summer Family
(1948).

Oil/canvas, 34 1/8" x 44 1/8".
Philadelphia Museum of Art,
Samuel Fleisher Memorial.

Figure 5-17
WILL BARNET
The Awakening
(1949).

Oil/canvas, 42" x 52".
Currier Gallery of Art,
1986.43.
Gift of Elena and Will
Barnet.

Figure 5-18
WILL BARNET
The Cave
(1953).

Oil/canvas 36" x 28".
Collection Neuberger
Museum of Art,
State University of New York
at Purchase.
Gift of Henry Pearson.
Photograph by Jim Frank.

Figure 5-19
WILL BARNET
Janus and the White Vertebra
(1955).

Oil/canvas, 41 1/8" x 23 7/8".
National Museum of American
Art, Smithsonian Institution.
Gift of Wreatham
E. Gathright.

refined it." Indeed, throughout the decade of the fifties and into the sixties, Barnet made a series of hard-edged, totemic abstractions marked by their "all-positive" space, which he described as austere, classical expressions of Indian culture. Nevertheless, he insists that the Indian-inspired forms in such paintings as *Male and Female* (1954) and *Janus and the White Vertebra* symbolize powerful emotions. He has speculated that because at the time "the interest was in the immediacy of expression," and because these works were not overtly raw and painterly, their emotional content was overlooked or misunderstood. Arguing that these carefully composed, tightly drawn images possessed the power to convey abstract emotions, Barnet observed that "the hard edge, as compared to the painterly edge, is like the white flame, as opposed to the red flame."[172]

Oscar Collier

Collier, who had studied with Phillip Guston at the University of Iowa, was an associate editor of *Iconograph* and exhibited in the "Semeiology" exhibition in 1946. Through his friendship with other Indian Space artists, notably Robert Barrell, he acquired a great appreciation of southwestern and Northwest Coast Indian art, as well as of Central and South American textiles. He was attracted in particular to blankets and carved chests and recalled being affected by Boas's translation of Haida myths.[173] In the spring of 1945 he traveled to Santa Fe and Taos, where he visited museums and private collections and purchased Zuni and Hopi pottery. In the fall of 1946 Beaudoin wrote in *Iconograph* that as a result of this trip to New Mexico, Collier had discovered a more satisfying "method of pictorial articulation."[174] Curiously, in his discussion of Collier's use of a primitivistic "pictorial metaphor," Beaudoin does not mention the artist's interest in Northwest Coast art, although he does refer to his presence in the Indian Space exhibition the previous spring.

Collier was drawn to the Indian Space paintings of Busa and Barrell, in which he recognized the influence of Miró, but he thought,

nevertheless, "that theirs was more pure and more useful." Barrell taught him the Indian Space technique, which, he observed, "was a natural and easy style for me." In fact, he had a strong facility for developing abstract linear structures with debts to a number of Native American traditions that he admired. In *War Gods III* (c. 1946, Fig. 5-20) Collier activates the entire picture surface with a tight mesh of geometric and organic forms that although nonspecific, are clearly of Native American derivation. The forms are both totemic and self-generating as the design spreads itself almost willfully across the two-dimensional surface. Thus, they embody a characteristic he admired in Navajo sand painting: the stretching and spreading of shapes.[175] Serpentine elements, mountain symbols, step-fret designs, crosses, and scroll motifs spawn at a dizzying rate within a Cubist grid. The linear movements and decorative patterns are hard-edged, and yet the overall image is one not of clarity but of confusion, as if he had simply tried to transport more ancient information into the present than his pictorial structure could bear.[176]

Part of Collier's goal was to translate some kind of ancient content into a language accessible to modern experience. Thus *War Gods III* appears to be "written" in an alphabet both primitive and modern. Beaudoin, who recognized in Collier's "primitive paintings" a deliberate and specific interest in traditional Indian art, saw evidence also of "a hunger for the more meaning-packed form, the more suggestive form." Ultimately, Beaudoin wrote, Collier's new "pictorial alphabet" might make possible "the more precise communication of the emotional and ideational drive behind the painting of a picture." However, according to Beaudoin, Collier's efforts had already yielded "a richer, more communicative art object for anyone sufficiently interested and imaginative to trace the symbolic roots of the forms."[177] In fact, on those occasions when Collier's hunger for packed form gave way to a more precise, more elegant form, the Native American origins and American essence of the sign language were far more intelligible. In *The Dog* (c. 1946, Fig. 5-21), where Collier has abandoned the

horror vacuii that characterizes *War Gods III* in favor of a more open-work space in which a single ideograph is "written," the clarity, and therefore the content, of the sign is greatly enhanced.

Clearly, the content of *The Dog* relates to Collier's desire to "write" about the primitive nature of modern experience in an American, not European, abstract visual language that possessed a human element missing in *l'art pour l'art*. Even if the absolute meaning of *The Dog* is equivocal, its essentially American character is inescapable; furthermore, Collier insisted that even abstract art should exist in relation to human beings. The Americanness of an ideograph such as *The Dog* or Collier's sketch for *The Cowboy and the Rattlesnake* (c. 1946, Fig. 5-22) is best understood in terms of his introduction to Indian Space. He recalled that both Wheeler's and Barrell's interest in Native American art was ideological and that, except for those following Piet Mondrian, "everybody had some interest in American Indian art." By *ideological* Collier meant that "those in our group had a powerful desire to establish an American art." The Indian Space painters, he insisted, "had something real to say, and we wanted a visibly different modern art that was recognizably American."[178]

The Indian Space painters' desire to establish an American modernism based, in part, on Native American sources, was shared, of course, by the myth-makers of early Abstract Expressionism. Although the two groups represented conflicting artistic paradigms, the boundary between the two camps was permeable, and furthermore, the oppositional quality of the two groups was not necessarily evident to all the participants at the time. Busa was on friendly terms in the early 1940s with Pollock and others who were experimenting with Surrealist automatism, and he felt comfortable, apparently, exhibiting his works at Guggenheim's gallery where both Surrealist and early Abstract Expressionist works were shown. And although Sonia Sekula showed her paintings in the "Semeiology" exhibition, she was a part of André Breton's circle, not Beaudoin's, and she was friends also with Betty Parsons (who dealt

in Abstract Expressionist paintings), with whom she exhibited totemic paintings in 1948.[179]

Beaudoin himself is evidence that the differing kinds of abstractions being developed in the mid-1940s had not yet hardened into doctrines or paradigms. Even as he was promoting Indian Space abstraction, Beaudoin was expressing an interest in the early Abstract Expressionism of Newman and Gottlieb, and in *Iconograph* (no. 4 [Winter 1946]) he published a painting by Rothko and Pollock's *Search for a Symbol* (1943).[180] The last version of the journal, which was retitled *The New Iconograph* (Fall 1947), edited by Collier and Jean Franklin, featured eight of Rothko's primitivistic, biomorphic paintings, including *Gethsemane* (1945). In the brief entry accompanying them, Collier announced that there were no elements in Rothko's style "that would enable one to classify it either as abstract, surreal, or non-objective."[181]

Ultimately, the strongest link between the Indian Space painters, who were themselves not a homogeneous group either aesthetically or ideologically, and the myth-makers of early Abstract Expressionism was their keen awareness of Native American art. As a result of visiting the same museums and reading the same materials, both groups were prompted by Native American pictographs, designs, and abstract symbols to create primitivistic ideographs that signified their intense and often ambivalent feelings about modern experience. Within the two paradigms was tacit agreement that the real ideas and meaningful content of the present could be expressed only by means of a new sign language derived from the "primitive" visual "grammar" of American Indians. Reflecting on this aspect of the early New York School, Robert Goldwater wrote in 1960, "Seen historically, these 'signs,' 'pictographs,' and symbolized nuclei, which tended toward the American Indian . . . were a sea-change on the more personal symbols of Surrealism. The Freudian reference, still present with [Arshile] Gorky, was now replaced . . . with overtones that were social, or cultural . . . and often meant to bring to mind a Native American past."[182]

Figure 5-21
OSCAR COLLIER
The Dog
(c. 1946).

Illustrated in *Iconograph*, no. 3 (Fall 1946).
Current location unknown.
Reproduced by permission of the artist.

Figure 5-22
OSCAR COLLIER
sketch for *The Cowboy and the Rattlesnake*
(c. 1946).

Illustrated in *Iconograph*, no. 3 (Fall 1946).
Current location unknown.
Reproduced by permission of the artist.

OPPOSITE
Figure 5-20
OSCAR COLLIER
War Gods III
(c. 1946).

Illustrated in *Iconograph*, no. 2 (Summer 1946).
Current location unknown.
Reproduced by permission of the artist.

The Myth-Makers

Some of the artists involved in the making of new signs (and myths), such as Rothko, showed their works in Newman's exhibition "The Ideographic Picture." Although Pousette-Dart, Gottlieb, and Pollock did not exhibit in "The Ideographic Picture," they, too, were inventive in their manipulation of signs from the Native American past for contemporary myth-making. Despite dissimilar backgrounds and temperaments, these three painters produced a body of work in the 1940s with many more common elements than they would ever have wanted to admit.[183] No small measure of the commonality in these myth-oriented, primitivist canvases may be attributed to the artists' shared interest in Native American art. Pousette-Dart, Gottlieb, and Pollock all created works whose respective titles, imagery, and coarse surfaces evoke the dark, totemic underworld of subterranean ritual: *Night World* (1948); *Night Forms* (c. 1949–1950); and *Night Sounds* (c. 1944), respectively. Pousette-Dart alluded to this common evocation in the 1940s of a subterranean world: "Many times I felt as if I were painting in a cave—perhaps we all felt that way, painting then in New York."[184] Likewise, all of these myth-makers made what are best described as telluric pictures—elemental signs, zoomorphs, and petroglyphs in stratified layers on seemingly primordial surfaces— the visual remembrances of ancient experience in the Americas.[185]

Richard Pousette-Dart

Like both Barnet and Pollock, Pousette-Dart's awareness of American Indian art dates from his youth. His father, noted painter, lecturer, and art critic Nathaniel Pousette-Dart, owned Native American objects and books on the subject and encouraged his son's interest. Indeed, Pousette-Dart still had in his home, at the time of his death in 1992, two pieces of Northwest Coast sculpture: one had previously hung in his father's studio, and the other he had given to his father as a gift.[186] A basically self-taught artist, Pousette-Dart came to know more about Native American art and other primitive arts from his frequent trips to the American Museum of Natural History, as well as from various books and exhibitions. Like Gottlieb, Newman, and Pollock, Pousette-Dart was acquainted with Graham, whose personally inscribed *System and Dialectics of Art* he owned and from whom he purchased primitive objects. As a result of these experiences Pousette-Dart came to believe that primitive artists had most clearly defined "the principles of dealing with pure form."[187]

Pousette-Dart's notebooks from the late 1930s and early 1940s show that like Graham, he, too, noted the distinctions between the conscious and unconscious mind: "Art is the resulting manifestation of the conscious mind reacting upon a submind spirit—the crystallization resulting when they meet—unknown experience reacting upon known experience creating a superhuman mystic body."[188] In 1985 he reaffirmed this belief: "Every whole thing has to do with the conscious and the unconscious—the balance, the razor's edge between the two. My work is the spirituality of that edge."[189]

An analysis of Pousette-Dart's art in the context of Native American traditions is appropriate, for he believed that his early work "had an inner vibration comparable to American Indian art . . . something which has never been perceived [before]. I felt close to the spirit of Indian art. My work came from some spirit or force in America, not Europe."[190] Perhaps the earliest of his paintings to reference Native American motifs is *Untitled, Birds and Fish* (1939), which he related to the Northwest Coast forms he had seen at the Museum of Natural History, although the composition is similar to that of Graham's *Blue Abstraction* (1931), which he once owned.[191] According to Robert Hobbs, in *River Metamorphosis* (1938–1939) Pousette-Dart associated Northwest Coast eye forms with the "mythic waters of the 'unconscious'"—that is, with the "atavistic and symbolic ways of seeing that modern people [may] still retain in their unconscious minds."[192] Similarly, in *Primordial Moment* (1939, Fig. 5-23), Pousette-Dart represents his subject (genesis and/or first growth) with a variety of shapes, patterns, and, especially at the upper right, mythic animals derived from Northwest Coast totemic sculpture.

Figure 5-23
RICHARD POUSETTE-DART
Primordial Moment
(1939).

Oil/linen, 36" x 48".
Estate of the artist.
Photograph courtesy
Indianapolis Museum of Art.

Figure 5-24
RICHARD POUSETTE-DART
Desert
(1940).

Oil/canvas, 43" x 72".
Collection of Museum of
Modern Art, New York.
Given anonymously.

Figure 5-25
RICHARD POUSETTE-DART
Bird in the Wind
(1942).

Oil/linen, 26 1/4" x 44 1/4".
Estate of the artist.
Photograph courtesy
Indianapolis Museum of Art.

A number of Pousette-Dart's paintings from the early forties, including *Desert* (1940, Fig. 5-24), *Abstract Eye* (1941–1943), and *Bird in the Wind* (1942, Fig. 5-25), are characterized by masks, fish and bird forms, and a tight interplay on the surface of organic and geometric forms locked together with a dark linear grid. As such they are highly reminiscent of the deeply moving Northwest Coast designs that he saw on "painted boards, tied together and painted with heavy black lines." In *Desert*, both the title and the rough, heavily impastoed, earthy surface also suggest southwestern native culture. Thus, it is instructive to note that Pousette-Dart felt sympathetic to the idea of Indian sand painting. He

likened the courage and the spirit of the sand painters and the impermanence of their materials to his own description of "the meaning of the artist" as one "who deals with the moment and eternity."[193] The surface and structure of *Symphony Number 1, The Transcendental* (1941–1942, Plate 9), the first "big picture" of Abstract Expressionism, continued his investigation of Indian traditions, orchestrating them on a heroic scale. Besides including birdstones and bannerstones—artifacts from Eastern Woodlands culture—*Symphony Number 1* pictorializes an "iconography of process,"[194] inviting once again comparisons with Navajo sand painting,

Figure 5-26
RICHARD POUSETTE-DART
Palimpsest
(1944).

Oil/canvas 49 1/2" x 43".
Current location unknown.
Formerly collection of Mrs.
Maximillian Rose.
Photograph by Geoffrey
Clements Photography.

which locates meaning in the indivisibility of image and process.

Because Pousette-Dart was especially attentive to the tactile surface of his primitivist paintings, he was successful in presenting emblems of the structural relationship between conscious and unconscious mind as it was conceived in the forties. Sigmund Freud, C. G. Jung, and even Jacques Lacan conceptualized that relationship in terms of stratified layers, such that as consciousness evolves, information and experience build up in strata like an archaeological site, where the present is associated with the surface, and the primordial and elemental are situated in the darkest depths. Works such as *Abstract Eye, Desert, Palimpsest*

(1944, Fig. 5-26), and *Figure* (1944–1945, Fig. 5-27) reflect an ancient American aboriginal tradition of painting and/or incising abstract and figurative images on the earth itself. The compelling images of Native American rock art are composite creations consisting of countless layers built up on the surface, sometimes over millennia. So, too, Pousette-Dart overpainted heavily, building up richly impastoed layers of primitivistic images that synthesize iconicity and indexicality. He sought to create iconic signs—marks and shapes that resemble Native American marks and shapes, and which symbolized for him a pure (primitive) form of con-

Figure 5-27
RICHARD POUSETTE-DART
Figure
(1944–1945).

Oil/linen, 79 7/8" x 50".
Estate of the artist.
Photograph courtesy
Indianapolis Museum of Art.

visual information on top of the old. The concept/title of palimpsest appealed to him because "he liked the idea of engraving over and over," an idea that simulated his own "process of evolving."[197] Palimpsest—rewriting the layers of the self—pictorializes not only the structure of the Jungian unconscious usually associated with forties primitivism, but the Lacanian as well. Jacques Lacan reconsidered the idea of the unconscious in light of a diachronic approach to linguistics and structural anthropology and decided that the structure of the unconscious is similar to that of language. Indeed, for Lacan, it is language that provides the conditions for the development of the unconscious.[198] Furthermore, in Lacanian theory, conscious discourse is conceived as being "like those manuscripts where a first text has been rubbed out and covered by a second." In such manuscripts, "the first text can be glimpsed through the gaps in the second," and the "true speech—the unconscious—breaks through usually in a veiled and incomprehensible form."[199] And so Pousette-Dart's *Figure* might be described in the following manner: in an unexpected reversal, the underpainting—call it the first text or primal image—appears to consist of a rectilinear geometry. In other words, it is less intuitive, not more, and is partially erased or hidden by an apparently frenzied overpainting—call it the "raw" second text. Like that curious nexus where the last moment of dream overlaps with waking consciousness, visual language is torn open in *Figure*, and the text of the primitive unconscious appears to us in a veiled and fragmented form. There is momentarily a tantalizing but frustrating glimpse into dream, metaphor, metonymy, déjà vu, and the other languagelike forms of the unconscious. Ruptured bits of primitivist narrative show themselves fleetingly but are immediately covered, dissolved, transformed by Pousette-Dart's palimpsest.

In considering the evocation of the archaic inherent in Pousette-Dart's telluric surfaces, it is useful to note that rock art, especially that found in caves and rock shelters, has often been

sciousness. And yet, his attention to, and desire for, a richly wrought surface suggests an interest in creating an indexical sign, one which, according to Richard Shiff, "works by a causal connection; it refers to its own origin by 'representing' or indicating the physical process that brought it into being."[195] Thus, the tactility issuing from all this layering is an indexical sign of a pictographic painting performance.[196]

As one of his titles demonstrates, Pousette-Dart associated his pictographic/petroglyphic surfaces with the idea of *palimpsest*, which is to obscure or partially erase earlier versions of a text (surface) by "rewriting," or inscribing new

linked to shamanism. This recalls Pousette-Dart's memory of "painting in a cave," and such paintings as *Night World* do imply the dark realm of myth, memory, and dream that the shaman seeks to explore in his state of transformation. As Pousette-Dart himself said in describing the affinity between the idea and the function of painting, "an artist is a transformer."[200]

Adolph Gottlieb

In the 1940s Gottlieb also explored the realms of the "Other," both ancient and psychological, in paintings that merged the structures, images, and surfaces of Indian art with themes and titles taken from Greek mythology. Like his contemporaries, he had intellectual and aesthetic justification for his belief in the value of Native American art. By his own recollection, he knew through his reading about Jung's idea of the collective unconscious, which interested him.[201] From his friend Graham, Gottlieb acquired a taste for primitive art (which he began collecting in 1935) and a belief in the collective nature and spontaneous, "unconscious" expression of the primitive arts. The primitivism of his own *Pictographs* series, 1941–1951, is a reflection of these ideas.[202] Graham gave Gottlieb a copy of *System and Dialectics of Art,* parts of which can be interpreted as instructions for making pictographs.[203] Furthermore, Gottlieb expressed great interest in the Indian art that he saw at the Arizona State Museum during his stay in Tucson in 1937–1938; he wrote of the weavings and ancient pottery on display, "I wouldn't trade all the shows of a month in New York for a visit to the State Museum here."[204]

Gottlieb also became familiar with Native American art, especially that from the Northwest Coast, from his visits to New York museums with Newman. In particular he would have been familiar with the collection of Indian art at the Brooklyn Museum, which was close to his home and where he exhibited watercolors in various exhibitions between 1934 and 1944. He probably saw the the Indian paintings and sculptures from Arizona and New Mexico exhibited there in 1940. It also seems likely that Gottlieb

would have attended "Indian Art of the United States" at the Museum of Modern Art in 1941, which included a full-scale canvas mural facsimile of ancient pictographs found at Barrier Canyon in Utah. Certainly Gottlieb would have seen his friend Newman's exhibition of "Northwest Coast Indian Painting" at the Parsons Gallery in 1946.

Gottlieb's inclusion of Native American forms in his paintings was predicated on his belief that all primitive and archaic art has a spiritual content accessible to anyone familiar with the "global language of art," which functioned as the "language of the spirit."[205] In defending the use of primitive art as a model for contemporary art, Gottlieb revealed his awareness of both Jungian psychology and Graham's conception of tribal art as the embodiment of race memory: "If it is true that it does not matter what the artist paints, why are so many attacks made on subject matter, i.e., totemic themes, race memories, etc.? . . . If it was right for Delacroix and Mattisse [*sic*] to travel to far and strange places like Tunis and Tahiti for subjects, what is wrong with travelling to the catacombs of the unconscious, or the dim recollections of a prehistoric past?"[206] In a similar defense of the mysterious and primitive subjects of contemporary art, Gottlieb stated that the "apparitions seen in a dream, or the recollections of our prehistoric past" were real and a part of nature.[207] In fact, this describes his own *Pictographs* series: apparitions seen during shamanic trances or mythical images from the collective prehistory, preserved in the early stages of symbol-making.

Although Gottlieb's *Pictographs* do make reference to African and Oceanic arts, the significant impact of Native American art on his enigmatic and eclectic series of paintings is revealed by two critical facts. First, Gottlieb himself chose to call his series of primitivistic paintings *Pictographs*. Second, he began them only after ancient pictures-on-the-earth from Barrier Canyon were reproduced at the Museum of Modern Art. Indeed, there is a provocative similarity between *Pictograph-Symbol* (1942, Fig. 5-28) and the illustration on the printed endpapers of the 1941 catalogue *Indian*

Figure 5-28
ADOLPH GOTTLIEB
Pictograph-Symbol
(1942).

Oil/canvas, 54" x 40".
Adolph and Esther Gottlieb
Foundation, Inc., New York.

Art of the United States (Fig. 5-29). Both might be described as having totemic masks, zoomorphs, and abstract forms, both geometric and organic, painted in a palette of earth tones and contained in the rectangular compartments of a grid formation.

The influence of Southwest Indian art was apparent even before that of the Northwest Coast in Gottlieb's *Pictographs*. The earth, clay, and mineral colors that came into his palette when he was still in Arizona and that continued in many of the *Pictographs* are reminiscent of the buffs, browns, tans, and rust colors of the Pueblo pottery on display at the Arizona State Museum.[208] Likewise, Gottlieb adopted the rough surfaces of real pictographs, as well as noting how the Pueblo potter adjusted figurative and abstract images to an overall design on a flat surface. Some of these modern *Pictographs*, including *Evil Omen* (1946), contain "site and path" motifs—concentric circles signifying encampment or occupation of the earth that straighten out into a line of travel—typical of Southwest art and pottery in general and specifically resembling the Barrier Canyon pictographs.

The structure of Gottlieb's *Pictographs* is no doubt related to Northwest Coast art, particularly Tlingit Chilkat-type blankets (Plate 8), as well as to other precedents in twentieth-century art.[209] Gottlieb's purchase of one blanket in 1942 postdates the beginning of his *Pictographs* series, but from his museum visits he certainly would have known the Northwest Coast convention of bisecting animal forms and presenting these flat and seemingly abstract sections of the body in compartments.[210] For example, when Newman wrote about Gottlieb's *Pictographs* in 1945 he explained this Northwest Coast convention for rendering "internal structure" in some detail and observed that "Gottlieb's canvases are built on a similar two-dimensional space, which he divides into 'pictographic' areas."[211] In fact, some of the later *Pictographs*, such as *Night Forms* (c. 1949–1950, Fig. 5-30), do have a surface organization reminiscent of Gottlieb's Chilkat blanket.[212] After Newman's exhibition of Northwest Coast art in

1946, totemic imagery appeared more frequently in Gottlieb's *Pictographs* and ensuing *Unstill Lifes*. *Pendant Image* (1946, Fig. 5-31) has as the lower part of its central image a pair of bear's ears, which are animated with eyes. This is a typical convention of Northwest Coast painting and sculpture, seen for example in the house screen of Chief Shakes (Plate 7) collected by Wolfgang Paalen. *Vigil* (1948, Fig. 5-32) shares with some of Gottlieb's paintings after 1946 a vertical format derived from carved totem poles.[213] The two pole units left of center in *Vigil* feature mysterious hybrid animals that transform themselves into other totemic forms. This organic transformation of one pictorial unit into another is, again, a convention of Northwest Coast art.

Gottlieb used this totem pole format for the iconic central form of *Ancestral Image* (1949, Fig. 5-33), one of his early *Unstill Lifes*. Besides the painting's obvious verticality, its title also signifies totem poles, which are representations of mythical ancestors—progenitors of the clans. The description of totem poles in the catalogue *Indian Art of the United States* notes that "they either display family crests or relate family legends, and were erected as memorials to dead leaders."[214] The mask/face that Gottlieb placed atop the pole is nearly a direct quotation of a Nishka shaman's mask from the Nass River region of British Columbia that depicts a cannibal spirit whistling to lure its victim (Fig. 5-34). From the permanent collection of the Museum of the American Indian, this mask was exhibited at the Museum of Modern Art in 1941. Both stylistically and iconographically—the puckered mouth implying whistling—the mask is similar to Kwakiutl masks representing Tsonoqua. A female ogre who devours children after luring them to the woods with her whistling, Tsonoqua, too, is always shown with a puckered mouth, as is Gottlieb's own totemic figure. Gottlieb's selection of this particular mask/myth suggests that, like Newman, he was drawn to what he must have perceived as the violent, Dionysian character of Northwest Coast art and culture.

Many of Gottlieb's *Pictographs* (such as *Altar* [1947], *Ancient Rite* [c. 1947], and *Amputation Ritual* [c. 1947]) refer to ritual and, by implica-

Figure 5-29
Printed endpapers,
Indian Art of the United States
(1941) by Frederick H.
Douglas and
René d'Harnoncourt.

Offset, printed in color,
10" x 15".
Photograph courtesy Museum
of Modern Art, New York.

Figure 5-30
ADOLPH GOTTLIEB
Night Forms
(c. 1949–1950).

Mixed media/masonite,
24" x 30". Adolph and Esther
Gottlieb Foundation, Inc.,
New York.

Figure 5-31
ADOLPH GOTTLIEB
Pendant Image
(1946).

Oil/canvas, 25" x 31 7/8".
Formerly Solomon R. Guggenheim Museum,
New York, sold Sotheby Parke-Bernet,
New York, 23 October 1975, lot 303.

tion, transformation. In 1947 he made explicit his own awareness of modernity's need for redemption and the artist's role in that transformation: "The role of the artist, of course, has always been that of image-maker. Different times require different images. Today when our aspirations have been reduced to a desperate attempt to escape from evil . . . our obsessive, subterranean and pictographic images are the expression of the neurosis which is our reality."[215] In creating different images of a neurotic reality, Gottlieb subjected what he assumed was the primal imagery of Native Americans (i.e., contents of the unconscious mind) to the conscious plastic order inherent to a modern painter. Appropriated and estranged from their original context, the Indian motifs are transfigured and become more than mere references to ancient American art. They take on new meaning as components in paintings that

164

attempt to redeem the darkness of the war years by bringing to the surface the atavistic roots of modern experience.[216]

Gottlieb's primitivism, like Newman's (and Rothko's), was an attempt to confront and redeem the Dionysian aspects of modernity. It is an inescapable fact that these artists often compared their project to primitive and archaic arts and myths that eschewed denial, addressing instead the barbarism and brutality of life directly. They saw forms and structures in aboriginal traditions that transfigured, and thus made bearable, the horror and violence of their subject matter. It cannot be coincidental that the Native American culture seizing their imagination most intensely was that of the Northwest Coast, in particular the Kwakiutl, whose most important myth/ceremony and associated arts

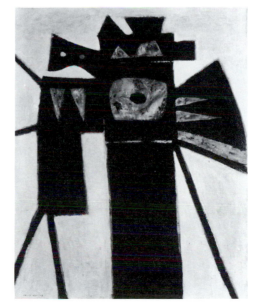

Figure 5-32
ADOLPH GOTTLIEB
Vigil
(1948).

Oil/canvas, 36" x 48". Collection Whitney Museum of American Art, purchase, 492. Photograph by Geoffrey Clements Photography.

Figure 5-33
ADOLPH GOTTLIEB
Ancestral Image
(1949).

Oil and smelts/canvas, 38" x 30". Destroyed by fire in 1953. Photograph courtesy Adolph and Esther Gottlieb Foundation, Inc., New York.

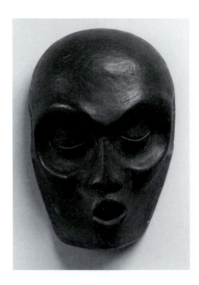

Figure 5-34
Nishka, shaman's mask
representing a man-eating
spirit, which is whistling
(Nass River, British Columbia,
1850–1900).

Carved wood, 10" high.
National Museum of the
American Indian,
Smithsonian Institution
(1/4238).

they understood to be given over to redeeming society from cannibalism. Newman, of course, realized that this was one of the primary reasons that Gottlieb rejected the "nationalist" tendencies of Social Realism and rooted himself instead "in the abstract symbolism of Northwest Coast Indian painting." Gottlieb's "link with the [aboriginal] American past," Newman wrote, was a search for "elemental truth" and "a common concern with art as a serious activity."[217]

Gottlieb's decision to incorporate Native American art into his own art was simultaneous with his and Rothko's decision in 1941 to try to resolve the crisis of subject matter in modern American painting by turning to the themes of Greek mythology. His choice of myths was consistent with that of Newman and Rothko— violent, tragic myths reflective of the Nietzschean atmosphere of the 1940s. The first of his *Pictographs, Eyes of Oedipus* (1941), refers to that tragic figure whom Nietzsche described as merely one of the masks of Dionysus, the original hero of Greek tragedy. And perhaps *Cave of the Oracle* (before 1947) is an evocation of the Theban seer Tiresias who revealed Oedipus' identity to him. Tiresias's bisexuality had been treated in T. S. Eliot's epic poem *The Wasteland* (1922), which was both subject

and title of one of Gottlieb's early paintings (c. 1930).[218] Speaking metaphorically, Gottlieb wrote in 1944 that the source of the mythic fragments in his *Pictographs* was the tomb of Melpomene, the muse of tragedy: "I disinterred some relics from the secret crypt of Melpomene to unite them through the pictographs, which has its own internal logic."[219]

In his reading of James Frazer's *The Golden Bough*, Gottlieb was exposed to an abundance of information about the myths of Native America and ancient Greece. Included in Frazer's classic study of the universal qualities of myth are chapters on such tragic figures as Dionysus, Persephone, and Osiris, as well as entries on various Indian cultures, including the Kwakiutl, Haida, and Tlingit of the Northwest Coast and the Zuni and Navajo of the Southwest. In particular, Frazer's account of Dionysus did nothing to discredit Nietzsche's claims about the Dionysian cults of ancient Greece: "His ecstatic worship, characterised by wild dances, thrilling music, and tipsy excess, appears to have originated among the rude tribes of Thrace, who were notoriously addicted to drunkenness. Its mystic doctrines and extravagant rites were essentially foreign to the clear intelligence and sober temperament of the Greek race. Yet appealing as it did to that love of mystery and that proneness to revert to savagery which seems to be innate in most men, the religion spread like wildfire through Greece."[220] As Frazer described them, the rituals associated with the myth of Dionysus were no less violent than the "witches' brew" described by Nietzsche, nor any less ecstatic than the Kwakiutl Hamatsa ceremony reported by Benedict: "[W]e find that the Cretans celebrated a biennial festival at which the passion of Dionysus was represented in every detail. All that he had done or suffered in his last moments was enacted before the eyes of his worshippers, who tore a live bull to pieces with their teeth and roamed the woods with frantic shouts. In front of them was carried a casket supposed to contain the sacred heart of Dionysus, and to the wild music of flutes and cymbals they mimicked the rattles by which the infant god had been lured to his doom."[221]

In a 1943 explanation of why he and Rothko had turned to Greek mythology for subject matter, Gottlieb denied "that these fabulous tales and fantastic legends are unintelligible and meaningless today, except to an anthropologist or student of myths."[222] Although (like his references to Northwest Coast totems and Southwestern pictographs) the fragments of Greek myth in Gottlieb's *Pictographs* are "decontextualized and deracinated," it is exactly this rupture from the original context that gives them, in Lawrence Alloway's words, "their new meaning."[223] Gottlieb also insisted that his and Rothko's interest in the "demonic and brutal images" of primitive art was not the result of a romantic nostalgia: "On the contrary, it is the immediacy of their images that draws us irresistibly to the fancies, the superstitions, the fables of savages and the strange beliefs that were so vividly articulated by primitive man." Like Newman, Gottlieb spoke of primitive art in terms reminiscent of Worringer's *Abstraction and Empathy*: "All primitive expression reveals the constant awareness of powerful forces, the immediate presence of terror and fear, a recognition and acceptance of the brutality of the natural world as well as the eternal insecurity of life."[224] Gottlieb, too, by living through the 1930s and 1940s, had learned that Nietzsche, Jung, and Worringer were right in proposing that the modern world, no less than the primitive, was characterized by horror and violence. Recognition of this common ground directed Gottlieb's and Rothko's attention to primitive art and myth. As Gottlieb explained, "If we profess a kinship to the art of primitive men, it is because the feelings they expressed have a particular pertinence today. In times of violence, personal predilections for niceties of color and form seem irrelevant."[225] Indeed, more than professing mere kinship with "the primitive," Gottlieb announced, "My whole conception is primitive—of a certain brutality." Thus, he thought, as did Nietzsche, that "life is a mixture of brutality and beauty."[226]

Gottlieb's paintings embodied the primitivistic and tragic Zeitgeist of New York in the 1940s, just as his statements gave voice to these concerns. Other primary materials reinforce my contention that Gottlieb and his colleagues were making manifest a common culture that was recognized as such at the time. The intellectual and spiritual content that I locate in Gottlieb's work was also recognized by certain critics of the period. Furthermore, these same critics discussed his paintings in terms that presupposed an understanding of texts by Nietzsche, Jung, and Worringer. In reference to an exhibition of Gottlieb's *Pictographs*, Victor Wolfson wrote what may be the classic primitivist text of the 1940s, uniting as it does an interest in totemic signs, existential dread, ritual mysteries, and the collective unconscious:

> Through these startling compositions, via these signs and cabalistic writings we descend into the universal underworld. Here man is primitive. Here terrors and anguishes have for him a single source. He has been born into the world; is alone and separate. Gottlieb's mysterious paintings are aids to contemplation of this most ancient and frightening Mystery. . . . Such contemplation is, of course, the essence of religion. And these paintings in their repetitive pattern are ritualistic. . . . The emotional impact of these totemic constructions is most surely experienced in the unconscious—where illumination and comprehension reside. . . . The fragments which he has unearthed in his excavations of our common underworld—an underworld which unites Mayan, Oceanic, Paleolithic and Atomic man—he has synthesized into a powerful and unmistakable signature.[227]

Writing about Gottlieb's *Pictographs*, Newman also focused on fragmentation as a key to the universality and existentialism embodied in the works. Newman explained that "Gottlieb's work, made up of fragments, . . . has as its dominant theme the sense of the tragedy of life." According to Newman, at the center of tragic human experience is a metaphysical problem: a person is *one*, is alone, and yet belongs to a larger whole that includes others. This conflicted dichotomous nature, as he called it, "is

the greatest of our tragedies." Gottlieb's compositions, Newman wrote, are the image of this irreconcilable conflict, as the juxtaposed fragments of symbols struggle among themselves in an effort to unite, only to disintegrate again. Not surprisingly, Newman also observed that Gottlieb's "constant preoccupation with myth" was the basis of the "intellectual content" of the *Pictographs*. Newman associated the earthiness of Gottlieb's palette with his ability to express "man's elemental feelings, the majestic force of our earthly ties and natures." This telluric aspect of the paintings, Newman wrote, "confronts us with the problem of man's spirituality," which he saw revealed in Gottlieb's earthy browns as "the tragedy of life."[228]

Conclusion

The idea of an aboriginal America, manifest in primitive art, myths, and rituals, was a staple of avant-garde discourse, both visual and verbal, in New York in the 1940s. Given the almost incessant presence of Native art (and myth) in New York art journals, gallerys, and museums after 1930, in general, and especially between 1941 and 1946, it is unimaginable that artists would not have absorbed such visual and textual information and then expressed that encounter aesthetically. Collectively, the primitivism of Indian Space and of the myth-making phase of early Abstract Expressionism constituted a generational response to an invitation issued by several critical voices, but most eloquently, perhaps, by Paalen, who had announced in 1943, "This is the moment to integrate the enormous treasure of Amerindian forms into the consciousness of modern art." From Barnet's totemic compressions and Collier's neoprimitive pictorial alphabet, to Newman's sublime color fields and Gottlieb's *Pictographs*, the range of responses, either direct or tangential, reveals that the meaning and value potent in Indian cultural forms, and therefore, available for appropriation, was constrained only by the number and needs of the cultural primitivists themselves. These artists, however, did not perceive themselves in a colonial situation vis-à-vis the use of Indian art, which, after all, was considered national cultural property. Moreover, modernism's self-defined universality seemed to justify its appetite for the cultural forms of Native Americans and other "Others." And yet, the artists constantly defended the originality and legitimacy of their primitivist paintings—especially, as with Gottlieb, when the borrowings were particularly obvious—by insisting that the work be experienced and evaluated in terms of forties' cultural contexts: atavism, avant-gardism, and the excavation of the collective unconscious. Just as Gottlieb explained that although the material might be subjective (or as he perceived it, from the unconscious), he remained objective (conscious), I could argue in their behalf that some of the forms, images, and signs were indeed indisputably Native American—but recast in an unmistakably Euro-American modernist context. However, not only was Indian art thus transfigured, but also, especially in the hands of Jackson Pollock, a specifically "Amerindian primitivism" altered forever the course of modern art.

Jackson Pollock and Native American Art

Jackson Pollock grew up in the Western states, and his interaction with Native American art and culture began early in life. According to his brother Frank, in 1920, when Jackson was eight years old, he witnessed a Northern Pauite Bear Dance near Janesville, California. Yet another brother, Sanford McCoy, reported that in 1924 young Jackson joined his brothers and father in an exploration of Indian cliff dwellings east of Phoenix, near the ranch where they were then living.[1] Such youthful adventures, however, were not isolated encounters with Native culture; as his brother Sanford recalled, "In all our experiences in the west, there was always an Indian around somewhere."[2] Similarly, Pollock's brother Jay had the "impression that Jack felt a kinship with the Indian people."[3] The sculptor Reuben Kadish, who first knew Pollock in high school in Los Angeles, recalled that "Pollock had a very definite and primary interest in American Indians that went back to his childhood when he lived on a Salt River farm." Kadish also remembered that in their high-school days he and Pollock often visited the Los Angeles County Museum where they went into the basement and got down on their hands and knees to view the Native American objects stored in cases low to the ground. They made similar trips, Kadish noted, to the Southwest Museum in Los Angeles where they saw Indian hide paintings, basketry, and headdresses, and together they marveled at the collection of Navajo rugs owned by Pollock's brother Jay.[4]

In the early 1930s, after he had moved to New York, Pollock often spoke to his friends of witnessing Indian rituals as a boy.[5] The sculptor Tony Smith, for example, remembered that Pollock was proud of his firsthand experience with southwestern Indians and that he knew Indian poetry as well. According to Smith, Pollock felt a "rapport with this—the authentic life of the west."[6] Alfonso Ossorio, another of Pollock's artist friends, stated that "Pollock knew the art of the American Indian because he had lived part of his life in the Southwest." Ossorio specifically remembered that Pollock had an appreciation of Indian sand painting, and Eskimo art as well.[7] The Indian Space

painter Peter Busa also noted Pollock's admiration of sand painting and his interest in Northwest Coast Indian transformation myths.[8]

After settling in New York Pollock continued to enhance his knowledge of Indian art and culture. Sometime between 1930 and 1935 he and his brother purchased twelve volumes of the *BAE Report*,[9] which feature detailed scholarly field reports on a variety of topics related to the ethnology and archaeology of Native Americans and have hundreds of reproductions, including color plates, of ancient and historic Indian art objects. In particular, there are numerous illustrations of ritual paraphernalia. In addition, there are many rare documentary photographs of late nineteenth- and early twentieth-century Indian rituals. Several of these topics and their illustrations were of special interest to Pollock: the masks and ceremonies of Northwest Coast Indians; the ceramic fragments excavated at prehistoric sites in Arizona and New Mexico; the folklore and mythology of Pueblo peoples; Plains and southwestern Indian pictographs; and the sand pictures associated with the curing rituals of Pueblo and Navajo Indians. Over the years these volumes of *BAE Report* were to serve Pollock well as a rich and authentic source of Native American imagery.

Pollock also read *DYN*, and other titles in his library attest to his broad interest in mythology, anthropology, and the "primitive" art of Indian and other cultures: Jane Ellen Harrison's *Ancient Art and Ritual* (1913); the 1922 edition of James Frazer's *The Golden Bough*; G. Baldwin Brown's *The Art of the Cave Dweller* (1928); Leonard Adam's *Primitive Art* (1940); and the 1946 edition of Ruth Benedict's *Patterns of Culture*.[10] Such textual materials helped Pollock understand the works of art he encountered in New York museums. The painter Fritz Bultman, Pollock's friend, reported that they "went everywhere looking at Indian art." These outings often took them to the Museum of the American Indian (cited hereafter as MAI) and to the American Museum of Natural History (cited hereafter as AMNH) where they saw Northwest Coast Indian art. Similarly, Kadish remembered that he and

Pollock "made many excursions" together to these same two museums.[11] Ossorio, too, confirmed that Pollock frequented museums and that he was well acquainted with the collections at the AMNH.[12]

Pollock's interest, therefore, was not limited to the southwestern Indian art of his youth, but rather he was fascinated by "the whole range of Indian arts in which he found very positive images."[13] He would have also learned about Northwest Coast art from the "Amerindian Number" of *DYN*, which reproduced his painting *Moon Woman Cuts the Circle*. Pollock also saved the issue of *Iconograph* that dealt with Northwest Coast art and its influence on New York's Indian Space painters, and he saved a number of clippings from *The Arts* dating from the late 1920s and early 1930s that included material on "west coast Indian ceremonial art."[14] Two articles in *The Arts* between 1925 and 1935 matched this description. The first of these, "Anonymous American Art," written in 1926, spoke of the rich, dark mystery to be found in the Northwest Coast art at the MAI.[15] All of the masks, rattles, and tools photographed (by the painter Yasuo Kuniyoshi) for this article were from George Heye's collection at the MAI. Considering that Pollock did not move to New York until 1930, if he read this article when it was first published, it may have been his first introduction to the MAI. The other article, "West Coast Art" (1928), not only reminded Pollock that "Native arts and crafts have frequently proved fertile sources of inspiration for the modern artist" but also suggested that "modern artists may possibly devise some way of saving the remnants" of the Northwest Coast tradition.[16]

Pollock's activities in the 1930s were in line with Jean Charlot's 1941 comment on the exhibition "Indian Art of the United States": "serious students" would have already visited the art and anthropology collections at the MAI and the AMNH.[17] Naturally, Pollock was one of the many members of the New York art community who attended "Indian Art of the United States." Bultman, who recalled that d'Harnoncourt's exhibition "generated a great deal of interest," insisted that "*everyone* was aware of Indian art at that time."[18] As a testament to his interest in the exhibition, Pollock saved a clipping from the Rotogravure Section of the Sunday *New York Times* for 19 January 1941 featuring photographs of ten Indian masks that were to be shown beginning on 22 January.[19] Furthermore, Dr. Violet Staub de Laszlo, then Pollock's Jungian psychotherapist, reported that the exhibition fascinated Pollock. After extended visits, they discussed the sand paintings made at the museum by visiting Navajo artists,[20] and during analysis Pollock's comments revealed a "kind of shamanistic, primitive attitude toward [their] images."[21] As Bultman attests, Pollock was aware of the "whole shamanistic dream culture of Indians."[22]

Pollock also made trips to view Indian art in the company of his patron/dealer Peggy Guggenheim. Dr. Frederick J. Dockstader, former director of the MAI, verified that Pollock frequented the museum in the 1930s and on several occasions after 1943 was accompanied by Guggenheim.[23] In her autobiography Guggenheim recalled that Pollock's deep feelings for Native American sculpture were revealed in some of the paintings shown in his first solo exhibition at her Art of This Century Gallery in 1943.[24]

During this period of exploring museum collections in New York and using *BAE Reports* and other textual materials as a source of information about Indian art, Pollock also read the writings of the Russian emigré painter/critic John D. Graham. Because of his well-established and deep involvement with the art and culture of Native America, Pollock's intellect and artistic sensibility were fertile ground for Graham's conclusions about primitive art and the unconscious mind. Graham's article "Primitive Art and Picasso" (1937) had impressed Pollock to the degree that he had made a point of meeting him, probably in 1937, around the time that he, Pollock, began treatment for alcoholism.[25] Indeed, Pollock still had a copy of that article and Graham's *System and Dialectics of Art* (1937) at the time of his death.[26] B. H. Friedman,

Pollock's first biographer, wrote that the interest Pollock showed in Graham's writings "led to mutual friendship and admiration."[27]

Graham, in turn, was so thoroughly taken with Pollock's art that he planned to include Pollock's name on the list of promising young painters in the second edition of *System and Dialectics of Art.*[28] In 1942 Graham included Pollock (along with Lee Krasner and Willem de Kooning) in the exhibition "French and American Painting" at the McMillen Gallery in New York. *Birth* (c. 1938–1941, Fig. 6-1), the Pollock painting selected by Graham for that exhibition, is one of three Pollock canvases from this period that Irving Sandler compared to the Eskimo mask (Fig. 6-2) used by Graham to illustrate his article "Primitive Art and Picasso."[29] This critical recognition of the "unknown" Pollock by Graham, who was at that time "highly regarded," placed the struggling young artist in a context with Picasso, Braque, Matisse, and the "Three Musketeers" of modern American art— Stuart Davis, Arshile Gorky, and Graham himself.[30] In 1967 de Kooning recalled Graham's discovery of Pollock: "Graham was very important and he discovered Pollock. I make that very clear. It wasn't anybody else, you know. . . . The other critics came later, much later. Graham was a painter as well as a critic. It was hard for other artists to see what Pollock was doing—their work was so different from his. . . . But Graham could see it."[31]

Despite the uncertainty concerning the date of the original meeting of Graham and Pollock, they had established a close relationship by the early 1940s. By this time Graham had forged a new circle of friends that, besides Pollock, included Bultman, Conrad Marca-Relli, and Theodoros Stamos.[32] When asked about Pollock and Graham, Bultman stated emphatically, "Pollock was *very good* friends with Graham . . . he saw Pollock as one of the *real* painters." Furthermore, Graham's knowledge of the literature on Russian shamanism paralleled Pollock's awareness of Native American shamanic art, and they shared a "coinciding and reinforcing interest in primitivism and Indian art."[33] Along with the exhibition "Indian Art of the United States,"

Graham, in his role as *animateur* of Pollock's art, was an essential stimulus in the development of Pollock's mythic/pictographic and, later, drip paintings. A reiteration of certain points from *System and Dialectics of Art* and "Primitive Art and Picasso" substantiates this idea while illuminating Pollock's use of Indian art in creating his own new process and imagery.

A particular passage from "Primitive Art and Picasso," noted in the previous chapter, bears repeating here. It is critical to observe that Graham exposed Pollock to the idea that "the art of the primitive races has a highly evocative quality which allows it to bring to our consciousness the clarities of the unconscious mind . . . with all the individual and collective wisdom of past generations and forms. In other words, an evocative art is the means and the result of getting in touch with the powers of our unconscious."[34] In his discussion of Eskimo masks and Northwest Coast carvings Graham referred to primitive art as the result of immediate access to an unconscious mind that is both collective and ancient.[35] Similarly, in *System and Dialectics of Art* Graham wrote, "Creative images are circumscribed by the ability to evoke the experiences of primordial past . . . and the extent of one's consciousness."[36] Pollock pointed out unequivocally the importance of these ideas in his own work: "The source of my painting is the unconscious."[37]

The reason for Pollock's desire to delve into the unconscious was, first of all, the Jungian call for a spiritual transformation of modern man by merging the unconscious and conscious mind.[38] Secondly, on a more individual level, Pollock sought, through Jungian psychotherapy, his own personal transformation by merging these seemingly opposed elements.[39] While the controversy is, and probably will remain, unresolved as to what he actually knew of Jung's writings, four points appear incontrovertible.[40] First, Pollock's initial Jungian analyst, Dr. Joseph Henderson, who recognized "the nature of the archetypal symbolism"[41] in Pollock's drawings, reported, "Pollock was acquainted with the principles of Jungian psychology."[42] Second, Pollock said of himself, "I've been a Jungian for a long time."[43] Perhaps even more important is that the direct, simplified nature of Graham's writings made

171

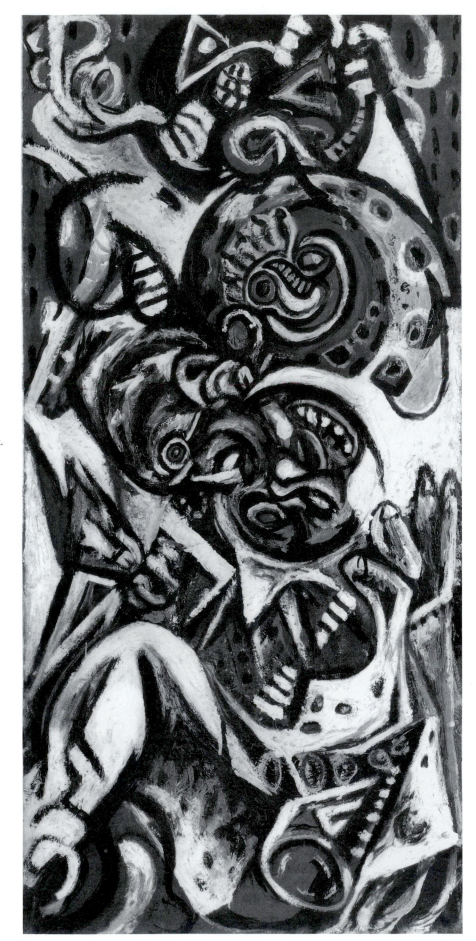

Figure 6-1
JACKSON POLLOCK
Birth
(c. 1938–1941).

Oil/canvas on plywood,
46" x 21 3/4".
Tate Gallery, London.
© 1993 Pollock-Krasner
Foundation/ARS, New York.

him a friendly source of information on Jungian theory for Pollock.[44] Furthermore, Pollock, according to Kadish, "was reading Jung, no doubt in my mind about that."[45] Besides all this, as Bultman recalled, "Jung was available in the air, the absolute texts were not necessary, there was general talk among painters. . . . Tony Smith also knew the Jungian material firsthand when he became a friend of Pollock. Smith was a walking encyclopedia of Jung shamanism, magic in general, ritual, the unconscious. People were alive to this material [Jung, dreams, Indian shamanism] and hoped this material would become universally known and used."[46]

Pollock was a logical participant in the wider American interest in Indian culture reflected in the enthusiasm for "Indian Art of the United States." His personal and psychological motivations drew him to the formal power and mythic content of Indian art. In retrospect, it seems only natural that Pollock, of all the New York avant-garde artists interested in myth, primitive art, and primitivism, had the most intense and innovative response to the influence of Native American art. Careful scrutiny of selected works in Pollock's oeuvre reveals conclusively that between 1938 and 1950 he borrowed with specificity and intent from particular works of Indian art known to him. The degree of similarity is so high as to disprove Pollock's assertion in 1944: "People find references to American Indian art and calligraphy in parts of my paintings. That wasn't intentional; probably was the result of early enthusiasms and memories."[47]

All of Pollock's varied incorporations and transfigurations of Indian art were informed and sustained by a shamanic intent.[48] In the first period of Pollock's artistic engagement with Native American art, from 1938 to 1947, he experimented with the visual grammar and ancient motifs of Indians as a way of penetrating the unconscious mind. This painterly method of shamanic self-discovery was related to two Jungian principles widely known in the late 1930s and early 1940s: that myths are archetypal forms that codify basic human experiences and that "conscious and unconscious are interfused,"

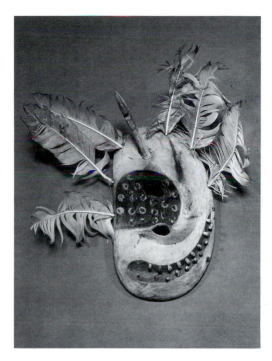

Figure 6-2
Inuit, mask (Yukon River region, c. 1900, collected at Hooper Bay, 1919).

Wood, feathers, pigment, horn, 33 cm high, 30 cm wide, 8.5 cm deep. University Museum, University of Pennsylvania, Philadelphia, neg. #G8-12010.

therefore transformed by allowing the consciousness to be drawn into the realm of the symbolic image.[49] In such paintings as *Guardians of the Secret* (1943, Fig. 6-13), Pollock relied on Indian myths, symbols, totems, and masks associated with rituals. The Indian images themselves are quoted, distorted, transformed, and always serve as a vehicle for Pollock's inimitable improvisations. In this period he often used an intentionally primitive, pictographic style of painting/drawing to refer to both archaic consciousness and the evolutionary stages of art.

In the second period of Pollock's pictorial investigation of Native American art, from 1947 to 1950, his overt use of Indian motifs gave way to an emphasis on art as a shamanic process for healing. Thus, he incorporated into the drip paintings information about the self, which he had discovered by exploring the symbolic realm, that is, by making mythic/pictographic paintings. In this second phase Pollock developed a personal art-as-healing process derived in part from the concepts of Navajo sand painting, which he had witnessed at the Museum of Modern Art in 1941.

173

Figure 6-3
Artist's rendering of abstract designs superimposed with pictographic figures in the Hohokam petroglyph style, near Phoenix, Arizona. Courtesy School of American Research, Santa Fe.

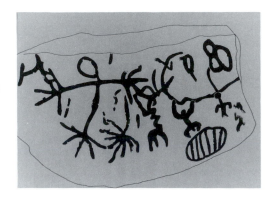

Figure 6-4
JACKSON POLLOCK
untitled page from a sketchbook
(c. 1938–1942).

India ink/paper, 17 3/8" x 13 3/8".
Metropolitan Museum of Art.
Gift of Lee Krasner Pollock, 1982 (1982.147.14).

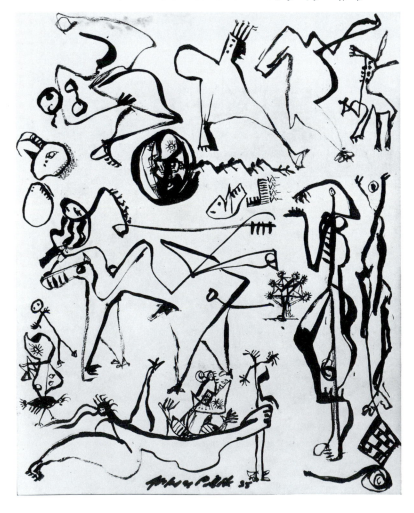

Myths, Totems, and Pictographs (1938–1947)

Pollock no doubt agreed with certain of Graham's statements in *System and Dialectics of Art* about the strength and continuity of symbols, such as: "The record of all human intercourse is perpetuated through the medium of symbols."[50] By 1937 Pollock was well aware of a type of American Indian art that was the organic, visual record of the development of consciousness from antiquity to the present. Since his youth Pollock had known of Indian pictographs and petroglyphs. For example, there are petroglyph sites near Phoenix where Pollock explored Indian ruins as a boy (Fig. 6-3). Years later, in 1934, while on a visit to his mother in Los Angeles, Pollock and his brother went camping in the Mojave Desert and "other places."[51] No matter which direction Pollock took to these "other places," he could have seen more Indian rock art. North of Los Angeles along the coast road toward Ventura are thousands of rock pictures, many in polychrome, made by the Chumash Indians.[52] Traveling northeastward into the Tehachapi Range of the Mojave, Pollock would have seen a variety of prehistoric design elements painted, pecked, or inscribed on rock surfaces. East and southeast of Los Angeles are numerous pictographic sites, especially in the western Shoshonean culture range.[53]

No doubt, the many images of Indian pictographs in *BAE Report*, vol. 1 (1881) caught Pollock's eye, and the information reported there about rock art ran parallel to Graham's ideas about primitive art. BAE Director John Wesley Powell wrote, "Nature worship and ancestor worship are concomitant parts of the same religion, and belong to a status of culture highly advanced and characterized by the invention of pictographs. . . . These pictographs exhibit the beginning of written language and the beginning of pictorial art."[54]

Perhaps the earliest examples of Indian influence in Pollock's work are the pictographic drawings in his sketchbooks from around 1938 (Fig. 6-4).[55] This kind of intentionally primitive drawing may have had its original impetus not in Surrealist automatism but in Pollock's

knowledge of pictographs. Stressing the primacy of Indian pictographs in the development of Pollock's "psychoanalytic drawings" and mythic paintings is not necessarily to deny Surrealist influence. Pollock was cognizant that the unconscious was the source of imagery for both Surrealist art and shamanic art, but he felt that the resources of the unconscious had not been fully explored.[56] What Pollock found acceptable in Surrealism, because it mirrored his own conclusions, was not so much a stylistic vocabulary but the idea of painting from the unconscious.[57] His loose, crude, linear language in these early drawings and mythic paintings is an effort to evoke an ancient, more authentic kind of automatic writing.

At the same time that Pollock was beginning his experiments with pictographic drawing, he also began to incorporate mask forms into his imagery. For example, in *Composition with Donkey Head* (c. 1938–1941, Fig. 6-5) Pollock uses the image of a Northwest Coast cannibal spirit (perhaps Tsonoqua). As I indicated in the previous chapter in reference to Gottlieb's *Ancestral Image*, Tsonoqua is a female ogre who devours children after luring them to the woods with her whistling. Thus, the mask of this supernatural being is always depicted with a puckered mouth. A mask of this type—whistling cannibal spirit—from the permanent collection of the MAI was exhibited at "Indian Art of the United States" (see Fig. 5-34).[58] In *Composition with Donkey*

Figure 6-5
JACKSON POLLOCK
Composition with Donkey Head
(c. 1938–1941).

Oil/canvas, 21 7/8" x 50".
Courtesy Jason McCoy Inc.
© 1993 Pollock-Krasner
Foundation/ARS, New York.

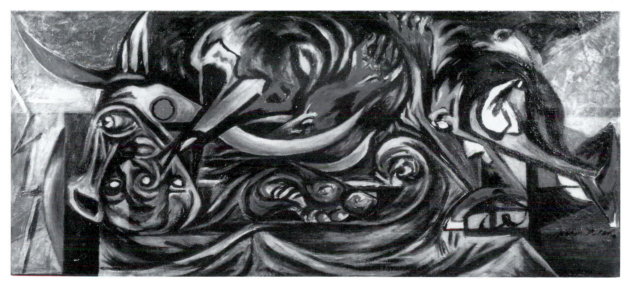

Head the mask is upside down and seemingly grafted onto the donkey's jawbone (Fig. 6-6). A bonelike shaft, edged in black, extends diagonally from the ogre's left cheekbone, and above this form a partial view of the left side of a second cannibal spirit is visible.

On his visits to "Indian Art of the United States" Pollock continued to assimilate the visual language of rock art. One of the more memorable exhibits there was the full-scale mural facsimile of Basketmaker Period pictographs from Barrier Canyon in southern Utah (discussed in Chapter 4 [Fig. 4-8]). Curator

Figure 6-6
Artist's rendering of detail of
Composition with Donkey Head.

175

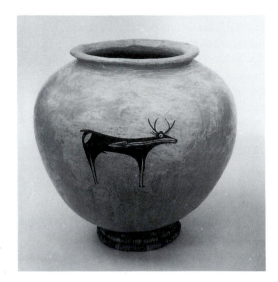

Figure 6-7
Zuni Pueblo,
pottery drum jar
(collected c. 1931).
18 1/2" high, 21" in diameter.
Taylor Museum,
Colorado Springs.

d'Harnoncourt described pictographs such as this as a blend of past and present: "They are still made today in certain sections. In the Southwest . . . modern Navajo drawings in charcoal may be found on top of ancient Pueblo rock paintings. . . . It is usually impossible to date rock pictures, though they were obviously made over a long period of time."[59] Thus, rock art, with its "masterly treatment of flat spaces,"[60] represented superimposed layers of artistic activity from different ancient and historic style periods. The stratification of human cultural activity is an important idea in Jungian theory. Jung wrote, "Through the buried strata of the individual we come directly into possession of the living mind of ancient culture."[61] Pollock responded in 1941 by mixing sand and oil paints to produce *The Magic Mirror* (1941), which has a faded and textured surface very much like the replicas of Barrier Canyon pictographs exhibited at the Museum of Modern Art that same year.

At "Indian Art of the United States" Pollock also saw a Zuni Pueblo drum jar that is decorated with a painted image of a deer bearing a heartline-arrow motif (Fig. 6-7). This jar was collected at Zuni in 1931 and reproduced in the Museum of Modern Art's exhibition catalogue. As a decorative device, the heartline was common as early as the mid-nineteenth century and

is not limited to Zuni but is used by other Pueblo and Navajo artists.[62] These lifeline motifs often begin near the mouth with a scroll shape representing the windpipe and move toward the midsection of the deer or buffalo, where the heart is symbolized by a triangle or arrowhead. In Pollock's painting *The She-Wolf* (1943, Fig. 6-8), a motif of this type begins at the mouth and travels from left to right down the body of an animal markedly more like a deer than a wolf. Furthermore, if Pollock's picture is examined again, but now read from right to left, there appears from head to tail, outlined in white and showing black horns, a white buffalo, an important animal in southwestern and Plains Indian mythology.[63] That Pollock would have paid attention to this Zuni jar is confirmed by Bultman's recollection, "Pollock was interested in the figurative images in Mimbres pottery of the Southwest."[64]

Another of the objects seen by Pollock at "Indian Art of the United States" (and reproduced in the catalogue), a pottery bowl made by the prehistoric Hohokam culture of southern Arizona (c. 800, Fig. 6-9), may well have been the inspiration for *Mural* (1943, Fig. 6-10), which he painted for Peggy Guggenheim's Sixty-first Street townhouse. As an ardent admirer of the figurative motifs of ancient southwestern pottery, Pollock no doubt recognized the painted figure on the Hohokam bowl as being the kachina (spirit effigy) Kokopelli, a humpbacked flute player associated with fertility. One probable source of his awareness of Kokopelli was the *BAE Report* of 1895–1896 (vol. 17, pt. 2) that he owned, which described Kokopelli in the following manner: "The doll of Kokopelli has a long bird-like beak . . . a hump on the back and an enormous penis. It is a phallic deity, and appears in certain ceremonials which need not be described here."[65] According to Pueblo mythology, Kokopelli, because of his misshapen appearance, slyly seduces and impregnates young women without their knowledge.[66] These fecund women are usually shown clinging to Kokopelli's back, as is the case with the Hohokam bowl exhibited in 1941. Likewise, Pollock created in the Guggenheim *Mural* a

rhythmic screen of black dancers, including two at the left that could be improvisations on the flute player (Fig. 6-11). Guggenheim herself wrote, "The mural was more abstract than Pollock's previous work. It consisted of a continuous band of abstract figures in a rhythmic dance painted in blue and white and yellow, and over this black paint was splashed in drip fashion."[67]

Guggenheim's description of the manner in which Pollock created *Mural* suggests a shaman's psychic preparation before a round of ritual activity. After weeks of brooding contemplatively in front of the blank canvas, "he began wildly splashing on paint and finished the whole thing in three hours."[68] That Pollock, after finally beginning to paint, did not stop until the image was complete suggests that for him, creating the image was a kind of ritual performance. Likewise, d'Harnoncourt's comments about the Hohokam image of Kokopelli are applicable to Pollock's line of dancers in *Mural*: "The figures are often repeated in long rows,"

and the "drawings are executed with a broad, free-flowing line."[69]

Besides the texts on Kokopelli noted already, three articles on the erotic flute player appeared in the *American Anthropologist* in the late 1930s. Given Pollock's probable interest in Kokopelli, and in Native American ethnography in general, it is quite possible that he was aware of these articles. A brief examination of these texts further illuminates yet another painting by Pollock in which Kokopelli appears. For example, in Florence Hawley's description of Kokopelli in 1937, he has a long, pointed snout and feathers on his head; the hump on his back and uncovered genitals are prominent; and groups of these kachinas appear in the spring to dance. Hawley noted, "The importance of Kokopelli in the prehistoric past is indicated by numerous pictographs" at various sites in New Mexico and Arizona.[70] Elsie Clews Parsons explained in 1938 that the name "Kokopelli" is related to a dipterous insect that is "humpbacked and does not desist from copu-

Figure 6-8
JACKSON POLLOCK
The She-Wolf
(1943).

Oil/goauche/plaster/canvas,
41 7/8" x 67".
Collection Museum of
Modern Art, New York.
Purchase.
Photograph courtesy of
Museum of Modern Art,
New York.

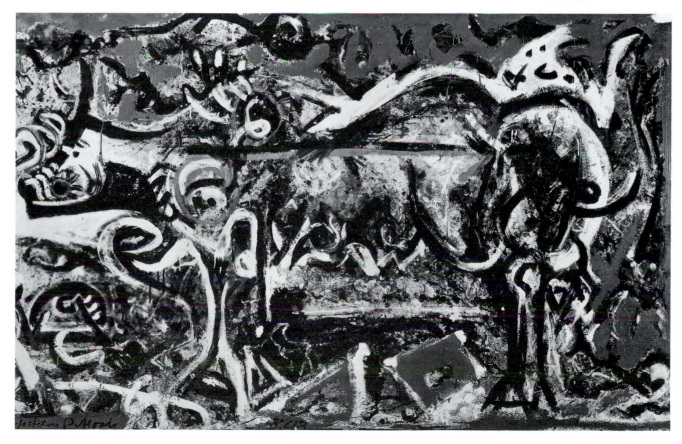

lating when disturbed." Parsons also reported that according to informants at the Hopi village of Oraibi, Kokopelli stored in his hump blankets, seeds, and belts, which he presented to the girls he seduced.[71] And Mischa Titiev reported in 1939 that according to the Hopi, Kokopelli defended himself against an attack by jealous rivals (members of the Feces Kachina cult) by following the instructions of Spider Woman, who told him, "Chew up your medicine and spurt it everywhere."[72]

Pollock's *Composition on Brown* (c. 1945, Plate 10) shows near the top center a Kokopelli flute player with feathers on his head, as Hawley had described him. This version of Kokopelli is comparable to one seen on a bowl excavated at

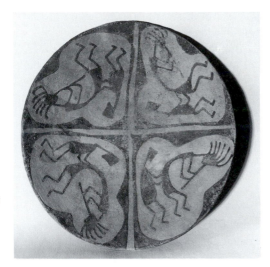

Figure 6-9
Santa Cruz red-on-buff pottery bowl (Hohokam, Southern Arizona, c. A.D. 800). 10 3/4" in diameter. Arizona State Museum, University of Arizona.

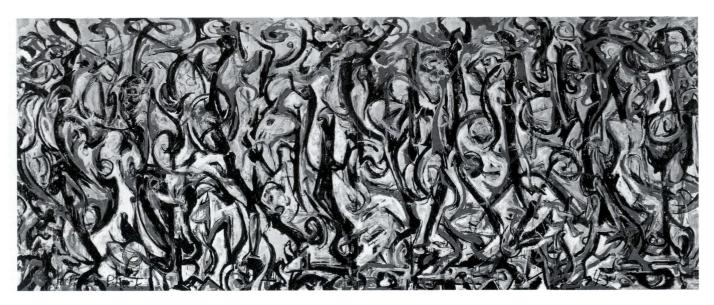

Figure 6-10
JACKSON POLLOCK
Mural
(1943).

Oil/canvas, 97 1/4" x 238".
Gift of Peggy Guggenheim, University of Iowa Museum of Art.
© 1993 Pollock-Krasner Foundation/ARS, New York.

Figure 6-11
Artist's rendering: detail of *Mural*.

the Hopi ruin at Sikyatki, Arizona, in 1895 and reported in the *Seventeenth Annual Report of the BAE* (Fig. 6-12). In both cases some kind of matter is being projected from the distal end of the flute.[73] It is tempting to explain the curious marks emanating from the end of the two flutes as the pictorial realization of music. But given Titiev's account, it seems more likely that Pollock's Kokopelli, in this instance, is not making music but rather, "spurting" his medicine. Since Kokopelli is a phallic symbol related to fertility, "medicine spurting" from a flute may well be a metaphor for ejaculation.

178

Figure 6-12
Artist's rendering of a ceramic
fragment (depicting Kokopelli)
excavated at Sikyatki, Arizona.
Illustrated in *Seventeenth Annual
Report of the Bureau of American
Ethnology*, pt. 2 (1898).
Courtesy National Anthropological
Archives, Smithsonian Institution.

Figure 6-13
JACKSON POLLOCK
Guardians of the Secret
(1943).

Oil/canvas, 48 3/8" x 75".
San Francisco Museum of Art,
Albert M. Bender Collection,
Albert M. Bender Bequest Fund,
purchase, 45.1808.

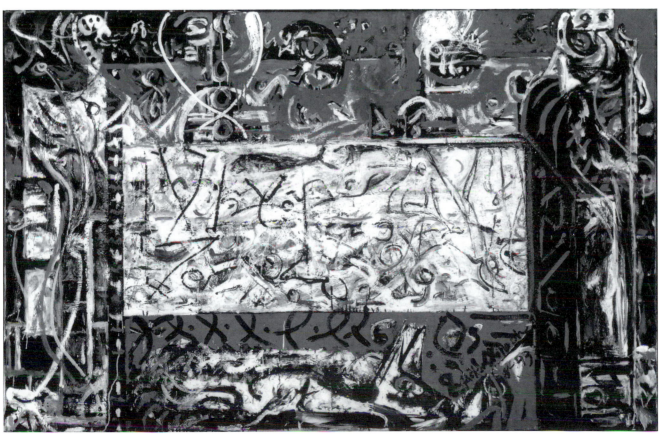

According to the treacherous plan, Kokopelli was lured into a kiva (subterranean ceremonial chamber), where the darkness would abet the attempt to "beat him to death."[74] Choosing, perhaps, to generate a fairly literal representation of an event in the Kokopelli legend, Pollock painted this scene on a dark brown canvas and suggested or symbolized the kiva with a white kiva-step motif (fret design) that occupies the lower and middle areas of the canvas. The *Seventeenth Annual Report of the BAE* has numerous artists' renderings of the geometric kiva-step used as a Hopi pottery motif.[75] Since the myth has Kokopelli jump up and hang from the rafters,[76] Pollock placed him near the top with his head touching a plank-shaped band of white. Filling up most of the area to the left of center is a thin, white pictographic stick figure holding what is clearly a stone club (meant for killing the flute player).

In 1943, in addition to painting such Indian-inspired works as *The She-Wolf* and *Mural*, Pollock continued to produce, in the style of *The Magic Mirror*, surface-oriented paintings covered with nonspecific stenographic marks, hieroglyphic slashings, numbers, and primitive symbols. For Pollock, like Gottlieb and Pousette-Dart, pictographic elements must have represented archaic kinds of writing that

signify the strata of consciousness and culture. Through the manipulation of primitive calligraphy, stick figures, zoomorphs, and totems, Pollock touched, as a shaman does, a world beyond ordinary perception.

Prior to the drip paintings, *Guardians of the Secret* (Fig. 6-13) is Pollock's most dramatic and successful visual statement about the shamanic potential of Indian art and the unconscious mind. At the heart of the image is a rectangular space filled with pictographic secrets.[77] Here, in an agitated linear code, is the timeless seed of human ritual. Flanking and guarding the secrets are two totemic figures highly reminiscent of Northwest Coast pole sculpture of the type placed at the entrance of "Indian Art of the United States." One of the articles on Northwest Coast art that Pollock clipped and saved stated clearly that pole sculpture and house posts were heraldic and commemorative. That is, they both announce and protect mythic ancestry.[78] Pollock made a more overt reference to Northwest Coast art just to the left of center at the top of the canvas. Outlined in white is the mask of a cannibal spirit (Fig. 5-34) seen in Gottlieb's *Ancestral Image* and also in *Composition with Donkey Head* (Fig. 6-5). Pollock knew this mask, no doubt, from his visits to the MAI and to "Indian Art of the United States."

Perhaps the demonic nature of cannibal spirits such as Tsonoqua suggested to Pollock the bestiality of "primal man." Certainly Tsonoqua's hunger for humans was similar to the violent cannibalism of the Hamatsa rites described by Benedict in *Patterns of Culture*, which Pollock kept in his library. D'Harnoncourt, too, commented on the relationship between humans and these cruel, mythical figures: "Some Northwest Coast masks were carved in the likeness of spirits or mythical beings who were believed to be ancestors of the various families. To suggest the unhuman character of these ancestors, the masks representing them were often given features which, though basically human, were exaggerated in a grotesque manner."[79] Pollock's use of the Tsonoqua mask confirms the overriding sense that *Guardians of the Secret* is the painterly evocation of a ritual scene.[80]

D'Harnoncourt's description of the Northwest Coast tradition also supports this idea: "Beside the dark sea and forest there developed an art in which men, animals and gods were inextricably mingled in strange, intricate carvings and paintings. Religion and mythology found their outlet in vast ceremonies in which fantastically masked figures enacted tense wild dramas."[81]

In its formal arrangement *Guardians of the Secret* refers to Southwest, not Northwest Coast, rituals. Immediately to the right of the Tsonoqua image Pollock placed a black insect. This curious creature, curled up in a fetal position, derives from the painted decoration on a Mimbres pottery bowl exhibited at the Museum of Modern Art (Fig. 6-14).[82] The painting's three flat, horizontal registers of activity,

hieratically framed by the totemic figures, suggest that it is a *"picture-within-a-picture."*[83] The probable source of this device is a pair of illustrations acompanying an article on the Indians of Zia Pueblo in the *Eleventh Annual Report of the BAE* (1894).[84] The first of these shows the altar and sand painting of the Zia Snake Society (Fig. 6-15). This image, like *Guardians of the Secret*, has its two-dimensional surface divided into flat, horizontal planes. Uppermost in the picture is a roughly rectangular wooden altar, which is braced by two hieratic posts topped by totemic heads.[85] Below the altar are two sand paintings, the lower of which shows an animal with sharply pointed ears framed in a rectangular space. Thus, this illustration of a ceremonial setting has a compositional

Figure 6-15
Altar and sand painting of the Snake Society at Zia Pueblo. Illustrated in *Eleventh Annual Report of the Bureau of American Ethnology* (1894). Courtesy National Anthropological Archives, Smithsonian Institution.

Figure 6-16
Guardians of the Knife Society at Zia Pueblo. Illustrated in *Eleventh Annual Report of the Bureau of American Ethnology* (1894). Courtesy National Anthropological Archives, Smithsonian Institution.

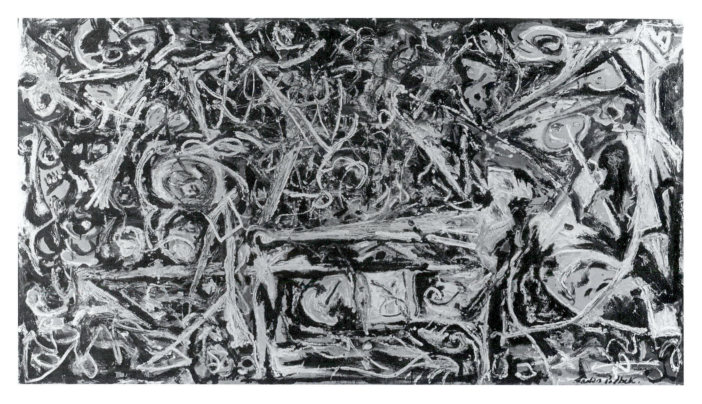

Figure 6-17
JACKSON POLLOCK
Night Mist
(c. 1944).

Oil/canvas, 36" x 74".
Norton Gallery and School
of Art, West Palm Beach,
Florida.
© 1993 Pollock-Krasner
Foundation/ARS, New York.
Photograph by Lee Brian.

arrangement similar to *Guardians of the Secret*, is a picture of a (sand) picture, and depicts at the bottom an animal similar to the dog/wolf in the bottom of Pollock's painting.

The second illustration shows the altar of the Knife Society hieratically flanked by two clan officials who are theurgists (Fig. 6-16). Again, the two-dimensional surface is organized into flat, horizontal planes, and the central altar and fetishes are "protected" by the two clan officials. This Zia custom, the report explains, is different from the Zuni, where each altar "with its medicines and fetiches is guarded during ceremonies by two members of the Society of Warriors. . . . Owing to the depleted numbers of the Society of Warriors of the Zuni, some of their altars have but one guardian."[86] Thus, Pollock's syncretic image, which mixes indiscriminately the two distinct aboriginal traditions that Benedict saw as symbolic of the Dionysian (Northwest Coast) and

Apollinian (Puebloan), represents a pair of secret-society guardians who protect a ritual painting made for healing purposes.[87] Like the collections at the AMNH, "Indian Art of the United States," Gottlieb's *Pictographs*, and Indian Space painting, *Guardians of the Secret* functions as a chronotope: painting as poetic fiction, in which primitive time and ritual space are recapitulated by means of scumbling, layering, "raw" drawing, and fevered painterly gestures to tell the story (Jungian myth) of the modernist discovery of the collective unconscious.[88]

In 1944 Pollock continued his exploration of primitive kinds of writing—pictographic elements—which indicate cultural, especially artistic, evolution. In *Night Mist* (c. 1944, Fig. 6-17), Pollock overlaid a hard, flat space with a ritual frenzy of rough and fast passages of paint. The surface is painted over with layers of symbols and forms, recalling cave walls or ritual chambers. Like Indian pictographs, each variety of mark or line, whether drawn, slashed, or in-

Figure 6-18
Inuit, mask (nineteenth
century).
Illustrated in *Third Annual
Report of the Bureau of American
Ethnology* (1884).
Courtesy National
Anthropological Archives,
Smithsonian Institution.

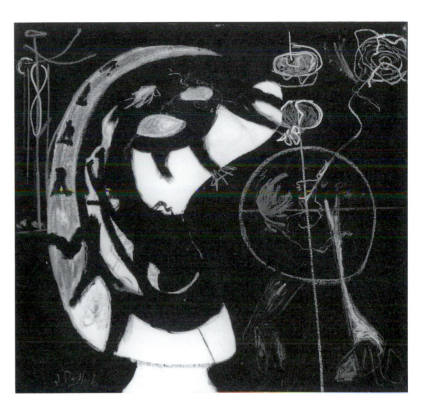

Figure 6-19
JACKSON POLLOCK
Night Sounds
(c. 1944).

Oil/pastel/paper, 43" x 46".
Courtesy Jason McCoy Inc.
© 1993 Pollock-Krasner
Foundation/ARS, New York.

scribed in paint, is the record of a different and enduring age of image-making on the pictorial surface. Paintings like this and *Guardians of the Secret* explored that point in cultural history when the creation of symbols was a ceremonial activity.

Pollock produced other works in 1944 that continued both an interest in the writings of Graham and the expressive potential of mask forms. Graham's essay, "Primitive Art and Picasso," which Pollock saved over the years, was illustrated with an Eskimo mask chosen to support his reference to the rearranging of the facial features in such masks (Fig. 6-2).[89] This article alerted Pollock specifically to the conceptual aspects of Indian art, attracting him to it in much the same way Picasso felt drawn to the conceptual treatment of the human figure in African art.[90] But Graham's essay was probably not Pollock's introduction to this masking tradition. An Inuit mask of the same variety (Fig. 6-18) illustrated an article on masks and

aboriginal customs in the *Third Annual Report of the BAE* (1884), which Pollock had owned for at least two years before the publication of Graham's article.[91] This ceremonial mask has the eyes stacked one above the other, a twisted mouth curving up the side of the face, and knobs carved in relief to suggest teeth. Pollock's awareness of these Eskimo masks served as the inspiration for his painting *Night Sounds* (c. 1944, Fig. 6-19). Pollock distorted and exaggerated the mask even further so that it practically fills the composition. Despite this accentuated elongation, the derivation of this image from Eskimo masks is still quite obvious.

In 1945 Pollock placed another of these Eskimo masks at the very center of *Frieze* (1945, Fig. 6-20). To the right of the mask, and extending almost the length of the canvas, is a tall pictographic figure with a child on his/her back. In the upper half of the far right corner is another pictographic figure with upraised arms, and just below this, in the lower right corner, is

183

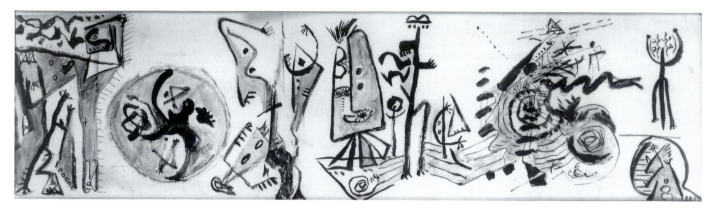

Figure 6-20
JACKSON POLLOCK
Frieze
(c. 1945).

Oil/canvas on masonite,
7 5/8" x 26 1/2".
Courtesy Jason McCoy Inc.
© 1993 Pollock-Krasner
Foundation/ARS, New York.
Photograph by Zindman/
Fremont.

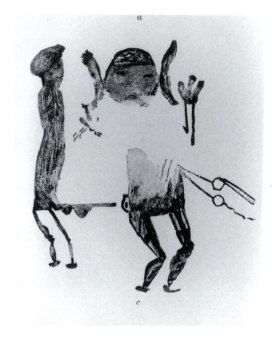

Figure 6-21
Ceramic fragment depicting
copulating figures, excavated
at Sikyatki, Arizona.
Illustrated in *Seventeenth
Annual Report of the Bureau of
American Ethnology* (1898).
Courtesy National
Anthropological Archives,
Smithsonian Institution.

a small, circular image remarkably similar to a
Kiowa-painted shield cover exhibited at the
Museum of Modern Art. Pollock also began in
1945 a series of paintings based on figurative
images on prehistoric ceramic fragments from
the Southwest. These pictures, which deal with
the mythic embodiment of the sexual duality of
nature, continue into the drip period and reveal
Pollock's radical abstraction of Indian motifs.

Along with reproducing the image of
Kokopelli cited previously (Fig. 6-12), the same
page of the *Seventeenth Annual Report of the BAE*
illustrated another ceramic fragment from
Sikyatki, this one showing a pair of copulating
figures (Fig. 6-21). In the text accompanying
this image, Jesse Walter Fewkes concluded that
there could be no doubt about the nature of the
act in which the figures are engaged.[92] Like-
wise, there can be little doubt that this image of
copulating figures is the source of Pollock's
painting *The Child Proceeds* (1946, Plate 11).
Pollock's two figures are joined in a sexual
union, and as the title suggests, the fetus is al-
ready visible in the lower portion of the female.
In both cases, the female figure of each couple
appears to have had her upper body pierced by
some form. With Pollock's female figure it is
obviously an arrow. There are differences, how-
ever, for Pollock has transformed the male to
suggest Kokopelli, whom Titiev noted could
appear as female as well as male.[93] For example,
Pollock's male figure is mythic/androgynous,
having breasts and a phallus.[94] Furthermore,

the male wears an insect attached to his back, as if it were a pack. In his description of Kokopelli in the *Seventeenth Annual Report of the BAE*, Fewkes wrote, "During the excavations at Sikyatki one of the Indians called my attention to a large Dipteran insect which he called Kokopelli."[95]

Fewkes's comments on the depiction of the act are equally important to an understanding of how Pollock would have perceived this graphic presentation of prehistoric sexual activity and its relationship to *The Child Proceeds:* "The attitude of the male and female depicted here was not regarded as obscene; on the contrary, to the ancient Sikyatki mind the picture had deep religious meaning. In Hopi ideas the male is a symbol of active generative power, the female of passive reproduction, and representations of these two form essential elements of the ancient pictorial and graven art of that people."[96] The pictorial and psychological force of this essential, generative imagery was compelling to Pollock. He used this motif as the basis for at least two other paintings. For example, in *Two* (c. 1945, Fig. 6-22), the subject matter is once again sexual union, and the image probably issues from Pollock's response to the copulating Sikyatki figures. Although there are some differences in *Two* (the female leans slightly forward and turns her head and looks at the male), the male is still portrayed with a visible hump (black shape) on his back, and the female, with feathers in her hair, has had her upper body pierced by a white shaft.

In 1950 Pollock used this same figurative arrangement, albeit covertly, for the drip painting *Number 10* (Plate 13). When viewed in chronological order—that is, Sikyatki figures, *Two* (c. 1945), *The Child Proceeds* (1946), and *Number 10* (1950)—the latter appears as the obvious result of a progressive abstraction of the image based on Pollock's painterly logic. Once accustomed to the relationship between the linear vocabulary of Pollock's drip paintings and their precursors, the mythic-pictographic pictures, the viewer's eye has no trouble in finding the not-so-veiled image of copulating figures in *Number 10*.[97] The coital position there is virtu-

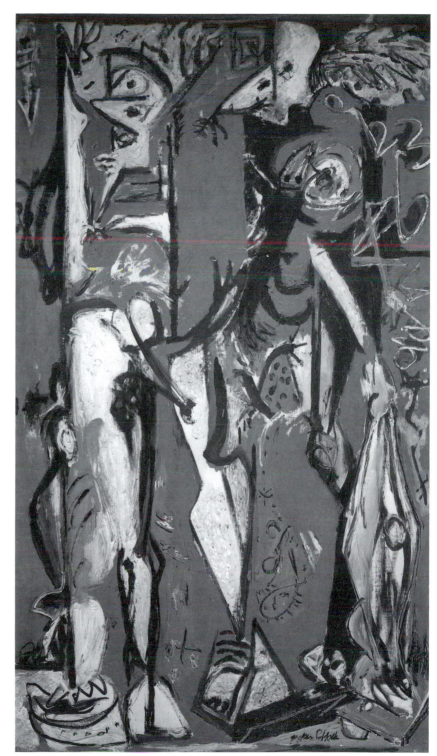

Figure 6-22
JACKSON POLLOCK
Two
(c. 1945).

Oil/canvas, 76" x 34 1/4". Peggy Guggenheim Collection, Venice. Photograph by David Heald. Solomon Guggenheim Foundation, New York. © 1993 Pollock-Krasner Foundation/ARS, New York.

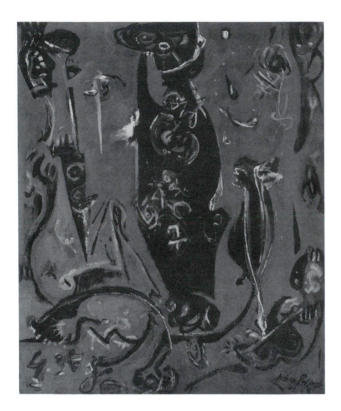

Figure 6-23
JACKSON POLLOCK
Totem Lesson 2
(1945).

Oil/canvas, 72" x 60".
Reproduced by permission
of the Australian National
Gallery, Canberra.
© 1993 Pollock-Krasner
Foundation/ARS, New York.

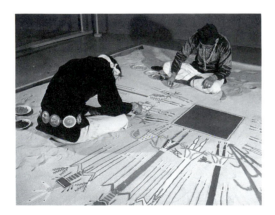

Figure 6-24
Navajo sand painters working
at the exhibition "Indian Art
of the United States" (1941).
Photograph courtesy
Museum of Modern Art,
New York.

ally the same as in *Two*. The remnants of the hump are now found as a series of red splashes grouped together that move from the middle of the male figure's back toward his pelvic region.

Sand Paintings and Drip Paintings: Ritual Art

Pollock's *Totem Lesson 2* (1945, Fig. 6-23), which once again makes reference to ritual transformation, is a transitional work that signals the sand-painting tradition that informs Pollock's drip paintings. The large, dark zoomorph in the center, with upraised arm and white pictographic writing on its body, is probably a painterly variation of the hard-edged Sky Father in a Navajo sand painting illustrated in *Indian Art of the United States* (Plate 12).[98] In several southwestern Indian cultures, sand paintings are an integral part of elaborate ceremonies designed to cure illnesses by restoring the patient to wholeness and to harmony with nature. Both physical and psychic ailments are cured by the pictures, whose iconography and process of creation are known only by special medicine men, called "singers" among the Navajo. These singers generate flat, linear images by sprinkling colored sand or pulverized minerals in a freehand manner directly onto the buckskin canvas on the ground or onto the ground itself (Fig. 6-24). The Navajo artist squeezes the colored sands tightly between thumb and forefinger and releases them in a controlled stream, resulting in a "drawn" painting.

Pollock, too, achieved "amazing control" in a seemingly freewheeling process by using a basting syringe "like a giant fountain pen."[99] The other similarities between the sand painter's process and that used by Pollock in the drip paintings are at once obvious. Just as the sand painter works strictly from memory, Pollock also worked without preliminary drawings, characterizing his paintings as "more immediate—more direct."[100] The Navajo sand painting exhibited in 1941 measured eight by ten feet, meaning it "functioned between the easel and the mural," which is how Pollock described the increased scale in his painting.[101]

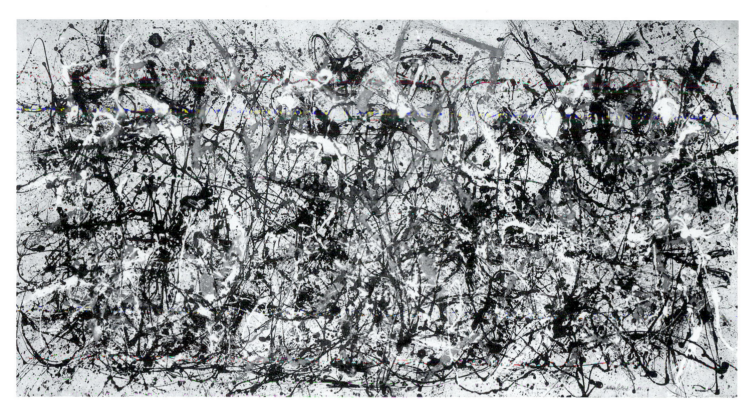

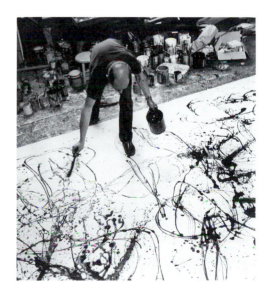

Furthermore, although it had been created on the ground, like Pollock's drip paintings, the sand painting, too, was displayed as if it were an easel painting.

In the face of bouts with alcoholism and deep depression, Pollock struggled, like the Indian patient, for self-integration.[102] Perhaps this was the basis of his fascination with Indian sand paintings like those shown in the *Sixteenth Annual Report of the BAE* (1897)[103] and those made in New York in 1941 by Navajo singers. Because of Pollock's own search for wholeness and his obvious interest in sand paintings, his drip paintings, such as *Autumn Rhythm* (1950, Fig. 6-25), may be intrepreted as ritual acts in which Pollock stands for the shaman who is his own patient.[104] In 1947 Pollock made the following statement about his work: "My painting does not come from the easel. I hardly ever

Figure 6-25
JACKSON POLLOCK
Autumn Rhythm
(1950).
Oil/canvas, 105" x 207".
Collection Metropolitan
Museum of Art, New York,
George A. Hearn Fund, 1957.

Figure 6-26
Jackson Pollock painting
in his studio (1951).
Black-and-white photograph
by Hans Namuth.
Courtesy Hans Namuth
Studio, New York.

Figure 6-27
Navajo mother holding her
sick child and sitting on a
sand painting.
Courtesy American Museum
of Natural History,
neg. #2A 3647

stretch my canvas before painting. I prefer to
tack the unstretched canvas to the hard wall or
floor. I need the resistance of a hard surface.
On the floor I feel nearer, more a part of the
painting, since this way I can walk around it,
work from the four sides and literally be in the
painting. This is akin to the method of the In-
dian sand painters of the West."[105] By being *in*
the painting (Fig. 6-26) Pollock became like the
Navajo patient, the one sung over, who sits atop
the curing ceremony (Fig. 6-27). The Navajo
believe that contact with the numinous power
of the image unifies the patient with nature by
putting him/her in touch with mythic progeni-
tors.[106] Pollock, too, Kadish noted, "found
numinous qualities in American Indian materi-
als, [and] he saw similar forces emanating from
objects in nature and in his own paintings as
well." According to Kadish, Pollock thought
Indian art "transmitted a power."[107]

Pollock stated, "When I am *in* my painting
. . . I have no fears about making changes, de-
stroying the image, etc., because the painting
has a life of its own. . . . When I lose contact
with the painting the result is a mess. Other-
wise there is a pure harmony, an easy give and
take, and the painting comes out well."[108] Sand

paintings also have a life of their own, from
sunup to sundown, after which they are ritually
destroyed.[109] The Indian sand painter, too,
must not lose "contact with the painting" and
demonstrates great concentration; he is free to
correct and adjust the composition so that, ac-
cording to the Navajo, "all is in accord
again."[110] Thus, in both Pollock's and the Na-
vajo singer's situation the process and experi-
ence have as much importance as the image
created.

Pollock had learned from Graham's article
that (supposedly) primitive people, children,
and geniuses have free access to the power of
the unconscious mind. For adults, Graham
wrote, the closure to the past "is sometimes
temporarily relaxed by such expedients as dan-
ger, or nervous strain, alcohol, insanity, and in-
spiration."[111] Those are exactly the situations
that describe Pollock's life in the thirties and
forties. Because of such feelings and circum-
stances, Pollock may have felt the part of the
primitive, or perhaps he believed that experi-
menting with the ancient motifs of Native
Americans had brought him in touch with the
strata of the unconscious mind. Pursuing this
logical speculation, it is helpful to observe
Garrick Mallery's comments concerning the re-
lationship between pictographs and sign lan-
guage in the *First Annual Report of the BAE*
(1881): "The most interesting light in which
the Indians of North America can be regarded
is in their present representation of a stage of
evolution once passed through by our ances-
tors. Their signs, as well as their myths and cus-
toms, form a part of the paleontology of
humanity to be studied in the history of the lat-
ter as the geologist, with similar object, studies
the strata of the physical world."[112]

Graham, however, observed that children,
the intoxicated, and the insane cannot make
proper use of knowledge gleaned from the col-
lective unconscious. It cannot be coincidental,
then, that the dramatic shift from the purposely
crude pictographic paintings to the lyrical drip
paintings came in 1947 when Pollock began a
three-year abstinence from alcohol. The result
was the all-over paintings of 1947–1950, such as

Autumn Rhythm. When he began to drink again in 1950, his style shifted again, with the noticeable reintroduction of overt figural elements. In 1947, the year the drip paintings emerged, Pollock said, "I have always been impressed with the plastic qualities of American Indian art. The Indians have the true painter's approach in their capacity to get hold of appropriate images, and in their understanding of what constitutes painterly subject matter. . . . Their vision has the basic universality of all real art."[113]

There is a significant correlation between Pollock's perception of Indians as those who "get hold of appropriate images" and Graham's belief that exposure to the unconscious is a "journey to the primordial past for the purpose of bringing out some relevant information."[114] The result of the first is a painterly subject matter, and of the second, a spontaneous expression of the primal self; both are primary characteristics of the drip paintings.

Conclusion

Pollock's responsive adaptation of Native American art may be understood as having two stages. The first stage, the pictographic paintings, relates to a shamanic kind of self-discovery. The second, the drip paintings, represents the use of art as ritual for psychic healing and self-realization. For Pollock, immersion in the ancient and historic imagery of Indians was a mode of access to the unconscious. He knew and valued the Indian concept of "discovering one's own image" through shamanic experience, and he and Bultman often discussed "magic and the shamanistic cult of traveling to spirit worlds."[115] The world of the spirit may be the ultimate nature of the self, and Pollock believed that nature as self was approachable through dreams and visions, which yielded his imagery.[116]

The gripping brilliance of *Guardians of the Secret* indicates that for Pollock, coming to know the self was like standing at the heart of a flame. It is a painting that exudes the ecstasy of ceremony, and yet the violent energy of its surface and the enigma of its pictographic secrets sug-

gest that realization of that discovered self was an arduous task. The loosening up or automatic quality of the linear movement in the drip paintings was an attempt to reveal the intangible contents of the unconscious mind. The abandonment of figuration and the sweeping poetic gesture in a work such as *Autumn Rhythm* may again have reference to Indian art. For example, as Mallery noted in the *First Annual Report of the BAE* (1881), "The reproduction of apparent gesture lines in the pictographs made by our Indians has, for obvious reasons, been most frequent in the attempt to convey those subjective ideas which were beyond the range of an artistic skill limited to the direct representation of objects."[117]

The move away from overt representation to convey subjective content is Pollock's "strongest point about Indian culture"[118] and is illuminated by his legendary reply to Hans Hofmann, "I am nature."[119] The strongest, most poignant fact of Indian life to Pollock was that "people living close to nature found nature in themselves rather than nature as a motif."[120] It follows that if Pollock were going to paint from nature, the resulting image would be an observation of the self. Lee Krasner's comments on the "I am nature" statement supports this idea: "It breaks once and for all the concept that was more or less present in the Cubist derived paintings, that one sits and observes nature that is out there. Rather it claims a oneness."[121]

The drip paintings do speak of a oneness, for Pollock must have felt they were the pictorial realization of his transformed consciousness. Elements of his unconscious mind had merged with his waking conscious, and the result was a lengthy period of abstinence from drink (1947 to 1949), a sense of wholeness, and a marked tranformation of his painting style. Typically, the drip paintings themselves are the merger of opposites: the image and the pictorial ground become one, the gesture and image become one, drawing and kinds of writing become painting, and, finally, the work of art is equivalent to the ritual process. In these paintings made between 1948 and 1950 Pollock sought unity between conscious decision and primitive instinct, and

with the impetus of Native American art he found it.

The drip paintings must be seen not only in the context of Pollock's own stylistic transformation but also in the context of the transformation within the New York avant-garde. While Pollock asserted a oneness with nature, Gottlieb spoke of "going forward to nature," and Pousette-Dart spoke of believing "in the primal" and "whole thinking."[122] In their search for holistic experience these painters helped resolve the crisis of subject matter common to American artists in the 1940s by establishing themes of universal relevance based on Native American traditions, images, and art processes. Through myth-making, evocation of archaic surfaces, and transformation of indigenous primitive forms in a manner both intuitive and calculated, they incorporated ancient American art into a modern Abstract Expressionism. Each in his own way helped to fulfill the prophecy so often heard in New York during the 1930s and 1940s, that Native American art and culture could be the wellspring for a modern art that portrayed what many believed was the collective experience.

Conclusion

The institutionalization of Native American art in the later nineteenth and early twentieth century laid the foundation for an avant-garde primitivism in New York (and its New Mexican colonies) having a specifically Amerindian inflection. My discussion of the collecting patterns, taxonomies, and exhibition designs in this nascent period of institutionalization was largely synthetic, weaving together for the first time a narrative about policy and practice that demonstrated how museums (and national fairs) conceptualized and packaged "The Indian" and his/her art as public spectacle. The artistic responses, which I traced and tracked in subsequent chapters, clearly indicate that New York modernists were an active, not passive, audience for the collections at the Museum of the American Indian, the American Museum of Natural History, and the Brooklyn Museum. In a very real sense, the history of these collections is the history of primary sources of inspiration for the primitivism of two generations of New York artists. Furthermore, there was a demonstrably organic relationship between the creation of Indian art collections in New York, salvage/philanthropic activity in New Mexico, and the avant-garde's progress toward, and into, abstraction.

Although the colonists at Santa Fe and Taos have been treated in studies whose focus is the Southwest, they have been ignored in most histories of American modernism, narratives generally having their geographic and aesthetic locus in New York. Here I have emphasized the symbiotic relationship between the New York avant-garde and the New Mexican art colonists in a context that expanded the definition of modernist primitivism to include theory and criticism of Indian art, as well as participation in preservationist projects. Like museum collections, patronage and critical texts also contributed to an atmosphere in which Native American values were perceived as an antidote to the ills of modernity. Generally speaking, the first generation of New York modernists who responded to Native American art and culture manifested a "soft" primitivism built on the notion of "the good Indian." For these artists

(Marsden Hartley), collectors (John Sloan), and critics (Mabel Luhan), the Indian community was a symbol of simplicity in a world become overly complex: small, holistic, natural, rural, agrarian, and ceremonial. Their perception of "The Indian" contrasted with that of the second generation, whose primitivist response to Native America began about 1941, that is, after the exhibition "Indian Art of the United States." Despite the centrality of this exhibition to the history of the New York avant-garde, this is the first art-historical study to give it and the "Exposition of Indian Tribal Arts" close and careful scrutiny, which the primary documents indicate they deserve.

The "hard" or "raw" primitivism[1] that typifies so much of the Indian-influenced art and theory produced after 1941 was based not so much on a notion of "the good Indian" as on the perceived universality of experience symbolized by the "natural Indian." Thus, for Barnett Newman, Jackson Pollock, and the other myth-makers of Abstract Expressionism, the "primitive," ecstatic Indian, who acted out directly and intuitively like animals and nature, was neither good nor bad, but authentic—unhampered by artifice. They, too, however, sought to transform modernity—not its secularized complexity, but its atavistic barbarism—by means of an artistic paradigm derived in large part from the myths, rituals, materials, and artistic practices of Native America. When writ large under the authority of Jung's collective unconscious, the healing ceremonies of the Navajo, the earthy sexuality of ancient Puebloan imagery, and the ritualized violence implicit in Kwakiutl masks became the transcultural psychic property of Everyman—but not necessarily transnational, since the forties generation was united with the generation of the Armory Show in a desire to incorporate the images, forms, and values of "The Indian" into a self-consciously *American* modernism.

From the years just prior to World War I, through the Depression, into the early years of War World II and beyond, artists, critics, curators, and government officials alike hailed the artistic and cultural forms of Native America for possessing the values needed by the United

States of America. They saw in Indian traditions the vitality and resilience necessary to weather adversity. By identifying with Native America, the national culture suddenly acquired "roots" deep in the American soil. The nation-state could thus incorporate the strength and tenacity of Indians, who had sprung, so it seemed, from the land itself. The desire to have an American art presupposes the desire to have an American national culture, and for both generations of the New York avant-garde considered here, whether hard or soft in their Amerindian primitivism, embracing Native America was also a way of rejecting Europe. Paradoxically, one of the most important lessons learned from Native American art—that abstract forms could symbolize the elemental forces of nature—actually reinforced a modernist paradigm of European origin. Thus, Pollock, the ultimate primitivist, crossbred Native American traditions with European modernism, generating a painting style whose kinetic vitality and elegant, transcendental presence remain unequaled in the history of American art.

But Pollock's use of Indian art signals a complex historical problem, one with moral implications still resonant in American art culture, which cannot be ignored. The sheer weight of the documentary and visual evidence reveals a debt of great magnitude owed to Indian art and artists by the modern artists who are the subjects of this study. Given the tremendous variety of responses to Native art and culture recorded here, I have used several words and terms—such as *borrowed, influenced by, engaged, stimulated, affirmed by, appropriated*—to describe the processes by which ideas about "The Indian" were manifest in avant-garde art. The term *dialogue*, however, which suggests a two-way exchange, is inappropriate unless the "conversation" is regarded as having a delayed Indian component. That is, the changes that took place in the various Indian arts between 1910 and 1950 were less the result of Native American artists engaging Euro-American art principles than they were adaptive responses that negotiated preservationist patronage and out-group market demands. After 1950, an "Indian modernism" began to emerge in the works

of such artists as Joe H. Herrera (Plate 14), Oscar Howe, George Morrison, and David Palladin, with developments occurring more rapidly after the opening of the Institute of American Indian Arts in Santa Fe in 1962. Furthermore, avant-garde artists, from Max Weber to Pollock, were addressing their comments, so to speak, not to a Native American audience but rather to their own non-Indian contemporaries. And although John Sloan and others of his generation promoted contemporary Indian art, there is no evidence to suggest that any New York artist, save George L. K. Morris, was ever influenced stylistically by the *new* Indian painting. Almost exclusively, ancient, historic, and "primitive" objects provided both the intellectual and aesthetic stimuli necessary for the New York avant-garde's modernist primitivism. Implicit in their aesthetic indifference to the work of Awa Tsireh, Tonita Peña, Harrison Begay, Fred Kabotie, and many others is a critique of the hybrid and acculturated elements in their painting. Contemporary Indian artists still confront the legacy of this highly selective appropriation: a widely held belief that "authentic" Native art belongs to, and comes from, a pure aboriginal past, one that is inscribed in texts written in the "ethnographic present."

And yet, I have to ask, was the appropriation of Native art by Pollock et al. inappropriate? My answer to this critical question is complicated and, frankly, not likely to satisfy all the various constituents of a book such as this. First of all, what exactly is artistic appropriation? The most succinct definition I have yet encountered was written by Martha Buskirk: "In discussions of contemporary art, appropriation is generally understood as a method that uses recontextualization as a critical strategy. In theory, when an artist places a familiar image in a new context, the maneuver forces the viewer to reconsider how different contexts affect meaning and to understand that all meaning is socially constructed."[2] But appropriation obviously did not begin with the advent of postmodernism: precedent for Pollock was established by Pablo Picasso's linkage of African

sculptural form with illicit sexuality; by Marcel Duchamp's "readymade" shovel, bottle rack, and urinal; and by Stuart Davis's transfiguration of pop culture imagery. Whether Pollock was trying to suggest that "all meaning is socially constructed" is debatable, but not the fact that he (as well as Adolph Gottlieb and others) believed that the contexts of contemporary culture, of necessity, overdetermined both imagery and technique.[3] Pollock knew full well that he was recontextualizing aboriginal imagery, and certainly the New York audience for "advanced" art in the forties had been exposed to Native American art repeatedly.

The dictionary is also straightforward about what it means to appropriate: to take exclusive possession of; to take or make use of without authority or right. Inasmuch as it produces a master narrative about the Primitive ("The Indian"), primitivist discourse, both visual and verbal, takes possession of colonized indigenous cultures by controlling representations of them. And Pollock, whom I'm using metonymically here, contributed by way of his paintings, as did Barnett Newman with his criticism, to the perpetuation of a representational fiction about Indians. But did he make use of Native American art without authorization? Does the fact of his appropriation invalidate or inauthenticate his work? I believe that the historically informed answer to both of these questions is yes and no, and it is my contention that Pollock can be made accountable to history without being cast as a villain.

As for authorization, a perfectly reasonable Native American response to the avant-garde's primitivism would be, "first you took our land, now you want our culture." This sentiment, in one form or another, has been expressed countless times by Indian advocates of Native American sovereignty. Indian people quite rightly resent Euro-America's vampiric attachment to indigenous culture for the purpose of filling in what many sense is the spiritually empty center of "Occidental" culture, that emptiness being the price modernity had paid for its "progress." To be more specific, let us consider yet again Pollock's *Guardians of the Secret*, which, as I

have demonstrated, features a number of references to Indian art, including a Nishka cannibal spirit mask and a figurative image derived from Mimbres pottery. In the highly stratified culture of the Northwest Coast, masks, songs, and other art forms are indications of both lineage and social rank. Such art ratifies certain privileges, establishes the proper nature of social relations, and quite literally reifies history. Pollock was unauthorized, in the indigenous sense, to display such a mask/image. And whether he was aware of it or not, most surviving Mimbres pots were food bowls buried as grave goods. In fact, the one exhibited in 1941, to which he responded, had been ceremonially "killed" by punching out a hole in the bottom. Furthermore, much of the historic Indian art seen by Pollock in both Los Angeles and New York was there as a result of museum anthropology's salvage paradigm, which was itself directly related to the economic and cultural decline of Indian communities in the Columbian era, especially after the beginning of the reservation period in the 1860s.

But *Guardians of the Secret* is a painting of the forties, not the nineties, and my belief in historicism forces me to insist that Pollock believed, consciously or otherwise, that he was authorized to appropriate the art forms, myths, and rituals of Native America. Pollock painted before the Civil Rights movement of the 1960s and before a sensitivity to both ethnic difference and the colonial implications of appropriation insinuated themselves—albeit tentatively—into the American art world in the 1980s. He worked without the benefit of texts by Frantz Fanon, Vine Deloria, Gerald McMaster, bell hooks, Trinh T. Minh-ha, James Clifford, and others.[4] What he did know was John Graham's notion of a racial memory of humanity's collective past, allegedly encoded in Kwakiutl, Haida, and Inuit art. From Wolfgang Paalen he and his generation learned that the time had come to create a world consciousness out of a universal art, one based on the integration of modern and American Indian art. Pollock's authorization, so to speak, was really a matter of historical impetus accruing from a variety of sources, not the least of which

was the Jungian myth of universality. Certainly René d'Harnoncourt's 1941 exhibition at the Museum of Modern Art, which stirred Pollock and his contemporaries, did nothing to articulate the colonial conditions in which many of the objects were acquired. On the contrary, the *explicit* message of the show was that Indian art "constitutes part of the artistic and spiritual wealth of this country."[5] I do not think it is too speculative to say that Pollock felt something akin to entitlement vis-à-vis the incorporation of Indian art into his own work. For example, if his own cultural experience suggested to him that Tsonoqua was symbolic of a particular stage in the evolution of consciousness, one that was recapitulated in the subconscious of each individual, it is hard to imagine that he would or even could have been conflicted about employing such a mask to signify *universal* "secrets."

I do not intend for my comments here to be interpreted as an apologia or justification, in a moral sense, for the appropriation inherent in avant-garde primitivism, but rather, to be understood as an explanation of how certain historical forces are given tangible form in cultural artifacts. If there is such a thing as a cultural imperative that determines to a great extent how and what a work of art can mean at any given moment in time—and I believe that there is—it confirms the usefulness of cultural relativism in preventing a cross-cultural work from being reduced, analytically, to a "Babel" of conflicting meanings that is ultimately meaningless. In tandem with historicism, cultural relativism

makes it possible me for to accept the fact that *Guardians of the Secret* "made sense," i.e., was "aesthetically correct," within one historic culture (Euro-America in the forties), and simultaneously, was a sacrilegious, imperious, nonsensical melange of "illegally" appropriated forms within other historic cultures (Nishka, Zia). I want neither to lose sight of the importance of Pollock's primitivizing paintings, packed as they are with information about the "deep structures" of Euro-American culture at midcentury, nor to overlook the colonial history implicated in those same structures.

I am being overly reductive, of course, in distilling a half century of cultural primitivism into a single primitivist trope: Pollock's appropriation of Indian art. Even so, the critical importance of Native America to his artistic development, and in turn, his central place in the history of Euro-American culture since the forties, justifies, I believe, this essentializing gesture on my part. Concentrated in the neoshamanic art of this troubled and troubling figure, whose image has so thoroughly haunted Euro-American consciousness, is perhaps an abstract of this narrative. We learn nothing from Pollock's paintings of the historic dislocation and dispossession of indigenous peoples after 1492, nor is there any cognizance in his work of the social conditions of his Native American contemporaries. But from museum collections and texts written about—not for or by—Indian artists, he salvaged decontextualized cultural forms to tell a story about distance and desire.

Notes

Introduction

1. The first important survey-type exhibitions of Native American art, the prototypes of those that followed, are examined at length in Chapter 4: "The Exposition of Indian Tribal Arts" (New York, 1931) and the Museum of Modern Art's "Indian Art of the United States" (1941). For documentation of selected recent exhibitions see the following: Ralph T. Coe, *Sacred Circles*, exh. cat.; Evan M. Maurer, *The Native American Heritage*, exh. cat. (Chicago: Art Institute of Chicago, 1977); Arthur Silberman, 100 *Years of Native American Painting*, exh. cat. (Oklahoma City: Oklahoma Museum of Art, 1978); Alan Wardwell, *Objects of Bright Pride*: *Northwest Coast Indian Art from the American Museum of Natural History*, exh. cat. (New York: Center for Inter-American Relations and American Federation of Arts, 1978); David S. Brose, James A. Brown, and David W. Penney, *Ancient Art of the American Woodland Indians*, exh. cat. (New York: Harry S. Abrams for the Detroit Institute of the Arts, 1985); Ralph T. Coe, *Lost and Found Traditions: Native American Art, 1965–1985,* exh. cat. (Seattle: University of Washington Press, 1985); Dorothy K. Washburn, ed., *Hopi Kachina: Spirit of Life*, exh. cat. (Seattle: University of Washington Press for the California Academy of the Sciences, 1980); Diana Fane, Iva Jacknis, and Lise M. Breen, *Objects of Myth and Memory: American Indian Art at the Brooklyn Museum*, exh. cat.; and Aldona Jonaitis, ed., *Chiefly Feasts: The Enduring Kwakiutl Potlatch*, exh. cat., (Seattle: University of Washington Press, 1991).

2. According to a recent article in a magazine popular with collectors, "If you purchased only the top dollar items at the major 1988 American Indian art auctions, a million would have bought you 30 items. That's not as many items as possible in 1987, but your collection would be an enviable one." See Laurence Smith, "Adding It Up: Your Million Dollar Collection of American Indian Art," *Antiques and Fine Art*, 6 (April 1989): 111.

3. George Kubler, quoted in Robert Goldwater, "Art History and Anthropology: Some Comparisons of Methodology," in

Robert Goldwater, *Primitivism in Modern Art*, 314; and Goldwater, "Art History," in Goldwater, *Primitivism*.

4. William Rubin, ed., preface to *"Primitivism" in 20th Century Art*, exh. cat., 1:x.

5. See Maurice Tuchman et al., *The Spiritual in Art: Abstract Painting, 1890–1985* (New York: Abbeville Press, 1986). Recent issues of the College Art Association's *Art Journal* also have participated in the revising of modernist art history. For example, see Richard Pommer, guest ed., "Revising Modernist History: The Architecture of the 1920s and 1930s," *Art Journal* 42 (Summer 1983); Linda D. Henderson, guest ed., "Mysticism and Occultism in Modern Art," *Art Journal* 46 (Spring 1987); and Ann Gibson and Stephen Polcari, guest eds., "New Myths for Old: Redefining Abstract Expressionism," *Art Journal* 47 (Fall 1988).

1. The Idea of The Indian/Collecting Native America

1. On etic versus emic observations, see Marvin Harris, *The Rise of Anthropological Theory*, 569–571, 575. For Boasian anthropology, see George W. Stocking, Jr., ed. *The Shaping of American Anthropology, 1883–1911*, 1–20.

2. On the "significance of *Indian* as a general category and conception" produced by "imagination and ideology," see Robert F. Berkhofer, Jr., *The White Man's Indian*, 23–25, 71.

3. On the good/bad Indian, see Berkhofer, *White Man's Indian*, 26, 28.

4. Rennard Strickland, quoted in Raymond William Stedman, *Shadows of the Indian*, x.

5. Stanley Diamond, *In Search of the Primitive*, 215.

6. Arthur O. Lovejoy and George Boas, *Primitivism and Related Ideas in Antiquity*, 7.

7. According to M. Jane Young, the Zuni believe that their mythical ancestors entered this world as "raw beings," and they associate the power of kachinas with rawness, which implies "closeness to the world of the myth" (*Signs from the Ancestors*, 127–128).

8. William Rubin, "Modernist Primitivism," in *"Primitivism,"* ed. Rubin, exh. cat., 1:4.

9. Marianna Torgovnick, *Gone Primitive: Savage Intellects, Modern Lives* (Chicago: University of Chicago Press, 1990). For a critique of Torgovnick's failure to investigate the (Native) American elements of modernist primitivism, see my review, "Primitivism," *Art Journal* 49 (Winter 1990): 432–434.

10. See George W. Stocking, Jr., *Race, Culture, and Evolution*, 114. This particular terminology for the stages—savagery, barbarism, and civilization—is associated with the work of the nineteenth-century American anthropologist Lewis Henry Morgan.

11. On Powell, evolutionism, and the BAE, see William Culp Darrah, *Powell of the Colorado* (Princeton: Princeton University Press, 1951), 255–269.

12. Tzvetan Todorov, "'Race,' Writing, and Culture," and Anthony Appiah, "The Uncompleted Argument: Du Bois and the Illusion of Race," in *"Race," Writing, and Difference*, ed. Henry Louis Gates, Jr. (Chicago: University of Chicago Press, 1986), 372–373, and 36. Gates himself has noted that "race, as a meaningful criterion within the biological sciences, has long been recognized to be a fiction." Even so, our discourse, he writes, is replete "with usages of race which have their sources in the dubious pseudoscience of the eighteenth and nineteenth centuries"; see "Editor's Introduction: Writing 'Race' and the Difference It Makes," in *"Race,"* ed. Gates, Jr., 4.

13. On the origins, historical contexts, and twentieth-century criticisms of recapitulation theory, see George W. Stocking, Jr., "American Social Scientists and Race Theory: 1890–1915," (Ph.D. diss., University of Pennsylvania, 1960), 348n. 47. According to Stephen Jay Gould, Haeckel coined the terms *ontogeny* and *philogeny*. However, Gould has demonstrated that the essential premise of recapitulation theory is as old as the history of biology; Steven Jay Gould, *Ontogeny and Philogeny* (Cambridge: Harvard University Press, 1977), 76, 13.

14. G. Stanley Hall, quoted in Stocking, Jr., "Race Theory," 351.

15. See Franz Boas, "The Limitations of the Comparative Method of Ethnology" (1896), "The Aims of Ethnology" (1888), and "The Aims of Anthropological Research" (1932), in Franz Boas, *Race, Language, and Culture*, 243–259, 270–280, 626–638.

16. See Ruth Benedict's comments in Thomas F. Gossett, *Race: The History of an Idea in America* (Dallas: Southern Methodist University, 1963), 422. For a discussion of the current controversy about the appropriateness of *Kwakiutl* as a unitary signifier for Native peoples residing in separate villages on and near Vancouver Island, see James Clifford, "Four Northwest Coast Museums," in *Exhibiting Cultures: The Poetics and Politics of Museum Display*, ed. Ivan Karp and Steven D. Lavine (Washington D.C., Smithsonian Institution Press, 1991), 249.

17. See William H. Truettner, "Science and Sentiment," in Charles Eldredge, Julie Schimmel, and William H. Truettner, *Art in New Mexico, 1900–1945*, exh. cat., 18–41.

18. See ibid., 19, 21–25, 27–28, 38, 40; Richard Frost, "The Romantic Inflation of Pueblo Culture," *American West* 17 (January–February 1980): 5–9, 56–60; and T. C. McLuhan, *Dream Tracks: The Railroad and the American Indian, 1890–1930* (New York: Harry Abrams, 1985), 11–41. For Lummis, see Joseph Traugott, "The Enchanted View: Charles Fletcher Lummis's Photographs of the American Southwest, 1888–1905," in Joseph Traugott, Anna Secca, and Mario Materussi, *La Terra Incantata Dei Pueblo: Fotografie Di Charles F. Lummis, 1888–1905*, exh. cat. (Treviso: Vianello Libri, 1991), 129–137.

19. Truettner, "Science and Sentiment," in Eldredge, Schimmel, and Truettner, *Art in New Mexico*, exh. cat., 28.

20. Cf. Berkhofer, *White Man's Indian*, 78.

21. On the elevation of nonwestern artifacts to the category of art as a taxonomic shift allowing such material to circulate within a "modern system of objects," see James Clifford, *The Predicament of Culture*, 196–200.

22. Rubin, "Modernist Primitivism," in *"Primitivism,"* ed. Rubin, exh. cat. 1:7. Rubin's reference to the arrival in the West of tribal

sculpture underscores the fact that for him primitive art is, by and large, African and Oceanic carvings. The relative lack of Native American material in his exhibition "'Primitivism' in 20th Century Art" is further evidence of this fact. Furthermore, what Rubin takes as a straightforward situation involving aesthetic recognition was much more complex.

23. See Joan Lester, "The American Indian: A Museum's Eye View," *Indian Historian* 5 (1972): 26, and Clifford, *Predicament of Culture*, 227.

24. Robert Rydell, *All the World's a Fair*, 25.

25. Lester, "View," 30; and Rydell, *Fair*, 58, 63. Concerning the culture-area concept, Harris has observed that in spite of Mason's primacy, it was "a community product of nearly the whole school of American anthropologists" (*Anthropological Theory*, 374).

26. Otis T. Mason, "Ethnological Exhibit of the Smithsonian," in *Memoirs of the International Congress of Anthropology*, ed. C. Staniland Wake (Chicago: Schute Publishing, 1894), 210, quoted in Harris, *Anthropological Theory*, 374.

27. Rydell, *Fair*, 64.

28. See his planning papers for the exposition in the Edward L. Hewett Collection, History Library of the Museum of New Mexico. As for "savagery," Ales Hrdlicka of the National Museum organized for Hewett two displays of artifacts; one was devoted to the physical development of "man" and the other to the evolution of culture. In these exhibits, praised by scientists and the lay public alike, Hrdlicka espoused a doctrine of racial evolution and racial hierarchy. See Rydell, *Fair*, 222–223.

29. W. H. Holmes, from the introduction to Edgar L. Hewett, "Ancient America at the Panama-California Exposition," *Art and Archaeology* 2 (November 1915): 65. See "Outlines of Exhibits in Science and Art," "Collections in the Department of Anthropology and Ethnology," and "Museum Collections in the Indian Arts Building," Hewett Collection Manuscripts (hereafter cited as Hewett MSS).

30. Edgar L. Hewett, "Archaeology at the Panama-California Exposition," 8, Hewett MSS.

31. T. Harmon Parkhurst and John P. Harrington, "Suggestions for Exhibiting the Indians of the Southwest at the Panama-California Exposition," 1, 10, Hewett MSS.

32. John P. Harrington, "The Indians Living along the Santa Fe Railroad in New Mexico, Arizona, and California," 1, 3, 4, Hewett MSS.

33. Ibid., 1, 3, 4, 5.

34. Ibid., 6.

35. W. H. Holmes, quoted in Hewett, "Ancient America," 103.

36. See Heye's comments in "Young Boswell Interviews George Gustav Heye," *New York Tribune* (21 December 1922), in the Archives of the National Museum of the American Indian, New York. See also U. Vincent Wilcox, "The Museum of the American Indian, Heye Foundation," *American Indian Art Magazine* 3 (Spring 1978): 43.

37. Wilcox, "Museum," 43.

38. Ibid., 44–47.

39. "New Museum in New York Houses Red Man's Record," *New York News* (11 December 1922), in the Archives of the National Museum of the American Indian.

40. George Heye, quoted in ibid.

41. See Alan Wardwell, *Objects of Bright Pride: Northwest Coast Indian Art from the American Museum of Natural History*, exh. cat. (New York: Center for Inter-American Relations and American Federation of Arts, 1978), 23–28; Douglas Cole, *Captured Heritage*, 36, 85, 132, 142–143; and Aldona Jonaitis, *From the Land of the Totem Poles*.

42. Wardwell, *Bright Pride*, 28–29; and Cole, *Captured Heritage*, 147, 153–154.

43. Wardwell, *Bright Pride*, 29–30; and Cole, *Captured Heritage*, 156–157, 161.

44. Wardwell, *Bright Pride*, 33; and Cole, *Captured Heritage*, 154.

45. Stewart Culin, "Games of the North American Indian," *Twenty-fourth Annual Report of the Bureau of American Ethnology* (Washington, D.C.: Government Printing Office, 1907), 3–809. See also Craig D. Bates and Brian Bibby, "Collecting among the Chico Maidu: The Stewart Culin Collection at the Brooklyn

Museum," *American Indian Art Magazine* 8 (Autumn 1983): 47. Information on the stages of Culin's career was acquired through personal communication from Ira Jacknis, former research associate in the Department of African, Oceanic, and New World Art at the Brooklyn Museum, 17 September 1986. See also Diana Fane, "The Language of Things: Stewart Culin as Collector," in Fane, Jacknis, and Breen, *Objects*, exh. cat., 14–17; and Ira Jacknis, "The Road to Beauty: Stewart Culin's American Indian Exhibitions at the Brooklyn Museum," in Fane, Jacknis, and Breen, *Objects*, exh. cat., 36.

46. Jacknis, "Road to Beauty," in Fane, Jacknis, and Breen, *Objects*, exh. cat., 30–31.

47. Fane, "Stuart Culin," in Fane, Jacknis, and Breen, *Objects*, exh. cat., 19.

48. Stuart Culin, quoted in ibid.

49. Fane, "Stuart Culin," in Fane, Jacknis, and Breen, *Objects*, exh. cat., 27.

50. Jacknis, "Road to Beauty," in Fane, Jacknis, and Breen, *Objects*, exh. cat., 32.

51. Cole, *Captured Heritage*, 223.

52. Bates and Bibby, "Stewart Culin Collection," 47.

53. Cole, *Captured Heritage*, 224.

2. *Avant-Garde Patronage and Criticism of Native American Art at the Santa Fe and Taos Colonies, 1915–1930*

1. Julie Schimmel, "From Salon to Pueblo," in Eldredge, Schimmel, and Truettner, *Art in New Mexico*, exh. cat., 51–53.

2. As long as his funds permitted, archaeology was central to Heye's collecting practices. Through his patronage, important sites in California, Nevada, and New Mexico were excavated in the 1920s, resulting in an increased awareness of the time-depth of ancient American cultures.

3. See Edwin L. Wade, "The Ethnic Art Market in the American Southwest, 1880–1980," in *Objects and Others*, ed. George W. Stocking, Jr., 170–171.

4. See Charles F. Lummis, *Some Strange Corners of Our Country: The Wonderland of the Southwest* (New York: Century Co., 1891).

5. See Edgar L. Hewett, "America's Archaeological Heritage," and Paul A. F. Walter, "The Santa Fe-Taos Art Movement," *Art and Archaeology* 4 (December 1916): 257–266 and 330–338.

6. Jesse Walter Fewkes, "Hopi Katcinas Drawn by Native Artists," *Bureau of American Ethnology [BAE] Report* 21 (Washington, D.C.: Government Printing Office, 1903; reprint, Glorietta, N. Mex.: Rio Grande Press, 1969). The original drawings are collected in four volumes known as the *Codex Hopiensis*, at the Smithsonian Institution, Washington, D.C.

7. This chronology of the new Indian painting is based on J. J. Brody, *Indian Painters and White Patrons*, 81–83, 85–102; Dorothy Dunn, *American Indian Painting*, 67–73; and Clara Lee Tanner, *Southwest Indian Painting* (Tucson: University of Arizona Press, 1973): 181–217.

8. See Arrell Morgan Gibson, *The Santa Fe and Taos Colonies*, 158.

9. See Clark S. Marlor, *The Society of Independent Artists* (Park Ridge, N.J.: Noyes Press, 1984), 15–16; and "The Indian Exhibit," in *Fourth Annual Exhibition of the Society of Independent Artists*, exh. cat. (New York: Society of Independent Artists, 1920), n.p., in the Archives of American Art (referred to hereafter as AAA), Smithsonian Institution, Washington, D.C.

10. John Sloan to Sheldon Parsons, quoted in "Paintings by Indians in New York," *El Palacio* 7 (March–April 1920): 79.

11. "The Indian Exhibit," in *Fourth Annual Exhibition*, exh. cat., n.p. The directors of the Society were so impressed with the public response to the Pueblo watercolors that they featured more of them in the annual exhibits of 1921 and 1922.

12. "Indian Artist Honored," *El Palacio* 8 (July 1920): 183.

13. Alice Corbin Henderson, "A Boy Painter among the Pueblo Indians and Unspoiled Native Work," *New York Times Magazine* (6 September 1925), 18–19.

14. See "Resurrection of the Red Man," *El Palacio* 8 (July 1920): 196.

15. Although this revival is often character-

ized as the result of the interaction between ethnologist Jesse Walter Fewkes and the renowned Hopi potter Nampeyo and her husband Lesou, most likely it was the trader Thomas V. Keam and his assistant Alexander M. Stephens who encouraged potters to incorporate prehistoric designs into vessels that were then fired according to traditional methods. See Wade, "Ethnic Market," 171–172. In spite of the dispute as to which non-Indian played the role of *animateur*, the Hopi ceramic revival is generally associated with Nampeyo and her work.

16. Ibid., 168. On the "tense see-sawing of power between collector/humanists and trader/dealers," see ibid., 167.

17. Dunn, *Indian Painting*, 228.

18. "First Annual Exhibition of Indian Arts and Crafts," *El Palacio* 7 (1 May 1922): 124.

19. Amelia Elizabeth White, quoted in Gibson, *Santa Fe and Taos*, 257. In later years Sloan's first wife, Dolly, managed this gallery, and it was she who influenced White in her 1938 decision to disperse her collection of Native art, begun in 1912, to various public institutions, including the Art Students League and the American Museum of Natural History. See "Amelia Elizabeth White Donates Her Collection of Indian Art to the People," *Art Digest* 12 (15 February 1938): 12.

20. The IAF evolved from the Pueblo Pottery Fund, a project begun in 1922; see Arthur H. Wolf, "The Indian Arts Fund Collection at the School of American Research," *American Indian Art Magazine* 4 (Winter 1978): 32. Other supporters included Santa Fe artist Frank Applegate; Hewett's associate Kenneth Chapman; anthropologists Frederick W. Hodge and Alfred V. Kidder; Harry Mera, an authority on Pueblo pottery; Santa Fe artist B. J. O. Nordfeldt; Elizabeth Shepley Sergeant, an essayist and biographer of Willa Cather; and Mary Cabot Wheelwright, founder of the Museum of Navajo Ceremonial Art (now the Wheelwright Museum of American Indian Art).

21. Willard Johnson, *Indian Arts Fund Bulletin*, 1925, no. 1:3, quoted in ibid.

22. Mary Austin, "Indian Arts for Indians," *The Survey* 60 (1 July 1928): 383.

23. "Indian Art, Preservation, and Development," *Indian Arts Fund Bulletin*, no. 2 (Santa Fe, 1926), quoted in Dunn, *Indian Painting*, 229.

24. See Dunn, *Indian Painting*, 232; Gibson, *Santa Fe and Taos*, 161; Wolf, "Indian Arts Fund," 33; and Nancy Fox, "Collections of the Laboratory of Anthropology," *American Indian Art Magazine* 8 (Spring 1983): 56–63.

25. Dunn, *Indian Painting*, 231.

26. See Herbert Joseph Spinden, "Indian Artists of the Southwest," *International Studio* 85 (February 1930): 49–51ff.

27. Hewett, "America's Archaeological Heritage," 257.

28. Ibid., 260.

29. Ibid., 259.

30. Ibid., 261, 262.

31. Ibid., 259, 261.

32. Ibid., 266.

33. Brody, *Indian Painters*, 85.

34. Edgar L. Hewett, "Crescencio Martinez—Artist," *El Palacio* 5 (3 August 1918): 67, 69. For a well-documented criticism of this belief, see Brody, *Indian Painters*, 91–97.

35. Hewett, "Crescencio Martinez," 67, 69.

36. Hewett, "Primitive vs. Modern Art," *El Palacio* 5 (25 August 1918): 133.

37. "Decorative Art of the Indian," *El Palacio* 5 (25 August 1918): 133.

38. Edgar L. Hewett, "Report of the Director of the School of American Research for the Year 1919," *El Palacio* 8 (July 1920): 169–171.

39. Ibid., 170–171.

40. On the repatriation of the "lost generation," see Malcolm Cowley, *Exile's Return: A Literary Odyssey of the 1920s* (1934; reprint, New York: Penguin Books, 1969).

41. "Indian Myths and American Art," *El Palacio* 11 (1 September 1921): 63–64.

42. Edgar L. Hewett, "Native American Artists," *Art and Archaeology* 13 (March 1922): 104–105.

43. Ibid., 104, 109.

44. Ibid., 105.

45. Ibid., 106, 104, 103, 106. Hewett expressed similar ideas in a lecture on "The Art of

the Earliest Americans" given to the American Federation of Art in Washington, D.C., which was reviewed in the *New York Times* and reprinted in "Primitive Art," *El Palacio* 13 (1 July 1922): 9.

46. As editor of *Poetry* she was instrumental in introducing the American public to Carl Sandburg, Robert Frost, Ezra Pound, and Vachel Lindsay. It was at her invitation that numerous American poets, including Lindsay, Sandburg, Frost, and Witter Bynner, visited Santa Fe, often giving public readings of their works. See Kay Aiken Reeve, "The Making of an American Place" (Ph.D. diss., Texas A&M University, 1977), 80–83, 87. Included among Henderson's publications are an anthology that she edited, *The Turquoise Trail: An Anthology of New Mexico Poetry* (1928) and the classic *Brothers of Light: Penitentes of the Southwest* (1937). See Shelley Armitage, "Red Earth: The Poetry and Prose of Alice Corbin," *El Palacio* 93 (Winter 1987): 36–44.

47. Henderson, "Boy Painter," 18.

48. Ibid.

49. Ibid.

50. Ibid.

51. Lois Palken Rudnick, *Mabel Dodge Luhan*, 169. Austin's oeuvre included thirty-two books and hundreds of articles. Through her publications she supported both the women's suffrage movement and free-choice birth control. As Rudnick has observed, Austin was drawn to powerful female figures from folk culture. The heroine of her play *The Arrow Maker* (1911) was a *chisera*, or Paiute Indian medicine woman; ibid., 170.

52. See her comments in T. M. Pearce, *Mary Hunter Austin*, 46.

53. According to Rudnick, Austin arrived in Santa Fe in the fall of 1918 and in Taos in March 1919 (*Luhan*, 346n. 47, and 171). However, Pearce, Austin's biographer, reported that she worked for the Carnegie Foundation surveying the Spanish population and its cultural institutions in northern New Mexico in the winter of 1917–1918 (*Austin*, 49). Another source also places Austin's first trip to New Mexico in 1917; see Barbara A. Babcock and

Nancy J. Parezo, *Daughters of the Desert: Women Anthropologists and the Native American Southwest, 1880–1980* (Albuquerque: University of New Mexico Press, 1988), 205, and the bibliography of Austin's writings on 229.

54. Austin's home, which she named *La Casa Querida* (Beloved House), was on a road populated by artists' studios. In a move typifying the attitude of the colonists, one of the Hendersons changed the name from Telephone Road to *El Camino del Monte Sol* (Road of the Mountain Sun). Pearce, *Austin*, 50.

55. On Austin's childhood mysticism and the two Marys, her interest in Pauite shamanism, and her belief in the influence of the "rhythmic environment" on art, see ibid., 21–22, 112, and 117.

56. Mary Austin, *The Land of Journey's Ending*, vii, 238, 241, 244–245, 263.

57. Ibid., 259.

58. Ibid., 259–260. But in apparent agreement with Sigmund Freud and C. G. Jung, she stated: "All early cultures are introspective, having no record of the past beyond the memory of their old men, and the writings on the deep self, most easily accessible in states of trance and sleeping. That is why Indians attach so much importance to dreams" (ibid., 260).

59. Ibid., 246.

60. Ibid., 264, 264–265, 265.

61. Austin, "Indian Arts," 388.

62. Ibid., 381, 388.

63. Ibid., 385, 381, 384, 382.

64. Mabel Dodge Luhan, *Movers and Shakers*. See also Rudnick, *Luhan*, 29–121. Born Mabel Ganson, she married four times; for convenience I have chosen to refer to her by the last of her married names.

65. Luhan, *Movers and Shakers*, 533–534.

66. Ibid.

67. Mabel Dodge Luhan to Maurice Sterne, quoted in Charlotte Leon Mayerson, ed., *Shadow and Light*, 136.

68. Mabel Dodge Luhan, *Edge of Taos Desert*, 62–63.

69. Rudnick, *Luhan*, 165.

70. Mabel Dodge Luhan, "From the

Source," *Laughing Horse*, no. 11 (September 1924): n.p.

71. Ibid.

72. Mabel Dodge Luhan, "A Bridge between Cultures," *Theatre Arts Monthly* 9 (May 1925): 300.

73. Ibid.

74. Ibid., 299, 298.

75. Ibid., 299, 300.

76. Ibid., 298. In this same passage Luhan refers to Oswald Spengler's belief in the predetermination of history.

77. Rudolph Steiner, quoted in Mabel Dodge Luhan, "Awa Tsireh," *The Arts* 11 (June 1927): 298.

78. Plotinus' mystical, pantheistic, and syncretic philosophy—neo-Platonism—stated that reality developed from a single, unknowable, essential One which transcended experience.

79. Luhan, "Awa Tsireh," 298.

80. Ibid., 298–299.

81. Mabel Dodge Luhan, "Beware the Grip of Paganism," *Laughing Horse*, no. 16 (Summer 1929): n.p. Parts of this narrative description of the dance at Santo Domingo were repeated later in Luhan, *Edge of Taos Desert*, 324–326.

82. The relationship between Mabel and Tony Luhan was almost certainly the inspiration for Lawrence's characters Kate and Cipriano in *The Plumed Serpent* (1926). Likewise, Kate's description of a (Mexican) Indian dance is remarkably similar to Luhan's recollections of her "oceanic" experience at Santo Domingo in 1917. Although she failed to see Luhan inscribed so clearly in *The Plumed Serpent*, Marianna Torgovnick's reading of the gendered nature of Lawrence's primitivism, vis-à-vis Kate's experience of the dance, is both cogent and illuminating (*Gone Primitive*, 163–170).

83. D. H. Lawrence, "America, Listen to Your Own," *New Republic* 25 (15 December 1920), 69.

84. D. H. Lawrence, "Just Back from the Snake Dance—Tired Out," *Laughing Horse*, no. 11 (September 1924): n.p.

85. Bert G. Phillips in Ernest L. Bluemenschein and Bert G. Phillips, "Apprecia-

tion of Indian Art," *El Palacio* 6 (9 May 1919): 178.

86. Bluemenschein, in ibid., 178–179.

87. See James Kraft and Helen Farr Sloan, *John Sloan in Santa Fe*, exh. cat., 34–35.

88. John Sloan, "The Indian Dance from an Artist's Point of View," *Arts and Decoration* 20 (January 1924): 17.

89. Ibid.

90. Ibid., 17, 56.

91. John Sloan, "Modern Art is Dying," *Echo* 4 (December 1926): 22.

92. Sandra Phillips, "The Art Criticism of Walter Pach," *Art Bulletin* 65 (March 1983): 110.

93. Ibid., 106, 108, 112, 115, 117; see also F. K., "Walter Pach, 1883–1958," *Arts Magazine* 33 (January 1959): 13.

94. Walter Pach, "The Art of the American Indian," *The Dial* 68 (January 1920): 62, 58, 63, 59, 60, 61.

95. Ibid., 58–59, 63–65.

96. Ibid., 64, 61, 65.

97. Walter Pach, "Notes on the Indian Water-Colours," *The Dial* 68 (March 1920): 343–345.

98. Ibid., 343–344.

99. See "Holger Cahill," *Art News* 59 (September 1960): 7; and "Holger Cahill," *Arts Magazine* 34 (September 1960): 11.

100. E. H. Cahill, "America Has Its Primitives," *International Studio* 75 (March 1920): 80.

101. Ibid., 82, 83, 81.

102. Ibid.

103. Ibid., 82–83.

104. Barbara Haskell, *Marsden Hartley*, exh. cat., 17–18, 26–27, 34.

105. See Gail Levin, "American Art," in "*Primitivism*," ed. Rubin, exh. cat., 2: 456–457; and Gail R. Scott, *Marsden Hartley*, 44.

106. Haskell, *Hartley*, exh. cat., 57–60.

107. Marsden Hartley, "Tribal Esthetics," *The Dial* 65 (November 1918): 400. It is not clear from Hartley's account whether he saw these dances at San Juan or Santo Domingo.

108. Ibid., 399, 400.

109. Ibid., 400–401.

110. Ibid., 401.

111. Marsden Hartley, "Aesthetic Sincerity," *El Palacio* 5 (9 December 1918): 332.

112. Ibid.

113. Hartley, "Tribal Esthetics," 400.

114. Marsden Hartley, "America as Landscape," *El Palacio* 10 (21 December 1918): 341.

115. Ibid., 340.

116. Ibid., 341.

117. Marsden Hartley, "Red Man Ceremonials: An American Plea for an American Esthetics," *Art and Archaeology* 9 (January 1920): 7, 13.

118. On the tendency in the visual arts to conceive nature as landscape, see Lawrence Alloway, *Topics in American Art since 1945*, 18.

119. Hartley, "Red Man Ceremonials," 7.

120. Ibid.

121. Ibid., 7, 12, 14.

122. Ibid., 11–12.

123. Ibid., 11–13.

124. Ibid., 14, 13.

125. Ibid., 14.

126. Marsden Hartley, "The Scientific Esthetic of the Redman," *Art and Archaeology* 13 (March 1922): 116–119; 138.

127. Ibid., 118. Hartley's own homosexuality, perhaps, led him to insist on the role of the body/sensuality in religious experience. He may have been influenced in this regard by the writings of the English socialist and mystic Edward Carpenter. Linda Dalrymple Henderson observed that Luhan (Hartley's Taos hostess) had absorbed Carpenter's ideas on the body and its sexuality, "which were integrally linked to his vision of the union of self and world in a cosmic consciousness." Accordingly, Carpenter's notion of a "pan-sexuality," which extended a Whitmanesque transcendentalism, established the background "against which Stieglitz circle [e.g., Hartley's] attitudes towards nature and sex must be seen." See Linda Dalrymple Henderson, "Mysticism as the 'Tie That Binds': The Case of Edward Carpenter and Modernism," *Art Journal* 46 (Spring 1987): 32.

128. Ibid., 116, 118, 113, 115.

129. Cf. J. J. Brody, "The Creative Consumer: Survival, Revival, and Invention in Southwest Indian Arts," in *Ethnic and Tourist Arts*, ed. Nelson H. H. Graburn, 76; Wade, "Ethnic Market," 167–168ff.; and Edwin L. Wade, "Straddling the Cultural Fence: The Conflict for Ethnic Artists within Pueblo Societies," in *The Arts of the North American Indian*, ed. Edwin L. Wade, 254.

130. There are striking parallels in both Russian and Australian history to revivalist projects in the American Southwest. On the efforts to revive/preserve an authentic Russian folk culture that could be used as an emblem of Russian *national* culture, see Ruth Wendy Salmond, "The Modernization of Russian Folk Art: The *Kustar* Art Industries, 1885–1917," (Ph.D. diss. University of Texas at Austin, 1989). The history of Australian interaction with Aboriginal art (and culture), in general, has remarkable similarities to the situation in the United States; see Philip Jones, "Perceptions of Aboriginal Art: A History," in *Dreamings: The Art of Aboriginal Australia*, ed. Peter Sutton (New York: George Braziller, 1988), 143–179. In particular, the recent emergence of a new "tradition" of acrylic painting in the Western Desert is reminiscent in many ways of the birth of the new Pueblo painting around 1918; see Christopher Anderson and Francoise Dussart, "Dreaming in Acrylic: Western Desert Art," in *Dreamings*, ed. Sutton, 89–142; and Meyer Raphael Rubenstein, "Outstations of the Postmodern: Aboriginal Acrylic Painting of the Western Australian Desert," *Arts Magazine* 65 (March 1989): 40–47.

131. On consumers of native arts as "form-creators," see Brody, "Creative Consumer," 71.

132. According to Graburn, among modern nations there is an "almost universal proclivity . . . to collect and display the art of their present and past minority peoples as symbols of national identity" ("Introduction: Arts of the Fourth World," in *Ethnic and Tourist Arts*, ed. Graburn, 28).

3. Pictorial Responses to Native America: Primitivist Painting, 1910–1940

1. Ernest Peixotto, "The Taos Society of Artists," *Scribner's Magazine* 60 (August 1916): 257.

2. Ibid., 260.

3. For Dow, see Frederick C. Moffatt, *Arthur Wesley Dow*. On Dow's assessment and support of modernism, see Arthur Wesley Dow, "Modernism in Art," *Magazine of Art* 8 (January 1917): 113–116; and Lawrence Chisolm, *Fenollosa: The Far East and American Culture* (New Haven: Yale University Press, 1963), 237–239.

4. Moffatt, *Dow*, 48–49, 95. Fenollosa, who claimed to be descended from "a dusky Aztec princess," proclaimed his interest in the "throbbing natural life" of the "more civilized races" of aboriginal America; see Chisolm, *Fenollosa*. On Cushing, see Jesse Green, ed., *Zuni: Selected Writings of Frank Hamilton Cushing* (Lincoln: University of Nebraska Press, 1978).

5. Moffatt, *Dow*, 98; and Arthur Wesley Dow, *Composition*, 2d ed. (1912), 5, where the artist noted that with Fenollosa's assistance he developed for use in the classroom in 1889 a "progressive series of synthetic exercises." On the Fenollosa-Dow system of art education, see Chisolm, *Fenollosa*, 177–195.

6. Moffatt, *Dow*, 98, 92–93, 95. Dow defined the natural method as "that of exercises in progressive order, first building up very simple harmonies, then proceeding on to the highest forms of composition" (*Composition*, 3).

7. Sylvester Baxter, "Handicraft, and Its Extension, at Ipswich," *Handicraft* 1 (February 1903): 256, 258.

8. Ibid., 253–258.

9. Dow, *Composition* (1899), 29. I am grateful to Arlette Klaric for sharing with me this reference and others relating to Dow's interest in Native American art.

10. Dow, *Composition*, 2d ed. (1912), 26.

11. Moffatt, *Dow*, 107–108, 123. See also Frank Hamilton Cushing, "Observations Relative to the Origin of the Fylfot or Swastika," *American Anthropologist* 9 (1907): 334–336; and Arthur Wesley Dow, "Designs from Primitive American Motifs," *Teachers College Record* 16 (March 1915): 33.

12. Letter from Joy S. Weber to W. Jackson Rushing, 18 September 1988; Holger Cahill,

"Max Weber: A Reappraisal in Maturity," *Magazine of Art* 42 (April 1949): 129–130; and Ala Story, *Max Weber*, exh. cat., 5–6.

13. See Percy North, *Max Weber*, exh. cat., 14–15. For a discussion of Weber's primitivism, see Gail Levin, "American Art," in *"Primitivism"*, ed. Rubin, exh. cat., 2:453–469.

14. Max Weber, quoted in Story, *Max Weber*, 12.

15. Alfred H. Barr, Jr., *Max Weber*, exh. cat., 7. According to Story, *Max Weber*, 6, he visited the Trocadero in 1905. If this date is correct it contradicts Levin's assertion that Weber's first exposure to African art was provided by Matisse in 1908; see Levin, "American Art," 453.

16. Cahill, "Max Weber," 130–131.

17. Benjamin De Casseres, introduction to *Primitives*, by Max Weber (New York: Spiral Press, 1926): n.p.

18. Holger Cahill, *Max Weber*, exh. cat., 27.

19. Letter from Joy S. Weber to W. Jackson Rushing, 18 September 1988.

20. See John R. Lane, "The Sources for Max Weber's Cubism," *Art Journal* 15 (Spring 1976): 236n. 14.

21. Cf. North, *Max Weber*, exh. cat., 28.

22. Max Weber, "Reminiscenses of Max Weber," interviews with Carol S. Gruber, 1958, Oral History Collection of Columbia University, 94. Joy Weber places great importance on this later reminisce by Weber: "I do feel that it does establish with certainty the interest and affinity that my father had for Native American art." Letter from Joy S. Weber to W. Jackson Rushing, 18 September 1988.

23. On this "early critical rejection," see North, *Max Weber*, 14; and Chisolm, *Fenollosa*, 235.

24. V. E. Chamberlain, quoted in Lane, "Weber's Cubism," 232, 235 n. 9.

25. Max Weber, "Chinese Dolls and Modern Colorists," *Camera Work* 31 (July 1910): 51.

26. North, *Max Weber*, 55.

27. Cahill, *Max Weber*, 26. Similarly, Chisolm noted that Weber's art "symbolized the bold cultural fusion which Fenollosa hoped would enliven American artistic imagination" (*Fenollosa*, 231).

28. Cahill, *Max Weber*, 26. According to David Hurst Thomas, curator of anthropology at the American Museum of Natural History, the museum "has extensive collections of the kinds of pottery" I have described here, "and much of this material was acquired before 1910." These pottery vessels, numbering in the thousands, were collected at several sites in the Southwest, including, among many others, Zuni Pueblo, the Rio Grande area, Pueblo Bonito, and Chaco Canyon. Letter from David Hurst Thomas to W. Jackson Rushing, 5 October 1992.

29. There is no evidence to suggest that Northwest Coast culture, in general, or its artists, in particular, had any "fear of space."

30. Max Weber, "The Totem Pole Man," in Weber, *Primitives*, n.p.

31. North, *Max Weber*, 55.

32. Weber, "Chinese Dolls," 51. Letter from Percy North to W. Jackson Rushing, 12 June 1987. According to Weber's daughter, he purchased a Hopi kachina in 1930; personal communication from Joy S. Weber, 8 August 1988.

33. North, *Max Weber*, 18; cf. Barr, *Max Weber*, exh. cat., 10.

34. Max Weber, *Cubist Poems*; see Lane, "Weber's Cubism," 236n. 14.

35. Cahill, *Max Weber*, 129–130. I should note, however, that Cahill's statement may well reflect the climate of the late 1940s in which the dominant paradigm of modernism had shifted from its original European context to an American (read New York) one.

36. For a discussion of Burlin's early years, see Sharyn Rohlfsen Udall, *Modernist Painting in New Mexico, 1913–1935*, 19–28. On Burlin's Abstract Expressionist paintings, see Irving Sandler, *Paul Burlin*, exh. cat., 3–4.

37. Paul Burlin Artist's File, Museum of Fine Arts, Santa Fe, and Udall, *Modernist Painting*, 19–20.

38. Udall, *Modernist Painting*, 28. On Burlin's centrality to the growth of the Santa Fe art colony, see Reeve, "The Making of an American Place," 73.

39. Sandler, *Paul Burlin*, exh. cat., 6.

40. Paul Burlin, "Autobiographical Sketch," Paul Burlin Papers, Archives of American Art,

Smithsonian Institution, Washington, D.C., quoted in Udall, *Modernist Painting*, 20.

41. See Robert J. Schwendinger's introduction to Natalie Curtis, *The Indians' Book* (1905; reprint, New York: Bonanza Books, 1987), xi.

42. Curtis, *Indians' Book*, xvii, xxxvi, xxxvii.

43. Ibid., xxxv–xxxvi.

44. Natalie Curtis, "The Perpetuating of Indian Art," *Outlook* 105 (22 November 1913): 625, 626.

45. Paul Burlin, quoted in Luhan, *Edge of Taos Desert*, 68.

46. Paul Burlin, "Autobiographical Sketch," quoted in Udall, *Modernist Painting*, 20.

47. Ibid.

48. Cf. Reeve, "American Place," 71, 72.

49. For an illustration and discussion of the romanticism implicit in Henning's *Passing By*, see William H. Truettner, "The Art of Pueblo Life," in Eldredge, Schimmel, and Truettner, *Art in New Mexico*, exh. cat., 87.

50. Natalie Curtis, "A New Art in the West," *International Studio* 63 (November 1917): xvii.

51. Udall, *Modernist Painting*, 24.

52. Curtis, "A New Art," xiv, xvi.

53. Guy Pene Du Bois, quoted in Sandler, *Paul Burlin*, 6.

54. Burlin, quoted in Udall, *Modernist Painting*, 26.

55. Udall, *Modernist Painting*, 26.

56. Ibid.

57. Sandler, *Paul Burlin*, 6.

58. On the Burlin-Hartley friendship, see Udall, *Modernist Painting*, 28.

59. Burlin, "Autobiographical Sketch," quoted in Udall, *Modernist Painting*, 26.

60. Curtis, "A New Art," xvi, xiv, and Burlin, quoted in ibid. After his wife's tragic death in Paris in 1921, Burlin sold their home in Santa Fe and returned to New York, where he combined Indian subjects, semi-Cubist forms, and a perceived archaism of the southwestern landscape in a series of murals for a private home in 1921. In a review of these murals—*Stone Age, Awaking, Rhapsody*—Hamilton Easter Field noted that the subject matter and forms embodied the fullness and richness of primitive life

("Decorations by Paul Burlin," *Arts* 1 [1921]: 31).

61. Haskell, *Marsden Hartley*, exh. cat., 27; Levin, "American Art," 456–457; and Scott, *Hartley*, 37. For the earlier date for Hartley's exposure to Indian art, see Elizabeth McCausland, *Marsden Hartley* (Minneapolis: University of Minnesota, 1952), 27.

62. Levin, "American Art," 456. Stieglitz himself was not unsympathetic to modernist interest in Native Americans. The first issue of *Camera Work* (January 1903) included Gertrude Kasebier's photograph, *The Red Man*. See ibid., and 469n. 26.

63. Marsden Hartley to Alfred Stieglitz, 9 October 1912, quoted in Levin, "American Art," 456.

64. Marsden Hartley to Alfred Stieglitz, 1 September 1912, quoted in Scott, *Hartley*, 37.

65. Another Hartley painting from 1912, *Still Life No. 1*, which is remarkable for its thickly painted passages of Cézannesque decoration, includes at the bottom right a small jar with geometric designs that Scott has identified as being Zia in origin; see Scott, *Hartley*, 37, and the illustration on 36.

66. Levin, "American Art," 457.

67. Scott, *Hartley*, 49.

68. On German ethnographic collections, see Christian F. Feest, "From North America," in *"Primitivism,"* ed. Rubin, 1: 91, 93–94; and Levin, "American Art," 457. On Karl May, see Berkhofer, Jr., *White Man's Indian*, 101; and Levin, "American Art," 457.

69. Levin, "American Art," 457.

70. Ibid., 459, 461.

71. See William I. Homer, *Robert Henri and His Circle* (Ithaca: Cornell University Press, 1969), 202.

72. Robert Henri to Henry Lovins, July 1914, Edgar L. Hewett collection, History Library of the Museum of New Mexico, Santa Fe.

73. Robert Henri to Edgar L. Hewett, August 1918, Hewett MSS.

74. See Homer, *Henri and His Circle*, 203.

75. See "Letter from New Mexico," in Robert Henri, *The Art Spirit*, 188–189. *The Art Spirit*, first published in 1923, is a compendium of Henri's notes, articles, letters, and lectures compiled by Margery A. Ryerson.

76. Robert Henri to Henry Lovins, Santa Fe, 24 September 1917; Hewett MSS.

77. Henri, *Art Spirit*, 128.

78. Ibid., 188.

79. Robert Henri to Henry Lovins, July 1914, Hewett MSS.

80. Edgar Hewett to Robert Henri, October 1914, Hewett MSS.

81. E.W.F., unidentified clipping; Hewett MSS.

82. Ibid.

83. Truettner, "Art of Pueblo Life," in Eldredge, Schimmel, and Truettner, *Art in New Mexico*, exh. cat., 78.

84. See David H. Snow, "Dieguito Roybal," *El Palacio* 88 (Summer 1982), 15–16. See also *El Palacio* 15 (15 September 1923).

85. Robert Henri to Edgar L. Hewett, 23 November 1916, Hewett MSS.

86. Robert Henri to Mary and Bill Roberts, 1920, quoted in Homer, *Henri and His Circle*, 203.

87. Robert Henri, "My People," *The Craftsman* 27 (February 1915): 460.

88. Truettner, "Science and Sentiment," in Eldredge, Schimmel, and Truettner, *Art in New Mexico*, exh. cat., 40.

89. Henri to Roberts, quoted in Homer, *Henri and His Circle*, 203–205.

90. Brody, *Indian Painters*, 91. Patricia Janis Broder, *The American West*, 9. Truettner, "Art of Pueblo Life," in Eldredge, Schimmel, and Truettner, *Art in New Mexico*, exh. cat., 68.

91. Henri, "My People," 467, 459, 467, 459, 462, 467.

92. Personal communication from Helen Farr Sloan, New York City, 26 September 1986. These scrapbooks are now part of the John Sloan Archives at the Delaware Art Museum. For Helen Farr Sloan's accounts, see Lloyd Goodrich's notes in the John Sloan Artist File at the Whitney Museum of American Art, New York City. On Sloan's life in Santa Fe, see Grant Holcomb, "John Sloan in Santa Fe," *American Art Journal* 10 (May 1978): 33–54; Kraft and Sloan, *John Sloan*, exh. cat., 21–33; and Broder, *American West*, 45–65.

93. John Sloan, *Gist of Art*, 14, 21–22. The principles of and ideas about art contained in *Gist of Art* were recorded by Helen Farr (Sloan) and first published in 1939. For Sloan's comments on social consciousness and art, see ibid., 3–5.

94. I am grateful to Helen Farr Sloan for her cooperation and in particular for drawing my attention to these collections. Thanks also to Hope Morrill, Registrar at the Montclair Art Museum, and to Mary Lou Hultgren, curator of the Hampton University Art Museum, for providing information about these objects.

95. Sloan, *Gist of Art*, 154.

96. Sloan's recollection of Henri's teaching, vis-à-vis religious subjects, was a personal communication from Helen Farr Sloan, 1986.

97. Sloan, *Gist of Art*, 263.

98. See ibid., 260, 308. The Corn Dance is common to all the Rio Grande Pueblos, but at Santo Domingo it is an especially long, elaborate, and dramatic ritual. Once the dances have begun, the tension and sobriety associated with such a formal occasion is relieved from time to time by the bawdy antics of the Koshares. In 1924 Sloan painted a more panoramic view, not just of the Koshares but of the whole Corn Dance at Santo Domingo, entitled *Dancers in the Dust*. It, too, was published in *Gist of Art* with the following comment about the dust: "Eyes, mouths, and ears filled with the gritty particles, but the show must go on" (ibid., 276).

99. Ibid., 265. It is remarkable how persistent are the myths of the noble savage and the vanishing race. As recently as 1978, Holcomb described the Pueblo Indians of Sloan's paintings as "the last significant vestiges in North America of an ancient, noble civilization" ("John Sloan," 43).

100. Personal communication from Helen Farr Sloan, 1986. Broder has quoted Sloan as stating that he "tried to assume a real understanding of their spiritual life" (*American West*, 55–56). Helen Farr Sloan insists emphatically that this is either a misquote or a misprint.

101. Sloan, *Gist of Art*, 270.

102. See Udall, *Modernist Painting*, 149.

103. See Broder, *American West*, 112–113; Udall, *Modernist Painting*, 149, 151.

104. Broder, *American West*, 113.

105. Ibid., 115.

106. On Synchromism, see Gail Levin, *Synchromism and American Color Abstraction, 1910–1925*, exh. cat. (New York: George Braziller, 1978).

107. Van Deren Coke, *Marin in New Mexico, 1929 and 1939*, exh. cat., 5.

108. John Marin to Paul Strand, 22–25 June 1929, quoted in *Letters of John Marin*, ed. Herbert Seligmann, n.p.

109. John Marin to Alfred Stieglitz, 21 July 1929, quoted in *Letters*, ed. Seligmann, n.p.

110. Coke, *Marin in New Mexico*, 26n. 1.

111. John Marin to Alfred Stieglitz and Georgia O'Keeffe, 9 October 1929, quoted in *Letters*, ed. Seligmann, n.p.

112. Coke, *Marin in New Mexico*, 15.

113. Marin to Strand, in *Letters*, ed. Seligmann.

114. John Marin, quoted in *John Marin by John Marin*, ed. Cleve Gray, 96.

115. John Marin to E. C. Zoler, 25 August 1929, quoted in *The Selected Writings of John Marin*, ed. Dorothy Norman, 132.

116. See Coke, *Marin in New Mexico*, 21.

117. John Marin to Alfred Stieglitz, 4, 10, 14 August 1930, quoted in *Selected Writings*, ed. Norman, 134. This letter, written after Marin had seen the Corn Dance a second time, included the mistaken reference to San (as opposed to Santo) Domingo, which mistake was apparently attached to the painting as its title. Now in the collection of the Metropolitan Museum of Art in New York, the work is almost always exhibited and published as *Dance of the San Domingo Indians*, the one important exception being Coke, *Marin in New Mexico*.

118. Coke, *Marin in New Mexico*, 20.

119. Broder, *American West*, 189. Cf. Coke, who observed that "the border of the composition also includes Marin's version of some Pueblo symbols, illustrated in an incomplete state" (*Marin in New Mexico*, 21).

120. Marin to Stieglitz, in *Letters*, ed. Seligmann.

121. On the salvaging of authentic culture, see Clifford, *Predicament of Culture*, 222–223, 228, 231.

122. According to Clifford Geertz, us/not us is the "dominant trope—extravagant otherness as self-critique," around which Ruth Benedict built her thesis in *Patterns of Culture* (1934). See Clifford Geertz, *Works and Lives* (Stanford: Stanford University Press, 1988), 113.

123. On the idea of collecting and using a single art object or ritual as an "ethnographic metonym" of a whole culture, see Clifford, *Predicament of Culture*, 220. O'Keeffe, Marin's New Mexican host, also made paintings (of kachinas) that signified, metonymically, "the spiritual implications of Pueblo culture." See Patricia Trent and Patrick T. Houlihan, *Native Americans: Five Centuries of Changing Images* (New York: Harry N. Abrams, 1989), 276.

124. Marin to Stieglitz, quoted in *Selected Writings*, ed. Norman, 135.

125. Broder, *American West*, 191–192.

126. Cf. Nicolai Cikovsky, Jr., "The Art of Raymond Jonson," *American Art Review* 3 (September–October 1976): 130.

127. There are useful chronologies on Jonson in the following: Van Deren Coke, *Raymond Jonson*, exh., cat., 27–29; Ed Garman, *The Art of Raymond Jonson* (Albuquerque: University of New Mexico Press, 1976), 173–185; and Elizabeth Anne McCauley, *Raymond Jonson: The Early Years*, exh. cat. (Albuquerque: University of New Mexico Art Museum, 1980), 31–32.

128. On Jonson's exhibition at the Delphic Studio, see the unidentified clipping in the Raymond Jonson Papers, Archives of American Art, Smithsonian Institution, Washington, D.C.

129. Raymond Jonson, quoted in Edna Manley Lewisohn, "Raymond Jonson, Painter," *El Palacio* 54 (April 1947): 113.

130. Raymond Jonson, quoted in Udall, *Modernist Painting*, 100, 102.

131. See Lewisohn, "Raymond Jonson," 113.

132. See his comments in Udall, *Modernist Painting*, 103.

133. Raymond Jonson, quoted in Coke, *Raymond Jonson*, exh. cat., 8.

134. See McCauley, *Raymond Jonson*, 11; Raymond Jonson, quoted in ibid., 12.

135. Cf. Reeve, "American Place," 150.

136. See his comments in Coke, *Raymond Jonson*, 8.

137. See my essay, "Authenticity and Subjectivity in Post-War Painting: Concerning Herrera, Scholder, and Cannon," in *Shared Visions: Native American Painters and Sculptors in the Twentieth Century*, ed. Margaret Archuleta, exh. cat. (Phoenix: Heard Museum, 1991), 14.

138. This company was founded in 1926 by the painters Andrew Dasburg, B. J. O. Nordfelt, and Walter Mruk, the poet Witter Bynner, and John Evans, son of Mabel Dodge Luhan; see Julie Schimmel, "The Hispanic Southwest," in Eldredge, Schimmel, and Truettner, *Art in New Mexico*, exh. cat., 112; and Udall, *Modernist Painting*, 60.

139. My thanks to Marian Rodee, curator of collections at the Maxwell Museum of Anthropology at the University of New Mexico, for providing information about this gift.

140. Raymond Jonson to Frank Hibben and J. J. Brody, 20 August 1965, on file in the archives of the Jonson Gallery, University of New Mexico.

141. In the only monograph on Jonson (which in many respects is more of an "appreciation" by a former member of the Transcendental Painting Group), only one of the works is published and the discussion of the series is cursory; see Garman, *Raymond Jonson*, 133–134. None of the *Pictographical Compositions* was included in the retrospective exhibition organized by Coke in 1964, nor were they mentioned in the catalogue.

142. Raymond Jonson to Reginald Fisher, 10 March 1956, quoted in Garman, *Raymond Jonson*, 134.

143. Garman, *Raymond Jonson*, 134.

144. Raymond Jonson to Bertha Dutton, 8 June 1973, on file in the archives of the Jonson Gallery. For the impact of Jonson's primitivism, in general, and his "pictographs" in particular, on the history of Native American painting since 1950, see Rushing, "Authenticity and Subjectivity," 12–15.

145. Biographical information on Bisttram is contained in the following: the artist's vita, compiled in 1971, in the artist's file at the New Mexico Museum of Fine Arts, Santa Fe; the biographical entry accompanying Emil Bisttram, "Art's Revolt in the Desert," *Contemporary Arts of the South and Southwest* 1 (January–February 1933): n.p., in the artists's file, New Mexico Museum of Fine Arts; Udall, *Modernist Painting*, 196; Broder, *American West*, 212; David Witt, *Emil James Bisttram*, exh. cat. (Taos: Harwood Foundation, 1938), n.p.; and the biographical entry in Eldredge, Schimmel, and Truettner, *Art in New Mexico*, exh. cat., 192.

146. Udall, *Modernist Painting*, 196.

147. An important exception to this was Bisttram's presence in the "spiritual retrospective" organized by the Los Angeles County Museum of Art; see Tuchman, "Hidden Meanings in Abstract Art," in Tuchman et al., *The Spiritual in Art*, 43. However, it is questionable whether or not Bisttram participated, as Tuchman asserts, in the Chicago group known as *Cors Ardens*; Jonson did participate; ibid.

148. See Emil Bisttram, "The New Vision in Art," *Tomorrow* 1 (September 1941): 35–38; and Emil Bisttram, "On Understanding Contemporary Art," *El Palacio* 64 (July–August 1957): 201–208.

149. Cf. Udall, *Modernist Painting*, 196.

150. Emil Bisttram, quoted in Witt, *Emil James Bisttram*, exh. cat., n.p.

151. V. W., "Emil Bisttram's Exhibition," *The Santa Fe New Mexican*, 19 July 1933, roll 581, Emil Bisttram Papers, Archives of American Art, Smithsonian Institution, Washington, D.C.

152. Leo Katz, introduction to Emil Bisttram, *Dancing Gods Series*, exh. cat. (New York: Delphic Studios, 1933), n.p.; see the artist's file at the Museum of Fine Arts, Santa Fe.

153. Ibid.

154. See Bisttram's comments in the untitled typescript, 7 May 1962, roll 2893, Archives of American Art, and Mayrion Bisttram's publicity notice to Bernard Frazier, Director of the Philbrook Art Center, Tulsa, Oklahoma (c. 1945 and probably in reference to an exhibition of Bisttram's work entitled *Indian Portraits and Indian Symbolism Abstracted*), roll 2892–2894, Archives of American Art.

155. Alfred Morang, "Abstract and Non-Objective Painters in Show at Museum," *The Santa Fe New Mexican*, 4 June 1938, roll 581, Archives of American Art.

156. David Witt of the Harwood Foundation in Taos assisted with the identification and dating of this painting.

157. See Melinda A. Lorenz, *George L. K. Morris*, 3–8; and Nicolai Cikovsky, Jr., "Notes and Footnotes on a Painting by George L. K. Morris," *University of New Mexico Art Museum Bulletin* 10 (1976–1977): 4.

158. Goerge L. K. Morris, "Contemporary Writers, British, and Americans," *Yale Literary Magazine* 93 (March 1928): 103, quoted in Lorenz, *Morris*, 5.

159. George L. K. Morris, "The Quest for an Abstract Tradition," in *American Abstract Artists*, ed. Balcomb Greene et al. (New York: American Abstract Artists, 1938), quoted in Cikovsky, "Notes," 4.

160. Ibid.

161. See Cikovsky, "Notes," 10n. 17; and George L. K. Morris, quoted in Broder, *American West*, 127.

162. Lorenz, *Morris*, 11, 27.

163. See Cikovsky, "Notes," 5, where this painting is described as a "curiously Old World image of the New." Cikovsky also notes that Morris may have acquired his teacher Fernand Léger's taste for the "Italian Primitive" (10n. 20).

164. Morris, quoted in Lorenz, *Morris*, 27.

165. Ibid.

166. See Lorenz, *Morris*, 27 and 11.

167. George L. K. Morris, "Fernand Léger Versus Cubism," *Bulletin of the Museum of Modern Art* 1 (October 1927): 7, 3, quoted in Cikovsky, "Notes," 4.

168. George L. K. Morris, "On America and a Living Art," in *Catalogue of the Living Art*, exh. cat. (New York: A. E. Gallatin Collection, 1936), n.p., quoted in Cikovsky, "Notes," 4.

169. Cikovsky, "Notes," 6.

170. Lorenz, *Morris*, 54 and 127n. 24.

171. Cikovsky, "Notes," 6.

172. A note of caution about Cikovsky's article is in order. Virtually all of the captions for the illustrations are wrong (e.g., works by Morris identified as examples of Pueblo painting; *Indians Hunting No. 2* identified as *Battle of Indians*, etc.). The reader not familiar with twentieth-century Pueblo art and/or Morris's oeuvre will find referring to the illustrations highly problematic.

173. George L. K. Morris to Van Deren Coke, 1975, quoted in Cikovsky, "Notes," 6.

174. Cikovsky, "Notes," 5.

175. Lorenz, *Morris*, 19.

176. Ibid.

177. This central image may well have been inspired by a replica of an ancient Pueblo mural from Awatovi (Arizona) depicting the Hopi kachina *wuwuyomo*, which was exhibited at the Museum of Modern Art in 1941; see Frederic H. Douglas and René d'Harnoncourt, *Indian Art of the United States*, exh. cat., 112. This comparison was noted in Debra Balken and Deborah Rothschild, *Suzy Frelinghuysen and George L. K. Morris: American Abstract Artists: Aspects of Their Work and Collection*, exh. cat. (Williamstown, Mass.: Williams College Museum of Art, 1992), 43.

178. See his comments in Balken and Rothschild, *Suzy Frelinghuysen*, exh. cat., 43.

4. Native American Art in New York, 1931–1941

1. Besides the numerous private lenders, "traditional crafts" were lent by the Peabody Museum; the American Museum of Natural History; the Museum of the American Indian (Heye Foundation); the Brooklyn Museum; the Museum of Northern Arizona; the Laboratory of Anthropology, Santa Fe; the Museum of New Mexico; and others. The contemporary art came from the collections of Alice Corbin Henderson; Dr. Edgar L. Hewett; Professor Oscar B. Jacobson, director of the School of Painting and Design at the University of Oklahoma; Abby Aldrich Rockefeller; and Amelia Elizabeth White. See "Review of *Introduction to American Indian Art*," *American Magazine of Art* 25 (August 1932): 130, and the checklist of the exposition in the John Sloan Archives, Delaware Art Museum (hereafter JSA).

2. "Annual Report of the Exposition of Indian Tribal Arts," 1931, JSA, 1.

3. "Constitution and By-Laws: The Exposition of Indian Tribal Arts, Inc." [n.d.], JSA, 1.

4. See the "Minutes of the Fourth Meeting of the Organizing Committee of the Exposition of the Indian Tribal Arts," 1931, JSA, 2.

5. *Prospectus* (New York: Exposition of Indian Tribal Arts, Inc.), 1. See the typescript in the Herbert J. Spinden Papers, Brooklyn Museum.

6. Liston M. Oak to Herbert J. Spinden, 21 April 1931; Herbert J. Spinden Papers, Brooklyn Museum.

7. *Prospectus*, 4.

8. Ibid.

9. Oliver La Farge to Dolly Sloan, 30 October 1931, JSA.

10. *Prospectus*, 5. When Dolly Sloan wrote to the Whitney Museum of American Art accepting an invitation to bring the exposition's twelve visiting Indian artists to the museum, she explained, "They are artists, and we do not . . . want them entertained or amused or 'bally-hooed' through New York City by any of the newspapers, meaning principally the tabloids." The organizers, who planned to bring the artists from New Mexico "on standard Pullmans" and house them in "a first class hotel," did think it appropriate that "American painters should see the first American museum" (Dolly Sloan to Hermon More, 25 November 1931, JSA).

11. *Prospectus*, 2.

12. Oliver La Farge and John Sloan, "Introduction to American Indian Art," in *Introduction to American Indian Art*, ed. F. W. Hodge, Oliver La Farge, and Herbert J. Spinden, exh. cat., 1:15, 13. Although both La Farge and Sloan signed the introduction, documentary evidence suggests that, in fact, Sloan wrote the first section, that on painting, and the conclusion, while La Farge wrote about "most of the arts and crafts." See La Farge to Sloan, JSA.

13. Herbert J. Spinden, "Fine Art and the First Americans," in *Introduction to American Indian Art*, ed. Hodge, La Farge, and Spinden, exh. cat., 2:69, 74, 70, 74.

14. Ibid., 74.

15. Mary Austin, "Indian Poetry," in *Introduction to American Indian Art*, ed. Hodge, La Farge, and Spinden, exh. cat., 2:95, 96.

16. Alice Corbin Henderson, "Modern Indian Painting," in *Introduction to American Indian Art*, ed. Hodge, La Farge, and Spinden, exh. cat., 2:101, 104–105.

17. Ibid., 101.

18. See Barbara Babcock and Nancy Parezo, *Daughters of the Desert: Women Anthropologists and the Native American Southwest, 1880–1980*, exh. cat. (Albuquerque: University of New Mexico Press, 1988), 209, 229.

19. Laura Adams Armer, "Sand-Painting of the Navaho Indians," in *Introduction to American Indian Art*, ed. Hodge, La Farge, and Spinden, exh. cat., 2:115, 116, 117. Information about sand paintings was readily available in New York in the 1930s. For example, the following description appeared in the *Brooklyn Museum Quarterly* in 1932: "The sand paintings of the Navajo are not craftwork but are part of an elaborate ceremonial conducted for the curing of some person who is ill. They are made only by the chanters of the group, i.e., the men who are versed in the art of sand painting and the lore which accompanies it, and who have been 'sung over.' . . . The picture is not intended to be the individual chanter's concept of something beautiful, but is a symbolic representation of the gods and sacred elements of Navajo mythology." See Jean Read, "Navajo and Pueblo Indian Crafts," *Brooklyn Museum Quarterly* 19 (April 1932): 67.

20. Charles C. Willoughby, "Indian Masks," in *Introduction to American Indian Art*, ed. Hodge, La Farge, and Spinden, exh. cat., 2:152, 149, 150, 152–153.

21. "Indian Tribal Art," *Brooklyn Eagle*, 6 December 1931.

22. John Sloan, quoted in "Great Tribal Exhibition Will Reveal Indian's True Place in Art," *Art Digest* 5 (1 September 1931): 5.

23. John Sloan, quoted in Ruth Laughlin Barker, "John Sloan Reviews the Indian Tribal Arts," *Creative Art* 9 (December 1931): 449.

24. Ibid., 445.

25. Walter Pach, "The Indian Tribal Arts," *New York Times*, 22 November 1931, JSA.

26. "Indian Tribal Art," *Brooklyn Eagle*, 6 December 1931.

27. Edward Alden Jewell, quoted in "Indian Tribal Arts Exhibition," *Art Digest* 6 (15 December 1931): 32.

28. Helen Johnson Keyes, "Tribal Arts for American Homes," *Christian Science Monitor*, 16 January 1932, JSA.

29. "Indian Tribal Arts," *Brooklyn Eagle*, 6 December 1931.

30. "Indian Tribal Arts Exhibition," *Art Digest*, 32. Almost all of these reviews were extremely enthusiastic. However, there were some notable exceptions. Malcolm Vaughan was concerned that in their efforts to promote the art as *art* the organizers had done little to teach the audience about either the historic development or the social matrix of objects. Even so, he admitted that the show remained "a delight to the eye"; see Malcom Vaughan, "American Indian Tribal Arts in First Aesthetic Exhibition," *New York American*, 6 December 1931, JSA.

31. "Exposition of Indian Tribal Arts," *Connoisseur* 88 (September 1931): 209.

32. Herbert J. Spinden, "Indian Art on Its Merits," *Parnassus* 3 (November 1931): 12.

33. The Indian Arts and Crafts Board was established, if not operational, in 1936; see Robert Fay Schrader, *The Indian Arts and Crafts Board*.

34. Elizabeth Shepley Sergeant, "A New Deal for the Indian," *New Republic* 15 June 1938, 151; see also John Collier, *Indians of the Americas*, Chap. 14, "The Indian New Deal."

35. Sergeant, "A New Deal," 152.

36. John Collier, "Does the Government Welcome the Indian Arts?" *American Magazine of Art*, supplement 27 (September 1934): 11.

37. Oliver La Farge, "Revolution with Reservations," *New Republic* 9 October 1935, 234.

38. Collier, "Does the Government?" 11.

39. Ibid., 10. Collier was one of eighty people who gathered at the New York apartment of Mabel Dodge Luhan on the evening of 9 February 1940 to discuss the plight of contemporary Native peoples. Some comments about that gathering are contained in John Collier, "Has the American Indian a Future?" *Transformations* 1 (1952): 141–142.

40. See Marcia Epstein Allentuck's Introduction to *System and Dialectics of Art*, ed. John D. Graham (reprint, Baltimore: Johns Hopkins Press, 1971), 12.

41. F. A. Whiting, Jr., "The New World Is Still New," *Magazine of Art* 32 (November 1939): 613.

42. Nicolas Calas, "Mexico Brings Us Art," *View* 1 (September 1940): 2.

43. Robert Hobbs, "Early Abstract Expressionism: A Concern with the Unknown," in Robert Hobbs and Gail Levin, *Abstract Expressionism*, exh. cat., 14. According to Dore Ashton, several painters in this period were attempting "to establish a sympathetic American tradition by doing what the Mexicans had done: turning back to the American Indian." See Dore Ashton, *The New York School*, 42.

44. George C. Vaillant, "North American Indian Art," *Magazine of Art* 32 (November 1939): 626. This article was based on the final chapter of George C. Vaillant, *Indian Arts in North America*.

45. See "Ubiquitous Primitive Art: Natural History Museum's New Show," *Art News* 37 (13 May 1939): 12, 22.

46. See "Art throughout America," *Art News* 38 (24 February 1940): 14.

47. René d'Harnoncourt, quoted in "All-American Art," *Art Digest* 15 (1 January 1941): 17; and René d'Harnoncourt, "Living Arts of the Indians," *Magazine of Art* 34 (February 1941): 72.

48. "20,000 Years of Indian Art Assembled for New York Show," *Newsweek* 17 (17 February 1941): 57–58.

49. Alfred H. Barr, Jr., et al., *René d'Harnoncourt 1901–1968: A Tribute* (New York: Museum of Modern Art, 1968): n.p.

50. Ibid. Wheeler had a long and distinguished career at the Museum of Modern Art. As director of exhibitions in 1941 he must have assisted d'Harnoncourt and Klumb with their rearrangement of the museum to accommodate "Indian Art of the United States." Later in his career Wheeler was both creator and director of the museum's publishing program, as well as a trustee.

51. All of these exhibitions were documented with scholarly publications: Holger Cahill, *American Sources of Modern Art*, exh. cat. (New York: Museum of Modern Art, 1937; reprint, New York: Arno Press, 1969); James Johnson Sweeney, *African Negro Art*, exh. cat. (New York: Museum of Modern Art, 1935; reprint, New York: Arno Press, 1969); Leo Frobenius and Douglas C. Fox, *Prehistoric Rock Pictures in Europe and Africa*, exh. cat. (New York: Museum of Modern Art, 1937; reprint, New York: Arno Press, 1972); Robert Montenegro with Nelson Rockefeller, *Twenty Centuries of Mexican Art*, exh. cat. (New York: Museum of Modern Art and Instituto de Antropológica e Historia de México, 1940; reprint, New York: Arno Press, 1972); Ralph Linton and Paul Wingert in collaboration with René d'Harnoncourt, *The Art of the South Seas*, exh. cat. (New York: Museum of Modern Art, 1946; reprint, New York: Arno Press, 1972); Wendell C. Bennett and René d'Harnoncourt, *Ancient Art of the Andes*, exh. cat. (New York: Museum of Modern Art, 1954; reprint, New York: Arno Press, 1966); and Rubin, ed., *"Primitivism,"* exh. cat.

52. For a review of the historical consensus that "Indian Art of the United States" effectively changed the public's attitude toward Indian art, see Aldona Jonaitis, "Creations of Mystics and Philosophers: The White Man's Perceptions of Northwest Coast Indian Art from the 1930s to the Present," *American Indian Culture and Research Journal* 5 (1981): 4.

53. Oliver La Farge, "Indians at the Museum of Modern Art," *New Republic* 10 February 1941, 181.

54. René d'Harnoncourt, "Suggestions for Future Activities of the Indian Arts and Crafts

Board," 21 September 1939, box 4, file 140.2, IACB, National Archives Record Group 435.

55. La Farge, "Indians at the Museum," 181. On the Federal government's lack of support for the "Exposition of Indian Tribal Arts," see Schrader, *Indian Arts and Crafts Board*, 49–50.

56. Excerpted from the Indian Arts and Crafts Board Act of 1935 in Schrader, *Indian Arts and Crafts Board*, 299. I am indebted to Schrader's study for drawing my attention to archival materials that have been invaluable in documenting "Indian Art of the United States."

57. Rockefeller and d'Harnoncourt, who shared a passion for Mexican folk art, met in Mexico in the mid-1930s; see Annie O'Neill, "Nelson A. Rockefeller: The Collector," in *The Nelson A. Rockefeller Collection of Mexican Folk Art*, ed. Annie O'Neill (San Francisco: Mexican Museum, 1986), 2. Rockefeller was voted president of MOMA's Board of Trustees in 1939, the same year that the museum invited d'Harnoncourt and the IACB to organize "Indian Art of the United States." It is inconceivable that Rockefeller's admiration for d'Harnoncourt and his position at the museum were not prime factors in the decision to host the exhibition. D'Harnoncourt had received Carnegie support for his curatorial activities as early as 1928; see Barr, Jr., et al., *René d'Harnoncourt*, n.p.; and René d'Harnoncourt, *René d'Harnoncourt Oral History Project* (New York: Columbia University Oral History Research Office, 1969), 2. Keppel was instrumental in securing Carnegie funding for d'Harnoncourt for the IACB's "Exposition of Indian Arts and Crafts" at San Francisco's Golden Gate International Exposition in 1938 (René d'Harnoncourt to Frederick P. Keppel, 19 August 1938, box 12, file 036, IACB). Once the plans for the 1941 exhibition were underway, d'Harnoncourt was able to assure MOMA Director Barr that he had "talked again with the Foundation's people and found their reactions so enthusiastic and encouraging that I have little doubt that that we can obtain what we need" (René d'Harnoncourt to Alfred H. Barr, Jr., 20 October 1939, box 19, file 534, IACB). D'Harnoncourt was confident enough of these personal connections to write to his collaborator Douglas, concerning the loan of objects from the Field Museum of Natural History: "I have not sent this request yet and will not do so until I see some of the New York people, because I have a hunch that I can get word to certain key trustees through influential friends, which would, I imagine, help more than any amount of official correspondence" (René d'Harnoncourt to Frederick H. Douglas, 6 September 1940, box 34, IACB). And, indeed, Clifford C. Gregg, director of the Field Museum, responded that although they did not normally loan the material in question, they would be glad to cooperate on this particular occasion (Clifford C. Gregg to René d'Harnoncourt, 11 November 1940, box 35, IACB).

58. For example, d'Harnoncourt wrote to Barr concerning his own first sketches of the floor plan, expressing a desire to simplify the layout "to eliminate some of the sudden changes in direction that are apt to give the visitor a feeling of confusion and restlessness." The entire plan, he explained, had been designed "in terms of visitor's vistas." Thus, he included a series of sketches, each representing "a vista seen by the visitor standing in the circle with corresponding number and looking in the direction of the arrow" (René d'Harnoncourt to Alfred H. Barr, Jr., 8 November 1939, box 34, IACB).

59. The lone exception appears to be a minor complaint about the lighting made by Jean Charlot, "All American," *Nation* 8 February 1941, 165.

60. Jeanette Lowe, "Lo, the Rich Indian: Art of the American Aboriginals," *Art News* 39 (1 February 1941): 7.

61. "Indian Art in the United States," *Design* 42 (March 1941): 15.

62. Barr, Jr., et al., *René d'Harnoncourt*, n.p.

63. M. D. C. Crawford, "Exhibit of Indian Art," *Women's Wear Daily*, 10 January 1941, 10.

64. René d'Harnoncourt to Frederick H. Douglas, 30 September 1939, box 36, file 300.36, IACB.

65. René d'Harnoncourt to George Heye, 9 October 1940, box 34, IACB.

66. René d'Harnoncourt to Alfred H. Barr, Jr., 8 November 1939, box 34, IACB.

67. According to Ira Jacknis, former research associate in the Department of African, Oceanic, and New World Art at the Brooklyn Museum, when the museum was reconstituted as an art museum (1931–1933), Spinden redefined and reinstalled ethnographic material as masterpieces of primitive art (personal communication, 1986). Spinden's papers at the museum bear this out. In 1934 he wrote that "a carefully considered plan of reinstallation on the ground floor of the Museum provides for a coordination of the fields of primitive art in the Old World and New, with special emphasis on Ancient American Art." See Herbert J. Spinden, "Annual Report of the Department of Primitive and Prehistoric Art," Herbert J. Spinden Papers, Brooklyn Museum Archives. Of his efforts in 1935 he observed: "The principal event of the year as regards this department was the opening of the series of halls devoted to primitive art and the early American civilizations . . . to emphasize scientific and educational values. . . . But over and above all this the problem was to find installation methods which would pick out the artistic merits of the individual specimens and broad effects in fresh color which would pull the entire exhibit into an esthetic unity." See Herbert J. Spinden, "Annual Report of the Department of Primitive and Prehistoric Art," Herbert J. Spinden Papers, Brooklyn Museum Archives.

68. For a lengthy discussion of d'Harnoncourt's involvment in the folk-art revival in Mexico, his early years at the IACB, during which time he sought to market the affinity of the primitive and the modern, and the nationalist and primitivist elements of the IACB's 1939 exhibition in San Francisco, see my essay, "Marketing the Affinity of the Primitive and the Modern: René d'Harnoncourt and Indian Art of the United States," in *The Early Years of Native American Art History*, ed. Janet Catherine Berlo, 191–236.

69. René d'Harnoncourt, "Suggestions for Future Activities of the IACB," 21 September 1939, box 4, file 140.2, IACB.

70. René d'Harnoncourt, "Proposed Activities for the Fall and Winter," 26 July 1939, box 4, file 140.2, IACB.

71. René d'Harnoncourt to Frederick Douglas, 30 September 1939, box 36, file 300.36, IACB.

72. Francis Henry Taylor to René d'Harnoncourt, 26 September 1939, box 36, IACB.

73. This appears to have been more a matter of ideology and political expediency than personal conviction. D'Harnoncourt was perfectly willing to exhibit historic Indian art made by Canadian tribes. Furthermore, he had insisted on occasion to George Heye that "political frontiers are meaningless in the definition of Indian cultures" (René d'Harnoncourt to George Heye, 9 October 1940, box 35, IACB).

74. On 30 September 1939 d'Harnoncourt made a detailed outline that he titled "Outline of the Content of the Exhibition Indian Art in North America" (1939, box 34, IACB). The first documented use by d'Harnoncourt of the title "Indian Art of the United States" appears on 21 October 1940 (René d'Harnoncourt to Fred Picard, box 34, IACB). In December 1940, however, he referrred to the show simply as "Indian Exhibit, Museum of Modern Art, New York City" (box 32, IACB). And as late as 17 June 1940, in correspondence with MOMA's Publicity Department, he again referred to the "Indian Exhibit at the Museum of Modern Art" (René d'Harnoncourt to Sara Newmeyer, box 34, IACB).

75. According to Aldona Jonaitis, "Indian Art of the United States" was motivated as much "by the political concerns of the United States government" as it was by any "sudden awareness of an intrinsic esthetic merit in the art itself" ("Creations of Mystics," 6). This is true, as is the fact that d'Harnoncourt was clearly aware of the ways in which the exhibition might serve national political interests. However, it is equally true that his awareness of Indian art's aesthetic merit can hardly be characterized as "sudden"; see Rushing, "Marketing the Affinity," 195–206.

76. D'Harnoncourt to Newmeyer, 17 June 1940.

77. Mrs. Roosevelt acted in d'Harnoncourt's behalf in submitting a request to the President that he sign the foreword to the catalogue (René d'Harnoncourt to Eleanor Roosevelt, 19 December 1940, box 34, file 300.36, IACB). Although the President declined, d'Harnoncourt was pleased that he was willing for the First Lady to do so (René d'Harnoncourt to Eleanor Roosevelt, 2 January 1941, box 36, IACB).

78. René d'Harnoncourt, in Douglas and d'Harnoncourt, *Indian Art of the United States*, exh. cat., 8.

79. George C. Vaillant, "Indian Art of the United States," *Art Bulletin* 33 (January 1941): 167.

80. "Indian Art of the United States," *Parnassus* 13 (February 1941): 77.

81. Lowe, "Rich Indian," 7.

82. René d'Harnoncourt, "Outline of Content of the Exhibition of Indian Art in North America," 30 September 1939, box 34, IACB.

83. René d'Harnoncourt to Alfred H. Barr, Jr., 8 November 1939, box 34, IACB.

84. Lowe, "Rich Indian," 7.

85. Ibid.

86. See Fred Kabotie to René d'Harnoncourt, 12 November 1940, box 34, IACB; and René d'Harnoncourt to G. Warren Spaulding, 9 October 1940, box 34, IACB. D'Harnoncourt felt that the rather free manner of copying used by the Hopi artists was compensated for by the fact that "their pictorial tradition has survived almost without change." Furthermore, Brew supplied the original drawings of the excavated murals and other information that helped "insure authenticity of color and design" (D'Harnoncourt to Barr, Jr., 8 November 1939).

87. Vaillant, "Indian Art," 168.

88. René d'Harnoncourt to Thomas C. Parker, 8 April 1940, box 34, file III-A-4, IACB.

89. D'Harnoncourt to Douglas, 30 September 1939.

90. Vaillant, "Indian Art," 168.

91. D'Harnoncourt, in Douglas and d'Harnoncourt, *Indian Art of the United States*, exh. cat., 146.

92. D'Harnoncourt to Barr, Jr., 8 November 1939.

93. René d'Harnoncourt to M. Dietrich, 23 December 1941, box 36, IACB.

94. René d'Harnoncourt, "Indian Exhibit, Museum of Modern Art," December 1940, box 32, IACB; and d'Harnoncourt to Barr, Jr., 8 November 1939.

95. D'Harnoncourt to Douglas, 30 September 1939.

96. Ibid.

97. D'Harnoncourt, "Indian Exhibit," box 32, IACB.

98. D'Harnoncourt to Newmeyer, 17 June 1940.

99. D'Harnoncourt, quoted in "All-American Art," *Art Digest* 17; and d'Harnoncourt, in Douglas and d'Harnoncourt, *Indian Art of the United States*, exh. cat., 197, 198.

100. René d'Harnoncourt to Fred Picard, 21 October 1940, box 34, IACB.

101. See Douglas and d'Harnoncourt, *Indian Art of the United States*, exh. cat., 206–207.

102. D'Harnoncourt to Douglas, 30 September 1939.

103. D'Harnoncourt, "Proposed Activities," 1939, box 4, 140.2, IACB.

104. "20,000 Years," *Newsweek*, 58; Frank Caspers, "Indian Art of the United States," *Art Digest* 15 (1 March 1941): 27; Oliver La Farge, "The Indian as Artist," *New York Times*, 26 January 1941, 9; "Indian Art," *Parnassus* 13; and "All-American Art," *Art Digest*, 17.

105. Two documents indicate that d'Harnoncourt was probably the principal author of the book. The first is a letter written by d'Harnoncourt to Herbert J. Spinden of the Brooklyn Museum stating that Douglas was to write the "captions in the catalogue" (René d'Harnoncourt to Herbert J. Spinden, 27 July 1940, box 35, file 300.36, IACB). The second is a planning document entitled "Collection of Material for Publication," which includes an incomplete page-by-page list of contents and shows d'Harnoncourt to be the author of the

introductory essays, "Tribal Tradition and Progress," "Indian Art," and "Indian Origins and History" (box 34, IACB). The point of view expressed in the last section, "Indian Art for Modern Living," is unquestionably d'Harnoncourt's. Furthermore, based on Douglas's entries in the catalogue's bibliography, it is not unreasonable to assume that while he contributed to the discussions on ethnography, material culture, and artistic technique, d'Harnoncourt was responsible for those on aesthetics, cultural tradition, and world view. This is again supported by the documents cited above and by Barr's recollection that it was d'Harnoncourt who planned the catalogue; see Barr's comments in Barr, Jr., et al., *René d'Harnoncourt*, n.p. Ira Jacknis observed that Douglas was trained as an artist and knew artist's materials quite well but was not interested in anthropological theory (personal communication, 1986). Thus, with this evidence as a guide, all the quotations used in my discussion of the catalogue may be attributed to d'Harnoncourt quite safely.

106. Florence Berryman, "Indian Art of the United States," *Magazine of Art* 34 (April 1941): 216, 218.

107. Caspers, "Indian Art," 27.

108. D'Harnoncourt, in Douglas and d'Harnoncourt, *Indian Art of the United States*, exh. cat., 10.

109. Ibid., 197, 10.

110. La Farge, "Indians at the Museum," 181.

111. La Farge, "Indian as Artist," 9.

112. La Farge, "Indians at the Museum," 182.

113. Charlot, "All American," 165.

114. Vaillant, "Indian Art of the United States," 167–169.

115. D'Harnoncourt, in Douglas and d'Harnoncourt, *Indian Art of the United States*, exh. cat., 13.

116. Ibid. D'Harnoncourt's concept of folk art/culture is perfectly compatible with Robert Redfield's 1947 characterization of the folk society "as small, isolated, nonliterate, and homogeneous, with a strong sense of group solidarity"; see Robert Redfield, "The Folk So-

ciety," *American Journal of Sociology* 52 (1947): 293–308, reprinted in *Readings in Anthropology*, ed. Morton Fried (New York: Thomas Y. Crowell, 1971): 316. Redfield explained that among such societies, such as the Papago Indians, "all activities, even the means of production, are ends in themselves, activities expressive of the ultimate values of the society" (ibid., 325). Furthermore, Redfield observed that folk societies have a tendency to regard objects as sacred. This latter is predicated on the fact that in the folk society, cultural activity is a unity of experience that does not differentiate between sacred and secular (ibid., 325, 319). As Elman R. Service pointed out, Redfield was defining "a polar, ideal construct having characteristics opposite to an urban society" (*Profiles in Ethnology* [New York: Harper and Row, 1971]: 504). More recently, the notion of folk culture has been associated with rural, peasant villages that are subcultures of urban cultures (ibid.). Thus, d'Harnoncourt's characterization of Indian art as folk art was theoretically correct in 1941. Whether such a definition of contemporary "traditional" Indian art is accurate today remains open to question. For a discussion of and bibliography on the recent radical critique of the current art-historical use of the term *folk art*, see Wanda Corn, "Coming of Age: Historical Scholarship in American Art," *Art Bulletin* 70 (June 1988): 205–206.

117. D'Harnoncourt, in Douglas and d'Harnoncourt, *Indian Art of the United States*, exh. cat., 12, 197.

118. Lowe, "Rich Indian," 7, 8, 20.

119. Charlot, "All American," 166.

120. La Farge, "Indian as Artist," 9.

121. Caspers, "Indian Art," 27.

122. D'Harnoncourt, in Douglas and d'Harnoncourt, *Indian Art of the United States*, exh. cat., 11.

123. Ibid., 199, 200.

124. Lowe, "Rich Indian," 8, 20.

125. Caspers, "Indian Art," 27.

126. Charlot, "All American," 165; Max Weber to Alfred H. Barr, Jr., 1 February 1941, box 34, IACB; Vaillant, "Indian Art," 168; and René d'Harnoncourt to Miller, 21 June 1940, box 35, IACB.

127. Charlot, "All American," 165.

128. Ibid.

129. See "Back to the Indian," *Washington Star*, 23 February 1941, box 32, IACB.

130. D'Harnoncourt, in Douglas and d'Harnoncourt, *Indian Art of the United States*, exh. cat., 200.

131. The idea of a "horizon of expectations" derives from Hans-Robert Jauss's description of an "aesthetics of reception and impact" in his "Literary History as a Challenge to Literary Theory," *New Literary History* 2 (1970): 9. My comments follow Susan R. Suleiman's discussion of Jauss in her essay "Varieties of Audience-Oriented Criticism," in *The Reader in the Text*, ed. Susan R. Suleiman and Inge Crossman (Princeton: Princeton University Press, 1980), 35–36.

132. Vaillant, "Indian Art," 169. Similarly, La Farge wrote that Indian art "is very much our own, but we have not yet made it part of us." He also argued that since America was not going to be given back to the Indians, "perhaps we shall have sense enough to give the Indians back to America" ("Indian as Artist," 23).

133. Charlot, "All American," 165.

134. La Farge, "Indian as Artist," 23.

135. D'Harnoncourt, in Douglas and d'Harnoncourt, *Indian Art of the United States*, exh. cat., 10.

5. Primitivism, 1940–1950: Theory, Criticism, Painting

1. The use of the term *myth-makers* originated with Mark Rothko in his introduction to *Clyfford Still*, exh. cat. (New York: Art of This Century Gallery, 1946), n.p. Although Rothko was not as involved with Native American art as the other myth-makers, he clearly was aware of its metaphysical implications. In 1947 Clay Spohn asked him if a painting could hint at "the meaning of or solution of, the absolute, or the universal design of things?" Rothko responded, "Yes, there are many examples among the primitive creations, such as . . . the symbolism of the field fetishes, dance wands, breath feathers, religious ceremonies, etc., of the Southwest Indians" (Clay Spohn Papers, Archives of American Art, Smithsonian Institution, Wash-

ington, D.C.). In some of Rothko's untitled works on paper from the mid-forties there are forms that could be interpreted as Indian tepees, shields, arrows, and gourd rattles. Other paintings, such as *Implements of Magic* (1945) and *The Source* (1946), feature pictographic and fetishistic forms, which perhaps were inspired by southwestern Indian art. If in fact this proves to be the case, it would reinforce Robert Rosenblum's suggestion that Rothko's *Slow Swirl at the Edge of the Sea* (1944) is related to a Navajo sand painting exhibited at the Museum of Modern Art in 1941. See Robert Rosenblum, "Notes on Rothko's Surrealist Years," in *Mark Rothko*, exh. cat. (New York: Pace Gallery, 1981), 8.

2. William Rubin used the term *intellectualized primitivism* to explain aspects of modernist primitivism since World War II. However, Robert Goldwater wrote of an "intellectual primitivism" as early as 1938 (*Primitivism in Modern Art*, 143–177). Although I agree in the main with Rubin's assertion that the "object-to-object relationship" between modernist artists and tribal art "has been largely displaced," there are powerful and notable exceptions, many of which are examined in this and the following chapter. See William Rubin, "Modernist Primitivism," in *"Primitivism,"* ed. Rubin, exh. cat., 1:10. I should add here that working independently I have arrived at some conclusions similar to those expressed by J. Kirk Varnedoe in his essay, "Abstract Expressionism," in *"Primitivism,"* ed. Rubin, exh. cat., 615–659. However, as the evidence presented here and in Chapter 6 demonstrates, the influence of Native American art on both the style and content of early Abstract Expressionism was much stronger than suggested by Varnedoe.

3. Graham was born in Kiev in 1886 of Polish heritage; his real name was Ivan Gratianovitch Dombrowski; see Eleanor Green, *John Graham*, exh. cat., 16. For Graham, see also the critical introduction by Allentuck in *System and Dialectics*, ed. Graham, 1–84; and Irving Sandler, "John D. Graham: The Painter as Esthetician and Connoisseur," *Artforum* 7 (October 1968): 50–53.

4. Peter Busa, quoted in Jeffrey Potter, *To a Violent Grave*, 54.

5. Graham recalled with pride that he was a student of Sloan, whom he described as the greatest teacher of any nationality he had ever known. Upon Sloan's passing in 1951 Graham noted with great emotion that his former teacher "has always been to me the most inspiring person in art." See John D. Graham to John Sloan, 17 November 1939 and 21 April 1949; and John D. Graham to Helen Farr Sloan, 5 October 1951, JSA.

6. John Graham, quoted in Green, *John Graham*, exh. cat., 19.

7. See Mary Davis McNaughton, "Adolph Gottlieb: His Life and Art," in Lawrence Alloway and Mary Davis McNaughton, *Adolph Gottlieb: A Retrospective*, exh. cat., 16. Green suggests that Graham met Gottlieb, Newman, and Alexander Calder at the League in 1922 or 1923 (*John Graham*, 27).

8. For Graham's account of seeing modern art in Moscow, see Green, *John Graham*, exh. cat., 19. On Graham's travels and his role in disseminating information to the New York avant-garde, see Irving Sandler, *The Triumph of American Painting*, 20; and McNaughton, "Gottlieb," in Alloway and McNaughton, *Gottlieb*, exh. cat., 20. These issues of *Cahiers d'Art* also featured numerous reproductions of the various members of the European avant-garde, such as Picasso, Max Ernst, and Joan Miró, whose primitivism was a response to tribal art.

9. Sandler, *Triumph of American Painting*, 20; and McNaughton, "Gottlieb," in Alloway and McNaughton, *Gottlieb*, exh. cat., 20.

10. Green, *John Graham*, 47.

11. Graham, *System and Dialectics*, 23; and McNaughton, "Gottlieb," in Alloway and McNaughton, *Gottlieb*, exh. cat., 31.

12. Green, *John Graham*, 47.

13. See John D. Graham, ed., *System and Dialectics of Art* (London and New York: Delphic Studios, 1937), 122, where he explains that a desire for ethnographical information results in "an inability to see the object as SUCH in all

its self-sufficiency." Cf. Allentuck's comments in the reprint edition, 72.

14. Graham, *System and Dialectics*, 33, 136–137, 25; 29; 21–22.

15. Ibid., 19, 15.

16. On the relevance of this aspect of Jung for New York artists in this period, see Stephen Polcari, "The Intellectual Roots of Abstract Expressionism: Mark Rothko," *Arts Magazine*, 54 (September 1979): 126. See also his more recent treatment of this subject in Stephen Polcari, *Abstract Expressionism and the Modern Experience* (New York: Cambridge University Press, 1991).

17. Graham, *System and Dialectics*, 15.

18. Ibid., 16.

19. Ibid., 21, 31, 125, 111; on Jung and primitive religion as spiritual transformation, see Polcari, "Intellectual Roots," 126.

20. Graham, *System and Dialectics*, 145.

21. In its original and purest sense the term *pre-Columbian* was a chronological designation that has taken on geographic, cultural, aesthetic, and ideological connotations. The boundaries between modern nation-states in the "New World" obscures the fact that prior to the arrival of Europeans considerable cultural exchange took place between "Mexican" and "American" Indians. Graham was certainly not alone in recognizing the relationship between pre-Columbian and Native American cultures. For example, d'Harnoncourt's foreword (signed by Eleanor Roosevelt) to the catalogue *Indian Art of the United States* dealt with this issue: "In dealing with Indian art of the United States, we find that its sources reach far beyond our borders, both to the north and to the south. . . . Related thoughts and forms that are truly of America are found from the Andes to the Mississippi Valley. . . . We acknowledge here a cultural debt not only to the Indians of the United States but to the Indians of both the Americas" (Douglas and d'Harnoncourt, *Indian Art of the United States*, exh. cat., 8).

22. John D. Graham, "Primitive Art and Picasso," *Magazine of Art* 30 (April 1937): 237.

23. Ibid., 237, 260.

24. Ibid., 237.

25. On Surrealist primitivism, see Elizabeth Cowling, "The Eskimos, the American Indians, and the Surrealists," *Art History* 1 (December 1978): 484–499; Jonaitis, "Creations of Mystics," 8, 13–15; Martica Sawin, "El surrealismo etnográfico y la america índigena," in *El Surrealismo Entre Viejo y Nuevo Mundo*, exh. cat. (Las Palmas, Canary Islands: Centro Atlantico Arte Moderno, 1990), 81–88; and especially Evan Maurer, "Dada and Surrealism," in *"Primitivism,"* ed. Rubin, exh. cat., 2:541–584.

26. Peggy Guggenheim, *Out of This Century*, 263; Cowling, "Eskimos," 493; and Maurer, "Dada and Surrealism," in *"Primitivism,"* ed. Rubin, exh. cat., 2:565.

27. Guggenheim, *Century*, 263, 265. On Ernst and Native American art, see Maurer, "Dada and Surrealism," in *"Primitivism,"* ed. Rubin, exh. cat., 2:561–575.

28. Fritz Bultman, personal communication, 26 April 1984.

29. See Ashton, *New York School*, 125; Seligmann contributed an article on Haida Indians to the final issue of the Surrealist journal *Minoutaure* in May 1939 (ibid., 93). While this book was in press, important new material on Paalen was published; see Amy Winter, "The Germanic Reception of Native American Art: Wolfgang Paalen as Collector, Scholar, and Artist," *European Review of Native American Studies* 6, no. 1 (1992): 17–26.

30. Irving Sandler has noted that the Gotham Book Mart was a regular meeting place for artists (interview with the author, 13 November 1984). An advertisement in *DYN* ("Amerindian Number," nos. 4–5 [December 1943]) announced that the Gotham Book Mart was the headquarters for *DYN, Transition, View, VVV, Broom*, and some other art journals. In addition, the advertisement for the bookstore announced several "scoops": books dealing with American Indian costumes, songs, and chants.

31. Sara L. Henry, "Paintings and Statements of Mark Rothko (and Adolph Gottlieb) 1941–1949: Basis of Mythological Phase of Abstract Expressionism" (M.A. thesis, New York University, Institute of Fine Arts, 1966), 63n. 76.

32. Wolfgang Paalen, "Le Paysage totemique," *DYN*, no. 1, pt. 1, (April–May 1942): 46–50; no. 2, pt. 2 (July–August, 1942): 42–47; no. 3, pt. 3 (Fall 1942): 27–31.

33. Wolfgang Paalen, editorial, *DYN*, "Amerindian Number," nos. 4–5 (December 1943): n.p., back of frontispiece.

34. Wolfgang Paalen, "Totem Art," *DYN*, "Amerindian Number," nos. 4–5 (December 1943): 13, 17, 18.

35. Ashton, *New York School*, 125, where she notes the transposition of Jungian ideas in Wolfgang Paalen, *Form and Sense* (New York: Wittenbonn and Schultz, 1945).

36. Paalen, "Totem Art," 18.

37. Bultman confirmed that Pollock read *DYN* (Fritz Bultman, personal communication, 26 April 1984). Motherwell traveled to Mexico with Matta in 1941 and became acquainted there with Paalen and his theories. Upon his return to New York he sometimes discussed with Pollock "the emergent post-Surrealist ideas" (Ashton, *New York School*, 126).

38. Barbara Reise, "'Primitivism' in the Writings of Barnett Newman: A Study in the Ideological Background of Abstract Expressionism" (M.A. thesis, Columbia University, 1965), 26.

39. My first knowledge of Graham's role in assembling the Crowninshield collection of primitive art came from Irving Sandler (personal communication, 1983); cf. also Allentuck's comments in the reprint edition of Graham, *System and Dialectics*, 72.

40. Barnett Newman, introduction to *Pre-Columbian Stone Sculpture*, exh. cat. (New York: Wakefield Gallery, 1944), reprinted in *Barnett Newman: Selected Writings and Interviews*, ed. John P. O'Neill, 61–62.

41. Bultman, personal communication, 26 April 1984. Bultman (1919–1985) was an active member of the New York avant-garde for many years and was well acquainted with numerous artists, including Graham, Hans Hofmann, Weldon Kees, Pollock, and Tony Smith. Along with Gottlieb, Newman, Pollock, Pousette-Dart, Rothko, and others, Bultman signed the famous "irascible" letter protesting the exhibi-

tion policies of the Metropolitan Museum of Art. Bultman, however, like Hofmann and Kees (who were also signers), was not available for the famous photograph of the "Irascibles" taken by Nina Leen and published in *Life* (15 January 1951). B. H. Friedman is convinced that the absence of these three from the photograph "contributed to their omission from the official, institutional Abstract-Expressionist 'list.'" See B. H. Friedman, "In Memoriam: An 'Irascible,'" *Arts Magazine* 60 (January 1986): 79.

42. Ashton, *New York School*, 132; Barnett Newman, *Northwest Coast Indian Painting*, exh. cat. (New York: Betty Parsons Gallery, 1946), reprinted in *Newman*, ed. O'Neill, 105–107.

43. Newman, *Northwest Coast Indian Painting*, exh. cat., in *Newman*, ed. O'Neill, 106, 107.

44. Newman wrote that "the modern painter, no matter of what school, is emotionally tied to primitive art," which he defined as the "romantic dream of our time." These comments first appeared in his essay "Las formas artisticas del pacifico," *Ambos Mundos* (June 1946), which was reprinted later as "Art of the South Seas," *Studio International* 179 (February 1970): 70–71, and has now been anthologized in *Newman*, ed. O'Neill, see 98, 101.

45. In his discourse on the "ideographic picture" Newman quoted from the *Century Dictionary*: "Ideographic—a character, symbol or figure which suggests the idea of an object without expressing its name"; see Barnett Newman, *The Ideographic Picture*, exh. cat. (New York:Betty Parsons Gallery, 1947), reprinted in *Newm an*, ed. O'Neill, 107–108. According to Lawrence Alloway, Newman used the term *ideograph* out of his "comparable sense of the usefulness of sign systems as an alternative to abstract art and realism" ("Melpomene and Graffiti," in Alloway, *Topics in American Art*, 29).

46. Newman, *Ideographic Picture*, exh. cat., in *Newman*, ed. O'Neill, 108. The others were Pietro Lazzari, Boris Margo, and Ad Rheinhardt.

47. Personal communication from Richard and Evelyn Pousette-Dart, Suffern, New York,

15 September 1986. In an unpublished book review (c. 1951) originally intended for *Partisan Review*, Newman noted that only by limiting the "field of vision" could one leave Pousette-Dart out of a discussion of American abstract art; see "Review of *Abstract Painting: Background and American Phase* by Thomas Hess," in *Newman*, ed. O'Neill, 120.

48. Newman, *Ideographic Picture*, exh. cat., in *Newman*, ed. O'Neill, 107–108.

49. Ibid. As Richard Shiff has observed, Newman "associated 'abstract' thought with the 'abstract' shapes of primitivism." See his introduction to *Newman*, ed. O'Neill, xv.

50. Newman, *Ideographic Picture*, exh. cat., in *Newman*, ed. O'Neill, 108.

51. Dore Ashton noted in 1972 that the juxtaposition of Greek and Northwest Coast Indian culture was commonplace in the 1940s and that "the repeated conjuration of Nietzsche . . . whose dual Apollonian-Dionysian position moved into the nineteen-forties, was a measure of the spiritual restlessness" (*New York School*, 188, 124). As Donald E. Gordon pointed out, one difference between Abstract Expressionism and German Expressionism was that the Americans preferred the early Nietzsche (i.e., *The Birth of Tragedy*), while the Germans preferred the later (i.e., *The Will to Power*). See Donald E. Gordon, *Expressionism: Art and Idea* (New Haven: Yale University Press, 1987): 199.

52. On the relevance of Nietzsche for the American "bohemian elite," see Ashton, *New York School*, 86, 124, 129, 187–188. See also the comments on Jung and the well-reasoned analysis of Nietzsche's importance to Abstract Expressionist theory in Ann Gibson, "Theory Undeclared: Avant-Garde Magazines as a Guide to Abstract Expressionist Images and Ideas," (Ph.D. diss., University of Delaware, 1984), 228–230, 239–255. I am indebted also to the discussion of the influence of Jung and Nietzsche on Abstract Expressionism, in general, and Mark Rothko, in particular, in Polcari, "Intellectual Roots," 124–134.

53. Friedrich Nietzsche, *The Birth of Tragedy*, trans. William A. Hausmann, 22. Although many texts in English use the term *Apollonian*

(e.g., Ruth Benedict's *Patterns of Culture*), I am using *Apollinian* because it more closely corresponds to Nietzsche's *Apollinische*; see *Die Geburt der Tragödie* in *Nietzsche Werke: Kritische Gesamtausgabe*, ed. Giorgio Colli and Mazzino Montinari, series 3, vol. 1 (Walter de Gruyter: Berlin and New York, 1972), 26, 29–30ff. Note also that Walter Kaufmann translates *Apollinische* as *Apollinian* (*Nietzsche*: *Philosopher, Psychologist, Antichrist* [Princeton: Princeton University Press, 1968], 128).

54. Nietzsche, *Birth of Tragedy*, 34, 28, 27, 29–30. It is not clear when Newman first encountered the writings of Nietzsche, Jung, and Worringer. In 1978, his wife, Annalee Newman, informed Stephen Polcari that he liked *The Birth of Tragedy* (see Polcari, *Abstract Expressionism*, 54). More recently she claimed that he was not impressed with either Nietzsche or Worringer. It is my belief, however, that the analysis of Newman's texts in this chapter argues against such a contention. Mrs. Newman's initial recollection was that Newman was first introduced to Worringer when Clement Greenberg, on an unspecified date, referred him to *Form in Gothic*. She also recalls that Newman obtained a copy of *Form in Gothic* either by loan from the public library or by borrowing a copy from a friend. As she remembers it, Newman, because of financial circumstances, often acquired reading materials in these ways. This may explain why pre-1940 editions of certain texts relating to the development of his art theory are not extant in his library. By her own admission, however, Mrs. Newman has continued to purchase, since Newman's death in 1970, the "kinds of books in which he was interested" (personal communication from Mrs. Annalee Newman, New York City, 25 September 1986, and telephone conversation, 1 April 1987). Thus, she has added to the collection a 1967 translation by Walter Kaufmann of *The Birth of Tragedy*, as well as several volumes on Northwest Coast Indian art that were published after 1970. I am grateful to Mrs. Newman for allowing me access to her husband's books.

55. Nietzsche, *Birth of Tragedy*, 24–25, 32–35, 25, 46.

56. Ibid., 85, 116, 174.

57. Ibid., 38, 50, 176.

58. C. G. Jung, *Psychology of the Unconscious*, trans. Beatrice M. Hinckle, 4. Jung freely acknowledged his intellectual debt to Nietzsche (5, 22, 35, 25) and quoted from him here (28).

59. Ibid., 27–28.

60. Ibid., 35.

61. Stephen Jay Gould, *Ontogeny and Philogeny* (Cambridge: Harvard University Press, 1977), 76, 13. For a discussion of recapitulation theory and Abstract Expressionism, see Polcari, "Intellectual Roots," 125.

62. Jung, *Psychology*, 35. On Jung and recapitulation theory, see Gould, *Ontogeny*, 161–162.

63. Jung, *Psychology*, 28.

64. Wilhelm Worringer, *Abstraction and Empathy* (1908), trans. Michael Bullock, 4, 123, 127, 131. Abstraction and empathy, Worringer explained, "are only gradations of a common need, which is revealed to us as the deepest and ultimate essence of all aesthetic experience" (ibid., 23).

65. On the debate over Newman's awareness of Worringer, see "Letters: An Exchange: Annalee Newman and W. Jackson Rushing," *Art Journal* 48 (Fall 1989): 268–271. See also T. E. Hulme, *Speculations* (London: Latimer Trend and Co., 1924), and Joseph Frank, "Spatial Form in Modern Literature," *Sewanee Review* 52 (April–June 1945): 221–240; 52 (July–September 1945): 443–456; and 52 (October–December 1945): 643–653.

66. See Mollie McNickle's annotation of Barnett Newman, "Painting and Prose," in *Newman*, ed. O'Neill, 86.

67. Newman, "Painting and Prose," in *Newman*, ed. O'Neill, 91.

68. See McNickle's annotation of Barnett Newman, "Frankenstein," in *Newman*, ed. O'Neill, 91.

69. Newman, "Frankenstein," in *Newman*, ed. O'Neill, 92–93.

70. Newman, "Art of the South Seas" (see n. 44) in *Newman*, ed. O'Neill, 100.

71. Richard Shiff has noted that Newman "only rarely invokes a preexisting authority," although "there are 'sources' for some of his

thoughts." According to Shiff, seeking out these sources "counteracts the directions of Newman's writing and art" (introduction to *Newman*, ed. O'Neill, xxiv). This is certainly true, but if taken literally, as Shiff suggests it should be (personal communication, 1991), it does not invalidate the goal of *my writing*, which is to show how Newman's texts do cultural work by participating in a dialogue grounded in a continuum of texts, including those, among others, of Nietzsche, Jung, and Worringer.

72. Worringer, *Abstraction and Empathy*, 18.

73. For example, concerning Newman's interest in Dionysian "dreams and intoxications," Thomas Hess observed: "*Dionysus*, the only title from Greek mythology among the seventeen pictures in 1949 is, of course, the fertility god, the creator and of special interest to Newman as the god of tragic art as well as the representative of the productive and intoxicating powers of nature" (*Barnett Newman* [New York: Museum of Modern Art, 1971], 82).

74. Barnett Newman, "The Object and the Image," *Tiger's Eye*, no. 3 (March 1948): 111, reprinted in *Newman*, ed. O'Neill, 170. Newman lamented the excessive emphasis on Apollinian qualities in Greek plastic art: "Pride of civilization prevented them from understanding the barbarians' totemic fanaticism. Unable to penetrate the numinal base of barbarian objects . . . Greek plasticity developed as an art of refinement"; see Barnett Newman, "The Plasmic Image" (1945), in Hess, *Newman*, 42.

75. Newman, "Object," 111.

76. Nietzsche, quoted in *Tiger's Eye*, no. 3 (March 1948): 91–92. According to Ashton, "Newman probably chose the Nietzsche text" (*New York School*, 187). Ann Gibson, however, reports that the passage was selected by the editors, Ruth and John Stephans ("Theory Undeclared," 239).

77. In addition to writing for *Tiger's Eye* and having his visual art reproduced there, Newman introduced the editors to artists and assisted them in acquiring photographs of contemporary art for publication. However, the Stephans must have thought of him as an associate editor, because he was listed as such in two issues. Newman himself contested that description of his work for the magazine. See Annalee Newman's comments as cited in n. 65.

78. Newman, *Ideographic Picture*, exh. cat., in *Newman*, ed. O'Neill, 108.

79. Newman, "Plasmic Image," in Hess, *Newman*, 37.

80. Newman, *Ideographic Picture, exh. cat.*, in *Newman*, ed. O'Neill, 108.

81. Worringer, *Abstraction and Empathy*, 127.

82. Ibid., 115.

83. Newman, *Northwest Coast*, exh. cat., in *Newman*, ed. O'Neill, 106.

84. Worringer, *Abstraction and Empathy*, 8.

85. Newman, *Northwest Coast*, exh. cat., in *Newman*, ed. O'Neill, 105–106. Prior to this, in 1945, he had written that "comprehending the work of the primitive artist involves a denial of Western European art" and that "the new painter who is emulating the primitive artist by his preoccupation with plasmic instead of plastic form is also denying Western European art" ("Plasmic Image," in *Newman*, ed. O'Neill, 146.

86. Newman, *Northwest Coast*, exh. cat., in *Newman*, exh. bated. O'Neill, 105.

87. Reise, "Writings of Barnett Newman," 42.

88. See Mollie McNickle, "The American Response to Surrealism: Barnett Newman," in *The Interpretive Link: Abstract Surrealism into Abstract Expressionism*, ed. Paul Schimmel, (Newport Beach: Newport Harbor Art Museum, 1986), 51–56. Although McNickle points out the scarcity of reference to myth in Newman's writings, she admits that his titles were not chosen arbitrarily. In fact, Newman intended such titles as *The Slaying of Osiris* (1944), *The Song of Orpheus* (1944–1945), *Gea* (1944–1945), and *Dionysus* (1947) to be clues to the audience about the mythic orientation of their pictorial content. See his comments about selecting titles in David Sylvester, "Concerning Barnett Newman," *The Listener* 88 (10 August 1972): 170.

89. On Newman and the sciences, see Hess, *Newman*, 26.

90. Bultman, interview with author.

91. See Phyllis Tuchman, "Interview with Esther Gottlieb," 1982, Mark Rothko Oral History Project, typescript, Archives of American Art, Smithsonian Institution, Washington, D.C., 6. On Newman's friendship with and admiration for Gottlieb, see Hess, *Newman*, 23. Newman wrote to Gottlieb (c. 1943–1944) praising the Northwest Coast collections he had seen at the Peabody Museum in Salem, Massachusetts; see "Letter to Adolph and Esther Gottlieb," in *Newman*, ed. O'Neill, 59–60.

92. After Newman's exhibition of pre-Columbian art in 1944, Graham gave him a portrait of the latter's third wife (personal communication from Annalee Newman, New York City, 25 September 1986).

93. My thanks to Judy Freeman, associate curator of Twentieth-Century Art, Los Angeles County Museum, for bringing these objects to my attention. The iconography and painting style are remarkably similar to that found on a Chiricahua Apache painted leather poncho in the collection of the Museum of the American Indian, which was exhibited in "Indian Art of the United States" in 1941; see Douglas and d'Harnoncourt, *Indian Art of the United States*, exh. cat., 30–31.

94. On the popularity of *Patterns of Culture*, see Ann Gibson, "Painting Outside the Paradigm: Indian Space," *Arts Magazine* 57 (February 1983): 104n. 9. On Newman's awareness of this book, see Polcari, *Abstract Expressionism*, 37.

95. Gibson, "Indian Space," 104n. 9.

96. Barnett Newman to Harry L. Shapiro, 1 August 1944, Archives of the Department of Anthropology, American Museum of Natural History, New York City.

97. Barnett Newman, "The New Sense of Fate," quoted in Hess, *Newman*, 41.

98. See Franz Boas, *The Mind of Primitive Man*, 156–157. Newman's copy of this volume is copyright 1943.

99. "Kwakiutl Shaman Song," collected by George Hunt, in Franz Boas, "Ethnology of the Kwakiutl," *Thirty-fifth Annual Report of the Bureau of American Ethnology*, pt. 2 (Washington, D.C.: Government Printing Office, 1921), 1294–1295; quoted in *Tiger's Eye*, no. 2 (December 1947): 83.

100. Any single ceremony is *Tseka*. *Tsetseka* is distinguished from *Bakoos*, the summer (secular) season, and *Klasila*, the transitional time, which begins with a period of mourning for those who have died since the last winter season. See Audrey Hawthorn, *Art of the Kwakiutl Indians*, 33, 35, 398.

101. Nietzsche, *Birth of Tragedy*, 31.

102. Ruth Benedict, *Patterns of Culture* (1934; reprint, Boston: Houghton Mifflin Co., 1961), 177–178.

103. Ibid., 175. Another book in Newman's library contained a similar account; see Pliny Earle Goddard, *Indians of the Northwest Coast* (New York: American Museum of Natural History, 1934), 147–150.

104. See Edwin L. Wade and Lorraine Laurel Wade, "Voices of the Supernaturals: Rattles of the Northwest Coast," *American Indian Art Magazine* 2 (November 1976): 32–39.

105. Nietzsche, *Birth of Tragedy*, 62.

106. Ibid., 68. In 1943, the noted French anthropologist Claude Lévi-Strauss, writing with a sense of poetic wonder and surrealist mystery about the Northwest Coast collections at the American Museum of Natural History, noted the "dithyrambic gift of synthesis" in Northwest Coast ritual masks. With references to Halloween and Baudelaire's "Correspondances," Lévi-Strauss observed that the "primitive message" of this art form "was one of such violence that even today the prophylactic isolation of the vitrine does not prevent its ardent communication." And, after explicating a transformation myth, he asked, "Is it not the Greeks who seem to play the barbarians and the poor savages of Alaska who may pretend to reach the purer understanding of beauty?" See Claude Lévi-Strauss, "The Art of the Northwest Coast at the Museum of Natural History," *Gazette Des Beaux-Arts* 24 (September 1943): 180, 182.

107. Benedict, *Patterns of Culture*, 180–181.

108. Sir James George Frazer, *The Golden Bough*, 449–450. This work was first published in two volumes in London in 1890. Subsequently, it was expanded to twelve volumes (London, 1911–1915). The citation here is to the second edition of a one-volume abridged version. Gottlieb, who had read *The Golden Bough*, recalled that he discussed myth, psychology, and philosophy with his well-read friends. See Henry, "Paintings and Statements," 15.

109. Nietzsche, *Birth of Tragedy*, 27.

110. Ibid., 63, 60.

111. Newman, *Northwest Coast*, exh. cat., in *Newman*, ed. O'Neill, 106. Newman referred to Northwest Coast painting as "pure painting" in a letter to Harry Shapiro, 23 September 1946, Archives of the Department of Anthropology, American Museum of Natural History.

112. Newman, *Northwest Coast*, exh. cat., in *Newman*, ed. O'Neill, 106.

113 . See Goddard, *Indians*, 158–159. Sisiutl is often double-headed, and Boas's report on the Kwakiutl contains several references to the monster; see Boas, "Ethnology of the Kwakiutl," 805–806, 812, 816, 820, 952, 1117, 1349. Unfortunately, most of Newman's works from the 1940s which I discuss here were not available for publication. For an illustration of these works, as well as for the comparative Northwest Coast objects, see my essay, "The Impact of Nietzsche and Northwest Coast Indian Art on Barnett Newman's Idea of Redemption in the Abstract Sublime," *Art Journal* 47 (Fall 1988): 192.

114. Newman, *Northwest Coast*, exh. cat., in *Newman*, ed. O'Neill, 106. For reproductions of the works of 1944 that are related to the one discussed here, see Brenda Richardson, *Barnett Newman*, exh. cat., Pls. 1–10.

115. Barnett Newman, quoted in Hess, *Newman*, 43.

116. Betty Parsons, quoted in Gerald Silk, "Interview with Betty Parsons," 11 June 1981, Mark Rothko Oral History Project, typescript, AAA. Smithsonian Institution, Washington, D.C., 8–9.

117. Nietzsche, *Birth of Tragedy*, 111, 46, 46–47.

118. Barnett Newman, quoted in Harold Rosenberg, *Barnett Newman*, 21.

119. Frazer, *Golden Bough*, 420–421.

120. On Abstract Expressionism and World War II, see Stephen Polcari, "Adolph Gottlieb's Allegorical Epic of World War II," *Art Journal* 47 (Fall 1988): 202–203.

121. Newman, "New Sense of Fate," quoted in Hess, *Newman*, 43. For a discussion of certain aspects of early Abstract Expressionism as a primitivistic response to the "awe and fear of a world born again into the atomic age," see Jeffrey Weiss, "Science and Primitivism: A Fearful Symmetry in the Early New York School," *Arts Magazine* 62 (March 1983): 81–87.

122. Barnett Newman, quoted in Hess, *Newman*, 43.

123. Nietzsche, *Birth of Tragedy*, 119.

124. See Barnett Newman, "The First Man Was an Artist," *Tiger's Eye*, no. 1 (October 1947): 59–60.

125. Hess reported that Newman made *Onement I* on his birthday, 29 January 1948; see Hess, *Newman*, 51. The discourse on the "abstract sublime" in postwar American art was initiated by Robert Rosenblum, "The Abstract Sublime," *Art News* 54 (February 1961): 38–41, 56–57. See also Lawrence Alloway, "The American Sublime," *Living Arts*, no. 2 (1963): 11–22.

126 Nietzsche, *Birth of Tragedy*, 62.

127. Barnett Newman, "The Sublime Is Now," *Tiger's Eye*, no. 6 (15 December 1948): 51.

128. Gibson finds in "The Sublime Is Now" Newman's preference for the Dionysian mode ("Theory Undeclared," 245–249).

129. Newman, "Sublime Is Now," 52, 53.

130. Nietzsche, *Birth of Tragedy*, 61.

131. The art historical "Otherness" of the Indian Space style has to do with the fact that it was produced by artists who were, vis-à-vis the critical/economic competition with incipient Abstract Expressionism, "eclipsed contenders" whose work was only later found to be a "retroactive source . . . of a new paradigm." See Gibson, "Indian Space," 98, 103. I am very

grateful to Professor Gibson for her generous assistance in researching these artists. On Indian Space, see also Sandra Kraskin et al., *The Indian Space Painters*, exh. cat. Some of my comments here first appeared in a review of the latter; see "Semeiology," *Art Journal* 51 (Summer 1992): 97–99.

132. Gibson, "Indian Space," 98.

133. See Ann Gibson, *Issues in Abstract Expressionism*, 67n. 39.

134. Sandra Kraskin, "The Indian Space Painters," in Kraskin et al., *Indian Space Painters*, 15.

135. On Beaudoin's interest in Peirce's semeiotics, see Gibson, *Issues*, 16; Barbara Hollister, "Indian Space: History and Iconography," in Kraskin et al., *Indian Space Painters*, 31.

136. Kenneth Beaudoin, "This Is the Spring of 1946," *Iconograph*, no. 1 (Spring 1946): 3. Beaudoin first published *Iconograph* in New Orleans from 1940 to 1943; issue no. 6 (1942) of the old (pre–New York) series featured a "free translation" of "Some Osage War Songs" and an untitled woodcut by Oscar Collier.

137. James Dolan, "Typography," *Iconograph*, no. 1 (Spring 1946): 9–10.

138. See Gibson, "Indian Space," 98.

139. "The Iconograph News," *Iconograph*, no. 4 (Winter 1946): 1.

140. Gibson, "Indian Space," 98, 101–102.

141. Beaudoin, "Spring of 1946," 4; and Clement Greenberg, "Review of Exhibitions of the Jane Street Group and Rufino Tamayo," *The Nation* 8 (March 1947): 284.

142. Gibson, "Indian Space," 99.

143. Kraskin, "Indian Space Painters," in Kraskin et al., *Indian Space Painters*, 9.

144. Steve Wheeler, "An Open Letter to Clement Greenberg," 15 March 1947; see the Steve Wheeler Artist's File, Library of the Museum of Modern Art.

145. See *View* (March 1945): n.p.; and *View*, "Tropical America" (1945): 42.

146. The information on "Adam Gates" as Wheeler was a personal communication from Ann Gibson, September 1986. A copy of "*Hello Steve*" is in the collection of the Library of the Museum of Modern Art.

147. See "Arts in Review," *View* (Summer 1944): 59.

148. Steve Wheeler, "A Close Up of '*Hello Steve*'"; see the Steve Wheeler Artist's File, Library of the Museum of Modern Art.

149. Adam Gates, "Face to Face," in Steve Wheeler, "*Hello Steve*," (New York: Press Eight, 1947).

150. Steve Wheeler, preface to "*Hello Steve.*"

151. See Kraskin, "Indian Space Painters," in Kraskin et. al, *Indian Space Painters*, 10.

152. Ibid. Kraskin noted the correlation between Peruvian art and the figuration in *The Children's Hour*.

153. Clifford, *Predicament of Culture*, 236.

154. On Claude Lévi-Strauss as an anthropological *flâneur* in New York in the 1940s, see ibid., 238.

155. See Sandler, *Triumph*, 38.

156. See Busa's comments in Potter, *Violent Grave*, 101. *Original Sin*, which Busa exhibited at the Whitney Museum in 1946, was probably one of the works he exhibited that same year at Art of This Century.

157. According to Busa, "Bill Baziotes had a drip period and so did others"; see Potter, *Violent Grave*, 101.

158. Ibid.

159. Peter Busa, quoted in "Art in Buffalo," *Buffalo Evening News*, 16 February 1955, 66.

160. Peter Busa, quoted in "An Interview with Peter Busa," *League Quarterly* 18, no. 3 (Winter 1946): 11.

161. Gibson, "Indian Space," 100.

162. Ibid., 100.

163. Will Barnet, personal communication, New York City, 25 April 1984.

164. Hollister, "Indian Space," in Kraskin et al., *Indian Space Painters*, 33.

165. Barnet, personal communication, 25 April 1984.

166. Barnet, personal communication, Bath, Maine, 19 June 1989.

167. Barnet, personal communication, 25 April 1984.

168. Barnet, quoted in Thomas Messer, *Will Barnet*, exh. cat., n.p.

169. Barnet, personal communication, 19 June 1989. *The Cave* has been published with

conflicting dates. When queried about this, Barnet indicated that he remembered working on it during 1950–1951.

170. Barnet, quoted in Gibson, "Indian Space," 104n. 24.

171. Barnet, personal communication, 25 April 1984.

172. Ibid.

173. Oscar Collier, personal communication, New York, 26 April 1984. Collier may have been thinking, perhaps, of the Haida myths that appeared in *Iconograph*, no. 4 (Winter 1946): 28–30.

174. Kenneth Beaudoin, "Oscar Collier: A Study in Pictorial Metaphor," *Iconograph*, no. 3 (Fall 1946): 19.

175. Oscar Collier, personal communication, 27 May 1992.

176. Beaudoin wrote that Collier "had decided that the business of a picture is to communicate . . . [and] even when the symbols don't clarify themselves he has done that" ("Collier," 22).

177. Ibid.

178. Collier, personal communication, 26 April 1984.

179. Gibson, "Indian Space," 100. Gibson, too, has noted that the "*Iconograph* group did not isolate itself from the rest of the New York art community"; see *Issues*, 22.

180. On Beaudoin's interest in Newman and Gottlieb, see Gibson, *Indian Space*, 98.

181. Oscar Collier, "Mark Rothko," *The New Iconograph* (Fall 1947): 41.

182. Robert Goldwater, "Reflections on the New York School," *Quadrum*, no. 8 (1960): 26.

183. Pousette-Dart always felt that there was a great difference between his works and those of his contemporaries (personal communication, 16 March 1985).

184. Ibid.

185. In addition to pictorializing arcane signs, primordial plants, and primitive fetishes in a *Primeval Landscape*, the title of one of his paintings (1945), many of Rothko's images of stratification evoke an elemental *aqueous* environment.

186. Richard Pousette-Dart, personal communication, Suffern, New York, 5 May 1985.

187. Pousette-Dart, quoted in Judith Higgins, "To the Point of Vision," in Sam Hunter, ed., *Transcending Abstraction: Richard Pousette-Dart, Paintings, 1939–1985*, exh. cat. (Fort Lauderdale: Museum of Art, 1986), 16.

188. Pousette-Dart, quoted in Gail Levin, "Pousette-Dart's Emergence as an Abstract Expressionist," *Arts Magazine* 54 (March 1980): 126. Levin writes that Pousette-Dart "diagrammed the polarity between the subconscious mind' and the 'conscious mind.'"

189. Pousette-Dart, personal communication, 16 March 1985.

190. Ibid.

191. See Joanne Kuebler, "Concerning Pousette-Dart," in Robert Hobbs and Joanne Kuebler, *Richard Pousette-Dart*, exh. cat., 22, 78n. 55.

192. Robert Hobbs, "Confronting the Unknown Within," in Hobbs and Kuebler, *Pousette-Dart*, 87.

193. Pousette-Dart, personal communication, 16 March 1985.

194. See Kuebler, "Concerning Pousette-Dart," in Hobbs and Kuebler, *Pousette-Dart*, 41.

195. Richard Shiff, "Performing an Appearance: On the Surface of Abstract Expressionism," in Michael Auping et al., *Abstract Expressionism: The Critical Developments*, exh. cat. (New York: Harry N. Abrams with the Albright-Knox Art Gallery, 1987), 98.

196. See W. Jackson Rushing, "Pousette-Dart's Spirit-Object," *Art Journal* 50 (Summer 1991): 75.

197. Pousette-Dart, personal communication, 16 March 1985.

198. Madan Sarup, *An Introductory Guide to Post-Structuralism and Postmodernism* (Athens: University of Georgia Press, 1989), 11. In an essay, "The Agency of the Letter in the Unconscious or Reason since Freud," Lacan noted: "As my title suggests, . . . what psychoanalytic experience discovers in the unconscious is the whole structure of language " (Jacques Lacan, *Ecrits*, trans. Alan Sheridan [London: Tavistock Publications, 1977], 147).

199. Sarup, *Postmodernism*, 11.

200. Pousette-Dart, personal communication, 16 March 1985.

201. Adolph Gottlieb, interview with Dorothy Seckler, 25 October 1967, typescript, Adolph and Esther Gottlieb Foundation, New York, 17.

202. Gottlieb's introduction to Native American art, however, may well have come from Sloan, with whom he studied at the Art Students League. Gottlieb recalled that Sloan, who "was a very liberal guy for his time," had "the most valuable influence" on his early development as an artist. In particular he remembered that a "good thing about Sloan" was that he encouraged people to create works that "were not exactly literal and to work from imagination or memory" (ibid., 6–7).

203. On Graham's gift to Gottlieb, see McNaughton, "Gottlieb," in Alloway and McNaughton, *Gottlieb*, exh. cat., 20; Sanford Hirsch, personal communication, New York, 3 April 1985.

204. Adolph Gottlieb, quoted in Sanford Hirsch, "Adolph Gottlieb in Arizona: 1937–1938," typescript (1984), Adolph and Esther Gottlieb Foundation, New York, 13. Much later (1967) Gottlieb recalled these collections: "There's a museum in Tucson of Indian art. But this is almost exclusively art of the Southwest which isn't very exciting—but it's quite good. There were some things there that were quite good, especially the early things. Curiously, the Indians just like other cultures, their art seems to disintegrate when they come into contact with our culture. So the earlier the things the better they were." (Seckler interview, 25 October 1967, 14). Admittedly, Gottlieb did not think then, some forty years after the fact, that he was much influenced by this experience (ibid.).

205. Adolph Gottlieb, quoted in McNaughton, "Gottlieb," in Alloway and McNaughton, *Gottlieb*, exh. cat., 171.

206. Adolph Gottlieb, from a talk given by the artist at "The Modern Artist Speaks," a forum at the Museum of Modern Art, 5 May 1948, typescript, Archives of American Art, Smithsonian Institution, Washington, D.C., 3.

207. Adolph Gottlieb, statement in "The Ides of Art: The Attitudes of Ten Artists on Their Art and Contemporaneousness," *Tiger's Eye*, no. 2 (December 1943): 43.

208. Newman wrote that Gottlieb's earthy palette intensified a state of mind that he associated with humanity's tragic dilemma; see Barnett Newman, "La Pintura de Tamayo y Gottlieb," *La Revista Belga* (April 1945): 25; reprinted as "The Painting of Tamayo and Gottlieb, in *Newman*, ed. O'Neill, 76.

209. For modern influences on Gottlieb's grid structure, see McNaughton, "Gottlieb," in Alloway and McNaughton, *Gottlieb*, exh. cat., 32.

210. Ibid., 38. McNaughton notes there the influence of Chilkat blanket patterns and Haida pole forms on Gottlieb's early *Pictographs*. As she rightly observes, Haida poles were on display both at the Brooklyn Museum and in the exhibition "Indian Art of the United States" (ibid).

211. Newman, "Tamayo and Gottlieb," in *Newman*, ed. O'Neill, 76.

212. Kirk Varnedoe, "Abstract Expressionism," in *"Primitivism,"* ed. Rubin, exh. cat., 2:632.

213. This fact was recognized by Gottlieb's contemporaries. One critic wrote that Gottlieb insinuated the details of "atavistic memories" in "episodic totem pole story-telling arrangements with cubistic overtones"; see Alfredo Valente, "Adolph Gottlieb," *Promenade* (February 1949): 40. Similarly, Robert Coates, the critic for the *New Yorker*, explained that Gottlieb's art was indebted to the primitive Indians of the Northwest Coast ("The Art Galleries," *New Yorker*, 5 June 1948, 78).

214. See Douglas and d'Harnoncourt, *Indian Art of the United States*, exh. cat., 176.

215. Gottlieb, quoted in "Ides of Art," 43.

216. For discussion of Gottlieb's art in the context of World War II, see Stephen Polcari, "Gottlieb's Allegorical Epic of World War II," *Art Journal* 47 (Fall 1988): 202–207.

217. Newman, "Tamayo and Gottlieb," in *Newman*, ed. O'Neill, 75, 76.

218. Gottlieb recalled that after Eliot's *The Wasteland* appeared in *The Dial* in 1929 he

made landscapes with "poetic themes" and "lonely figures." His friends in the 1920s, he noted, were intellectuals with literary interests, and this "was valuable for him" (Seckler interview, 25 October 1967, 11–13). See also Mary Davis McNaughton, "Adolph Gottlieb: The Early Work," *Arts Magazine* 55 (May 1981): 127.

219. Adolph Gottlieb in Sidney Janis, *Abstract Art and Surrealist Art in America* (New York: Reynal and Hitchkock, 1944), quoted in Alloway, "Melpomene," in Alloway, *Topics in American Art*, 27. According to Alloway, implicit in Gottlieb's statement is an archaism "in which cultural artifacts are emblems of the unconscious."

220. Frazer, *Golden Bough*, 449. Because much of Gottlieb's library was destroyed in a fire, it cannot be established with absolute certainty which editions of Frazer (or Jung) he might have read (Hirsch, personal communication, 3 April 1985).

221. Frazer, *Golden Bough*, 452.

222. Adolph Gottlieb, in Adolph Gottlieb and Mark Rothko, "The Portrait and the Modern Artist," typescript of a broadcast on Radio WNYC, New York, 13 October 1943; reprinted as Appendix B in Alloway and McNaughton, *Gottlieb,* exh. cat., 171.

223. Alloway, "Melpomene," in Alloway, *Topics in American Art*, 26.

224. Gottlieb and Rothko, "Portrait and Modern Artist," in Alloway and McNaughton, *Gottlieb*, exh. cat., 171.

225. Ibid.

226. Adolph Gottlieb, quoted in "A Pair of Inner Men," *Newsweek*, 31 December 1945.

227. Victor Wolfson, introduction to *Adolph Gottlieb*, exh. cat. (New York: Sam Kootz Gallery, 1947).

228. Newman, "Tamayo and Gottlieb," in *Newman*, ed. O'Neill, 76–77.

6. Jackson Pollock and Native American Art

1. See Steven Naifeh and Gregory White Smith, *Jackson Pollock* (New York: Clarkson Potter, 1989), 83–85, 101–102.

2. Sanford Pollock, quoted in Francis V. O'Connor, "The Genesis of Jackson Pollock" (Ph.D. diss., Johns Hopkins University, 1965), 7.

3. Jay Pollock to James Valliere, 25 April 1965, Jackson Pollock Papers, AAA, Smithsonian Institution, Washington, D.C.

4. Reuben Kadish, personal communication, 24 September 1986. See also Reuben Kadish, interview with James Valliere, c. 1963–1965, typescript, Jackson Pollock Papers, AAA, 4. According to Jay Pollock, in late 1945 his brother Jackson acquired from him some ten or twelve Indian blankets and rugs that he had collected. Jay recalled that Jackson was given information about the provenance, age, and symbolic meaning of these textiles; see Pollock to Valliere, as in n. 3. Likewise, Sylvia Pollock, second wife of Pollock's brother Charles, made the following observation: "Concerning Jackson's interest in Indians, I think you would find that all five Pollock brothers had a certain feeling for Indian art and life" (Sylvia Pollock to James Valliere, 3 March 1965, Jackson Pollock Papers, AAA).

5. Fritz Bultman, personal communication, 26 April 1984.

6. Tony Smith, interview with James Valliere, c. 1963–1965, typescript, Jackson Pollock Papers, AAA, 4. Smith observed that Pollock, noting that "Indians built mounds around their villages," often spoke of building "a huge dirt mound" in front of the house he shared with Lee Krasner in East Hampton (ibid., 6).

7. Alfonso Ossorio, quoted in Francine du Plessix and Cleve Gray, "Who Was Jackson Pollock?" *Art in America* 55 (May–June 1967): 58.

8. Peter Busa, quoted in Potter, *Violent Grave*, 88.

9. Francis V. O'Connor and Eugene Thaw, *Jackson Pollock: Catalogue Raisonné* 4:192. The *Pollock: Catalogue Raisonné* (hereafter cited as *Pollock CR*) shows that Pollock had in his library the following *Reports of the BAE*: "Vol. 1 (1881); vols. 3, 6, 12, 13, 14, 16, 17, parts 1 and 2; vol. 18, parts 1 and 2; vol. 19, parts 1 and 2; Annual report of 1889–90; and parts 1 and 2 of the Annual report of 1900–01" (ibid).

10. Bultman confirmed that Pollock read *DYN* (personal communication, 26 April 1984). This is only a partial listing of Pollock's holdings that relate to mythology, anthropology, and primitive art. For a complete listing of the contents of Pollock's library at the time of his death, see O'Connor and Thaw, *Pollock CR* 4:187–199.

11. Bultman, personal communication, 26 April 1984; Kadish, personal communication, 24 September 1986.

12. Ossorio, quoted in du Plessix and Gray, "Who Was Jackson Pollock?" 58.

13. Bultman, personal communication, 26 April 1984.

14. O'Connor and Thaw, *Pollock CR* 4:199.

15. Henry Varnum Poor, "Anonymous American Art," *Arts* 10 (July 1926): 9.

16. Douglas Leechman, "West Coast Art," *Arts* 14 (October 1928): 204, 207.

17. Jean Charlot, "All American," *Nation*, 8 February 1941, 165.

18. Bultman, personal communication, 26 April 1984.

19. See O'Connor and Thaw, *Pollock CR* 4:199.

20. See Donald E. Gordon, "Pollock's *Bird*, or How Jung Did Not Offer Much Help in Myth-Making," *Art in America* 68 (October 1980): 48, 53n. 50.

21. Dr. Violet Staub de Laszlo, quoted in Elizabeth Langhorne, "A Jungian Interpretation of Jackson Pollock's Art through 1946" (Ph. D. diss., University of Pennsylvania, 1977), 140n. 139. According to de Laszlo, she received from Pollock during his therapy sessions two mixed media works on paper, both entitled *Ritual Figure* (c. 1941, in O'Connor and Thaw, *Pollock CR* 3:589, 590), which were responsive to "Indian Art of the United States"; see Elizabeth Langhorne, "Pollock, Picasso, and the Primitive," *Art History* 12 (March 1989): 74.

22. Bultman, personal communication, 26 April 1984.

23. Sara L. Henry, "Paintings and Statements," Chap. 4, n. 42. See also Langhorne, "Jungian Interpretation," 103.

24. Peggy Guggenheim, *Out of This Century*, 296.

25. Francis V. O'Connor, *Jackson Pollock* (New York: Museum of Modern Art, 1967), 21. See also Sandler, "John D. Graham," 52. Some sources place Pollock and Graham's first meeting as late as 1941, although this now seems unlikely. For information that may support the later date, see Gordon, "Pollock's *Bird*," 51. According to B. H. Friedman, Pollock admired Graham's article sufficiently to write him a letter (*Jackson Pollock*, 50).

26. O'Connor and Thaw, *Pollock CR* 4:197. Willem de Kooning recalled Pollock's unusual insistence that a borrowed Graham article be returned to him; see his comments in Ashton, *New York School*, 68.

27. Friedman, *Jackson Pollock*, 50.

28. Ibid.

29. See Irving Sandler's rejoinder to William Rubin in William Rubin, "More on Rubin on Pollock," *Art in America* 68 (October 1968): 57. Sandler writes, "Graham most likely showed such works [as the Eskimo mask] to Pollock in the original or in reproduction." The result, according to Sandler, was that between 1938 and 1941 Pollock produced three paintings, *Masqued Image*, *Head*, and *Birth*, which incorporate this Eskimo mask (or variations on its form). Graham's article notes only that the mask is from the University Museum. Made around 1900 and collected at Hooper Bay on the Bering Sea, this object was then and remains today in the collection of the University Museum, Philadelphia; see Ralph T. Coe, *Sacred Circles*, exh. cat., 188, Fig. 218.

30. Willem de Kooning, interview with James Valliere, quoted in Graham, *System and Dialectics* (reprint ed., 1971), 20, 21.

31. Ibid., 21.

32. See Graham, *System and Dialectics* (reprint ed., 1971), 22, and Elia Kokkinen, "John Graham During the 1940s," *Arts Magazine* 51 (November 1976): 99.

33. Bultman, personal communication, 26 April 1984. According to Bultman, Graham called Pollock "the good boy."

34. Graham, "Primitive Art and Picasso," 237.

35. Cf. Sandler's comments in Rubin, "More on Rubin," 57. Kadish insisted that the idea that Indian art made reference to the unconscious was "absolutely a widely-held idea in the 1940s" (personal communication, 24 September 1986).

36. Graham, *System and Dialectics* (reprint ed., 1971), 102, 103.

37. This remark was part of a draft for Jackson Pollock, "My Painting," *Possibilities* 1 (Winter 1947–1948): 78.

38. On Jung, see Polcari, "Intellectual Roots," 126.

39. As Elizabeth Langhorne observed, "Pollock's symbol making during the period 1938–41 . . . revolves around the theme of a union of opposites" ("Jackson Pollock's *Moon Woman Cuts the Circle*," *Arts Magazine* 53 [March 1979]: 130).

40. A number of scholars have considered Pollock's art in light of Jungian theory, including Judith Wolfe, "Jungian Aspects of Pollock's Imagery," *Artforum* 11 (November 1972): 65–73; B. H. Friedman, "Reply to Judith Wolfe's Article," *Artforum* 11 (February 1973): 11; Elizabeth Langhorne, "Reply to Judith Wolfe's Article," *Artforum*, 11 (February 1973): 7; Langhorne, "Jungian Interpretation"; Langhorne, "Pollock's *Moon Woman*," 128–136; William Rubin, "Pollock as Jungian Illustrator: The Limits of Psychological Criticism," *Art in America* 68, pt. 1 (November 1979): 104–123; and 67, pt. 2 (December 1979): 72–91; Gordon, "Pollock's *Bird*," 43–53; Rubin, "More on Rubin," 55–67 (contains rejoinders to the first two Rubin articles cited from Irving Sandler, David Rubin, and Elizabeth Langhorne); David S. Rubin, "A Case for Content: Jackson Pollock's Subject Was the Automatic Gesture," *Arts Magazine* 53 (March 1979): 103–109; and Jonathan Welch, "Jackson Pollock's 'The White Angel' and the Origins of Alchemy," *Arts Magazine* 53 (March 1979): 138–141.

41. Joseph Henderson, quoted in Friedman, *Jackson Pollock*, 41.

42. C. L. Wysuph, *Jackson Pollock: Psychoanalytic Drawings* (New York: Horizon Press, 1970): 20.

43. Jackson Pollock, quoted in Seldon Rodman, *Conversations with Artists* (New York: Devin-Adair, 1957), 82. As Langhorne pointed out, this reference to himself as a Jungian could mean "Jung as a compiler of myths and other archetypal manifestations to be found in man's culture" ("Pollock's *Moon Woman*," 128).

44. Bultman, personal communication, 26 April 1984.

45. Kadish, personal communication, 24 September 1986.

46. Bultman, personal communication, 26 April 1984. Kadish, too, remembered that Pollock "believed in magic" and that there was a parallel between Pollock's "interest in Jung and shamanism," which "was all part of the mystery of the unknown" (personal communication, 24 September 1986).

47. Jackson Pollock, "Jackson Pollock," *Arts and Architecture* 61 (February 1944): 14.

48. Indeed, Langhorne presents a strong case for seeing Pollock's *Naked Man* (c. 1941) as a shamanic self-portrait ("Pollock and the Primitive," 78–79).

49. C. G. Jung, *Integration of the Personality*, 53, 91.

50. Graham, *System and Dialectics* (reprint ed., 1971) 23.

51. O'Connor, "Genesis," 19.

52. The site and path motif (concentric circles that straighten out into a line indicating travel) visible in the Chumash pictograph is also seen in the upper right corner of Pollock's *Night Sounds* (1944, Fig. 6-19).

53. Campbell Grant, *Rock Art of the American Indian* (New York: Thomas Y. Crowell, 1967), 104.

54. J. W. Powell, "On Limitations to Use of Some Anthropological Data," *First Annual Report of the BAE* (Washington, D.C.: Government Printing Office, 1881), 375. Likewise, there were literally hundreds of pictographs reproduced in Garrick Mallery, "Picture Writing of the American Indians," *Tenth Annual Report of the BAE* (Washington, D.C.: Government Printing Office, 1893), 37–329, and pl. 54.

Kadish is positive that Pollock saw "reproductions of pictographs" (personal communication, 24 September 1986).

55. It is not my intention either to discuss each instance in Pollock's oeuvre where he references Native American art/culture, or to psychoanalyze these primitivist paintings and drawings ad nauseam, as some others have done. Obviously and admittedly, Indian art was not Pollock's only source of inspiration, but in this text at least, it is my primary concern.

56. Bultman, personal communication, 26 April 1984. Pollock's knowledge of the principles of psychic automatism is a matter of record; see O'Connor, *Jackson Pollock*, 26; and William Rubin, "Notes on Masson and Pollock," *Arts Magazine* 34 (November 1959): 36. In the latter Rubin observed similarities between André Masson's *Meditation On an Oak Leaf* (1942) and Pollock's *Totem Lesson 1*; Rubin, "Notes," 36n. 6. Elsewhere, Rubin described the "entire configuration" of this Masson painting as a "totem of a private myth"; see William Rubin and Carolyn Lanchner, *André Masson* (New York: Museum of Modern Art, 1976), 61. Bultman recalled, "Pollock was interested in Masson's *Reflection* [sic] *On an Oak Leaf*, which was Masson's interpretation of Indian lore." In fact, the painting is one in a series of telluric pictures painted in the early forties after Masson had visited the MAI and AMNH in New York; see Rubin and Lanchner, *Masson*, 63, 216. These pictures of the earth, painted in the countryside near New Preston, Connecticut (1942–1945), have titles suggesting that Masson and Pollock had arrived at some similar conclusions: *Indian Summer*, *Iroquois Landscape*, and *Germination*.

57. See Robert Motherwell's comments, quoted in Rubin, "Notes," 36.

58. Although not reproduced in the catalogue, this Tsonoqua mask was reproduced as part of the frontispiece of *Art News* 34 (1 February 1941): 6.

59. Douglas and d'Harnoncourt, *Indian Art of the United States*, exh. cat., 97–98.

60. Ibid., 84.

61. C. G. Jung, quoted in Polcari, "Intellectual Roots," 126.

62. Larry Frank and Francis Harlow, *Historic Pottery of the Pueblo Indians: 1600–1800* (Boston: New York Graphics Society, 1974), 156.

63. I first made this comparison in a paper delivered at the seventh Whitney Museum Symposium on American Art in the spring of 1984; subsequently it appeared in my M.A. thesis in August 1984, "The Influence of American Indian Art on Jackson Pollock and the Early New York School" (University of Texas at Austin), 46.

64. Bultman, personal communication, 26 April 1984. The Mimbres Valley area of southwestern New Mexico spawned a rich ceramic tradition often noted for lively animal decorations and zoomorphic figures. The Mimbres culture was part of a broader cultural continuum known as the Mogollon (A.D. 700–1300). The historic descendants of the Mogollon peoples are the Zuni. See Coe, *Sacred Circles*, exh. cat., 194; and Robert F. Spencer and Jesse D. Jennings et al., *The Native Americans* (New York: Harper & Row, 1977), 261. Two examples of Mimbres pottery were reproduced in the catalogue of the Museum of Modern Art's 1941 exhibition; see Douglas and d'Harnoncourt, *Indian Art of the United States*, exh. cat., 88–89.

65. Jesse Walter Fewkes, "Archaeological Expedition to Arizona in 1895," *Seventeenth Annual Report of the BAE*, pt. 2 (Washington, D.C.: Government Printing Office, 1898), 663n. 4. The "doll of Kokopelli" refers to the fact that children learn the names and attributes of the hundreds of kachinas that make up the pantheon of mythological figures by being given effigies made in the likeness of the deities.

66. Bruce A. Anderson, "Kokopelli: The Humpbacked Flute Player," *American Indian Art Magazine* 1 (Spring 1976): 37. Other sources report that Kokopelli represents a concern for fertility "via the expression of particular attributes—such as the bow and arrow, hump, flute, and phallus" (Susan von Beckefeldt, "The Humpbacked Flute Player," *Masterkey* 51 (July–September 1977): 115.

67. Guggenheim, *Out of This Century*, 296.

68. Ibid. According to O'Connor, Lee Krasner recalled "that he would sit in front of the blank canvas for hours. Sometime in December of 1943 . . . he suddenly locked himself in his studio and finished the painting in one day" (O'Connor and Thaw, *Pollock CR* 1:94).

69. Douglas and d'Harnoncourt, *Indian Art of the United States*, exh. cat., 102.

70. Florence Hawley, "Kokopelli, of the Southwestern Pueblo Pantheon," *American Anthropologist* 29 (1937): 644–645.

71. Elsie Clews Parsons, "The Humpbacked Flute Player of the Southwest," *American Anthropologist* 40 (1938): 337.

72. Mischa Titiev, "The Story of Kokopele," *American Anthropologist* 41 (1939): 93.

73. According to Anderson, some representations of Kokopelli "indicate bulbous protrusions from the distal end of his flute, which may indicate the use of the flute as a cloudblower or as a drinking-tube for drawing water from a gourd" ("Kokopelli," 36).

74. Titiev, "Story of Kokopele," 93.

75. Fewkes, "Expedition," 706–728, especially fig. 294, pl. 164a, and figs. 302, 307, and 309.

76. Titiev, "Story of Kokopele," 93.

77. Cf. Frank O'Hara, *Jackson Pollock* (New York: George Braziller, 1959), 20.

78. See Leechman, "West Coast Art," 205.

79. Douglas and d'Harnoncourt, *Indian Art of the United States*, exh. cat., 172.

80. Concerning Northwest Coast and Eskimo masks, the following was printed by the *BAE*: Thus masks . . . take their place among religious paraphernalia, not only of the community in its direct relations to the supernatural, but in the probably earlier forms of such relation through an intermediary individual, in the form of a shaman or his logical predecessors in culture" (W. H. Dall, "On Masks, Labrets, and Certain Aboriginal Customs, with an Inquiry into the Bearing of Their Geographical Distribution," *Third Annual Report of the BAE* (Washington, D.C.: Government Printing Office, 1884), 75.

81. Douglas and d'Harnoncourt, *Indian Art of the United States*, exh. cat., 161.

82. See ibid., 104. Most extant Mimbres painted pottery has been excavated from burial sites, with the pots having been ceremonially "killed." See Coe, *Sacred Circles*, exh. cat., 201.

83. On the "picture-within-a-picture," see Rubin, "Pollock as Jungian Illustrator," *Art in America* 67, pt. 2 (December 1979): 88.

84. See Matilda Coxe Stevenson, "The Sia," *Eleventh Annual Report of the BAE* (Washington, D.C.: Government Printing Office), pls. 14, 15.

85. In explaining this altar, Stevenson wrote: "The Sia do not differ from the Zuni, Tusayan, and Navajo in their process of preparing sand paintings, the powdered pigment being sprinkled between the index finger and thumb. All these Indian artists work rapidly" (ibid., 76).

86. Ibid., 73.

87. Pollock's primitivism, contrary to what David Craven has written, has a Pan-Indian quality: in a leveling of difference, he "assimilated" into a single work of art unrelated styles of Native art. See David Craven, "Abstract Expressionism and Third World Art: A Post-Colonial Approach to 'American' Art," *Oxford Art Journal* 14 (1990): 54.

88. Given the importance of Native American imagery to *Guardians of the Secret*, *Bird* (1941), made two years earlier, is neither "the seeming culmination of Pollock's attempts to consummate his intense longing to tap into the energy of primitive art" nor the "last work in which an obvious dependence on indigenous sources" predominates, as Ellen G. Landau has argued. Similarly, her identification of the totemic figure on the left in *Guardians* as "dressed in a flowing gown" and "wearing a horse-faced mask" is entirely unconvincing, as is her suggestion that the Tsonoqua mask at the top is actually an African reliquary figure. As for *Bird*, her attempt to link it to the Nootka painting from the AMNH, which was exhibited at MOMA in 1941, is unsuccessful. See Ellen G. Landau, *Jackson Pollock* (New York: Harry Abrams, 1989), 66–67, 70, 126.

89. Graham, "Primitive Art and Picasso," 237.

90. As Kadish recalled, "I think we were looking for something as a culture, for something that had as much kinship to us as African art did for Cubism." In another comment on the similarity in the relationship between African art and Cubism, and Indian art and American art of the 1940s, Kadish stated that "we were trying to do a similar thing [here], trying to establish some kind of pride" (personal communication, 24 September 1986).

91. See Dall, "On Masks," pl. 27, fig. 70.

92. Fewkes, "Expedition," 663.

93. According to Titiev, Kokopelli sometimes appears as a masculine character, sometimes as a female, although it is customary for Hopi men to personify both of Kokopelli's genders ("Story of Kokopele," 91).

94. The androgyny of this figure suggests the mythic unification of dual generative forces in nature. These images symbolize Pollock's own psychic struggle for unification, perhaps of the male and female elements of his psyche. Langhorne described this struggle for unification in specifically Jungian terms: "The goal is realization of the archetypal self" by achieving a "union of psychological opposites" ("Jungian Interpretation," 130).

95. Fewkes, "Expedition," 663.

96. Ibid., n. 3.

97. In regard to representation and figuration, Pollock said, "When you're painting out of your unconscious, figures are bound to emerge." Quoted in Rodman, *Conversations with Artists*, 82.

98. Douglas and d'Harnoncourt, *Indian Art of the United States*, exh. cat., 29.

99. Lee Krasner, interview with B. H. Friedman, quoted in *Jackson Pollock: Black and White*, exh. cat. (New York: Marlborough Gallery, 1969), 10.

100. Jackson Pollock, interview with William Wright (1951), quoted in O'Connor, *Jackson Pollock*, 81.

101. Jackson Pollock, application for a Guggenheim Fellowship, quoted in ibid., 39.

102. Pollock's sister-in-law, Arloie McCoy, recalled that in the late 1930s his alcoholic binges were preceded by periods of isolation and depression, and that after the drinking bouts were over he was even more withdrawn. Pollock's wife, Lee Krasner, noted that this behavior continued into the late 1940s. See Wysuph, *Jackson Pollock*, 14. There are innumerable reports of Pollock's drinking, depression, and anxiety in Potter, *Violent Grave*.

103. Jesse Walter Fewkes, "Tusayan Snake Ceremonies," *Sixteenth Annual Report of the BAE* (Washington, D.C.: Government Printing Office, 1897), pls. 63, 72.

104. Langhorne has written that Pollock associated shamanism "with being an artist" ("Pollock and the Primitive," 79). According to Langhorne, the primary source for Pollock's interest in shamanism was the AMNH (ibid., 78).

105. Pollock, "My Painting," 14.

106. "When a dry painting is completed, the patient is seated on it in a prescribed fashion, to bring him into a direct communication with the Holy People." See Spencer and Jennings et al., *Native Americans*, 308–309; see also Clyde Kluckhohn and D. C. Leighton, "An Introduction to Navajo Chant Practice," *American Anthropological Association Memoir* 53 (1946).

107. Kadish, personal communication, 24 September 1986.

108. Pollock, "My Painting," 78.

109. Spencer and Jennings et al., *Native Americans*, 309.

110. Franc J. Newcomb and Gladys A. Reichard, *Sandpaintings of the Navajo Shooting Chant* (New York: Dover Publications, 1937), 12, 20, 24.

111. Graham, "Primitive Art," 237.

112. Garrick Mallery, "Sign Language among North American Indians Compared with that among Other Peoples and Deaf-Mutes," *First Annual Report of the BAE* (Washington, D.C.: Government Printing Office, 1881), 368.

113. Pollock, "Jackson Pollock," 14.

114. Graham, "Primitive Art and Picasso," 237.

115. Bultman, personal communication, 26 April 1984.

116. Bultman informed me of Pollock's interest in the relationship between magic, shaman-

ism, and "the nature of self." Bultman's statement about the dream vision as a source of imagery for Pollock is quoted by Langhorne, in Rubin, "More on Rubin," 63.

117. Mallery, "Sign Language," 370.

118. Bultman, personal communication, 26 April 1984.

119. Quoted in O'Connor, *Jackson Pollock*, 26.

120. Bultman, personal communication, 26 April 1984.

121. Lee Krasner, quoted in Bruce Glaser, "Jackson Pollock: An Interview with Lee Krasner," *Arts Magazine* 41 (April 1967): 38.

122. Gottlieb et al., "Ides of Art," 10; Pousette-Dart, personal communication, 5 May 1985.

Conclusion

1. Although I have borrowed the terms "soft" and "hard" primitivism from Rosalind Krauss, my conception and usage of them diverge from hers; see Krauss, "Giacometti," in Rubin, ed., "*Primitivism*," 1:507, 514.

2. Martha Buskirk, "Appropriation under the Gun," *Art in America* 80 (June 1992): 38–39.

3. I am thinking of Gottlieb's statement that "different times require different images," and Pollock's statement that "new needs need new techniques." See Gottlieb et al., "Ides of

Art," 43; and Pollock's 1951 interview with William Wright, quoted in Francis V. O'Connor, "Documentary Chronology," in O'Connor and Thaw, *Pollock CR* 4:248.

4. Frantz Fanon, *Black Skin, White Masks* (New York: Grove Press, 1967); Vine Deloria, *Custer Died for Your Sins* (New York: Macmillan, 1969); bell hooks, *Yearning: Race, Gender, and Cultural Politics* (Boston: South End Press, 1990); Gerald McMaster and Lee-Ann Martin, eds., *INDIGENA: Contemporary Native Perspectives* (Vancouver: Douglas and McIntyre, 1992); Gerald McMaster, "Colonial Alchemy," in *Partial Recall: Photographs of Native North Americans*, ed. Lucy Lippard (New York: New Press, 1992); Trinh T. Minh-ha, *Woman, Native, Other: Writing Postcoloniality and Feminism* (Bloomington: Indiana University Press, 1989); and Clifford, *Predicament of Culture*.

5. René d'Harnoncourt, "Foreword" (signed by Eleanor Roosevelt), in Douglas and d'Harnoncourt, *Indian Art of the United States*, exh. cat., 8.

Selected Bibliography

Books

Adam, Leonard. *Primitive Art*. New York: Pelican Books, 1940.

Alloway, Lawrence. *Topics in American Art since 1945*. New York: W. W. Norton, 1975.

Annual Report of the Bureau of American Ethnology. See Powell, J. W., ed.

Ashton, Dore. *The New York School*. New York: Penguin Books, 1972.

Austin, Mary. *The Land of Journey's Ending*. New York: Century Company, 1924.

Berkhofer, Robert, Jr. *The White Man's Indian*. New York: Alfred A. Knopf, 1978.

Berlo, Janet C., ed. *The Early Years of Native American Art History: The Politics of Scholarship and Collecting*. Seattle: University of Washington Press, 1992.

Boas, Franz. *Anthropology and Modern Life*. New York: W. W. Norton, 1928.

———. *The Mind of Primitive Man*. New York: Macmillan, 1929.

———. *Race, Language, and Culture*. New York: Macmillan, 1940.

Benedict, Ruth. *Patterns of Culture*. 1934. Reprint. Boston: Houghton Mifflin Co., 1961.

Broder, Patricia Janis. *The American West: The Modern Vision*. Boston: Little, Brown & Co., 1984.

Brody, J. J. *Indian Painters and White Patrons*. Albuquerque: University of New Mexico Press, 1971.

Cahill, Holger. *American Painting and Sculpture, 1862–1932*. New York: Museum of Fine Art, 1932. Reprint ed., New York: Arno, 1969.

———. *American Sources of Modern Art*. New York: Museum of Modern Art, 1933. Reprint ed., New York: Arno, 1969.

Chauvenet, Beatrice. *Hewett and Friends: A Biography of Santa Fe's Vibrant Era*. Santa Fe: Museum of New Mexico Press, 1983.

Clifford, James. *The Predicament of Culture*. Cambridge: Harvard University Press, 1988.

Coke, Van Deren. *Taos and Santa Fe: The Artist's Environment, 1882–1942*. Albuquerque: University of New Mexico Press, 1963.

Cole, Douglas. *Captured Heritage*. Seattle: University of Washington Press, 1985.

Collier, John. *Indians of the Americas*. New York: New American Library, 1947.

Curtis, Natalie. *The Indians' Book*. 1905. Reprint. New York: Bonanza Books, 1987.

Diamond, Stanley. *In Search of the Primitive*. New Brunswick: Transaction Books, 1974.

Dunn, Dorothy. *American Indian Painting*. Albuquerque: University of New Mexico Press, 1968.

Frazer, James George. *The Golden Bough*. 1890. New York: Macmillan, 1951.

Friedman, B. H. *Jackson Pollock: Energy Made Visible*. New York: McGraw-Hill, 1972.

Gibson, Ann. *Issues in Abstract Expressionism: The Artist-Run Periodicals*. Ann Arbor: UMI Research Press, 1990.

———. "Theory Undeclared: Avant-Garde Magazines as a Guide to Abstract Expressionist Images and Ideas." Ph.D. diss., University of Delaware, 1984.

Gibson, Arrell Morgan. *The Santa Fe and Taos Colonies: Age of the Muses, 1900–1942*. Norman: University of Oklahoma Press, 1983.

Goldwater, Robert. *Primitivism in Modern Art*. 1938. Rev. ed. Cambridge: Belknap Press of Harvard University, 1966.

Graburn, Nelson H. H., ed. *Ethnic and Tourist Arts: Cultural Expressions from the Fourth World*. Berkeley: University of California Press, 1976.

Graham, John D., ed. *System and Dialectics of Art*. London and New York: Delphic Studios, 1937. Reprint, with introduction and annotation by Marcia Epstein Allentuck. Baltimore: Johns Hopkins Press, 1971.

Gray, Cleve, ed. *John Marin by John Marin*. New York: Holt, Rinehart and Winston, 1977.

Guggenheim, Peggy. *Out of This Century*. New York: Universe Books, 1946.

Harris, Marvin. *The Rise of Anthropological Theory*. New York: Thomas Y. Crowell, 1968.

Hawthorn, Audrey. *Art of the Kwakiutl Indians*. Seattle: University of Washington Press, 1967.

Henri, Robert. *The Art Spirit*. 1923. Reprint. New York: J. B. Lippincott, 1960.

Hess, Thomas B. *Barnett Newman*. New York: Museum of Modern Art, 1971. Includes excerpts from Barnett Newman, "The New Sense of Fate," and "The Plasmic Image."

Jonaitis, Aldona. *From the Land of the Totem Poles: The Northwest Coast Indian Art Collections at the American Museum of Natural History*. Seattle: University of Washington Press, 1988.

Jung, C. G. *Integration of the Personality*. Translated by Stanley Dell. New York: Farrar & Rinehart, 1939.

———. *Psychology of the Unconscious*. Translated by Beatrice M. Hinckle. New York: Moffat, Yard and Co., 1916.

Langhorne, Elizabeth. "A Jungian Interpretation of Jackson Pollock's Art through 1946." Ph.D. diss., University of Pennsylvania, 1977.

Lorenz, Melinda A. *George L. K. Morris: Artist and Critic*. Ann Arbor: UMI Research Press, 1981.

Lovejoy, Arthur O., and George Boas. *Primitivism and Related Ideas in Antiquity*. Baltimore: Johns Hopkins Press, 1935.

Luhan, Mabel Dodge. *Edge of Taos Desert*. New York: Harcourt and Brace, 1937. Reprint. Albuquerque: University of New Mexico Press, 1987.

———. *Movers and Shakers*. New York: Harcourt and Brace, 1936. Reprint. Albuquerque: University of New Mexico Press, 1985.

Mayerson, Charlotte Leon, ed. *Shadow and Light: The Life, Friends, and Opinions of Maurice Sterne*. New York: Harcourt, Brace & World, 1952.

Moffatt, Frederick C. *Arthur Wesley Dow*. Washington, D.C.: Smithsonian Institution Press for the National Collection of Fine Arts, 1977.

Nietzsche, Friedrich. *The Birth of Tragedy*. Translated by William A. Hausmann. London: T. N. Foulis, 1909. Translated by Walter Kaufmann. New York: Vintage Books, 1967.

Norman, Dorothy, ed. *The Selected Writings of John Marin*. New York: Pellegrini and Cudahy, 1949.

O'Connor, Francis V., and Eugene Victor Thaw. *Jackson Pollock: Catalogue Raisonné*. 4 vols. New Haven: Yale University Press, 1978.

O'Neill, John P., ed. *Barnet Newman: Selected Writings and Interviews*. New York: Alfred A. Knopf, 1990.

Pearce, T. M. *Mary Hunter Austin*. New York: Twayne Publishers, 1965.

Potter, Jeffrey. *To a Violent Grave: An Oral Biography of Jackson Pollock*. New York: G. P. Putnam's Sons, 1985.

Powell, J. W., ed. *Annual Report of the Bureau of American Ethnology*. Vols. 1 (1881); 3 (1884); 10 (1893); 11 (1894); 16 (1897); 17, pt. 2 (1898); 24 (1907); 35, pt. 2 (1921). Washington, D.C.: Government Printing Office.

Rosenberg, Harold. *Barnett Newman*. New York: Harry Abrams, 1978.

Rudnick, Lois Palken. *Mabel Dodge Luhan*. Albuquerque: University of New Mexico Press, 1984.

Rydell, Robert. *All the World's A Fair: Visions of Empire at American Expositions, 1876–1916*. Chicago: University of Chicago Press, 1984.

Sandler, Irving. *The Triumph of American Painting*. New York: Harper and Row, 1970.

Seligmann, Herbert, ed. *Letters of John Marin*. New York: An American Place, 1931.

Schrader, Robert Fay. *The Indian Arts and Crafts Board: An Aspect of New Deal Indian Policy*. Albuquerque: University of New Mexico Press, 1983.

Scott, Gail R. *Marsden Hartley*. New York: Abbeville Publishers, 1988.

Sloan, John. *Gist of Art*. 1939. Reprint. New York: Dover Publications, 1977.

Stedman, Raymond William. *Shadows of the Indian*. Norman: University of Oklahoma Press, 1982.

Stocking, George W., Jr. "American Social Scientists and Race Theory, 1890–1915." Ph.D. diss., University of Pennsylvania, 1960. Ann Arbor: University Microfilms, 1972.

———, ed. *Objects and Others*. Madison: University of Wisconsin Press, 1985.

———. *Race, Culture, and Evolution*. New York: Free Press, 1968.

———. *The Shaping of American Anthropology, 1883–1911: A Franz Boas Reader*. New York: Basic Books, 1974.

Torgovnick, Marianna. *Gone Primitive: Savage Intellects, Modern Lives*. (Chicago: University of Chicago Press, 1990).

Udall, Sharyn Rohlfsen. *Modernist Painting in New Mexico, 1913–1935*. Albuquerque: University of New Mexico Press, 1984.

Vaillant, George C. *Indian Arts in North America*. New York: Harper and Bros., 1939.

Wade, Edwin L., ed. *The Arts of the North American Indian: Native Traditions in Evolution*. New York: Hudson Hills Press, 1986.

Weber, Max. *Cubist Poems*. London: Elkin Matthews, 1914.

———. *Primitives*. New York: Spiral Press, 1926.

Wheeler, Steve. *"Hello Steve."* New York: Press Eight, 1947.

Worringer, Wilhelm. *Abstraction and Empathy*. Translated by Michael Bullock. London: Routledge, 1965.

Young, M. Jane. *Signs from the Ancestors: Zuni Cultural Symbolism and Perceptions of Rock Art*. Albuquerque: University of New Mexico Press, 1988.

Articles

"An Interview with Peter Busa." *League Quarterly* 18, no. 3 (Winter 1946): 10–11.

Austin, Mary, "Indian Arts for Indians." *The Survey* 60 (1 July 1938): 381–385, 388.

Barker, Rugh Laughlin. "John Sloan Reviews the Indian Tribal Arts." *Creative Art* 9 (December 1931): 444–449.

Beaudoin, Kenneth. "Oscar Collier: A Study in Pictorial Metaphor." *Iconograph*, no. 3 (Fall 1946): 19, 21.

———. "This is the Spring of 1946." *Iconograph*, no. 1 (Spring 1946): 3–4.

Berryman, Florence. "Review of *Indian Art of the United States* by Frederic H. Douglas and René d'Harnoncourt." *Magazine of Art* 34 (April 1941): 216, 218.

Bisttram, Emil. "Art's Revolt in the Desert." *Contemporary Arts of the South and Southwest* 1 (January–February 1933): n.p.

———. "The New Vision in Art." *Tomorrow* 1 (September 1941): 35–38.

———. "On Understanding Contemporary Art." *El Palacio* 64 (July–August 1957): 201–208.

Bluemenschein, Ernest L., and Bert G. Phillips. "Appreciation of Indian Art." *El Palacio* 6 (9 May 1919): 178–179.

Cahill, E. H. "America Has Its Primitives." *International Studio* 75 (March 1920) 80–83.

———. "Max Weber: A Reappraisal in Maturity." *Magazine of Art* 42 (April 1949): 128–133.

Caspers, Frank. "Review of *Indian Art of the United States* by Frederic H. Douglas and René d'Harnoncourt." *Art Digest* 15 (March 1941): 27.

Charlot, Jean. "All American." *The Nation*, 8 February 1941, 165–166.

Cikovsky, Nicolai, Jr. "The Art of Raymond Jonson." *American Art Review* 3 (September–October 1976): 129–136.

———. "Notes and Footnotes on a Painting by George L. K. Morris." *University of New Mexico Art Museum Bulletin* 10 (1976–1977): 3–11.

Coates, Robert. "Indians." *New Yorker*, 1 February 1941, 43–44.

Collier, John. "Does the Government Welcome the Indian Arts?" *American Magazine of Art*, supplement, 27 (September 1934): 10–11.

———. "Has the American Indian a Future?" *Transformations* 1 (1952): 141–142.

Cowling, Elizabeth. "The Eskimos, the American Indians, and the Surrealists." *Art History* 1 (December 1978): 484–499.

Curtis, Natalie. "A New Art in the West." *International Studio* 63 (November 1917): xiv–xvii.

———. "The Perpetuating of Indian Art." *Outlook* 105 (22 November 1913): 623–631.

d'Harnoncourt, René. "Living Arts of the Indians." *Magazine of Art* 34 (February 1941): 72–77.

———. "North American Indian Arts." *Magazine of Art* 32 (March 1939): 164–167.

Dolan, James. "Typography." *Iconograph*, no. 1 (Spring 1946): 9–10.

Dow, Arthur Wesley. "Modernism in Art." *Magazine of Art* 8 (January 1917): 113–116.

"Exposition of Indian Tribal Arts." *American Magazine of Art* 23 (December 1931): 516–517.

Frost, Richard. "The Romantic Inflation of Pueblo Culture." *American West* 17 (January–February 1980): 5–9, 56–60.

Gibson, Ann. "Painting Outside the Paradigm: Indian Space." *Arts Magazine* 57 (February 1983): 98–104.

Glaser, Bruce. "Jackson Pollock: An Interview with Lee Krasner." *Arts Magazine* 41 (April 1967): 36–38.

Goldwater, Robert. "Reflections on the New York School." *Quadrum*, no. 8 (1960): 17–36.

Gottlieb, Adolph, et al. "The Ides of Art: The Attitudes of Ten Artists on Their Art and Contemporaneousness." *Tiger's Eye*, no. 2 (December 1943): 43.

Graham, John D. "Primitive Art and Picasso." *Magazine of Art* 30 (April 1937): 236–239, 260.

Hartley, Marsden. "Aesthetic Sincerity." *El Palacio* 5 (9 December 1918): 332–333.

———. "America as Landscape." *El Palacio* 5 (21 December 1918): 340–342.

———. "Red Man Ceremonials: An American Plea for American Esthetics." *Art and Archaeology* 9 (January 1920): 7–14.

———. "The Scientific Esthetic of the Redman." *Art and Archaeology* 13 (March 1922): 113–119.

———. "Tribal Esthetics." *The Dial* 65 (November 1918): 399–401.

Henderson, Alice Corbin. "A Boy Painter among the Pueblo Indians and Unspoiled Native Work." *New York Times Magazine,* 6 September 1925, 18–19.

Henri, Robert. "My People." *Craftsman* 27 (February 1915): 459–469.

Hewett, Edgar L. "America's Archaeological Heritage." *Art and Archaeology* 4 (December 1916): 257–266.

———. "Ancient America at the Panama-California Exposition." *Art and Archaeology* 2 (November 1915): 65–103.

———. "Crescencio Martinez—Artist." *El Palacio* 5 (3 August 1918): 67–69.

———. "Native American Artists." *Art and Archaeology* 13 (March 1922): 103–112.

———. "Primitive Art vs. Modern Art." *El Palacio* 5 (25 August 1918): 133–134.

———. "Recent Southwestern Art." *Art and Archaeology* 9 (January 1920): 31–49.

———. "Report of the Director of the School of American Research for the Year 1919." *El Palacio* 8 (July 1920): 169–172.

———. "The School of American Archaeology." *Art and Archaeology* 4 (December 1916): 317–329.

"Indian Tribal Arts." *American Magazine of Art* 22 (April 1931): 303–304.

Jonaitis, Aldona. "Creations of Mystics and Philosophers: The White Man's Perceptions of Northwest Coast Indian Art from the 1930s to the Present." *American Indian Culture and Research Journal* 5 (1981): 1–45.

Jonson, Raymond. "The Role of Abstract Art." *El Palacio* 48 (March 1941): 62–70.

Kokkinen, Elia. "John Graham During the 1940s." *Arts Magazine* 51 (November 1976): 99–103.

La Farge, Oliver. "Indians at the Museum of Modern Art." *New Republic* 104 (10 February 1941): 181–182.

———. "Revolution with Reservations." *New Republic* 85 (9 October 1935): 232–234.

Lane, John R. "The Sources for Max Weber's Cubism." *Art Journal* 15 (Spring 1976): 231–236.

Langhorne, Elizabeth. "Jackson Pollock's *Moon Woman Cuts the Circle.*" *Arts Magazine* 53 (March 1979): 128–136.

———. "Pollock, Picasso, and the Primitive." *Art History* 12 (March 1989): 64–92.

Lawrence, D. H. "America, Listen to Your Own." *New Republic* 25 (15 December 1920): 69.

———. "Just Back from the Snake Dance—Tired Out." *Laughing Horse*, no. 11 (September 1924): n.p.

Lester, Joan. "The American Indian: A Museum's Eye View." *Indian Historian* 5 (1972): 25–31.

Levin, Gail. "Richard Pousette-Dart's Emergence As an Abstract Expressionist." *Arts Magazine* 54 (March 1980): 125–129.

"Lo the Adaptable Indian." *Time*, 17 February 1941, 58–61.

Lowe, Jeanette. "Lo, the Rich Indian: Art of the American Aboriginals." *Art News* 39 (1 February 1941): 7–8, 20.

Luhan, Mabel. "A Bridge between Cultures." *Theatre Arts Monthly* 9 (May 1925): 297–301.

———. "Awa Tsireh." *The Arts* 11 (June 1927): 298–300.

———. "Beware the Grip of Paganism." *Laughing Horse*, no. 16 (Summer 1929): n. p.

———. "From the Source." *Laughing Horse*, no. 11 (September 1924): n.p.

Newman, Barnett. "The First Man Was an Artist." *Tiger's Eye*, no. 1 (October 1947): 57–60.

———. "The Object and the Image." *Tiger's Eye*, no. 3 (March 1948): 111.

———. "La Pintura de Tamayo y Gottlieb." *Revista Belga* (April 1945): 16–25.

———. "The Sublime Is Now." *Tiger's Eye*, no. 6 (15 December 1948): 51–53.

O'Connor, Francis V. "The Genesis of Jackson Pollock, 1912–1923." *Artforum* 5 (May 1967): 16–23.

Paalen, Wolfgang. "Totem Art." *DYN*, "Amerindian Number," nos. 4–5 (December 1943): 13–30.

Pach, Walter. "The Art of the American Indian." *The Dial* 68 (January 1920): 57–65.

———. "Notes on the Indian Water-Colours." *The Dial* 68 (March 1920): 343–345.

Peixotto, Ernest. "The Taos Society of Artists." *Scribner's Magazine* 60 (August 1916): 257.

du Plessix, Francine, and Cleve Gray. "Who Was Jackson Pollock?" *Art in America* 55 (May–June 1967): 48–59.

Polcari, Stephen. "Adolph Gottlieb's Allegorical Epic of World War II." *Art Journal* 47 (Fall 1988): 202–207.

———. "The Intellectual Roots of Abstract Expressionism: Mark Rothko." *Arts Magazine* 54 (September 1979): 124–134.

Pollock, Jackson. "Jackson Pollock." *Arts and Architecture* 61 (February 1944): 14.

———. "My Painting." *Possibilities* 1 (Winter 1947–1948): 78.

"Resurrection of the Red Man." *El Palacio* 8 (July 1920): 196.

"The Revival of Indian Art." *American Magazine of Art* 24 (May 1932): 376.

Rushing, W. Jackson. "The Impact of Friedrich Nietzsche and Northwest Coast Indian Art on Barnett Newman's Idea of Redemption in the Abstract Sublime." *Art Journal* 47 (Fall 1988): 187–195.

———. "Pousette-Dart's Spirit-Object." *Art Journal* 50 (Summer 1991): 72–75.

———. "Ritual and Myth: Native American Culture and Abstract Expressionism," in Maurice Tuchman et al., *The Spiritual in Art: Abstract Painting*, 1890–1985. New York: Abbeville Press, 1986.

Sandler, Irving. "John D. Graham: The Painter as Esthetician and Connoisseur." *Artforum* 7 (October 1968): 50–53.

Sergeant, Elizabeth Shepley. "A New Deal for the Indian." *New Republic* 95 (15 June 1938): 151–154.

Sloan, John. "Modern Art Is Dying." *Echo* 4 (December 1926): 22–23.

———. "The Indian Dance from an Artist's Point of View." *Arts and Decoration* 20 (January 1924): 17, 56.

Spinden, Herbert J. "Indian Art on Its Merits." *Parnassus* 3 (November 1931): 12–13.

———. "Indian Artists of the Southwest." *International Studio* 95 (February 1930): 40–51, 86.

"20,000 Years of Indian Art Assembled for New York Show." *Newsweek* 17 (3 February 1941): 57–58.

Vaillant, George C. "North American Indian Art." *Magazine of Art* 32 (November 1939): 622–627.

———. "Review of the Exhibition Indian Art of the United States." *Art Bulletin* 23 (June 1941): 167–169.

"The Vanishing Indian." *Art Digest* 14 (1 August 1940): 29.

Wade, Edwin L., and Lorraine Laurel Wade. "Voices of the Supernaturals: Rattles of the Northwest Coast." *American Indian Art Magazine* 2 (Winter 1976): 32–39, ff.

Walter, Paul A. F. "The Santa Fe–Taos Art Movement." *Art and Archaeology* 4 (December 1916): 330–338.

Whiting, F. A. "The New World Is Still New." *Magazine of Art* 32 (November 1939): 613.

Wilcox, U. Vincent. "The Museum of the American Indian, Heye Foundation." *American Indian Art Magazine* 3 (Spring 1978): 40–49.

Wolf, Arthur H. "The Indian Arts Fund Collection at the School of American Research." *American Indian Art Magazine* 4 (Winter 1978): 32–37.

Wolfe, Judith. "Jungian Aspects of Pollock's Imagery." *Artforum* 11 (November 1972): 65–73.

Exhibition Catalogues

Alloway, Lawrence, and Mary Davis McNaughton. *Adolph Gottlieb: A Retrospective*. New York: Arts Publishers, 1978.

Barr, Alfred H., Jr. *Max Weber*. New York: Museum of Modern Art, 1930.

Cahill, Holger. *Max Weber*. New York: Downtown Gallery, 1930.

Cikovsky, Nicolai, Jr. *Raymond Jonson: Pioneer Modernist of New Mexico*. New York: Berry-Hill Galleries, 1986.

Coe, Ralph T. *Sacred Circles*. Kansas City, Mo.: Nelson Gallery Foundation—Atkins Museum of Fine Arts, 1977.

Coke, Van Deren. *Marin in New Mexico, 1929 & 1930*. Albuquerque: University Art Museum, University of New Mexico, 1968.

———. *Raymond Jonson*. Albuquerque: University of New Mexico Press, 1964.

Douglas, Frederic H., and René d'Harnoncourt. *Indian Art of the United States*. New York: Museum of Modern Art, 1941. Reprint. New York: Arno Press, 1969.

Eldredge, Charles, Julie Schimmel, and William H. Truettner. *Art in New Mexico: 1900–1945: Paths to Taos and Santa Fe*. New York: Abbeville Press, 1986.

Fane, Diana, Ira Jacknis, and Lise M. Breen. *Objects of Myth and Memory: American Indian Art at the Brooklyn Museum*. Brooklyn: Brooklyn Museum in association with University of Washington Press, 1991.

Green, Eleanor. *John Graham: Artist and Avatar*. Washington, D.C.: Phillips Collection, 1987.

Haskell, Barbara. *Marsden Hartley*. New York: Whitney Museum of American Art, 1980.

Hobbs, Robert Carleton, and Gail Levin. *Abstract Expressionism: The Formative Years*. New York: Whitney Museum of American Art, 1978. Reprint. Ithaca, N.Y.: Cornell University Press, 1981.

———, and Joanne Kuebler. *Richard Pousette-Dart*. Indianapolis: Indianapolis Museum of Art, 1990.

Hodge, F. W., Oliver La Farge, and Herbert J. Spinden, eds. *Introduction to American Indian Art*. 2 vols. New York: Exposition of Indian Tribal Arts, 1931.

Kraft, James, and Helen Farr Sloan. *John Sloan in Santa Fe*. Washington, D.C.: Smithsonian Institution, 1981.

Kraskin, Sandra, Barbara Hollister, Ann Gibson, et al. *The Indian Space Painters: Native American Sources for American Abstract Art*. New York: Baruch College Gallery, 1991.

Messer, Thomas. *Will Barnet*. Boston: Institute of Contemporary Art, 1961.

Newman, Barnett. *The Ideographic Picture*. New York: Betty Parsons Gallery, 1946.

———. *Northwest Coast Indian Painting*. New York: Betty Parsons Gallery, 1946.

———. *Pre-Columbian Stone Sculpture*. New York: Betty Parsons Gallery, 1944.

North, Percy. *Max Weber*. New York: Jewish Museum, 1982.

O'Connor, Francis V. *Jackson Pollock*. New York: Museum of Modern Art, 1967.

Richardson, Brenda. *Barnett Newman: The Complete Drawings, 1944–1969*. Baltimore: Baltimore Museum of Art, 1979.

Rubin, William, ed. *"Primitivism" in 20th-Century Art*. 2 vols. New York: Museum of Modern Art, 1984.

Sandler, Irving. *Paul Burlin*. New York: American Federation of Arts, 1962.

Story, Ala. *Max Weber*. Santa Barbara: Art Galleries, University of California at Santa Barbara, 1968.

Index

(Boldface numbers indicate illustrations)